the *Art of* SEAMLESS KNITTING

SIMONA MERCHANT-DEST *and* FAINA GOBERSTEIN

INTERWEAVE.
interweave.com

Dedication

Faina:

To Simon, Eli, and Rebecca with unconditional love. You are my strength and inspiration.

Simona:

To my Grandmother, and my daughters Eliška, Marina, and Sofia. You are the force and bottomless pit of inspiration behind everything I do.

Editor
Ann Budd

Technical Editor
Lori Gayle

Photographer
Joe Hancock

Photo Stylist
Pamela Chavez

Hair and Makeup
Kathy MacKay

Art Director
Liz Quan

Cover and Interior Design
Pamela Norman

Layout Designer
Adrian Newman

Illustrations
Ann Swanson

Production
Katherine Jackson

Library of Congress Cataloging-in-Publication Data

Merchant-Dest, Simona.

The art of seamless knitting / Simona Merchant-Dest and Faina Goberstein.

 pages cm

 ISBN 978-1-59668-788-2 (pbk.)
 ISBN 978-1-59668-813-1 (PDF)

1. Knitting--Patterns. I. Goberstein, Faina. Title.

 TT825.M485 2013

 746.43'2041--dc23

 2012033944

10 9 8 7 6 5 4 3 2 1

 Interweave Press LLC
A division of F+W Media, Inc
201 East Fourth Street
Loveland, CO 80537
interweave.com

Manufactured in China by Asia Pacific Offset Ltd

Contents

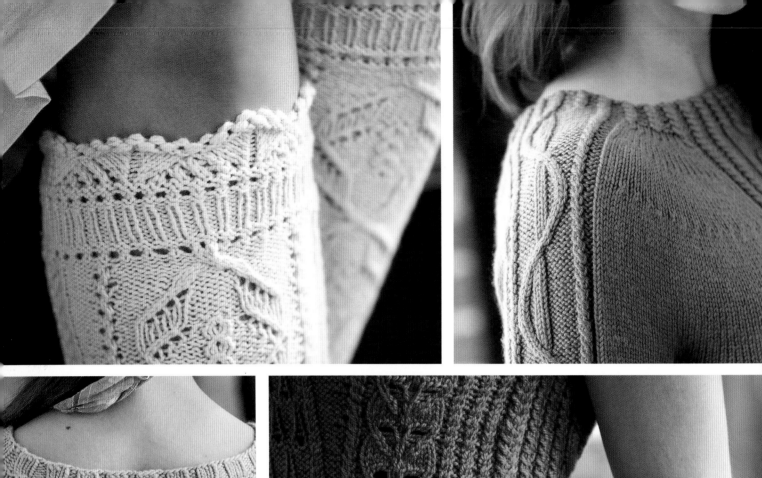

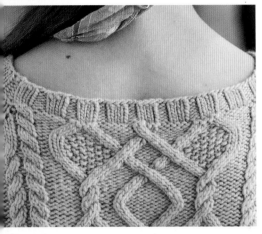

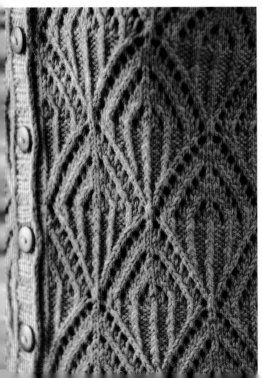

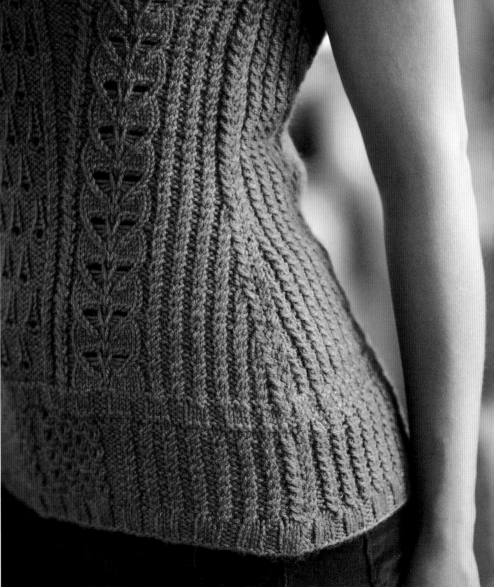

Introduction

Do you have the pieces of a garment hidden in a closet somewhere just waiting to be sewn together? If you're like a lot of knitters, those pieces have been waiting a long time because you prefer knittting to sewing. That goes a long way in explaining why we design as seamlessly as possible, but there are many other benefits as well.

Because there are no seams to sew, it takes much less time to put the finishing touches on a seamless garment—just bind-off, weave in the loose ends, block, and you're done! Because there are no seams, seamless garments tend to be less bulky, which is good news if you like to work with bulky yarns. Because there are no seams, you can be confident that there will be the same number of rows in the front and back to the armholes—no need to juggle mismatched lengths.

If you work seamlessly from the top down, whether you're working in rounds or rows, you have the added advantage of being able to try on the garment and adjust the armhole length or the waist shaping for a perfect fit. If you work seamlessly in rounds, the right side of the fabric is always facing you—you don't have to worry about gauge differences between right- and wrong-side rows and color and stitch patterns are much easier to work, especially those that involve pattern on every row.

In *The Art of Seamless Knitting*, we will take you on a journey to a deeper understanding of various seamless constructions and their usage with different stitch patterns, including the details that go into designing or customizing existing patterns. We'll discuss placement of stitch patterns for a flattering fit, converting flat patterns into working in the round, how to read and use charts, and much more. You will learn about the importance of gauge and how to use a swatch for your own designing to get the best custom fit. In addition to all of the technical information and in-depth topics, we offer a collection of 11 designs that apply the essential elements of seamless design and knitting.

The projects in this book are divided into chapters based on the type of stitch pattern used: lace, cables, and texture. Each chapter addresses particular design elements and techniques relevant to successful seamless construction. Tips and tricks offered throughout the book will help you to experiment with and make any design seamlessly yours.

We hope you will enjoy using book as much as we enjoyed writing it.

—Simona and Faina

All About Seamless Knitting

There are many ways to work seamlessly. Most of us are familiar with the classic raglan or seamless yoke styles. But almost any construction can be converted to seamless knitting if given a little thought, calculations, and good planning. Instead of ending by sewing pieces together, stitches are picked up along the edges of the existing piece for sleeves, collars, and edgings, and worked as extensions of these pieces.

Garments are typically worked from the top down or from the bottom up, and there are advantages to each method. Garments worked from the top down are easier to adjust for length and width, since you can try them on as you knit. The drawback is that you don't always have absolute control over shaping the yoke or neck openings, because these parts are closely related to armhole depth. So in some cases, a design decision is dictated by math.

Garments worked from the bottom up give you more control over the design process because they most closely mimic knitting flat (back and forth in rows) in pieces. The only difference between knitting flat and knitting seamlessly is that in seamless knitting we work all the sections in one piece right from the beginning, rather than sewing them up after they have been knitted. Some styles can be completely converted into seamless knitting while others, such as

garments with set-in sleeves, require a bit of sewing. We believe that the best fit for set-in sleeve styles occurs if the sleeve caps are knitted flat, then sewn in place, which is the method we employ in this book.

Most knitters equate seamless knitting with knitting in rounds. Even though this method is most commonly used, seamless knitting can also refer to garments knitted in rows, in which the body is worked in a single piece, as for cardigans.

Seamless Construction

To begin, let's review how seamless garments are constructed, whether they are worked from the bottom up or from the top down and whether they are knitted in rounds or rows.

Bottom-Up Construction Worked in Rounds

To work pullovers seamlessly from the bottom up, you'll first work the lower body in rounds to the armholes, then you'll add the sleeves (also worked in rounds) and work the yoke in a single piece to the shoulders, shaping the armholes and neck along the way.

Lower Body

For pullovers (and cardigans with steeks) worked in rounds from the bottom up, cast on the appropriate number of stitches for the front and the back, then join the stitches for working in rounds. Work the desired length to the underarms, shaping the waist and bust along the way, if desired.

Sleeves and Yoke

Continue for the specified type of armhole shaping as follows.

RAGLAN STYLE

On the next round, place the underarm stitches—usually about 1" to 4" (2.5 to 10 cm) in width—at each side onto a holder. Stitches for the front and back will remain on the needles. Set the body aside.

Cast on stitches for the cuffs and work the sleeves in the round for the desired length to the underarms, working increases as necessary to shape the sleeves to the upper arm circumference.

On the next round, place the underarm stitches (the same number of stitches as for the body underarm) onto a holder.

Bottom-Up Construction Worked in Rounds

Lower Body

Work the lower body in one piece from the lower edge to the armholes, shaping the waist along the way, if desired.

Raglan Shaping

Work the sleeves to the underarms, then join the sleeves to the body and decrease stitches along raglan lines to the neck, adding neck shaping if desired.

Circular Yoke Shaping

Work the sleeves to the underarms, then join the sleeves to the body and decrease stitches on specified rounds to the neck, adding neck shaping if desired.

Dolman Shaping

Work the upper front first by casting on the appropriate number of stitches for each sleeve and working sleeves and upper front in one piece to the shoulder, adding neck shaping if desired. Then pick up stitches at the base of the front sleeves for the back sleeves, and work the back and sleeves to the shoulders, shaping the neck along the way. To finish, join the shoulder stitches.

Set-in Sleeve Shaping

Work the upper back first by shaping the armhole, then work straight to the shoulder, adding neck and shoulder shaping if desired. Next, work the upper front to match, adding neck shaping along the way. To finish, join the shoulder stitches. Work sleeves in rounds from cuffs to underarms, then work sleeve caps back and forth in rows. Sew the sleeve caps into the armholes.

To join the sleeves to the body, work across the left sleeve stitches, place a marker, work across the front stitches, place a second marker, work across the right sleeve stitches, place a third marker, work across the back stitches, and place a fourth marker (it's a good idea for this marker to be a unique color) to denote the beginning of the round.

To shape the raglan, decrease one (or more) stitch before and after each marker every other round or every few rounds as specified. Working decreases on each side of each marker to shape the raglan lines as specified, continue in rounds to the neck.

If there is no neck shaping, work to the end in rounds. If there is front (or back) neck shaping, bind off the desired number of stitches at the center front (or back) and work in rows to the shoulders while continuing to decrease along the raglan lines.

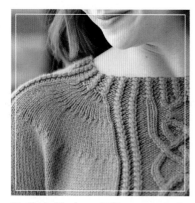

The Cabled Top (page 106) is an example of circular yoke construction worked from the bottom up in rounds.

CIRCULAR YOKE STYLE

On the next round, place the underarm stitches—usually about 1" to 4" (2.5 to 10 cm) in width—at each side onto a holder. Stitches for the front and back will remain on the needles. Set the body aside.

Cast on stitches for the cuffs and work the sleeves in the round for the desired length to the underarms, working increases as necessary to shape the sleeves to the upper arm circumference.

On the next round, place the underarm stitches (the same number of stitches as for the body underarm) onto a holder.

To join the sleeves to the body, work across the left sleeve stitches, the front stitches, the right sleeve stitches, then the back stitches. Place a marker to denote the beginning of the round.

Working the specified number of decrease rounds, continue to work in rounds to the neck. If there is no neck shaping, work to the end in rounds. If there is front (or back) neck shaping, bind off the desired number of stitches at the center front (or back) and work in rows while continuing to decrease to shape each side of the neck.

DOLMAN STYLE

For dolman sweaters, the upper front and back are worked separately.

FRONT: With the right side facing, work across the front stitches to the right side "seam." Cast on the desired number of stitches for the right sleeve, turn the work so the wrong side is facing and work to left side "seam." Cast on the same number of stitches for the left sleeve, then continue to work back and forth in rows to the beginning of the front neck shaping. Shape the sleeves with short-rows, if desired.

Shape the neck and shoulders as desired, then place the remaining sleeve and shoulder stitches on to a holder.

BACK: With the right side facing, join the yarn at the cast-on edge of the right sleeve. Pick up and knit one stitch in each cast-on stitch at the base of the right sleeve, work

across the back stitches to left side "seam," then pick up and knit one stitch in each cast-on stitch at the base of the left sleeve.

Continue to work back and forth in rows to the shoulders, shaping the sleeves (with short-rows, if desired), neck, and shoulders along the way.

Use the three-needle bind-off method to join the sleeve and shoulders stitches of the front to the corresponding stitches of the back.

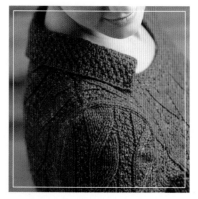

The Textured Pullover (page 142) is an example of set-in-sleeve construction worked from the bottom up in rounds.

SET-IN-SLEEVE STYLE

Mark the underarm stitches— usually about 1" to 4" (2.5 to 10 cm) in width—centered over each side "seam." Beginning at the left side "seam," bind off half the underarm stitches, work across front stitches to the marked underarm stitches, bind off the full number of underarm stitches centered over the right side "seam," work across the back stitches to the marked underarm stitches, then bind off the remaining underarm stitches. The body is now divided into front and back.

Place the front stitches onto a holder and work the back and front separately.

BACK: Continue on the back stitches only, shape the armholes, neck, and

shoulders as specified, then place the remaining shoulder (and neck) stitches on separate holders.

FRONT: Transfer the held front stitches to the needles. Join yarn and shape the armholes as for the back. Shape the neck and shoulders as specified, then place the remaining shoulder stitches onto a holder.

Use the three-needle bind-off or Kitchener stitch to join the front and back shoulders. Set the body aside.

Cast on stitches for the cuffs and work the sleeves in the round for the desired length to the underarms, working increases to shape the sleeves to the upper arm circumference. On the next round, bind off the underarm stitches centered over the "seam"

(the same number of stitches as for the body underarm). Shape the cap as specified and bind off the remaining stitches.

Sew the sleeve caps into the armholes.

Bottom-Up Construction Worked in Rows

Lower Body

To work cardigans seamlessly from the bottom up, you'll work the lower body back and forth in rows to the armholes, then add the sleeves (worked in the round) and work the yoke to the shoulders, shaping the armholes and neck along the way.

For cardigans worked in rows from the bottom up, cast on the

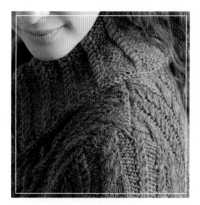

The Cabled Cardigan (page 90) is an example of set-in-sleeve construction worked from the bottom up in rows.

Bottom-Up Construction Worked in Rows

Lower Body

Work the lower body in one piece back and forth in rows to the armholes, beginning and ending at the center front.

Raglan Shaping

Work the sleeves to the underarms, then join the sleeves to the body and decrease stitches along raglan lines to the neck, adding neck shaping as desired.

Circular-Yoke Shaping

Work the sleeves to the underarms, then join the sleeves to the body and decrease stitches on specified rounds to the neck, adding neck shaping if desired.

Dolman Shaping

Work the right front first by casting on the appropriate number of stitches for each sleeve and working to the neck edge, adding neck shaping, if desired. Work the left front the same way. For the back, pick up stitches at the base of the front sleeves and work to the shoulders, shaping the neck along the way. To finish, join the shoulder and sleeve stitches.

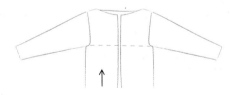

Set-in Sleeve Shaping

Work the upper back first by shaping the armholes, then working straight to the shoulder, adding neck and shoulder shaping if desired. Then work the upper right front to match, followed by the upper left front. To finish, join the shoulder stitches.

appropriate number of stitches for the right front, place a marker to denote the right side "seam," cast on the appropriate number of stitches for the back, place a second marker to denote the left side "seam," then cast on the appropriate number of stitches for the left front. Work the desired length to the underarms, shaping the waist and bust along the way, if desired, and ending with a wrong-side row.

Sleeves and Yoke

Continue for the specified type of armhole shaping as follows.

RAGLAN STYLE

On the next wrong-side row, place the underarm stitches—usually about 1" to 4" (2.5 to 10 cm) in width—at each side of the side "seam" marker onto a holder. The right front, back, and left front stitches will remain for the body. Set the body aside.

Cast on stitches for the cuffs and work the sleeves in the round for the desired length to the underarms, working increases as necessary to shape the sleeves to the desired upper arm circumference.

On the next row, place the underarm stitches (the same number of stitches as for the body underarm) onto a holder.

To join the sleeves to the body, with right-side facing, work across the right front stitches, place a marker, work across the right sleeve stitches, place a second marker, work across the back stitches, place a third marker, work across the left sleeve stitches, place a fourth marker, then work across the left front stitches.

To shape the raglan, decrease one (or more) stitch before and after each marker every other or every few rows as specified.

To shape the front (and back) neck, bind off the desired number of

stitches at the center front (and back) and continue in rows while working decreases to shape each side of the neck.

CIRCULAR-YOKE STYLE

On the next right-side row, place the underarm stitches—usually about 1" to 4" (2.5 to 10 cm) in width—at each side onto a holder. Stitches for the right front, back, and left front body will remain on the needles. Set the body aside.

Cast on stitches for the cuffs and work the sleeves in the round for the desired length to the underarms, working increases as necessary to shape the sleeves to the upper arm circumference. On the next row, place the underarm stitches (the same number of stitches as for the body underarm) onto a holder.

To join the sleeves to the body, work across the right front stitches, then the right sleeve stitches, the back stitches, the left sleeve stitches, and the left front stitches.

To shape the yoke, work three (or more) decrease rows, decreasing the specified number of stitches at the specified intervals.

To shape the front (and back) neck, bind off the desired number of

The Textured Jacket (page 128) is an example of dolman construction worked from the bottom up in rows.

stitches at the center front (and back) and work the shoulders separately while working decreases to shape each side of the neck.

DOLMAN STYLE

For dolman sweaters, the front and back are worked separately.

RIGHT FRONT: With the right side facing, work across the right front stitches to the right side "seam." Cast on the desired number of stitches for the right sleeve, turn the work so that the wrong side is facing and work to the center front. Work the right front in rows to the neck.

Shape the neck and shoulder as desired, working short-rows across the top of the sleeve. Place stitches onto a holder.

LEFT FRONT: With the right side facing, join the yarn to the left side "seam" and work to the center front. Turn the work and, working to the left side "seam," cast on the desired number of stitches for the left sleeve, turn the work so that the right side is facing and work to the center front. Work the left front in rows to the neck.

Shape the neck and shoulder as desired, working short-rows across the top of the sleeve. Place stitches onto a holder.

BACK: With the right side facing, join the yarn to cast-on edge of right front sleeve. Pick up and knit one stitch for every cast-on stitch for the right sleeve, work across the back stitches to the left side "seam," then pick up and knit one stitch for every cast-on stitch for the left sleeve. Work the back in rows to the neck.

Shape the neck and shoulders as desired, working short-rows across the top of the sleeves. Place the stitches onto a holder.

Use the three-needle bind-off or the Kitchener stitch to join the fronts to the back along the sleeves and shoulders.

SET-IN-SLEEVE STYLE

Mark the underarm stitches—usually about 1" to 4" (2.5 to 10 cm) in width—centered over each side "seam." Beginning at the center front, work to the marked stitches at the right side "seam," bind off the marked stitches, work across the back to the next set of marked stitches, bind off the marked stitches, then work to the center front. The body is now divided into a right front, back, and left front.

Place the front stitches on separate holders. Work the back and the two front sections separately.

BACK: Continue on the back stitches only, shape the armholes, neck, and shoulders as specified, then place the remaining shoulder (and neck) stitches onto separate holders.

RIGHT FRONT: Transfer the held right front stitches onto a needle. Join yarn and shape the armhole as for the back. Shape the neck and shoulder as specified, then place the remaining shoulder stitches onto a holder.

LEFT FRONT: Transfer the held left front stitches onto a needle. Join yarn and shape the armhole as for the back. Shape the neck and shoulder as specified, then place the remaining shoulder stitches onto a holder.

Use the three-needle bind-off or Kitchener stitch to join the front and back shoulders. Set the body aside.

Cast on stitches for the cuffs and work the sleeves in the round for the desired length to the underarms, working increases to shape the sleeves to the upper arm circumference. On the next round, bind off the underarm stitches (the same number of stitches as for the body underarm). Shape the cap as specified and bind off the remaining stitches.

Sew the sleeve caps into the armholes.

Top-Down Construction Worked in Rounds

To work pullovers seamlessly from the top down, cast on stitches for the neck and work to the base of the armholes, shaping the neck and armholes along the way. Then work the body (in the round) to the lower edge. To finish, work the sleeves (in the round) to the cuffs.

Yoke

Cast on and work for the specified type of armhole shaping as follows.

RAGLAN STYLE

Cast on the necessary number of stitches for the neck circumference, placing markers to denote the raglan lines between the front, back, and sleeves. If the front neck is deeper than the back neck, begin by casting on the appropriate number of stitches for the back and

Top-Down Construction Worked in Rounds

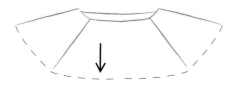

Raglan Shaping

Cast on stitches for the neck and shape the neck as desired while working increases along the raglan lines to the base of the armholes. Place the sleeve stitches onto holders and work the remaining body stitches in rounds to the lower edge. To finish, work the sleeves in rounds to the desired length.

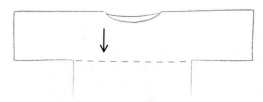

Dolman Shaping

Provisionally cast on stitches for the front right shoulder and sleeve and work back and forth to the base of the neck shaping. Repeat for the left front shoulder and sleeve, joining the two halves at the base of the neck and working in a single piece to the base of the armholes. Then pick up stitches from the provisional cast on for the back; work the back to the base of the armholes, shaping the back neck as desired. Bind off the front and back sleeve stitches together, then work the remaining body stitches in rounds to the lower edge.

Circular-Yoke Shaping

Cast on stitches for the neck and shape the neck as desired while working the specified number of increase rounds to the base of the armholes. Place the sleeve stitches onto holders and work the remaining body stitches in rounds to the lower edge. To finish, work the sleeves in rounds to the desired length.

Lower Body

Work the body stitches in rounds to the lower edge, shaping the waist and hips as desired.

sleeves and just one or two stitches for each front.

To shape the front neck, work back and forth in rows while increasing stitches each side of each marker for the raglan lines, and at the same time cast on and increase stitches for the front neck as specified.

When the desired front neck depth and shape is reached, cast on the necessary number of additional neck stitches (if any) to join the two fronts, and join for working in rounds. Rounds begin at the back left marker, at the start of the back stitches.

Continue in rounds, increasing stitches each side of each marker to shape the raglan lines, to the base of the armholes.

On the next round, place the sleeve stitches onto holders as follows, removing markers when you come to them: Work across the back stitches, place the right sleeve stitches onto a holder, cast on the desired number of underarm stitches, work across the front stitches, place the left sleeve stitches onto another holder, cast on the specified number of underarm stitches. Place a new marker in the center of the last group of underarm stitches to denote the beginning of the round.

Skip to Lower Body.

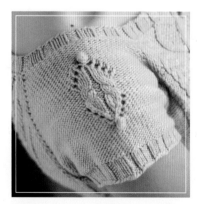

The Cabled Tunic (page 80) is an example of raglan construction worked from the top down in rounds.

CIRCULAR-YOKE STYLE

Cast on the necessary number of stitches for the neck circumference. If the front neck is deeper than the back neck, begin by casting on the appropriate number of stitches for the back and sleeves and just one or two stitches for each front.

To shape the front neck, work back and forth in rows while increasing stitches as specified for yoke shaping and, at the same time, cast on and increase stitches for the front neck.

When the desired front neck depth and shape is reached, cast on the necessary number of additional neck stitches (if any) to join the two fronts, and join for working in rounds, placing a marker to denote the beginning of the round between the back and left sleeve at the start of the back stitches.

Continue in rounds, working increase rounds as specified, to the base of the armholes.

On the next round, place the sleeve stitches onto holders as follows: Work across the back stitches, place the right sleeve stitches onto a holder, cast on the specified number of underarm stitches, work across the front stitches, place the left sleeve stitches onto another holder, cast on the specified number of underarm stitches. Place a new marker in the center of the last group of underarm stitches to denote the beginning of the round.

Skip to Lower Body.

DOLMAN STYLE

Beginning with the back, use a provisional method to cast on stitches for the right shoulder and sleeve. Working back and forth in rows, work to the base of the neck, shaping the neck as desired, ending with a wrong-side row. Place these stitches onto a holder. Work the left back in the same way, reversing the neck shaping. With the right side facing, join the two halves together

by working the left half, then casting on the necessary number of stitches for the back neck, then working the right half. Continue to work back and forth in rows across all back and back sleeve stitches to the base of the armholes. Place all of these stitches onto a holder.

With the right side facing, carefully remove the waste yarn from the provisional cast-on and place the exposed stitches onto a needle for each half of the front. Work the same as each half of the back, shaping the neck as desired, until the piece measures to the base of the armholes.

To complete the sleeves, use the three-needle method to bind off the specified number of right front sleeve stitches together with the corresponding right back sleeve stitches. Repeat for the left side. Place the remaining front and back stitches onto a single circular needle to work in rounds, placing a marker at the left side "seam."

Lower Body

Working the front and back stitches in rounds to the desired length, shape the waist and hips as desired. Bind off all stitches at the lower body edge.

Sleeves

Note: The sleeves are already completed for the dolman style.

Return the held sleeve stitches onto the needles. With the right side facing, join yarn at the center of the underarm cast-on edge, pick up and knit half of the stitches cast on across the underarm, work the sleeve stitches, then pick up and knit the same number of stitches along the other half of the underarm cast-on edge. (To help prevent holes, pick up and knit an extra stitch at each end of the underarm stitches, then work each extra stitch together with the neighboring underarm stitch on the next round). Place a marker and

join for working in rounds. Continue in rounds, tapering the sleeves as desired to the cuffs.

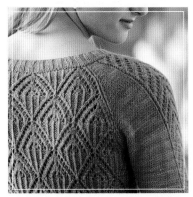

The Lace Cardigan (page 48) is an example of raglan construction worked from the top down in rows.

stitches on each side of each marker for the raglan lines and, at the same time, cast on and increase stitches for the front neck.

When the desired front neck depth and shape is reached, cast on the necessary number of stitches to achieve the desired front widths.

Continue in rows, increasing stitches each side of each marker to shape the raglan lines to the base of

the armholes, ending with a wrong-side row.

On the next right-side row, place the sleeve stitches onto holders as follows, removing markers when you come to them: Work across the left front stitches, place the left sleeve stitches onto a holder, cast on the desired number of underarm stitches, work across the back stitches, place the right

Top-Down Construction Worked in Rows

Raglan Shaping
Cast on stitches for the neck and shape the neck as desired while working back and forth in rows, increasing along the raglan lines to the base of the armholes. Place the sleeve stitches onto holders and work the remaining body stitches in rows to the lower edge. To finish, work the sleeves in rounds to the desired length.

Circular-Yoke Shaping
Cast on stitches for the neck and shape the neck as desired while working the specified number of increase rows to the base of the armholes. Place the sleeve stitches onto holders and work the remaining body stitches in rows to the lower edge. To finish, work the sleeves in rounds to the desired length.

Top-Down Construction Worked in Rows

To work cardigans seamlessly from the top down, cast on stitches for the neck and work back and forth in rows to the base of the armholes, shaping the neck and armholes along the way. Then work the lower body in one piece in rows to the lower edge. To finish, work the sleeves (in the round) to the cuffs.

Yoke
Cast on and work for the specified type of armhole shaping as follows.

RAGLAN STYLE
Cast on the necessary number of stitches for the neck circumference, placing markers to denote the raglan lines between the fronts, back, and sleeves. If the front neck is deeper than the back neck, begin by casting on the appropriate number of stitches for the back and sleeves and just one or two stitches for each front section.

To shape the front neck, work back and forth in rows while increasing

Dolman Shaping
Provisionally cast on stitches for the back right shoulder and sleeve and work back and forth to the base of the neck shaping. Repeat for the back left shoulder and sleeve, joining the two halves at the base of the neck and working in one piece to the base of the armholes. Then pick up stitches from the provisional cast-on for the front, work the front to the base of the armholes, shaping the front neck as desired. Bind off the front and back sleeve stitches together, then work the remaining body stitches in rows to the lower edge.

Lower Body
Work the lower body in one piece in rows to the lower edge, shaping the waist and hips as desired.

sleeve stitches onto a holder, cast on the desired number of underarm stitches, then work across the right front stitches.

Skip to Lower Body.

CIRCULAR-YOKE STYLE

Cast on the necessary number of stitches for the neck circumference. If the front neck is deeper than the back neck, begin by casting on the appropriate number of stitches for the back and sleeves and just one or two stitches for each front.

To shape the front neck, work back and forth in rows while increasing stitches as specified for yoke shaping and, at the same time, cast on and increase stitches for the front neck.

When the desired front neck depth and shape are reached, cast on the necessary number of stitches to achieve the desired front widths.

Continue working back and forth in rows, working increase rows as specified, to the base of the armholes, ending with a wrong-side row.

On the next right-side row, place the sleeve stitches onto holders as follows: Work across the left front stitches, place the left sleeve stitches onto a holder, cast on the desired number of underarm stitches, work across the back stitches, place the right sleeve stitches onto a holder, cast on the desired number of underarm stitches, then work across the right front stitches.

Skip to Lower Body.

DOLMAN STYLE

Beginning with the back, use a provisional method to cast on stitches for the right shoulder and sleeve. Working back and forth in rows, work to the base of the neck, shaping the neck as desired, ending with a wrong-side row. Place these stitches onto a holder.

Work the left back in the same way, reversing the neck shaping. With the right side facing, join the two halves together by working across the left half, casting on the necessary number of stitches for the back neck, then working across the right half. Continue to work back and forth in rows across all back and back sleeve stitches to the base of the armholes. Place all of these stitches onto a holder.

With the right side facing, carefully remove the waste yarn from the provisional cast-on and place the exposed stitches on a needle for each half of the front. Work the same as each half of the back, shaping the neck as desired, until the piece measures to the base of the armholes.

To complete the sleeves, use the three-needle method to bind off the specified number of right front sleeve stitches together with the corresponding right back sleeve stitches. Repeat for the left side. With the right side facing, place the remaining right front, back, and left front stitches onto a single circular needle to work in rows, placing a marker at the right and left side "seams."

Lower Body

Beginning and ending at the center front, work the body in rows to the desired length, shaping the waist and hips as desired. Bind off all stitches at the lower body edge.

Sleeves

Note: *The sleeves are already completed for the dolman style.*

Return the held sleeve stitches to the needles. With the right side facing, join yarn at the center of the underarm cast-on edge, pick up and knit half of the stitches cast on across the underarm, work the sleeve stitches, then pick up and knit the same number of stitches along the other half of the underarm cast-

on edge. (To help prevent holes, pick up and knit an extra stitch at each end of the underarm stitches, then work each extra stitch together with the neighboring underarm stitch on the next round). Place a marker and join for working in rounds. Continue in rounds, tapering the sleeves as desired to the cuffs.

Using Charts

We are both fans of using charts instead of endless row-by-row instructions, and that's what you'll find in this book. Charts are symbolic representations of how knitted fabric will look when viewed from the right side (the public, or outside) of the fabric. Charts let you see how certain stitch manipulations relate to one another both from stitch to stitch and from row to row, and they take up much less space than row-by-row instructions. Therefore, it is much easier to follow a pattern and to catch mistakes right away.

Another advantage that charts have over row-by-row instructions is that they provide a grid upon which you can plan the placement of increases and decreases, such as when you want to plan armhole, neck, or waist shaping. By superimposing shaping increases and decreases on a chart, you can be sure to place them in such a way as to maintain the integrity of the stitch pattern so that it can flow smoothly from one part of the garment to another.

Reading Charts

A chart is a grid of cells aligned in columns and rows. The number of columns represents the number of stitches; the number of rows represents the number of rows or rounds in the pattern. Unless otherwise specified, the rows are read from the bottom to the top, and each cell represents one stitch. The symbol within each cell indicates how that stitch should be worked. Each row of a chart indicates what the knitting will look like after the row has been worked, as viewed from the right side (the public side) of the knitting.

The same chart can be used for knitting circularly in rounds or for knitting back and forth in rows. When working in rounds, in which the right side of the work is always facing you, every chart row is read from right to left. In this case, the rows may be numbered along the right edge of the chart (**Figure 1**).

When working back and forth in rows, in which you alternate between right- and wrong-side rows, the chart is read from right to left for right-side rows and from left to right for wrong-side rows. For these charts, right-side rows are numbered on the right edge and wrong-side rows are not numbered (**Figure 2**).

If the first row of a chart is labeled on the right edge, you'll begin that chart with a right-side row. If the first row is labeled on the left edge, you'll begin with a wrong-side row.

Symbols

The symbols in a chart represent how the stitches look when viewed from the right side, after a particular row has been completed. When working right-side rows or rounds, you'll work each stitch exactly as the symbol appears. But when you work a wrong-side row, you'll have to work some of the stitches differently so that they

appear correct on the right side of the fabric. For example, if you want a knit stitch to appear on the right side, you'll need to purl that stitch when you work a wrong-side row. These differences should be made clear in the key that accompanies any chart (**Figure 3**). If a stitch is worked the same on right- and wrong-side rows, the key will give a single definition.

Pattern Repeats

Groups of stitches that are repeated both widthwise and lengthwise in a chart are considered pattern repeats. These repeats are typically bordered with a thick red line, such as the ten stitches and six rows outlined in **Figure 3**. You would begin working this chart with Row 1, which is a wrong-side row that is read from left to right. For this row, you would work the first stitch, then repeat the next ten stitches until one stitch remains, then work the last stitch.

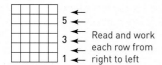

Figure 1

When knitting in rounds, every row of a chart is read from right to left.

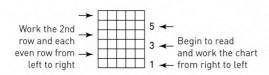

Figure 2

When knitting in rows, the chart is read alternately from right to left (for right-side rows) and from left to right (for wrong-side rows).

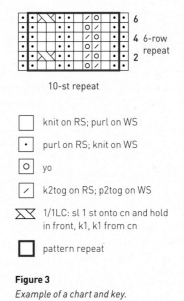

Figure 3

Example of a chart and key.

The written instructions for Row 1 would read:

ROW 1: (WS) K1, *k1, p2, k2, p1, yo, p2tog, p1, k1; rep from * to last st, k1.

Row 6 of the same chart would read:

ROW 6: (RS) P1, *p1, k1, yo, k2tog, k1 p2, 1/1 LC, p1; rep from * to last st, p1.

Notice that the written instructions specify exactly how wrong-side rows are worked, whereas the chart only shows stitches as they appear on the right side of the fabric—it's up to you to recognize that the symbols have different meanings for wrong-side rows.

Converting Stitch Patterns Written for Working in Rows to Working in Rounds

When designing a garment or an accessory, we usually reach for one of our many trusted stitch dictionaries. If you've ever flipped through a stitch dictionary, you might have noticed that the stitch patterns are almost always written for knitting back and forth in rows. In order to work any of these patterns in rounds, the row-by-row instructions need to be converted for working every row as a right-side row. The easiest way to do this is to translate the instructions into a chart that represents the pattern worked in rows. Then you can extrapolate for knitting in rounds by reading each row as a right-side row, as explained below.

Converting Row-by-Row Instructions into a Chart

It's not difficult to translate row-by-row instructions into chart form. All you need is some graph paper, a pencil, and an eraser.

STEP 1: Identify the number of stitches and rows in a pattern repeat.

Mark a grid on the graph paper that equals the number of stitches wide and the number of rows tall as the pattern requires. It's a good idea to plot two full pattern repeats in width to see how the stitches relate to each other at the boundaries between pattern repeats. For example, the Fairy Wings stitch pattern is a multiple of four stitches plus three, and is worked over four rows. The written instructions are as follows (the chart is in **Figure 4**):

**FAIRY WINGS
(MULTIPLE OF 4 STS + 3)**

ROW 1: (RS) K1, *yo, k3tog, yo, k1; rep from * to last 2 sts, yo, ssk.

ROWS 2 AND 4: Purl.

ROW 3: K2tog, yo, *k1, yo, k3tog, yo; rep from * to last st, k1.

Repeat Rows 1–4 for pattern.

To translate this pattern into a chart, mark a grid on your graph paper that is two full repeats wide (8 stitches) plus 3 balancing stitches, for a total of 11 stitches wide. Because this is a four-row repeat, draw an outline that is 11 cells wide and 4 cells tall.

STEP 2: Identify which are right- and which are wrong-side rows.

Look at the written instructions and identify the right- and wrong-side rows. For the Fairy Wings pattern, odd-numbered rows are right-side rows, which means that the first row of the chart will be labeled on the right-hand edge of the chart. Odd-numbered rows are wrong-side rows and may or may not be labeled on the left edge of the chart.

STEP 3: Place symbols in each box that represent the way each stitch will appear when viewed from the right (public) side.

Beginning with Row 1 of the pattern at the lower right-hand corner and working from right to left, place a symbol in each cell to specify how each stitch is worked. Working from

left to right for Row 2 (a wrong-side row), place a symbol in each cell, being careful to use symbols that indicate how the stitches will appear from the right (public) side. For example, instead of placing purl dots across Rows 2 and 4, you will leave the cells blank to indicate that they appear as knit stitches when viewed from the right side of the fabric.

STEP 4: Mark the pattern repeat.

The stitch repeat is indicated by the group of stitches that begin with an asterisk (*) in the written instructions. Outline these stitches with red so that they will stand out. In our example, the pattern repeat is shown twice widthwise (plus balancing stitches) and once lengthwise.

Balancing Stitch Patterns

The chart for the Fairy Wings pattern in **Figure 4** assumes the pattern will be knitted in rows, as for a cardigan. Balancing stitches on each side of the pattern repeat ensures the overall pattern will appear balanced between the first stitch of the row and the last stitch of the row, both of which will be visible along the center front opening. If this pattern were to be worked in rounds, the balancing stitches would not be necessary.

When knitting seamlessly in rows, as for a cardigan, you need to be particular about the position of the stitch pattern around the entire circumference of a piece. For garments that are assembled with seams, selvedge stitches are typically worked at each edge of each piece. These selvedge stitches become the seam allowances when the pieces are sewn together. The purpose of seamless knitting is to avoid sewing pieces together. Therefore, when working a cardigan seamlessly, there will be no side

seams and no need for selvedge stitches at the sides. However, you do need to maintain the balancing stitches at the center front edges in order to add a buttonband, as for the Lace Cardigan on page 48, or to add a decorative edging, as for the Textured Jacket on page 128.

A great variety of projects can be knitted in rounds—hats, socks, gloves, pullovers, and even cardigans if steeks are used along the center front and armholes. The way to convert a chart designed for knitting in rows into one that can be used for knitting in rounds depends on the type of stitch pattern.

Self-Standing (Vertical) Patterns

Self-standing patterns appear balanced within the pattern repeat. In most cases, these patterns do not include extra balancing stitches for overall symmetry, even though the patterns themselves may be symmetrical or asymmetrical.

Symmetrical patterns are those that are symmetrical within each pattern repeat. Corresponding, or mirrored, stitches appear the same distance each side of the central point. If there is an odd number of stitches in the pattern repeat, the central point is represented by a central stitch, as shown in **Figure 5**. If there is an even number of stitches in the pattern repeat, the central point lies between the two center stitches.

In asymmetrical patterns, the stitches to the left of the central point do not mirror the stitches to the right, as shown in **Figure 6**. Notice that this pattern involves balancing stitches at the beginning and end of each row.

Self-standing charts, whether they are symmetrical or asymmetrical, are the easiest to convert for knitting in rounds. Simply extract the pattern repeat outlined in red and repeat it the necessary number

of times each round, as shown in **Figures 7** and **8**.

Non-Self-Standing Patterns

Non-self-standing patterns require balancing stitches to appear complete. Even though the chart in **Figure 9** (page 18) is very similar to one in **Figure 5**, it is not symmetrical because it includes an extra knit stitch at the beginning of each pattern repeat that is not mirrored

at the end of the repeat. The result is a slightly lopsided pattern where the central point of the chart is not aligned with the central point of the pattern.

When converting this type of chart for working in rounds, it's necessary to know whether or not the pattern has to be centered. If the pattern is used for a hat or cowl, the pattern does not have to be centered in any particular way. In these cases, it's necessary to only repeat the part

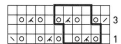

Figure 4

The Fairy Wings pattern repeats over 4 stitches, plus 3 balancing stitches, and over 4 rows.

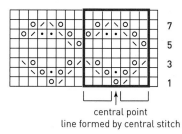

central point
line formed by central stitch

Figure 6

An asymmetrical self-standing pattern is not symmetrical around a center point in the pattern.

	knit on RS; purl on WS
•	purl on RS; knit on WS
o	yo
╱	k2tog on RS; p2tog on WS
╲	ssk on RS; ssp on WS
⋀	sl 2 sts as if to k2tog, k1, p2sso
⋏	k3tog
	pattern repeat

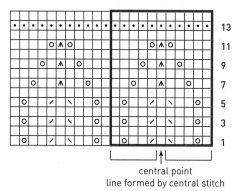

central point
line formed by central stitch

Figure 5

A symmetrical self-standing pattern is symmetrical around a center point in the pattern.

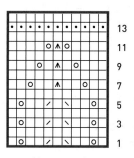

11-st repeat

Figure 7

The symmetrical self-standing pattern in Figure 5 converted for knitting in rounds.

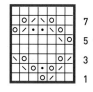

7-st repeat

Figure 8

The asymmetrical self-standing pattern in Figure 6 converted for knitting in rounds.

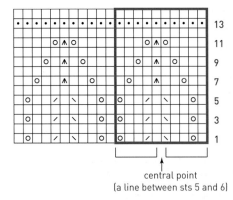

central point
(a line between sts 5 and 6)

Figure 9

A non-self-standing pattern is not symmetrical around a center point and requires balancing stitches to appear complete.

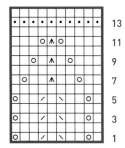

Figure 10

The non-self-standing pattern in Figure 9 converted for knitting in rounds when it's not critical where the pattern begins or ends, as for a hat or cowl.

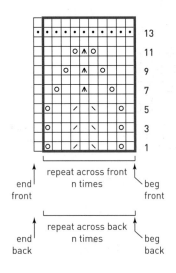

repeat across front
n times

end front | beg front

repeat across back
n times

end back | beg back

Figure 11

If a non-self-standing pattern is used for a pullover, at least one balancing stitch is required at the end of the last pattern repeat (i.e., the last stitch on each front and back).

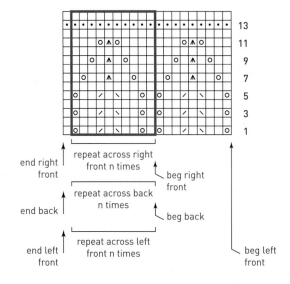

end right front | repeat across right front n times | beg right front

end back | repeat across back n times | beg back

end left front | repeat across left front n times | beg left front

Figure 12

If a non-self-standing pattern is used for a seamless cardigan, at least one balancing stitch is added at the end of the last pattern repeat (i.e., the last stitch of the left front).

☐ knit on RS; purl on WS

• purl on RS; knit on WS

○ yo

╱ k2tog on RS; p2tog on WS

╲ ssk

⋀ sl 2 sts as if to k2tog, k1, p2sso

☐ pattern repeat

of the pattern that is outlined in red (**Figure 10**). However, if the same pattern is used in a project in which a centered pattern is important, as in a pullover, the pattern needs to be centered in such a way that the front and back will appear symmetrical. In these cases, it's important to add a balancing stitch (or stitches) for a symmetrical look, as shown in **Figure 11**.

When converting this type of chart for working seamlessly in rows, as for cardigans, the pattern has to be centered in much the same way as for a pullover. A simplified example is shown in **Figure 12**, but does not take into account possible adjustments for button and buttonhole bands on the fronts. This example assumes the front edges will be "raw" or finished with single crochet. For more on how to place patterns on cardigans, see page 16.

Diagonal and Travelling Stitch Patterns

Travelling stitch patterns are those that are mostly worked on a diagonal or those that involve stitches that cross over their neighbors in a diagonal progression. These patterns are non-self-standing.

The chart in **Figure 13** is an example of a diagonal pattern. Notice that the 14th stitch on Row 11 is k2tog, whereas a centered double decrease is worked in the similar position in previous rows. Because there are not enough stitches available to work the double decrease in Row 11, it is replaced with a single (k2tog) decrease. The yarnover and the missing decrease have moved to the beginning of the chart (as the 2nd and 3rd stitches). To balance the pattern, this decrease at the beginning of the row is worked as ssk instead of k2tog, and the overall pattern has moved one stitch to the left.

Converting charts of diagonal patterns from working in rows to working in rounds requires little more than simply extracting the pattern repeat, then adding additional stitches to the multiple to complete a pattern. If we worked just the pattern repeat in rounds, as shown in **Figure 14**, we would run out of stitches at some point and be unable to work or shift the complete pattern. Round 3 is such an example. According to this row of the chart, a yarnover should be worked at the beginning of the repeat, but because there is no decrease paired with this yarnover, there will be an increase of one stitch at the beginning of the repeat. At the end of this round, there are not enough stitches to work the centered double decrease—the missing stitch is the same stitch that was added at the beginning of the round. A similar problem occurs on Round 5, where there are not enough stitches to work the centered double decrease at the beginning of the round and a yarnover is worked without a decrease at the end of the round.

For the chart to work properly when knitting in rounds, the stitch repeat needs to be extracted on a diagonal, as shown in **Figure 15**. In doing so, the beginning of the round shifts one stitch to the left every other round. For hats or cowls, where it doesn't matter if the beginning of the round shifts every row, the chart can be worked exactly as it appears. For projects such as pullovers, where it is important to keep the beginning of the round at the same place, the marker will need to be moved to its original position after every vertical pattern repeat, as shown in Round 12.

When working seamlessly in rows, as for a cardigan that involves side, armhole, and neck shaping, it's important to maintain divisions between the back and fronts so that the shaping is worked symmetrically between

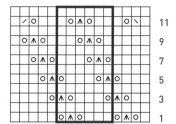

Figure 13

For some rows of some patterns that travel on the diagonal, the decreases and increases can be split between the beginning and the end of the row.

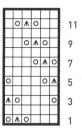

Figure 14

If just the pattern repeat is extracted from a diagonal pattern, there are rounds (i.e. Round 3 and Round 5) where there is an extra stitch added by a yarnover at one end of the round and not enough stitches to perform the accompanying decrease at the other end.

return marker for beg of round to its original position here

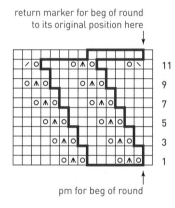

pm for beg of round

Figure 15

If the pattern repeat travels on a diagonal as the stitch pattern, the beginning-of-round marker needs to be moved to its original position at the end of every vertical pattern repeat.

	knit on RS; purl on WS
o	yo
/	k2tog on RS; p2tog on WS
****	ssk
⋀	sl 2 sts as if to k2tog, k1, p2sso
	pattern repeat

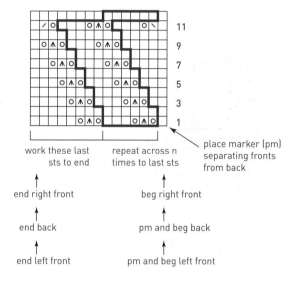

work these last sts to end repeat across n times to last sts

place marker (pm) separating fronts from back

end right front beg right front

end back pm and beg back

end left front pm and beg left front

Figure 16

Work balancing stitches at the beginning and end of the fronts and back of cardigans worked seamlessly in rows.

the sections. Balancing stitches are added at the beginning and end of the charted pattern across the fronts and back, as shown in **Figure 16**, and create faux seams. In this example, there will be two plain

knit stitches next to each other at each side "seam." However, these stitches could be worked in some other decorative pattern just as well (see Lace Cardigan on page 48). For

more on pattern stitch placement, see page 38.

If the diagonal pattern is to be used only on the lower portion of the body before the armholes are shaped, it is possible to work the chart shown in **Figure 16** from right to left, always repeating the six-stitch repeat across the right front, back, and left front, beginning and ending with the plain knit stitches and omitting the need for faux seams.

To keep track of the boundaries between the fronts and back, place side "seam" markers at the beginning of the necessary pattern repeats on Round 1, move them one stitch to the left every other round through Round 11, then move them back to their original locations (five stitches to the right) on Round 12.

Patterns with Fluctuating Stitch Counts

For some patterns that change stitch count, it becomes necessary to chart all of the shaping in order to keep track of the number of increases or decreases that have been worked. The Trinity pattern **(Figure 17)**, which is used in the Textured Jacket on page 128, is such an example. In this particular pattern, the number of stitches remains constant from row to row within the pattern repeat, so it can easily be worked even. However, if shaping (with increases or decreases) is introduced, the fluctuating stitches can become problematic.

To convert this asymmetrical self-standing pattern for knitting in rounds, simply extract the pattern repeat and work each row from right to left, as shown in the chart in **Figure 18**. To use this pattern in a garment, you can use the chart shown in **Figure 18** and work in uninterrupted rounds, or you can use it as a panel that includes balancing stitches, which can guide the position of any shaping increases or decreases, as shown in **Figure 19**. Note that this pattern cannot be truly "centered" because the number of stitches fluctuates from row to row, as shown in **Figure 20**—a multiple of four stitches plus three on Rows 1 and 4, a multiple of four stitches plus one on Rows 2 and 3. This fluctuation would make it very difficult to keep track of how many stitches there actually are, or have been decreased or increased.

Because the Trinity Pattern is self-standing, it can be worked in rows for seamless knitting of cardigans **(Figure 21)**.

Each 4-stitch repeat of the Trinity Pattern is composed of two sets of stitches that fluctuate in count between one and three stitches. Together, these two sets always

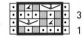

Figure 17
The Trinity Pattern involves stitches that shrink and grow in vertical lines.

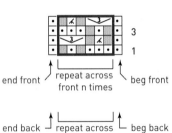

end front — repeat across front n times — beg front

end back — repeat across back n times — beg back

Figure 19
If you would like to add shaping while working the Trinity Pattern in rounds, add a faux seam stitch at the beginning and end of the front and back that will guide the placement of increases and decreases.

	purl on RS; knit on WS
	k3tog
	1-into-3 inc
	no stitch
	pattern repeat

Figure 18
To work the Trinity Pattern in rounds, simply extract the pattern repeat.

← 7 sts
3 ← 5 sts
← 5 sts
1 ← 7 sts

Figure 20
The Trinity Pattern cannot be truly centered because the number of stitches fluctuates between a multiple of 4 stitches plus 3 and a multiple of 4 stitches plus 1.

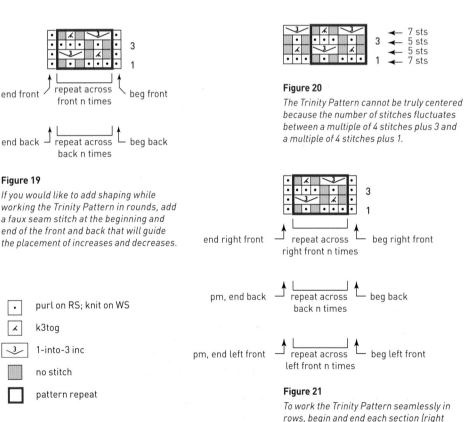

end right front — repeat across right front n times — beg right front

pm, end back — repeat across back n times — beg back

pm, end left front — repeat across left front n times — beg left front

Figure 21
To work the Trinity Pattern seamlessly in rows, begin and end each section (right front, back, left front) with a reverse stockinette balancing stitch to create faux seams.

add up to four stitches. For side shaping of a garment, one stitch is typically decreased (or increased) at each side at regular intervals. If the garment is worked in the Trinity Pattern, decreasing one stitch at each side of the garment will produce an effective decrease of four stitches, as shown in **Figure 22**, instead of the intended two stitches. For example, if one stitch were decreased on each side while working Row 3 (decreases shown in pink), then an entire set of three stitches would be eliminated on the right side and one stitch would be eliminated on the left. On the next row of pattern, it would appear as if no stitches had been decreased on the left and the overall effect of the shaping would be asymmetrical.

To ensure symmetrical shaping, the two sets of stitches need to be treated as a pair, composed of four stitches total (shown in pink in **Figure 23**). In order to decrease one stitch at each side, two stitches need to be decreased at each side, so that two stitches remain in the pair. The easiest and seamless way to do this is to work the shaping decreases on even-numbered rounds in this pattern, in which there is a single stitch in each set of stitches. For example, to make the decreases on Round 6, work k3tog (highlighted pink) at the beginning of the front (or back), and simply purl the last stitch (highlighted pink) of the front (or back) instead of working the "(k1, p1, k1) in one stitch" increase—two stitches are decreased at the beginning of the sequence by working k3tog and two stitches are effectively decreased at the end by not working the three-into-one increase. As a result, two stitches remain of the original four stitches in this pair. It's important to remember to work these stitches as purl stitches on subsequent rounds and not to include them in the pattern. In our example, the second decrease is worked on Round 10. This shaping

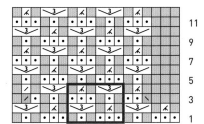

Figure 22

If one stitch is decreased at each side of the front or back of a pullover on Row 3 of the Trinity Pattern, the overall effect is to eliminate one to three stitches at the beginning of the row and no stitches at the end of the row.

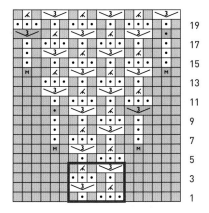

Figure 24

For symmetrical increases, work make-one (M1) increases at each edge, then work these increased stitches into the stitch pattern.

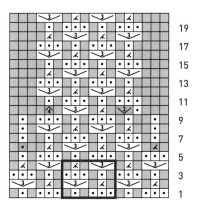

Figure 23

To ensure symmetrical shaping, the decreases must be worked in a way that will eliminate two stitches from the two sets of stitches treated as a pair (highlighted pink) so that two stitches remain in each pair after the first decrease and no stitches after the second decrease.

□	knit on RS; purl on WS
•	purl on RS; knit on WS
╱	k2tog on RS; p2tog on WS
╲	ssk
⅄	k3tog
M	M1
⬆	4-into-1 dec
▨	no stitch
▢	pattern repeat
ⱱ	k1f&b
ⱱ	1-into-3 inc

decrease is a bit trickier because each of the stitches remaining from the previous decrease on Round 6 is worked together with a stitch from another pair. In this case, a single increase (k1f&b) is worked at the beginning of the sequence (instead of a double increase) and a three-stitch decrease (k4tog) is worked at the end of the sequence (instead of a double decrease)— one less stitch is increased at the beginning of the sequence and one

more stitch is decreased at the end. The stitch remaining at the beginning of the sequence becomes part of the next pair. There are a number of ways that you can achieve symmetrical shaping of this type, but it's important to remember that there must be two fewer stitches in the front (or back) at the end of a decrease round.

The same principles apply when stitches are increased (shown in pink). In the example in **Figure 24**,

Figure 25

The number of stitches in this charted pattern fluctuates between 6 and 10 stitches per repeat (Figure 25).

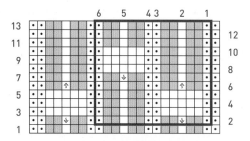

Figure 26

Plan shaping decreases (highlighted pink) to be worked on rounds or rows that have just 6 stitches in each repeat.

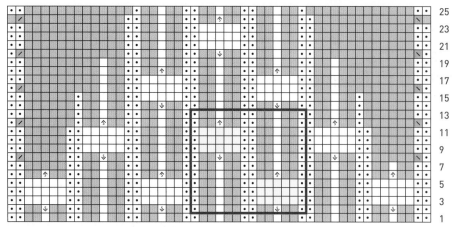

Figure 27

Work make-one (M1) shaping increases (highlighted pink) at each edge, then work these stitches into the established pattern as they become available.

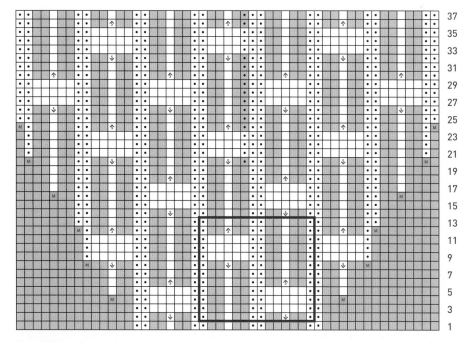

the make-one method (M1; see Glossary) is used to increase one stitch on each side of the center pattern repeat in Round 6. These increased stitches form the foundation of a new pair of stitches and are purled until the next increases are worked on Round 10. On this round, "(k1,p1,k1) in the same stitch" is worked at the beginning of the section and the last stitch is purled, for a total of two stitches increased. Continue increasing in similar manner on consequent rounds.

In this example, the shaping was worked every fourth round. There is nothing magical about this number, there can be any number of rounds between shaping rounds as long as the overall number of stitches at the end of the round reflects the number of stitches that were increased or decreased in that round. See the Textured Jacket on page 128 for additional ways to work decreases and increases within fluctuating stitch patterns.

PATTERNS WITH CHANGING NUMBERS OF STITCHES

Some patterns involve changes in the number of stitches within a repeat throughout the vertical pattern repeat, so that there are more stitches in the repeat on some rows than on others.

☐	knit on RS; purl on WS
•	purl on RS; knit on WS
╱	k2tog on RS; p2tog on WS
╲	ssk
M	M1
⇩	1-into-5 inc (see Stitch Guide)
⇧	5-into-1 dec (see Stitch Guide)
▨	no stitch
☐	pattern repeat

The six-stitch pattern repeat shown in **Figure 25** fluctuates to ten stitches on Rows 3, 4, 5, and again on rows 8, 9, and 10, due to the addition of a five-stitch cluster. This pattern is therefore a non-self-standing pattern. To convert it for knitting seamlessly, follow the instructions on page 16.

The changing number of stitches does not pose a problem when working this pattern even without shaping, but if decreases or increases are introduced, it's important to understand how the pattern works. On the rounds or rows when the stitch count increases to ten stitches per repeat, the five-stitch cluster (highlighted yellow in **Figure 26**) must be counted as a single stitch in order for the stitch count to remain constant throughout the vertical repeat. Be careful not to work shaping decreases in any of the five cluster stitches. Doing so would only reduce the cluster to

four stitches and wouldn't change the overall stitch count.

When working shaping increases in the same pattern, use the make-one (M1) method to increase one stitch at each side, as shown in **Figure 27**. Work the increased stitches into the established cluster pattern as they become available.

Preventing Jogs in Patterns Worked in Rounds

One of the biggest issues that arises when working in rounds is the visible jogs that form between the end of one round and the beginning of the next. These jogs appear because a tube of knitting actually progresses in a continuous spiral instead of truly concentric circles. To prevent a jog, you need to make the first stitch of a round appear to be at the same level as the last stitch of the previous round.

Jogs can appear in lace, cable, and texture patterns, but they are most visible in colored stripes (see **Figure 28**), which is what we have used for examples here.

Slip the First Stitch

This method of minimizing jogs comes from TechKnitter at TechKnitting.com. Simply knit the first round of the new color as usual, then slip the first stitch of the next round to bring the first stitch of the color change in line with the last stitch of the round. Continue knitting the stripe for the desired number of rounds, then repeat the process for each new color change.

If you use this technique for narrow two-row stripes, the slipped stitches cause one-stitch stripes that stack at the color changes, as shown in **Figure 29**. To prevent this from happening, shift the beginning of the round one stitch to the left with every color change as follows (see **Figure 30**):

Figure 28
Jogs appear at boundary between rounds of four-, two-, and one-row stripes.

Figure 29
To minimize the jog, slip the first stitch of the second round of a color change. Notice that this technique does not work well with narrow stripes.

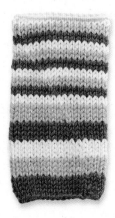

Figure 30
If the beginning of the round shifts one stitch to the left at every color change, narrow stripes appear as concentric circles.

ROUND 1: With the new color, knit to the end of the round and remove the marker at the end of the round.

ROUND 2: Slip one stitch purlwise, return the marker to the needle after this slipped stitch (effectively moving the beginning of the round one stitch to the left), then knit to the end of the round.

Knit the desired number of rounds with this color, then repeat from Round 1 at each color change.

If you need to keep track of where the rounds originally began, leave the beginning-of-round marker in its original place and use a separate color-change marker (preferably of a unique color) to mark the one-stitch shifts as follows:

SET-UP ROUND: As you knit the round before the color-change round, place the color-change marker at any point in the round.

ROUND 1: Knit with the old color to the color-change marker, slip the marker, join the new color, and work to the end-of-round marker with the new color.

ROUND 2: With the new color, work to the color-change marker, temporarily remove the color-change marker, slip one stitch, return the color-change marker to the right needle (one stitch to the left of where it had been), then knit to the end of the round.

Knit the desired number of rounds with this color, then repeat this sequence from the set-up round for every subsequent color change.

If desired, you can place the color-change marker at a different place on every set-up round so that the slipped stitches will be scattered throughout the circumference.

Knit the First Stitch Together with the Stitch Below

This simple technique was first introduced by Meg Swansen in *Handknitting with Meg Swansen*

(Schoolhouse Press, 1995). It is similar to the method of slipping the first stitch, but instead of slipping the first stitch after the color-change marker, this stitch is worked together with the stitch in the round directly below it (**Figure 31**) as follows:

SET-UP ROUND: As you knit the round before the color-change round, place the color-change marker at any point in the round.

ROUND 1: Knit with the old color to the color-change marker, slip the marker, join the new color, and work to the end-of-round marker with the new color.

ROUND 2: With the new color, work to the color-change marker, temporarily remove the color-change marker, use the right needle to pick up the stitch below the first stitch on the left needle and place this lifted stitch onto the left-needle tip, knit the first two stitches together (the first stitch on the left needle together with the lifted stitch from the round below), return the color-change marker to the needle (effectively moving it one stitch to the left), then knit to the end of the round—the stitch lifted from below will completely cover the original stitch of the new color.

Knit the desired number of rounds with this color, then repeat this sequence from the set-up round for every subsequent color change.

Helix Method

The helix method is the best way to prevent jogs in one-row stripes as shown in **Figure 32**. In this method, the stripes "chase" each other around the circumference of the piece. The drawbacks to this method are that you can never change the order of the stripes and the yarns tend to tangle around each other. It's best to work this method with fewer than five colors; if there are more than five colors, the stripes will appear to spiral

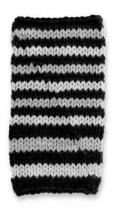

Figure 31
Eliminate jogs by working the first stitch of the second round together with the stitch below. Notice that the beginning of the round shifts one stitch to the left with each color change.

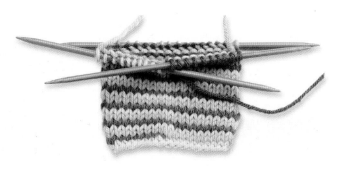

Figure 32
Using the helix method, one-row stripes appear as concentric circles.

steeply and the yarns will become even more tangled.

Work the helix method as follows:

STEP 1: Plan to use a separate double-pointed needle for each color in the stripe pattern. For example, if there are four colors in the stripe sequence, you'll want to use four needles (plus a fifth to knit with).

STEP 2: Divide the total of number of stitches by the number of colors to be used. This is the number of stitches you'll want on each needle. For example, if the pattern calls for 80 stitches, you'll want 20 stitches on each needle. If the number of total stitches doesn't divide evenly by the number of colors, there won't be exactly the same number of stitches on each needle. It's okay if there are one or two more stitches on some needles than the others.

STEP 3: Using the color of the first stripe, cast on the appropriate number of stitches onto each needle, and join for working in rounds, being careful not to twist the stitches.

STEP 4: Join the second color and knit to the end of the first needle; repeat for the third color on the second needle, and so on until each needle has a different color.

STEP 5: Continuing with the last color worked, knit the stitches on the first needle and let the yarn hang to the front of the work where it will be easy to spot on the next round.

STEP 6: Pick up the yarn from the previous round that's attached to the right-hand needle and use it work the stitches on the next needle; repeat for the remaining colors.

Repeat Steps 5 and 6 until the piece measures the desired length.

STEP 7: Bind off all stitches with the desired color.

Although this method is designed for one-row stripes of multiple colors, you can also use it to get the appearance of one-row stripes against several rows of a different color, as shown in **Figure 33**. To do so, decide on the number of rows you want between the one-row stripes to determine the number of needles you'll need. Divide the stitches as evenly as possible on these needles with the contrasting color on one needle and the background color on all the others. For the example shown in **Figure 34**, four needles were used—one needle for the contrasting color and three needles for the background color. You will need a separate ball of yarn for each needle, even though the same color is worked on three of them.

Transition-Needle Method

An alternative to the helix method that eliminates tangling yarn and the necessity of a different ball for each needle involves a "transition needle." For this method, all of the colors are changed, or transitioned, in such a way that a single color is used for each round. All of the yarns will hang off the same needle and the position of the color change moves one stitch to the right every round. If you're working with double-pointed needles, it will be necessary to rearrange the stitches periodically to keep close to the same number of stitches on each needle. This will help eliminate ladders of loose stitches forming at the needle boundaries, but the technique is most easily worked if a circular needle is used.

To work this method, follow Steps 1 to 6 of the helix method once, then continue as follows:

STEP 7: Return to the color that is to the right of the yarn just used (the yarn at end of the needle to your right) and knit until only one stitch of the old color remains, letting the yarn drop to the front of the work. Repeat for every other color until all of the colors are separated by one stitch and all of the yarns are hanging in front of the work, as shown in **Figure 34**.

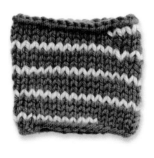

Figure 33
To get the appearance of one-row stripes against several rows of a different color, set up the helix method by working the one-row color on the first needle and the background color on the remaining needles.

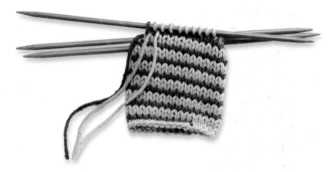

Figure 34
The last stitch of each color are side by side and the yarns hang to the front of the work.

Figure 35

For the first 6 rounds, there is an uncorrected jog at the beginning of the round. For the remaining rounds, the jog is obscured by moving the first stitch of the round to right one stitch every round.

STEP 8: Slip the last stitch of each color from the left-hand needle to the right-hand needle.

STEP 9: Pick up the yarn attached to the first stitch on the left needle (this will be the yarn attached to the first row of the sequence) and knit around, stopping when there is just one stitch remaining of the previous color. Let the yarn drop to the front of the work. Repeat for the other colors until the piece measures the desired length.

STEP 10: *Starting with the next color in the sequence, knit the number of stitches that were worked with this color in Step 1, drop the yarn to the front. Repeat for each of the other colors so that the yarns are dropped at even intervals around the circumference, just as they started on the first row.

STEP 11: Choose the color you want to bind off with and use that color to bind off all of the stitches. Cut off the other colors and weave in the loose ends.

In Fair Isle Patterns

When working Fair Isle patterns, in which each round is composed of two colors, the jogs are less visible than in stripe patterns. In the swatch shown in **Figure 35**, the rounds begin on the ninth stitch of the pattern. While it's difficult to pinpoint exactly where the jog occurs, there is a bit of telltale skewing in the general area. If this is too much distortion for your liking, you have a couple of options.

If the Fair Isle pattern is vertical in nature, you can conceal the jog by working the first and last stitch of every round in the same color to cause a vertical break in the pattern. The eye will not be able to see any difference between the end of the pattern on one side of this vertical line and the beginning of the pattern on the other. Ideally, you'll want to incorporate similar vertical breaks between motifs so that the one at the beginning of the round doesn't stand out as a singular oddity in the pattern.

If the Fair Isle pattern is predominantly horizontal, a solid vertical line might be even more

distracting than the jog. If so, try the following technique, which is a modification of the slip-stitch method introduced by TechKnitter.

ROUND 1: Knit to the end of Round 1 of the pattern, slip the end-of-round marker, slip the next stitch purlwise, then place the color-change marker on the needle.

ROUND 2: Beginning with the second stitch of the chart, work Round 2 to the end-of round marker, slip this marker, work the first stitch of Round 2, remove the color-change marker, slip the next stitch purlwise, return the color-change marker to the needle.

ROUND 3: Beginning with the third stitch of the chart, work Round 3 to the end-of-round marker, slip this marker, work the first two stitches of Round 3, remove the color-change marker, slip the next stitch, return the color-change marker to the needle.

Continue in this manner, always beginning the chart one stitch to the left, working to the end-of-round marker, working the next batch of stitches according to the stitches of the chart that haven't been worked yet to the color-change marker, temporarily removing the color-change marker, slipping the next stitch purlwise, then replacing the color-change marker.

If it's important to keep track of where the round originally began, use a separate color-change marker to keep track of the shifting chart pattern. You might find it helpful to make a color photocopy of the chart and use a highlighter to track the progression of the color-change marker as it travels one stitch to the left each round.

Make It Fit!

To make a garment fit properly, you need to know your body measurements, how much ease you want to add, and the gauge of the pattern with the yarn and needles you plan to use.

Taking Measurements

If you don't have a well-fitting sweater for reference, you'll need to start by taking your body measurements.

For best results, ask a friend to take the measurements for you when you're wearing just your undergarments or a thin, close-fitting T-shirt. It is helpful if you tie a length of yarn around your waist for reference. Record your measurements in the table on page 28.

Use a flexible tape measure to measure your bust, waist, hip, neck, wrist, and upper arm circumferences. It's a good idea to measure you hips at several places: the widest part (called the full hip), as well as the circumference at various places where you might want the lower edge of a garment to fall. Also measure the width of your shoulders from one shoulder bone to the other (this should correspond to the sleeve seams on a close-fitting T-shirt). All of these width measurements will translate into numbers of stitches.

Next, take vertical measurements of the total body length from the desired lower edge to the shoulder, the body length from the desired lower edge to the armhole, the armhole length from the base of the armhole to the shoulder, the length between the waist and armhole, the length between the waist and desired lower edge, and the sleeve length from cuff to underarm. Also measure the sleeve cap length along the outside of your arm from the shoulder bone to the base of the armhole (it is helpful to tie a length of yarn around your arm at the armhole depth for this measurement). All of these length measurements will translate to numbers of rows.

Adding Ease

Unless you want your sweater to fit like a glove, you'll want to add some ease to your actual body measurements. The amount of ease to add (or subtract for a body-hugging fit) depends on personal taste and the style of the sweater. Refer to the ease chart on page 28 for guidelines.

Measuring an Existing Garment

The easiest way to determine the dimensions of the garment you want to knit (including the desired amount of ease) is to measure a sweater that already fits the way you want.

Lay the existing sweater on a flat surface and smooth out any wrinkles or folds. Take the same measurements as you would if measuring your body, but keep in mind that these measurements already include the desired amount of ease and that many of these measurements will be width measurements that are only half of

Body Measurement Table

MEASUREMENTS	EXAMPLE	YOUR MEASUREMENTS	NOTES
HORIZONTAL BODY MEASUREMENTS			
❶ *Hips at desired hem*	*36"*		
❷ *Waist circumference*	*30"*		
❸ *Bust circumference*	*34"*		
❹ *Shoulder width*	*14½"*		
VERTICAL BODY MEASUREMENTS			
❺ *Length from hem to waist*	*5"*		
❻ *Length armhole to waist*	*7"*		
❼ *Armhole length*	*7"*		
❽ *Front neck depth*	*6"*		
SLEEVE MEASUREMENTS			
❾ *Sleeve length to underarm*	*13"*		
❿ *Cap length*	*6"*		
⓫ *Upper arm circumference*	*15"*		
⓬ *Wrist circumference*	*8"*		

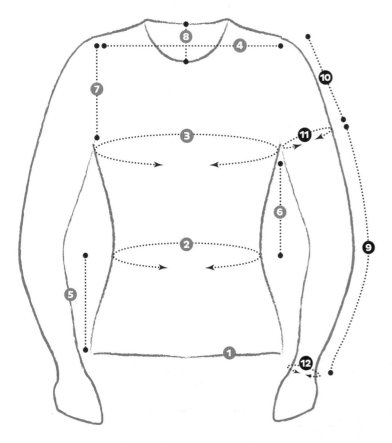

You'll need 12 measurements in order to design your own garment.

Ease

DESIRED FIT	AMOUNT OF EASE TO ADD TO BODY MEASUREMENT
Very close fit	*-2" to 0" (-5 to 0 cm)*
Close fit	*0" to 2" (0 to 5 cm)*
Standard fit	*2" to 4" (5 to 10 cm)*
Loose fit	*4" to 6" (10 to 15 cm)*
Oversized fit	*6" (15 cm) and more*

the finished circumferences. It's a good idea to take each measurement two or three times to make sure you've measured correctly.

Determining Gauge

Gauge is a measurement of the number of stitches and rows per inch of knitted fabric. In order to follow a pattern successfully, you need to match the gauge in the pattern exactly (which may mean using different needle sizes than specified). If you plan to design your own garment, you'll use your gauge measurements to determine the numbers of stitches and rows to work in order to create the desired shape. It is therefore imperative that your gauge measurements are accurate.

The Gauge Swatch

To determine your gauge, you'll need to knit a generous swatch—at least 6" (15 cm) square—using the yarn, needles, and stitch pattern that you'll use in the garment. This will allow you to measure 4" (10 cm) both horizontally and vertically without influence from the edge, cast-on, or bind-off stitches, which can be distorted or draw in the fabric. It's a good idea to include at least two pattern repeats both horizontally and vertically in the swatch. Depending on the number of stitches and rows in a repeat, your swatch may be considerably larger than 6" (15 cm). But that is good—the larger the swatch, the more accurate your measurements will be.

If a stitch pattern is to be worked as an isolated panel in a garment, you can cast on the number of stitches for the panel and add a few selvedge stitches at each side.

If you plan to work your project in the round, you should also work your gauge swatch in the round. Many knitters knit and purl at slightly different gauges, so that the gauge measured for any stitch pattern that has more knit stitches on one side and more purl stitches on the other (such as stockinette stitch) will be different if the swatch is knitted in rows (which alternate predominantly knit rows with predominantly purl rows) than if the swatch is knitted in rounds (in which case, knit stitches are always predominant.)

However, in order to measure a gauge over 4" (10 cm) in a swatch knitted in rounds, you'd need to cast on at least 8" (20.5 cm) of stitches.

If this is too daunting, you can cast on about 6" (15 cm) of stitches plus 8 extra stitches. Work the swatch in rounds, working the extra 8 stitches as p2, k4, p2 centered over the end-of-round marker. Work the swatch for about 6" (15 cm). Then wet the swatch as for blocking to help set the yarn so it won't ravel, use sharp scissors to cut through the center of the k4 column, and lay the swatch flat to air-dry. You can then make your gauge measurements on the flat swatch, knowing that it represents knitting in rounds.

Gauge Swatch for Working in Rounds

Stockinette-stitch gauge swatch knitted in rounds as viewed from the front.

Stockinette-stitch gauge swatch knitted in rounds as viewed from the back.

Swatch cut and laid flat for measuring gauge.

Swatch knitted in rows with the right side always facing and a yarn float across the back of the work (shown here) after every row.

Floats cut and swatch laid flat for measuring gauge.

Tips for Adjusting Gauge

Make sure that the numbers you calculate for widthwise measurements will accommodate full multiples of the stitch pattern you plan to use. For example, if you calculate that you need 216 stitches for the body circumference and you're working a pattern that has a 5-stitch repeat, you can only use 215 of the 216 stitches. In this case, it is easiest to simply decrease the calculated number of stitches by 1 stitch to fit the pattern repeat. In other cases, you might want to add a few stitches.

Keep in mind that for cardigans, the desired number of stitches might include selvedge stitches, front bands worked concurrently with the body, and balancing stitches to make the pattern appear symmetrical across the center front. Typically, the front bands account for about 1" (2.5 cm) of the finished circumference. You will want to take all of this into consideration when you decide how many stitches to cast on.

If the individual stitches are difficult to see, loop a contrasting yarn through every fifth stitch at the bottom and top of the swatch and through every tenth row as you knit. Measure the gauge between the lines formed by the contrasting yarn.

Another way to measure gauge for projects that will be worked in rounds is to work the swatch flat, but work every row as a right-side row, leaving long loops of unworked yarn across the back of the fabric between rows. You'll need double-pointed needles for this technique, switching the needle from your right hand to your left at the end of every row. At the end of a row, simply push the stitches to the opposite needle tip and bring the working yarn loosely across the back of the work, leaving enough slack so that the edge stitches don't stretch or distort. It's a good idea to add four "edge" stitches, working two in garter stitch at each end of the needle. Again, work the swatch for about 6" (15 cm). Then wet the swatch for blocking, use sharp scissors to cut the center of the floats, and lay the swatch flat to air-dry before measuring the gauge.

Measuring Gauge

In most cases, the gauge reported in a pattern is based on the finished garment measurements after blocking. Therefore, you'll want to block your swatch in the same way that you will wash and block the garment. In general, we recommend washing the swatch, then placing the damp swatch on a flat surface, patting it lightly to set the stitches, then letting it air-dry completely before taking measurements.

To measure your gauge, place the dry swatch on a flat surface and use a ruler (a transparent ruler is ideal) to measure the number of stitches in 4" (10 cm) both widthwise (for the stitch gauge) and lengthwise (for the row gauge). Be careful not to press down on the ruler as you measure or you might inadvertently stretch the fabric and get an inaccurate reading. Measure the gauge a number of times in each direction and calculate the average of the readings if they differ (it's not uncommon to get slightly different measurements in different places on the same swatch).

Chances are that there will not be a whole number of stitches or rows in the average 4" (10 cm) width or length. But the partial stitches and rows are important and should not be ignored. While half a stitch every 4" (10 cm) may not seem like much, it will add up to 12 stitches in a 48" (122 cm) circumference.

It's also likely that when you divide the number of stitches or rows by 4" (10 cm) to give the number of stitches per inch, you will not get a whole number. For example, let's say we measure 23.5 stitches in a 4" (10 cm) width. To determine the number of stitches per inch, we'd divide the number of stitches by the width:

23.5 stitches ÷ 4" = 5.875 stitches/inch

Don't be tempted to round this number up to 6 stitches per inch unless you don't really care about the finished dimensions (this may be okay for scarf, but not for a garment). If you want a finished circumference of 48" (122 cm) at your gauge of 5.875 stitches/inch, you'd want to have:

48" × 5.875 stitches/inch = 282 stitches

If you rounded the gauge to 6 stitches/inch, you'd calculate needing:

48" × 6 stitches/inch = 288 stitches

In this case, that's a 6-stitch difference, which is more than an inch at a gauge of 5.875 sts/inch.

If the yarn you're using is heavy or slippery, such as alpaca or silk, or if the garment will be long, such as a tunic, it's important to let the swatch hang for a few days before measuring the gauge. Again, this may not be important for a small garment such as a hat or scarf, but for a tunic or jacket, the weight of the fabric will pull on the garment, adding inches as it is worn. In these cases, hang the blocked swatch from a clothesline or hanger, clipping a

few clothespins to the lower edge to simulate the weight of the finished garment. Allow it to hang for at least a day before measuring the gauge, which is typically called the "hang gauge." An alternative is to stretch the wet swatch a little more in the vertical direction than in the horizontal direction, then take the measurements after it has completely dried.

Alternative Method for Measuring Gauge

If you plan to work a complicated stitch pattern in which it's difficult to count stitches and rows, cast on a multiple of 5 stitches—40 stitches is usually sufficient. Work in your chosen stitch pattern for 6 rows. Next, thread a long length of contrasting yarn on a tapestry needle. Then, with the right side facing, leaving a 10" (25.5 cm) tail hanging in the front of the work and, beginning with the 5th stitch, sew through every 5th stitch, inserting the tapestry needle from front to back to front around that stitch, always keeping the contrasting yarn in front of the work and ending 5 stitches before the end of the swatch. Leave a 10" (25.5 cm) tail hanging in front of the work as well.

Work 10 more rows in pattern, then use the tails to mark the stitch that's 5 stitches in from each selvedge. Continue in this manner, marking the same 2 stitches every 10th row two more times. Work 10 more rows, then mark every 5th stitch as you did at the beginning of the swatch. Work 6 rows in pattern, then bind off all the stitches.

Block the swatch, gently adjusting the marking yarn if necessary to form straight lines. You can now measure your gauge between these marking lines, which, in this case, are 30 stitches and 40 rows apart. Again, you'll want to measure several times in each direction and take the average of the measurements.

For example, let's say that the outlined rectangle measures an average of 4.63" (11.76 cm) wide and 5.25" (13.34 cm) tall. To get the stitch gauge, simply divide the number of stitches by the width:

30 stitches ÷ 4.63" = 6.48 stitches/inch

To get the row gauge, simply divide the number of rows by the length:

40 rows ÷ 5.25" = 7.62 rows/inch

Multiply these numbers by 4 to get the gauge over standard 4" (10 cm) widths and lengths:

6.48 stitches/inch × 4" = 26 stitches per 4" (10 cm)

7.62 rows/inch × 4" = 30.5 rows per 4" (10 cm)

For simplicity, round the stitch gauge to the nearest quarter stitch, which, in this case, is 6.5 stitches/inch, and the row gauge to the nearest quarter row, which, in this case, is 7.75 rows/inch.

Unblocked Gauge

Even though you want to match the gauge of a blocked swatch, it can be useful to measure the unblocked gauge as well. Any measurements you take while a garment is on the needles will reflect the unblocked gauge. Most instructions will direct you to work until a piece measures a particular length. However, this length reflects the blocked length. If you know the row gauge of your unblocked swatch, you can easily calculate the number of rows you'll need to work to achieve the specified length after the piece has been blocked.

For example, let's say there are 22 rows/4" (10 cm) in the unblocked swatch (5.5 rows/inch) and 20 rows/4" (10 cm) in the blocked swatch (5 rows/inch). If the pattern instructs you to work until the piece measures 6" (15 cm) in length and you measure this length in the

unblocked fabric, you will have worked 33 rows:

6" × 5.5 rows/inch = 33 rows

However, once the project is blocked, these 33 rows will measure about 6½" (16.5 cm) instead:

33 rows ÷ 5 sts/inch = 6.5"

To get the proper length after blocking, which is 6" (15 cm) in this case, you'll want to work 30 rows, which will measure about 5½" (14 cm) before the piece is blocked:

30 rows ÷ 5.5 rows/inch = 5.45"

Changing an Existing Pattern

There are times when you'll just want to adjust existing instructions—to change the length or accommodate a different stitch pattern and gauge, for example.

Adding or Subtracting Length Without Shaping

If you merely want to make a garment longer or shorter than specified in the pattern, simply work more or fewer rows between the lower edge and the base of the armhole.

Adjusting for a Different Gauge

If you want to substitute a different gauge for an existing pattern, follow these simple steps:

STEP 1: Read through the entire pattern (without concentrating on specific numbers) to become familiar with the general construction.

STEP 2: Knit a generous swatch of the stitch pattern(s) you plan to use (see page 29).

STEP 3: Measure your new stitch and row gauges (see page 30).

STEP 4: Using the numbers on the schematic as a guide, calculate the

Tip

When working a sweater in pieces that will be seamed, the waist and bust shaping typically involve periodically decreasing one stitch at each edge of the front and back. When working seamlessly (either in rounds or rows), there aren't any "edges." Instead, use markers of different colors to indicate the positions of the right and left "seams" (aligned with the sides of the body) and decrease before and after these "seam" markers.

new stitch counts and row lengths based on your stitch and row gauges, adding and subtracting stitches as necessary to accommodate and balance pattern repeats.

For example, let's say the pattern specifies a gauge of 5 stitches and 7 rows per inch and you'd like to substitute a different yarn or pattern that works up best at 6 stitches and 8 rows per inch. Let's also say that the schematic shows that the body is 38" (96.5 cm) in circumference and 22" (56 cm) long. To recalculate the number of stitches you'll need for the body, simply multiply the circumference by your stitch gauge.

38" × 6 stitches/inch = 228 stitches

Likewise, multiply the length by your row gauge.

22" × 8 rows/inch = 176 rows

Repeat these calculations for all the width and length measurements.

Keep in mind that when you substitute a different gauge, you'll probably also want to re-calculate the shaping sequences for the waist, neckline, and sleeves to reflect your new gauge.

Calculating Shaping Sequences

Using an Existing Pattern

Chances are that if you've decided to work an existing pattern at a different gauge, you'll need to re-calculate the increase and decrease sequences to shape the waist, V-neck, and taper the sleeves based on your new row gauge.

For example, let's say that the pattern for a pullover worked from the bottom up calls for a gauge of 4 stitches/inch and 5 rows/inch, and let's say you determined from your swatch that you're getting a gauge of 6 stitches/inch and 7 rows/inch. Let's also say that the pattern says to decrease every 6th row/round 5 times for a total of 6 decreases.

STEP 1: Adjust the number of stitches to decrease for the waist based on gauge. The instructions say to work 5 decrease rows/rounds. Most likely, each decrease represents 4 stitches decreased in total circumference—2 stitches at each side "seam." If this is the case, there will be a total of:

5 decrease rows/rounds × 4 stitches decreased per each decrease row/round = 20 stitches decreased in total

At the gauge specified in the pattern, these 20 stitches translate to:

20 stitches ÷ 4 stitches/inch = 5" (12.5 cm)

At your gauge, however, 5" (12.5 cm) translates to:

5" (12.5 cm) × 6 stitches/in = 30 stitches

In order to get the same shape as shown in the pattern, you'll therefore want to decrease 30 stitches instead of the 20 specified in the pattern.

STEP 2: Adjust the number of decrease rows/rounds involved in the shaping sequence according to your gauge. The instructions say to work this shaping over:

6 decrease rows/rounds × 5 rows/ rounds = 30 rows/rounds available for shaping

At the gauge specified in the pattern, this shaping is worked over:

30 rows/rounds ÷ 5 rows/inch = 6" (15 cm)

At your gauge, however, this shaping will be worked only over:

30 rows/round ÷ 7 rows/inch = 4.28" (11 cm)

To maintain the proportions of the original instructions, you'll want to add about 1.72" (4.5 cm) to your shaping interval in order to have your shaping worked over 6" (15 cm). At your gauge, 1.72" (4.5 cm) translates to:

1.72" (4.5 cm) × 7 rows/inch = 12.04 rows, which, when rounded to the nearest whole number, is 12 rows/ rounds

You'll therefore want to add 12 rows/ rounds to the initial interval over which the shaping was worked:

30 rows/rounds + 12 rows/rounds = 42 rows/rounds total for shaping to be worked

You now know that you'll want to decrease 30 stitches evenly spaced over 42 rows/rounds:

30 stitches ÷ 4 stitches decreased per each decrease row/round = 7.5 decrease rows/rounds

Obviously, you can't work a partial decrease row/round. In this case, there will be 7 decrease rounds in which 4 stitches per round are decreased (28 stitches) and there will be 2 stitches left over to decrease. You can deal with these extra stitches either by working two double decreases (one at each side "seam" for balance) in one of the decrease rows or by adding a decrease row/ round of just 2 stitches (instead of 4) somewhere in the sequence.

To work the 7 decrease rows/rounds evenly spaced over the 42 rows/

rounds available for shaping, simply divide 42 by 7:

42 rows/rounds available ÷ 7 decrease rows/rounds = 6 rows/ rounds

You now know that you'll want to decrease every 6th row/round 7 times and decrease 2 more stitches somewhere along the way to decrease a total of 30 stitches over 42 rows.

Calculating Your Own Shaping Sequences

If you change one or more dimensions from the existing pattern, such as bust, waist, or hip circumference, you'll need to calculate your own shaping sequence.

For example, let's say that your gauge is 6 stitches and 7.5 rows/inch and that you want a 36" (91.5 cm) circumference at the hips and a 30" (76 cm) circumference at the waist. To figure out the number of stitches you'll need to decrease (or increase) and the rate at which to decrease (or increase) to shape the waist, follow the steps below.

STEP 1: To begin, calculate the number of stitches you want at the waist and hips by multiplying the waist and hip circumferences by the stitch gauge.

30" × 6 stitches/inch = 180 stitches at waist

36" × 6 stitches/inch = 216 stitches at hips

Next, calculate the number of stitches to decrease by subtracting the number of stitches at the waist from the number of stitches at the bust or hips:

216 stitches at hips – 180 stitches at waist = 36 stitches to decrease

STEP 2: You now need to calculate the number of decrease rows or rounds. Let's say you want to shape the waist by decreasing 1 stitch at each side of each the left and right

"seam" for a total of 4 stitches decreased in each decrease row/ round. To determine the number of decrease rows/rounds, simply divide the total number of stitches to decrease by the number of stitches decreased in each decrease row/ round:

36 stitches to decrease ÷ 4 stitches decreased per decrease round = 9 decrease rounds

You now know that it will take 9 decrease rows/rounds (of 4 stitches each) to reach your desired waist circumference.

STEP 3: The next step is to calculate the total number of rows/rounds available for these decreases, or the length (in rows) between the lower edge (hip circumference) and the waist (if working from the bottom up). For a smooth transition, it's a good idea to start these decreases about 1" (2.5 cm) above the lower edge and end about 1" (2.5 cm) below the center of the waist. Let's say that the center of the waist is 7" (18 cm) above the lower edge. If you work the first and last inch even, you have 5" (12.5 cm) of rows over which to work the decreases:

7" length between lower edge and waist – 1" worked even at bottom – 1" worked even at top = 5" over which to decrease

To convert this measurement into the number of rows, simply multiply the length by the row gauge:

5" × 7.5 rows/inch = 37.5 rows/ rounds

It isn't possible to knit a partial row or round, so you'll need to round this to a whole number. If you're working in rows, you'll also need this to be an even number (every right-side row is followed by a wrong-side row). Therefore, round this up to 38 rows.

STEP 4: You can now calculate how to space the 9 decrease rows/ rounds evenly throughout the 38 available shaping rows. This is

Tip

When calculating the shaping sequence, it's easiest if the increases or decreases are worked on right-side rows only.

a simple matter of dividing the available rows/rounds by the number of decrease rows/rounds:

38 available rows/rounds ÷ 9 decrease rows/rounds = 4.22

This tells us that if you decrease every 4th row/round 9 times (36 rows/rounds), there will be 2 rows/ rounds left over. For simplicity, you can either work these remaining 2 rows even (before or after the shaping), or you can space these extra rows/rounds evenly throughout the decreases. For example, you can decrease every 4th row 4 times, then decrease every 6th row (it's best to always work shaping on right-side rows) once, then decrease every 4th row 4 more times—9 decrease rows worked over 38 rows.

Increase rates are calculated in the same way.

Designing Your Own Seamless Garment

It's really not that difficult to design your own seamless garment if you take it one step at a time. To begin, you need a clear vision of what it is that you want.

STEP 1: Make a sketch of your design (see construction on page 6 and stitch pattern placement on page 38). This is where you'll decide the size; whether it will be a pullover or cardigan; if you want to work from

the top down or from the bottom up; the type of armhole and neck construction; the stitch pattern(s); and any other specifics.

STEP 2: Draw a schematic of your idea to scale on graph paper and label all the width and length measurements.

STEP 3: Choose the stitch pattern(s) you'll use.

STEP 4: Choose a yarn that's suitable for the stitch pattern(s) and the silhouette.

STEP 5: Make a generous swatch for the pattern stitch(es) you plan to use (see page 29) and measure the stitch and row gauges.

STEP 6: Translate all the width and length measurements into numbers of stitches and rows based on your gauge measurements.

STEP 7: Adjust the stitch numbers to accommodate full pattern repeats and balancing stitches, where necessary.

For example, let's say you want to use a stitch pattern repeat that is a multiple of 10 stitches plus 4, and your gauge is 6 stitches and 7.5 rows per inch. Let's also say that you want a body circumference of 36" (91.5 cm).

To begin, multiply the desired circumference by the stitch gauge to determine the number of stitches needed for the body.

36" × 6 stitches/inch = 216 stitches

Next, you'll need to figure out how many of the 10-stitch pattern repeats will fit in this circumference:

216 stitches ÷ 10 stitches in each pattern repeat = 21.6 pattern repeats

This tells us that you'll have 21 full pattern repeats and a partial repeat of 6 stitches. Partial repeats can be distracting in seamless knitting, so ideally you'll want to work 21 or 22 full pattern repeats, which require 210 or 220 stitches, respectively.

You have two choices for how to proceed.

OPTION 1: You can add 4 more stitches to the body to make 22 full repeats across 220 stitches. Adding these 4 stitches will increase the circumference by about ¾" (2 cm).

OPTION 2: You can subtract 6 stitches from the body to make 21 full repeats across 210 stitches. Subtracting these 6 stitches will reduce the circumference by 1" (2.5 cm).

However, this option leaves you with an odd number of pattern repeats, which can be problematic when it comes to centering the pattern across the front or back of a garment. This can be especially noticeable along the shoulders, which are quite visible in any garment design. You therefore want to think ahead about how the front and back stitches will meet at the shoulders before you attempt this option.

Pullover Body

For pullovers, it's best to plan for an even number of repeats of whatever pattern stitch you choose. This will ensure that there will be the same number of repeats on the front as on the back and that the patterns will appear continuous across the shoulders. Keep in mind that balancing stitches are not necessary when working pullovers—you will work with full pattern repeats only. If working from the top down, you'll want to make sure that the pattern will appear continuous around the body after the sleeve stitches have been placed on holders. If you need to add stitches beyond an even number of pattern repeats to achieve the correct body circumference, place these additional stitches along the side "seams."

Cardigan Body

Cardigan bodies, even those knitted seamlessly, are broken down into three parts—one back and two fronts. Therefore, slightly different calculations are necessary to center a stitch pattern on cardigans.

Back

The number of back stitches is calculated the same way as for a pullover—there will be the number of stitches that translates to half of the body circumference. If additional stitches are needed, align them over each side "seam."

For example, let's say that based on your gauge and desired finished measurement, you calculated that you need about 80 stitches in the back section of your cardigan and you want to use a pattern that repeats over 10 stitches with 4 balancing stitches. You can include 8 pattern repeats in 80 stitches.

80 stitches ÷ 10 stitches/pattern repeat = 8 pattern repeats

You now need to add the balancing stitches for the pattern to appear symmetrical:

80 stitches + 4 balancing stitches = 84 stitches for the back

Fronts

Each front is half the width of the back; therefore each front should have half number of back stitches. If the back is worked over an even number of pattern repeats, each front will include half that number of repeats. For example, if there are 8 pattern repeats across the back, there will be 4 pattern repeats on each front. You might need to add balancing stitches to make the pattern appear symmetrical across the front opening.

For our example, you'll have 4 repeats of the 10-stitch pattern on each front.

*4 repeats × 10 stitches/repeats =
40 stitches*

However, for the pattern to be symmetrical across the center front opening, you need to add the 4 balancing stitches:

*40 stitches + 4 balancing stitches =
44 stitches*

This tells us that you'll have to plan for 44 stitches on each front if the pattern is to be balanced. But if each front has 44 stitches and the back has 84 stitches, the fronts as a whole will be 4 stitches wider than the back:

*44 left front stitches + 44 right front
stitches = 88 stitches total*

Depending on the design, this discrepancy may or may not be a problem. If the garment is non-fitted, with draped or flared fronts and no significant front bands, a few extra front stitches will not be noticeable. In most cases, however, a wider front will distract from the overall fit of the garment and you'll want to make more adjustments so that the two fronts add up to the same width as the back.

The way we make these adjustments depends on whether

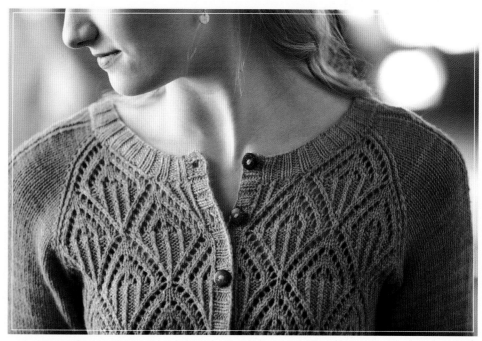

Partial repeats of the pattern are worked at the center fronts of the Lace Cardigan (page 48).

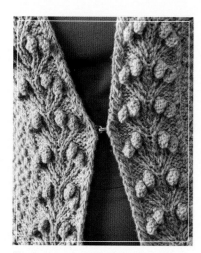

The front bands on the Textured Jacket (page 128) do not overlap.

or not there is an overlapping front band (i.e., a buttonband) and if there is, whether it is worked simultaneously with the fronts or added during the finishing phase.

NO OVERLAPPING BANDS

If there is to be no overlap between the two fronts, you can add a wider, decorative edging with selvedge stitches at each front, as in the Textured Jacket on page 128. Because the decorative edge accounts for part of the front width, each front is made narrower. In our example, you might do this by removing one pattern repeat (10 stitches) from each front:

*44 stitches – 10 stitches =
34 stitches*

Because there are 84 stitches in the back section, each front should have 42 stitches. If you work with only 34 stitches for each front, you'll

have about 8 fewer stitches than we want for each front:

*42 desired stitches – 34 adjusted
stitches = 8 stitches too few*

These 8 stitches can be added as a vertical panel along each front edge (perhaps 7 stitches in some pattern stitch plus 1 selvedge stitch):

*34 adjusted stitches + 8 panel
stitches = 42 stitches*

Each front now has half the number of the back stitches and, together, the fronts measure the same width as the back. The pattern for the edging could be a continuation of the existing pattern or a completely different pattern that complements the rest of the design. Choose what looks best to you.

If the pattern repeat is large—say, 15 stitches or more—you probably won't be able to remove an entire repeat from each front without

adversely affecting the integrity of the overall design. In such cases, you might want to work partial repeats instead. In many stitch patterns, it's possible to add half a pattern repeat without affecting the overall design, as in the Lace Cardigan on page 48. If this is not an option with your design, you might want to center the large pattern across the front and back, and work panels of another stitch pattern (such as stockinette stitch) to fill in the missing stitches along each side "seam." For more on this, see Stitch Pattern Placement on page 38.

VERTICAL BUTTONBANDS WORKED CONCURRENTLY WITH FRONTS

If you want to work button- and buttonhole bands concurrently with the garment, follow the same calculations as for no overlapping buttonbands above, replacing the "decorative" edging with the desired button- and buttonhole bands. See the Cable Cardigan on page 90 for an example.

If you've chosen a buttonband that is very wide and makes it difficult to match the front and back widths, try working knitted-on bands described

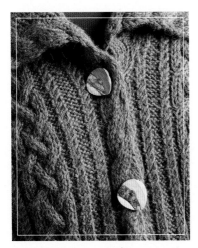

The buttonbands are worked concurrently with the fronts of the Cabled Cardigan (page 90).

below, adding the band stitches to the stitch count for each front.

KNITTED-ON BUTTONBANDS

In many garments, the button- and buttonhole bands are added by picking up stitches along the center front edges after the fronts have been knitted. For this type of band, you'll want to plan for each front to be about ½" to ¾" (1.3 to 2 cm) narrower to allow for the bands, which will overlap about 1" to 1½" (2.5 to 3.8 cm).

To calculate the number of stitches you'll want for each front, begin by omitting one full pattern repeat on each front as if there were no overlapping bands. For example, instead of planning for 4 pattern repeats on each front, plan to work 3. In this case, we'd have 34 stitches for each front (the same as in the example for no overlapping bands):

3 pattern repeats × 10 stitches/ repeat + 4 balancing stitches = 34 stitches

But, remember, we want the overall width of one front to be 42 stitches minus half of the width of the buttonband, which is about ½" (1.3 cm), or about 3 stitches:

½" (1.3 cm) × 6 stitches/inch = 3 stitches

This tells us that we need the overall front width to be 39 stitches:

42 stitches – 3 stitches = 39 stitches

Therefore, we are 5 stitches short for the front. There are two ways to adjust for this discrepancy.

OPTION 1. You could work half a repeat (5 stitches), followed by 1 selvedge stitch at each front edge. You need to add the selvedge stitch to give you something to pick up into when picking up stitches for the bands; it won't add to the final width. This would bring the stitch count to 40 stitches:

34 stitches + 5 stitches (half pattern repeat) = 39 stitches

39 stitches + 1 selvedge stitch = 40 stitches for each front

This leaves sufficient space to add button- and buttonhole bands while keeping the front and back widths equal.

OPTION 2. Another option is to add a vertical stitch pattern that has the necessary number of stitches to achieve the desired width, less about ½" to ¾" (1.3 to 2 cm). In our example, you'd simply add a new 5-stitch pattern, plus 1 selvedge stitch to each front edge, for a total of 40 stitches, which will effectively be 39 stitches once the selvedge stitch has been eliminated when the band stitches are picked up:

34 stitches + 5 stitches in new pattern + 1 selvedge stitch = 40 stitches

CENTERING A STITCH PATTERN

For a cardigan, it's easiest to center a stitch pattern if there is an odd number of pattern repeats across the back. This way, the stitch patterns placed in fronts and the back match at the shoulder seams because the front stitches that correspond to the center back repeat can be omitted from the front opening to accommodate the button bands. You could use an even number of pattern repeats as well, but depending on the chosen stitch repeat, you might end up with partially worked stitch patterns at the front edges when accounting for front bands. This is not always easy or aesthetically pleasing.

In the back section of our pullover example above, there were 8 repeats of the 10-stitch pattern plus 4 balancing stitches across the entire back width. But for a cardigan where you want to use the stitch pattern as a centered panel, you

might want to change this to an odd number of repeats.

If you want to have 7 pattern repeats centered across the back, you'll need to devote 74 stitches to the stitch pattern:

7 repeats × 10 stitches/repeat + 4 balancing stitches = 74 stitches

However, you need 84 stitches to get the desired back width. Therefore, you'll need to add half of the stitches (5 stitches) from the eliminated repeat (10 stitches) to each edge:

74 stitches + 5 stitches added at left edge + 5 stitches added at right edge = 84 stitches

These added stitches can be worked in any stitch pattern that you like (see Combining Stitch Patterns on page 40).

To compute the number of stitches for each front, remove the center repeat from the back 7 repeats to allow for the width of the front bands:

7 pattern repeats in back – 1 center pattern repeat = 6 pattern repeats for fronts

These 6 pattern repeats will be divided evenly between the two fronts:

6 pattern repeats for fronts ÷ 2 fronts = 3 pattern repeats/front

To balance the pattern on the front, add the 4 balancing stitches on one side, resulting in 34 stitches for each front:

3 pattern repeats × 10 stitches/ repeat + 4 balancing stitches = 34 stitches

To finish, you need to add 5 stitches to each front side, just as you did for each side of the back, in order to have the stitch patterns begin the same distance from the side "seams." You'll also want to add 1 selvedge stitch, resulting in 40 stitches for each front:

34 stitches + 5 stitches added at side "seam" edge + 1 selvedge stitch = 40 stitches

Remember that 42 is the ideal number of front stitches for our example, which is 2 stitches more than just calculated. The selvedge stitch effectively adds no width because it is eliminated when the stitches for the front bands are picked up, so these 40 stitches in fact will represent 39 stitches in width. This means the calculation is 3 stitches short of the ideal number:

42 ideal stitches – 39 stitches = 3 stitches short

These 3 stitches will account for about the width that will be added by the button- and buttonhole bands. If you want wider bands, plan on 5 fewer stitches at each center front.

If, after your calculations, the number of front stitches accounts for more than the ideal number of stitches for your front width, you may need to recalculate based on fewer pattern repeats—five repeats instead of seven, for example.

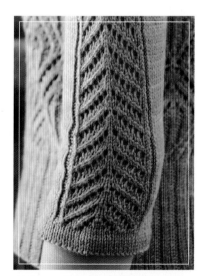

A lace panel is centered along the sleeve of the Lace Cardigan (page 48).

Sleeves

Whether you're making a pullover or cardigan, the sleeves will be worked the same way. For our example, let's say that you are working the sleeve upward from the cuff in rounds and you have a gauge of 4.5 stitches/ inch and 6 rows/inch and that you want to use an allover stitch pattern that repeats over 10 stitches plus 4 balancing stitches. Let's also say that you want the sleeve to measure 8" (20.5 cm) in circumference at the cuff.

To calculate the number of stitches to cast on, multiply the desired width by the stitch gauge:

8" × 4.5 stitches/inch = 36 stitches

Overall Stitch Pattern

To calculate the number of pattern repeats that will fit in this number, divide the number of stitches by the number of stitches in each pattern repeat:

36 stitches ÷ 10 stitches/repeat = 3.6 pattern repeats, or 3 pattern repeats plus 6 stitches

For simplicity, let's say that you'll use 3 full pattern repeats and ignore the extra stitches for now. As the sleeve expands to the upper arm circumference, stitches will be increased at each side of a "seam" stitch, in much the same way stitches are increased at each end of the needle when working back and forth in rows. When planning the placement of the stitch pattern for a symmetrical look, think of the sleeve as if it were knitted back and forth in rows, with the addition of some unique stitch pattern worked along a faux "seam." This could be a purl stitch, a few knit stitches, or another small pattern to form a vertical ("seam") line around which the increases are worked.

Now, let's go back and calculate the number of stitches to cast on for a sleeve with 3 full pattern repeats,

including the necessary balancing stitches:

3 pattern repeats × 10 stitches/ repeat + 4 balancing stitches = 34 stitches

You still need to add the "seam" stitches. If you allow for 2 such stitches, you'll end up with the desired 36 stitches:

34 stitches + 2 "seam" stitches = 36 stitches

You can choose to work the increased stitches in stockinette stitch if you want the pattern to form a panel along the top of the sleeve, or you can work the increased stitches into the 10-stitch pattern repeat. If the stitch pattern is rather complicated, you might want to chart it out to keep your place.

Centered Stitch Pattern

To center the stitch pattern, as for the Lace Cardigan on page 48, you need to first decide how many pattern repeats you want for the center panel and what stitch pattern you'll use on each side of this panel. For example, let's say that you want to center 2 pattern repeats on the sleeve and work the extra stitches at each side in stockinette stitch.

From our previous calculations, you know that you'll need 36 sts for an 8" (20.5 cm) width at the cuff edge, given the same gauge.

If you calculate the number of stitches in 2 pattern repeats plus the balancing stitches, you'll find that you'll want to center 24 stitches:

2 pattern repeats × 10 stitches/ repeat + 4 balancing stitches = 24 stitches

This will leave you with 12 extra stitches that will not be part of the pattern:

36 desired stitches – 24 pattern stitches = 12 extra stitches

Divide this number in half so that the extra stitches are equally divided on each side of the center panel:

12 extra stitches ÷ 2 sides = 6 extra stitches each side

You can choose to work these extra stitches however you want, designating your choice of stitches for the underarm "seam" and the rest of the stitches in stockinette or any other stitch pattern that coordinates with your design. When a pattern is centered in this way, the increases made to taper the sleeve to the upper arm circumference are worked in the "extra" stitches area and don't interfere with the pattern.

Stitch Pattern Placement

One of the most important decisions a designer makes when planning a garment is where to position stitch patterns. Pattern placement is a

Stitch Pattern Placement Options

Place a contrasting pattern along the raglan lines.

Place a contrasting pattern along the neck, sleeve, and lower body edges.

Pattern stitches that are worked as center panels in the front, back, or sleeves are not affected by garment shaping.

Allover patterns placed on the lower body and sleeves will not be interrupted by the neck and armhole shaping.

Overall stitch patterns worked across the entire front and back will be affected by the armhole shaping.

Overall stitch patterns worked just on the sleeves will also be affected by the armhole shaping.

key to a visually pleasing design and it can be important for the functionality of each design element (such as using cables to cinch in a waist). When planning a garment, a designer needs to consider body shape, stitch gauge, yarn and stitch pattern suitability, the number of stitches in a pattern repeat, how stitch patterns complement each other, technical execution of a certain stitch pattern at particular placement, and any other factors that might pertain to a specific garment design.

Let's say that you have a pattern for a stockinette-stitch sweater to which you'd like to simply add another stitch pattern. To be successful, you'll need to begin by knitting a generous swatch with the yarn and stitch pattern you plan to use, to make sure you can match the gauge in the existing pattern. You'll also need to convert the chart of your stitch pattern for seamless knitting in rows or rounds (see page 16) and you'll want to draw a sketch (to proportion) of the sweater showing where the new stitch pattern will be used.

You can add the stitch pattern to isolated areas of the sweater or to the entire garment. Typically, more

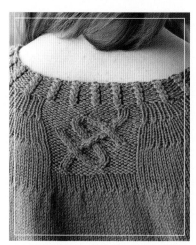

An isolated motif adds interest to the upper back of the Cabled Top (page 106).

visually interesting stitch patterns are worked on an understated pattern, such as stockinette stitch, seed stitch, reverse stockinette stitch, etc. For simplicity, let's assume that the background is simple stockinette.

Inserts or Small Motifs

If you'd like to insert an isolated patch of a contrasting pattern, such as the upper back motif in the Cabled Top (page 106) or the sleeve motif in the Cabled Tunic (page 80), in which the stitch pattern will be limited to just a small area, any differences in gauge will have a small or insignificant effect on the overall sweater dimensions. If there is a large difference in gauges, however, you might need to decrease or increase a few stitches in the row or round before the first row of the pattern insert.

Along Raglan Lines

A simple way to add interest to a sweater with raglan shaping is to add narrow panels of a contrasting stitch pattern along the four raglan lines. Position a small lace, cable, or texture pattern along each raglan line, then work the raglan shaping (increases if working from the top down; decreases if working from the bottom up) on each side of this pattern motif. For this type of pattern insertion, it's important that the number of stitches is constant throughout the vertical repeat.

Along Edgings

You can get a completely different look by placing the stitch pattern along the neckline, cuffs, and lower body edges. For best results, the gauge of the contrasting pattern should match that of the rest of the garment. If there are differences in gauge, you may need to increase or decrease some stitches at the boundaries between the stockinette stitch and the contrasting pattern to maintain the same circumference.

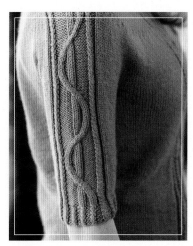

A cable panel is centered along each sleeve of the Cabled Top (page 106).

Center Panels

You can also choose to add a contrasting stitch pattern in panels along the center of the front, back, and sleeves. Because only a relatively few stitches extend from cuff to neck on sleeves, it's best to use small pattern repeats (i.e., ones that repeat over two or four stitches) in these areas. The panels in the center front or back can contain more stitches without interfering with the neck shaping. Positioning the contrasting patterns in this way ensures that they will not be affected by side, armhole, sleeve, or neck shaping. For a pullover, simply make the front and back panels the same number of stitches wide. For a cardigan, each front panel will measure half the back panel width minus the width of the overlapped button- and buttonhole bands. Be sure to split the pattern symmetrically at the fronts so that the pattern appears continuous across the front opening.

Overall Stitch Patterns on Lower Body and Sleeves

If you plan for no waist shaping or sleeve taper, you can easily place a stitch pattern throughout the lower body and sleeves without interfering

with any shaping increases or decreases. In this scenario, waist shaping is still possible through the use of gradational changes in needle size without affecting the integrity of the stitch pattern (see Shaping in Lace Patterns on page 41). When working cardigans, remember that the button- and buttonhole bands (which will be added later) will contribute to part of the front width. Again, be sure to split the pattern symmetrically at the center front so that the pattern will flow nicely across the front opening. If you can't achieve the desired circumferences with full repeats of the pattern you've chosen, consider filling in with a bit of stockinette or another simple pattern along the sides so that any waist or bust shaping will be worked in the simple pattern without interfering with the decorative pattern you've chosen. Otherwise, it's a good idea to use the method of changing needle sizes for shaping.

Overall Stitch Patterns

If you choose to place a more complicated stitch pattern across the entire front and back of a garment and work the sleeves in stockinette, it's important that the gauges between the two stitch patterns are similar if you choose raglan construction so that the raglan lines on the body and sleeves will match in length and the rate of decrease (or increase, if working from the top down). If there is a noticeable difference in gauge between the two stitch patterns, you may need to recalculate the shaping rate for the body side of the raglan line.

Overall stitch patterns worked on just the sleeves have similar considerations for the gauge and rate of decrease (or increase). If the gauges are significantly different

between the sleeves and body, the rate of decrease or increase has to be calculated separately for the sleeves to match the body without puckers.

If you decide to substitute a different stitch pattern as an allover pattern throughout the body and sleeves of a garment, you'll need to consider the difference in gauge and figure a way to perform all the shaping decreases and increases while maintaining pattern integrity. Before you jump into this type of design, read about gauge (page 29), charts (page 14), and shaping in the type of stitch pattern you've chosen (see Chapters Three, Four, and Five).

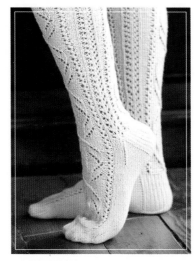

A number of stitch patterns are combined in the Lace Stockings (page 68).

Combining Stitch Patterns

It's always best to combine patterns that have similar gauges. But, it's possible to use the differences to your advantage. For example, if you use a stitch pattern with a gauge of 4 stitches per inch for the body of a sweater and add a different

pattern with a tighter gauge of 5 stitches per inch at the waist, you can achieve waist shaping without decreasing any stitches. Try adding cable or ribbed stitches to draw in the width at the waist, yoke, or cuff of a sweater.

When combining stitch patterns in vertical columns, it's important to pay attention to the stitch and row gauges of each pattern. When combining patterns vertically, the row gauge must be the same for all of stitch patterns used—otherwise, there will be stretching and puckering along the boundaries between different patterns. For example, if a slip-stitch pattern is adjacent to stockinette stitch, the stockinette area will pucker next to the slip-stitch pattern because fewer rows are worked for the same length in stockinette than slip-stitch patterns. Use these patterns side by side only if you want the fabric to pucker. It is very important to knit generous gauge swatches for each pattern you plan to include in a garment so that you can understand how the patterns will work side by side or stacked in horizontal bands across the garment.

If you want to stack patterns that repeat over different numbers of stitches, such as working a 4-stitch pattern on top of a 6-stitch pattern, you may need to add or subtract stitches in order to maintain full repeats of both patterns. In these cases, you might want to play around with charts of various stitch patterns to find ones that will fit evenly into the number of stitches in the garment.

If the patterns have significantly different gauges, you might be able to use a different-size needle for each stitch pattern to bring them closer in gauge without having to increase or decrease stitches.

Lace Patterns

Lace patterns create beautiful and delicate openwork fabric through the pairing of yarnovers, which produce holes, with decreases, which produce prominent lines.

The type of decrease used can cause these lines to slant to the right, such as k2tog and k3tog decreases, or slant to the left, such as ssk and sssk decreases. The lines can also have a vertical orientation if centered double decreases (sl 2 tog kwise, k1, p2sso) are used. Yarnovers and their corresponding decreases can be worked on every row (or round) or they can be separated by one or more "resting" or "plain" rows (rounds); these plain rows (rounds) are typically worked in stockinette or garter stitch. Patterns that involve yarnovers and decreases worked on every row are most easily worked in rounds, in which the right side of the knitting always faces you.

When knitting lace, yarnovers create new stitches while the decreases remove stitches. If the fabric is to remain the same width throughout, every yarnover must be paired with a decrease. If there are more yarnovers than decreases in a particular row, the fabric will become wider. Conversely, if there are more decreases than yarnovers, it will become narrower.

To reveal the full beauty of an openwork lace pattern, lace fabric needs to be blocked so that the stitches are stretched. That said, because the final garment measurements are based on the blocked gauge during knitting, it's quite likely that if you don't block a lace garment, it will appear to be too small. It is crucial to measure both the blocked and unblocked gauges correctly from your swatch, especially when working lace garments.

Designing with Lace Patterns

Openwork lace patterns can be used as isolated panels or as allover patterns. They combine well with most other stitch patterns, but they should have similar gauges unless you're willing to work a lot of extra calculations to prevent unwanted stretching or puckering.

Lace looks best when worked on larger needles than would be used to knit the same yarn in stockinette stitch. Knit a generous swatch with a series of needle sizes to determine the best combination for the yarn and lace pattern you've chosen. Remember that the beauty of lace isn't fully revealed until it has been blocked and stretched.

Shaping in Lace Patterns

There are a number of ways to shape garments while maintaining the overall integrity of a lace pattern—some don't interfere with the lace patterns, others take advantage of the increases and decreases within the patterns.

Changing Needle Size

The easiest way to add waist, bust, or hip shaping in lace patterns is to

Tips for Working Lace Patterns

STITCH MARKERS: Stitch markers are invaluable for helping you keep track of where you are in a pattern—place a marker on the needle after every pattern repeat and count the number of stitches between markers often to ensure that you've neither inadvertently added nor decreased a stitch. It is very easy to omit a yarnover, but if you count the number of stitches for each pattern repeat separated with markers, you'll notice the omission right away and will be able fix it before you proceed.

JOINING NEW YARN: Join a new ball of yarn at the end of row or along a faux seam where it will be easiest to weave in the ends invisibly. If possible, join the new yarn in a decrease stitch where the fabric is slightly thicker anyway—the ends won't be as visible.

LIFELINES: A lifeline is a thin thread that is drawn through all of the stitches on the needle. It provides a secure base to rip out to if you find a mistake. Because lace is a combination of yarnovers and decreases, it is often hard to pick up all of the stitches after raveling; if there is a lifeline, you can easily rip back to that thread, where you know that the stitches are in the correct order. Typically, a lifeline is added to the last row of a pattern repeat, but if the pattern repeat is long, you may want to add a lifeline after every 8 or 12 rows. Mark the rows on the chart where you've placed lifelines so you'll know where to continue from after ripping out.

GAUGE: The gauge reported for lace garments is based on the blocked measurements. Because lace patterns stretch upon blocking, the gauge you measure before the swatch is blocked will undoubtedly be different than that of the blocked swatch. When working a garment in a lace pattern, it's a good idea to measure both the unblocked gauge and the blocked gauge to refer to as you're knitting so you'll be sure to end up with the size you want. For more information, see Determining Gauge on page 29.

systematically change the size of the needles as you knit. Because needle size affects gauge, it is obvious that if you change to smaller needles, the stitches will be smaller and, therefore, the width will be narrower. On the other hand, if you change to larger needles, the stitches will be larger and the result is a wider overall width.

However, this type of shaping strategy limits you to the gauges (and, consequently, the widths) produced by the different needle sizes and the jumps in gauges between them. Moreover, changing more than a couple of needle sizes can make the fabric appear too loose and floppy or too dense and stiff. Be sure to knit swatches to ensure that you'll be happy with this type of shaping.

Adding or Removing Stitches

For the most refined type of shaping, you'll want to add or remove stitches from the existing pattern, taking care to preserve the integrity of the lace pattern by always pairing a yarnover with a corresponding decrease. When shaping, you'll need to ensure that if there are not enough stitches left to pair a decrease with each yarnover, one knit stitch is worked instead. Depending on the type of shaping desired, stitches can be added or removed along the edge of the lace pattern, within the pattern repeats, or by casting on or binding off a group of stitches.

To shape raglan lines, waists, busts, and hips, for example, you'll add (if working from the top down) or remove (if working from the bottom up) stitches along the edges of the lace pattern. Another option is to add or remove stitches within each individual pattern repeat. You can do this gradually by adding or removing stitches in just a few repeats at a time.

Some shaping, such as at the base of an armhole or neck, requires an abrupt change in the number of stitches. While the cast-ons or bind-offs are simple to do, it's important to remember that the resulting added or removed stitches will affect your position in the lace pattern. You might find it helpful to pinpoint the chart position of the first stitch following the cast-on or bind-off, so you'll maintain pattern continuity after the group of stitches has been added or removed.

Decreasing in Lace Patterns

When using decreases to narrow the width of a lace garment, it's likely that these decreases will interfere with the yarnover/decrease pairs in the lace pattern. In extreme cases, it's possible to end up inadvertently increasing a stitch or decreasing multiple stitches. However, it's often possible to achieve the shaping you want by simply adding or subtracting yarnovers or decreases within the lace pattern.

DECREASING ALONG EDGES

For symmetrical hip, waist, and bust shaping, a left-leaning ssk decrease is typically paired with a right-leaning k2tog decrease along

the "seam" lines. When working such decreases in association with lace patterns, however, you might be able to preserve the visual continuity of the lace at the edge by omitting the yarnover or substituting a double decrease for the single decrease in a yarnover/decrease pair.

For example, in the chart in **Figure 1**, some of yarnover/decrease pairs are highlighted pink within the outlined pattern repeat. In this chart, traditional paired decreases (ssk on the right; k2tog on the left) are used to shape the edges. In order to maintain the integrity of the lace pattern, the yarnover has been eliminated from

each yarnover/decrease pair at each edge of the chart (outstide the pattern repeat box) for an effective decrease of one stitch from each pair. In this case, the stitch that remains (called the remnant stitch) is worked in stockinette stitch. Notice also that the centered double decrease in the center of the pattern repeat on Row 15 is replaced with two single decreases (k2tog on the right and ssk on the left; highlighted in orange) so that each yarnover continues to be paired with a decrease.

The chart in **Figure 2** shows slightly different shaping in which the yarnovers have simply been eliminated from the edge-most

yarnover/decrease pair at each side. In this case, it's not necessary to substitute single decreases for the centered double decreases at the edges of Row 15 and the pattern maintains its integrity all across the row (or round).

For patterns in which all of the yarnovers are concentrated in the center of a pattern repeat and the decreases are on the edges, it's a bit more complicated to work traditional symmetrical decreases without affecting the appearance of the lace. In these cases, it's a good idea to chart out the pattern and superimpose the desired shaping on the chart.

	knit on RS rows and all rnds; purl on WS rows
·	purl on RS rows and all rnds; knit on WS rows
ℛ	k1tbl on RS rows and all rnds; p1tbl on WS rows
o	yo
╱	k2tog
╲	ssk
⋀	sl 2, k1, p2sso
▓	no stitch
▢	pattern repeat

Figure 1 (top)

To shape the edges of this lace pattern, traditional single decreases (ssk and k2tog) are worked at each edge. To maintain the integrity of the lace pattern, yarnover/decrease pairs are eliminated from each side of the chart and the centered double decrease is replaced by two single decreases.

Figure 2

A simpler way to get the same shaping is to simply eliminate the yarnover from the edge-most yarnover/decrease pair at each side.

The three stitches marked in pink represent double yarnover-decrease pairs. Only one stitch from this double yarnover-decrease pair is used for side shaping at each edge; therefore the double decrease is worked as a single decrease (in orange).

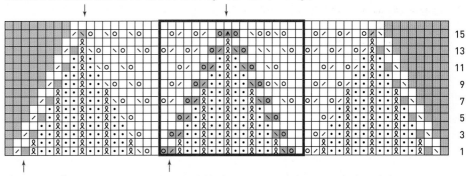

The yarnover/decrease pair marked in pink within the pattern repeat is now worked as a knit stitch at the edges because there are not enough stitches to work the yarnover/decrease pair.

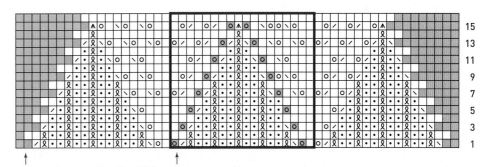

The yarnovers marked in pink have been removed from the repeats at the edges causing an invisible decrease.

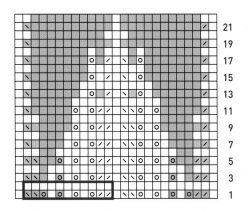

Figure 3

For the shaping in this chart, traditional ssk and k2tog shaping decreases require that yarnovers are eliminated in some places and decreases are eliminated in others.

It is very hard to keep track of all the yarnover pairs when decreasing in a traditional way. The 4 stitches in pink represent 2 yarnover/decrease pairs.

One shaping decrease occurs at each side over the stitches marked in orange.

Notice that there is one fewer stitch on each side (2 sts total decreased) when working a row with orange stitches.

Rows 3 and 5: dec 1 st each side by omitting pairing yo.

Rows 7, 9, and 11: traditional decreases at edges.

Row 13: omitting 2 pairing decreases by working k1 st only because there are not enough sts to work corresponding yarnovers, while traditional shaping at edges continues.

Row 19: we ran out of sts to a complete yarnover/decrease pair and substituted knit stitches.

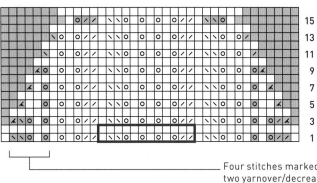

Figure 4

A simpler way to get the same shaping is to substitute double decreases for the single decreases at each edge.

On Row 15, the shaping decrease will "enter" the next double yarnover/decrease pair from where yarnovers are concentrated; side shaping is worked by removing the yarnover. Notice that the side decrease still happens because there is one decrease that is not paired with a yarnover.

On Rows 11 and 13, stitches of the two yarnover-decreasing pairs have been removed by the shaping decreases; therefore traditional shaping decrease is worked here.

Four stitches marked in pink represent two yarnover/decrease pairs. When a shaping decrease is worked at the edge, the first single decrease becomes a double decrease. Because no additional yarnover is paired with this extra decrease, shaping occurs.

▢	knit on RS rows and all rnds; purl on WS rows
O	yo
∕	k2tog
＼	ssk
⋏	k3tog
⋌	sl 1, k2tog, psso
▦	no stitch
▢	pattern repeat

For example, the chart in **Figure 3** represents a chevron pattern that gets progressively narrower. For this pattern, each repeat consists of four yarnover/decrease pairs; two of the pairs are highlighted pink on Row 1. On Rows 3 and 5, the decrease shaping is achieved by omitting one yarnover from the pattern repeat at each edge—each pattern repeat now consists of three decreases and three corresponding yarnovers for an effective decrease of two stitches. On Rows 7, 9, and 11, each pattern repeat now

consists of two decreases and two corresponding yarnovers; the lace pattern doesn't interfere with the shaping decreases so traditional k2tog and ssk decreases are worked for the shaping. On Rows 13 and 15, there are not enough stitches to work two yarnover/decrease pairs so one decrease in the center of the pattern repeat is replaced with a knit stitch instead—the pattern repeat is reduced to one decrease and one yarnover on Row 13 and to a single knit stitch on Row 19.

A simpler way to achieve the same shape is to substitute double increases for single decreases in some places and eliminate yarnover increases in others, as shown in **Figure 4**. In this case, a third 12-stitch pattern repeat is added to the center of the chart for illustration. Again, each pattern repeat consists of four yarnover/decrease pairs; two of the pairs are highlighted in pink on Row 1. On Row 3, the edge-most single decrease on each side is replaced with a double decrease. On Row 5,

the remaining single decreases are replaced with double decreases and the nearest yarnover is eliminated (it is worked as k1 instead). On Rows 7 and 9, double decreases replace single decreases. On Rows 11 and 13, the lace pattern doesn't interfere with the shaping decreases so traditional k2tog and ssk decreases are worked. On Row 15, where the shaping decreases meet the next yarnover/decrease pair on each side of the lace pattern, the yarnover is eliminated (worked as k1 instead), to effectively decrease one stitch on each side. Notice that throughout the entire 16-row sequence, the center part of the lace pattern remains intact.

Decreasing Within a Pattern Repeat

You can decrease within each pattern repeat by omitting a yarnover or by replacing a single decrease with a double decrease. This decrease method is typically used to shape the top of a hat or the upper body of a seamless yoke sweater, where a number of decreases are worked around the full circumference in a single round or row of knitting. The number of stitches within the individual pattern repeats will change, but the overall look of the lace remains intact.

You can achieve the effect of decreased stitches by simply omitting one or more yarnovers within a pattern repeat. Although this will change the look of the pattern somewhat, you can choose to omit the yarnovers that give the most pleasing visual results. If done with care, the general character of the pattern remains intact—it's just on a smaller scale and over fewer stitches. In the chart in **Figure 5**, yarnovers are removed at each edge of a 16-stitch pattern repeat. The remaining unpaired decreases then act as shaping decreases.

You can also substitute double (or triple) decreases for select single (or double) decreases, as shown in **Figure 6**. This strategy is useful when you want to keep the yarnovers to maintain the integrity of the lace pattern.

Increasing in Lace Patterns

Ideally, we want increases to be as invisible as possible in lace patterns. Most likely, stitches that are added to expand the width in lace—especially if make-one (M1) or bar (k1f&b) increases are used—will stand out quite noticeably. To increase invisibly in lace patterns, it's best to omit decreases in the increase/decrease pairs.

INCREASING ALONG EDGES

For symmetrical hip, waist, and bust shaping, paired make-one (M1) increases—a right-leaning increase (R) and a left-leaning (L) increase—are typically worked along the "seam" lines. In Rows 17 to 37 of **Figure 7** (see page 46), this type of M1 increase is worked along the left edge only and is denoted by "R" in the chart to indicate a right-slanting increase. Notice that two stitches must be increased before a new yarnover/decrease pair can be introduced to the expanding pattern. The increased stitches are typically worked in stockinette stitch until there are enough stitches to work a new pair.

Instead of working make-one increases, which can cause visible shaping lines, you can choose to add unpaired yarnovers that maintain the visual integrity of the lace pattern, as shown along the left edge of Rows 39 to 47 of the chart in **Figure 7**. In some cases, this will allow you to better maintain continuity of the established lace pattern. When using unpaired yarnovers for shaping, the yarnovers should be placed at least one stitch in from the selvedge,

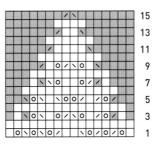

Figure 5

To decrease by omitting yarnovers, simply omit yarnovers so that some decreases (in pink) are not paired with increases. Unpaired decreases are highlighted.

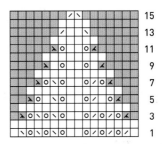

Figure 6

Convert selected single decreases to double decreases (in pink) to add shaping without compromising the openwork pattern created by yarnovers.

	knit on RS rows and all rnds; purl on WS rows
o	yo
/	k2tog
\	ssk
⋌	k3tog
⋋	sl 1, k2tog, psso
	no stitch
	pattern repeat

faux seam, or raglan edge—the yarnovers need to be separated by at least one stitch to maintain pattern continuity.

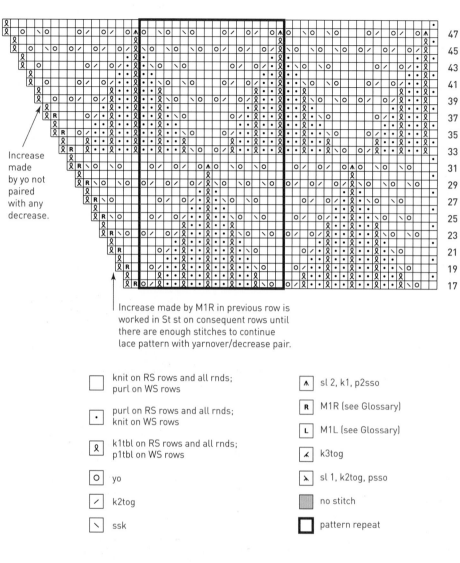

Increase made by yo not paired with any decrease.

Increase made by M1R in previous row is worked in St st on consequent rows until there are enough stitches to continue lace pattern with yarnover/decrease pair.

	knit on RS rows and all rnds; purl on WS rows
•	purl on RS rows and all rnds; knit on WS rows
ℛ	k1tbl on RS rows and all rnds; p1tbl on WS rows
O	yo
╱	k2tog
╲	ssk

⋀	sl 2, k1, p2sso
R	M1R (see Glossary)
L	M1L (see Glossary)
⋋	k3tog
⋌	sl 1, k2tog, psso
▨	no stitch
▢	pattern repeat

Figure 7

For shaping the Lace Cardigan (page 48), stitches added by make-one right-leaning increases (R) along the left edge of the charted pattern are worked in stockinette stitch until there are enough stitches to work a new yarnover/decrease pair.

Increasing Within a Pattern Repeat

It's possible to increase by adding unpaired yarnovers or by substituting a single decrease for a double decrease in every pattern repeat across the circumference of a piece. When increasing in this manner, you want to be careful that the increased stitches are incorporated into the original pattern in a logical way that maintains the integrity of the pattern. You can get a variety of looks, depending on whether the new stitches are added to the center of each repeat, along the edges of each repeat, or scattered throughout the repeats. If the increases are positioned symmetrically within a pattern repeat, the pattern will expand symmetrically. If, on the other hand, increases are worked along just one side of a repeat, the fabric will grow in that direction only. If increases are scattered across the pattern repeat, spiral or zigzag patterns can develop. It's a good idea to chart the increases to be sure that they will produce the look you want.

Adding Yarnovers

In the chart in **Figure 8**, unpaired yarnovers are added to each pattern repeat on Rows 12 and 20. The increased stitches are worked in stockinette or reverse stockinette as necessary to maintain pattern continuity. When the shaping is completed on Row 24, the new yarnovers are paired with decreases (both in orange) to maintain visual continuation of the pattern as well as to maintain a consistent stitch count. At this point, there is no more widthwise expansion of the pattern.

Combinations of Make-One and Yarnover Increases and Omitted Decreases

Depending on the lace pattern and the number of stitches being added within a vertical repeat, you will most likely want to use a combination of the possible make-one and yarnover increases and omitted decreases to maintain continuity as you expand the pattern. In the chart in **Figure 9**, make-one right (M1R) increases are used in Rows 2 and 7 and yarnovers are used on Rows 5 and 9. It would be possible to omit a decrease in Rows 2 and 7 instead, but that would require that two stitches be worked in stockinette, which would interrupt the overall pattern. Similarly, if make-one increases were worked on Rows 5

and 9 instead of yarnovers, there would be a more noticeable break in the pattern. Notice that only after two stitches have been added, can a new yarnover/decrease pair (in pink) be worked to continue the pattern.

Combining Lace with Other Stitch Patterns

Lace patterns are often combined with other knitting techniques and stitch patterns such as cable, color, and texture. When lace is combined with other stitch patterns, pay close attention to the gauge of all the stitch patterns included in the design. If combined patterns have different stitch and row gauges (see Determining Gauge on page 29), you'll want to adjust number of stitches or rows between patterns accordingly. Not all stitch patterns can be successfully combined.

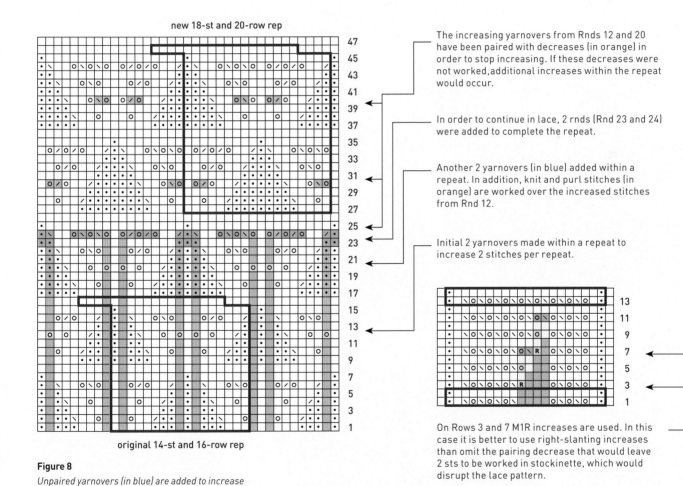

The increasing yarnovers from Rnds 12 and 20 have been paired with decreases (in orange) in order to stop increasing. If these decreases were not worked, additional increases within the repeat would occur.

In order to continue in lace, 2 rnds (Rnd 23 and 24) were added to complete the repeat.

Another 2 yarnovers (in blue) added within a repeat. In addition, knit and purl stitches (in orange) are worked over the increased stitches from Rnd 12.

Initial 2 yarnovers made within a repeat to increase 2 stitches per repeat.

On Rows 3 and 7 M1R increases are used. In this case it is better to use right-slanting increases than omit the pairing decrease that would leave 2 sts to be worked in stockinette, which would disrupt the lace pattern.

Figure 8

Unpaired yarnovers (in blue) are added to increase the size of each pattern repeat in this chart. When the desired width is achieved, the yarnovers are paired with decreases to prevent the stitch count from growing.

Figure 9

You can use a combination of increase methods to maintain continuity throughout a pattern repeat.

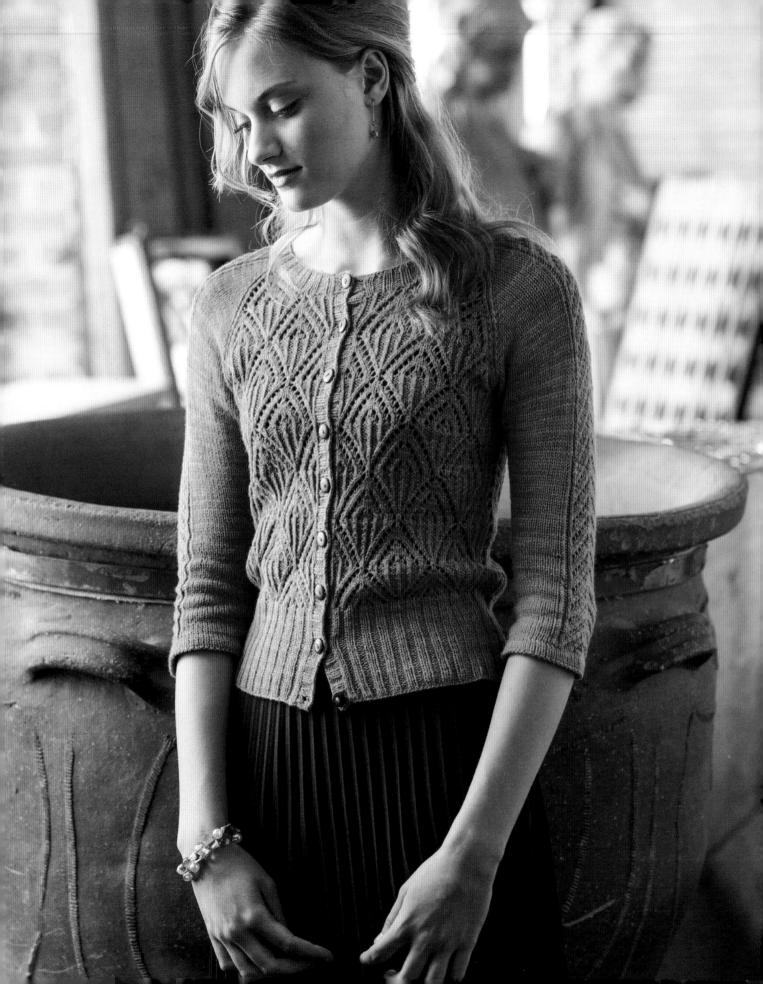

Lace Cardigan

This classic cardigan showcases how to position a pattern that repeats over a relatively large number of stitches in the body and how to adjust the number of stitches in side panels to achieve the desired bust circumference. Constructed seamlessly from the top down and shaped along raglan lines, a beautiful chandelier lace pattern in the main body is combined with a smaller lace pattern along the center of each sleeve. Stitches are picked up along the center front selvedges and the bands are worked perpendicular to the body.

designed by **SIMONA MERCHANT-DEST**

FINISHED SIZE
About 35 (37, 41, 43, 47, 49, 53)" (89 [94, 104, 109, 119.5, 124.5, 134.5] cm) bust circumference, buttoned, including ½" (1.3 cm) front band.

Cardigan shown measures 35" (89 cm).

YARN
Sportweight (#2 Fine).

Shown here: Bijou Basin Ranch Lhasa Wilderness (75% yak, 25% bamboo; 180 yd [165 m]/2 oz [56 g]): #05 salmonberry, 5 (6, 6, 7, 7, 7, 8) skeins.

NEEDLES
Body and sleeves: size U.S. 3 (3.25 mm): 32" and 16" (80 and 40 cm) circular (cir) and set of 4 or 5 double-pointed (dpn).

Waist and sleeve hems: size U.S. 2 (2.75 mm): 32" (80 cm) cir and set of 4 or 5 dpn.

Adjust needle sizes if necessary to obtain the correct gauge.

NOTIONS
Markers (m); stitch holders; tapestry needle; nine ⅝" (1.5 cm) buttons.

GAUGE
24 sts and 34 rows/rnds = 4" (10 cm) in St st on larger needles.

24 sts and 34 rows = 4" (10 cm) in patt from Chandelier chart on larger needle.

Design Techniques

Raglan construction worked in rows from the top down, page 13.

Shaping in lace patterns, page 41.

Knitted cast-on, page 173.

One-row buttonholes, page 171.

TIPS & TRICKS

• The cardigan yoke is worked in one piece from the neck down to the underarms, then the sleeve stitches are placed on holders. The fronts and back are worked back and forth in rows in a single piece to the lower edge. After completing the lower body, the sleeves are worked in rounds to the cuffs.

• In Row 31 of the Chandelier chart (page 57), the beginning or ending point for some sizes does not permit the double decrease to be worked with both its yarnovers. If this occurs at the start of the pattern, work the first 2 pattern stitches as "ssk, yo" instead. If this occurs at the end of the pattern, work the last 2 stitches as "yo, k2tog" instead.

• When joining the fronts and back for the lower body, it is sometimes not possible to add full pattern repeats (for invisible insertion) at the underarms to keep the pattern continuous all the way around the body. In this case, side panels can be inserted in a different pattern to make up the desired circumference.

• You can create a side insert panel that complements the main pattern by isolating one motif or section of the main stitch pattern and using it for the insert. Make a separate chart for the insert pattern that contains the same number of rows or rounds as the main stitch pattern, if possible, to make it easier to keep track of the patterns.

• When calculating the number of lower body stitches, remember to add 1 selvedge stitch at each front edge for a cardigan to make it easier to pick up the front band stitches. In this project, the selvedge stitches are shown on the Right Front and Left Front charts where they are worked in garter stitch (knit every row) at the front edges.

STITCH GUIDE

K2, P2 RIB (MULTIPLE OF 4 STS)

ROW 1: (WS) P3, *k2, p2; rep from * to last 5 sts, k2, p3.

ROW 2: (RS) K3, *p2, k2; rep from * to last 5 sts, p2, k3.

Rep Rows 1 and 2 for patt.

SL 2, K1, P2SSO

Sl 2 sts as if to k2tog, k1, pass 2 slipped sts over—2 sts dec'd.

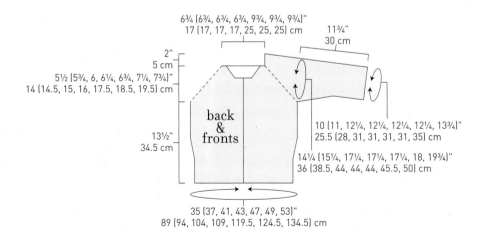

6¾ (6¾, 6¾, 6¾, 9¾, 9¾, 9¾)"
17 (17, 17, 17, 25, 25, 25) cm

11¾"
30 cm

2"
5 cm

5½ (5¾, 6, 6¼, 6¾, 7¼, 7¾)"
14 (14.5, 15, 16, 17.5, 18.5, 19.5) cm

back & fronts

10 (11, 12¼, 12¼, 12¼, 12¼, 13¾)"
25.5 (28, 31, 31, 31, 31, 35) cm

13½"
34.5 cm

14¼ (15¼, 17¼, 17¼, 17¼, 18, 19¾)"
36 (38.5, 44, 44, 44, 45.5, 50) cm

35 (37, 41, 43, 47, 49, 53)"
89 (94, 104, 109, 119.5, 124.5, 134.5) cm

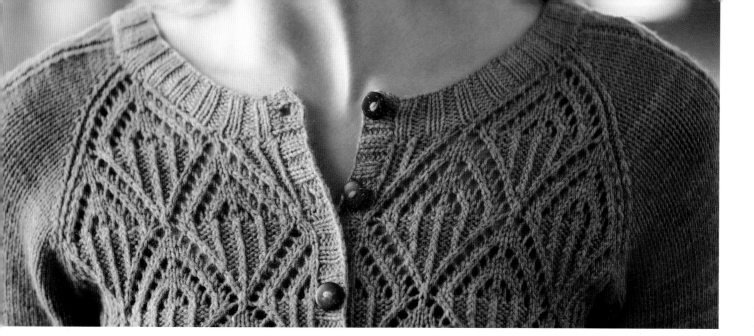

Yoke

With longer cir needle in larger size, CO 101 (101, 101, 101, 119, 119, 119) sts. Do not join.

SET-UP ROW: (WS) P5 for right front, place marker (pm), p25 for right sleeve, pm, p41 (41, 41, 41, 59, 59, 59) for back, pm, p25 for left sleeve, pm, p5 for left front.

Note: For the following instructions, use the Left Front and Right Front charts for your size. See pages 52–57 for charts.

NEXT ROW: (RS) Inc as shown on charts, work Row 1 of Left Front chart for your size to m, slip marker (sl m), *k1tbl, M1L (see Glossary), k2, pm, work Row 1 of Sleeve chart over 19 sts, pm, k2, M1R (see Glossary), k1tbl, sl m,* work Row 1 of Back chart to m working 18-st patt rep 2 (2, 2, 2, 3, 3, 3) times, sl m; rep from * to * for second sleeve, work Row 1 of Right Front chart for your size to end—111 (111, 111, 111, 129, 129, 129) sts total: 7 sts for each front, 27 sts for each sleeve, 43 (43, 43, 43, 61, 61, 61) sts for back.

NEXT ROW: (WS) Work next row of Right Front chart to m, sl m, *p1tbl, purl to m, sl m, work next row of Sleeve chart over 19 sts, sl m, purl to 1 st before m, p1tbl, sl m,* work next row of Back chart to m, sl m; rep from * to * for second sleeve, work next row of Left Front chart to end.

NECK AND RAGLAN INC ROW: (RS) Work next row of Left Front chart to m, sl m, *k1tbl, M1L, knit to next m, sl m, work next row of Sleeve chart over 19 sts, sl m, knit to 1 st before next m, M1R, k1tbl, sl m,* work next row of Back chart to m, sl m; rep from * to * once more for second sleeve, work next row of Right Front chart to end—10 sts inc'd: 2 sts each for each front, each sleeve, and back.

Cont in patt, rep the shaping of the last 2 rows 6 more times, ending with a RS inc row (Row 15 of fronts and back)—181 (181, 181, 181, 199, 199, 199) sts total: 21 sts each front, 41 sts each sleeve, 57 (57, 57, 57, 75, 75, 75) back sts.

NEXT ROW: (WS; Row 16 of fronts and back) Use the knitted method (see Glossary) to CO 9 (9, 9, 9, 18, 18, 18) sts at right front edge, work across new sts as k1, p8 (8, 8, 8, 17, 17, 17) as shown on Right Front chart, *p1tbl, purl to m, sl m, work next row of Sleeve chart over 19 sts, sl m, purl to 1 st before m, p1tbl, sl m,* work next row of Back chart; rep from * to * for second sleeve, work next row of Left Front chart to end, use the knitted method to CO 9 (9, 9, 9, 18, 18, 18) more sts at left front edge as shown on chart—199 (199, 199, 199, 235, 235, 235) sts total: 30 (30, 30, 30, 39, 39, 39) sts for each front, no change to sleeve and back sts; piece measures 2" (5 cm) from CO.

Note: In this row, the new sts on the Left Front chart are shown using the CO symbol because they have not been worked yet.

RAGLAN INC ROW: (RS) Work next row of Left Front chart to m, sl m, *k1tbl, M1L, knit to next m, sl m, work next row of Sleeve chart over 19 sts, sl m, knit to 1 st before next m, M1R, k1tbl, sl m,* work next row of Back chart to m, sl m; rep from * to * once more for second sleeve, work next row of Right Front chart to end—8 sts inc'd: 1 st at raglan edge of each front, 2 sts each sleeve, 2 back sts.

NEXT ROW: (WS) Work next row of Right Front chart to m, sl m, *p1tbl, purl to next m, sl m, work next row of Sleeve chart over 19 sts, sl m, purl to 1 st before next m,

LEFT FRONT—SIZES 35", 37", 41", 43"

Legend:

- ⬚ knit on RS rows and all rnds; purl on WS rows
- • purl on RS rows and all rnds; knit on WS rows
- ۾ k1tbl on RS rows and all rnds; p1tbl on WS rows
- ○ yo
- ⟋ k2tog
- ⟍ ssk
- ⋀ sl 2, k1, p2sso (see Stitch Guide)
- R M1R (see Glossary)
- L M1L (see Glossary)
- + cast-on st
- ▨ no stitch
- ⬚ pattern repeat

Row numbers (right side): 65, 63, 61, 59, 57, 55, 53, 51, 49, 47, 45, 43, 41, 39, 37, 35, 33, 31, 29, 27, 25, 23, 21, 19, 17, 15, 13, 11, 9, 7, 5, 3, 1

p1tbl, sl m,* work next row of Back chart to m, sl m; rep from * to * once more for second sleeve, work next row of Left Front chart to end.

Cont in patt, rep the shaping of the last 2 rows 14 (15, 16, 14, 19, 20, 21) more times, then work the raglan inc row one more time, working new sleeve sts in St st—327 (335, 343, 327, 403, 411, 419) sts total: 46 (47, 48, 46, 60, 61, 62) sts each front, 73 (75, 77, 73, 83, 85, 87) sts each sleeve, 89 (91, 93, 89, 117, 119, 121) back sts. Cont for your size as foll:

Sizes 35 (37, 41, 47)" only

Yoke shaping is complete, ending with RS Row 47 (49, 51, 57) of front and back charts—piece measures 5½ (5¾, 6, 6¾)" (14 [14.5, 15, 17] cm) from CO, including set-up row.

LEFT FRONT—SIZES 47", 49", 53"

Row numbers along right and within chart: 65, 63, 61, 59, 57, 55, 53, 51, 49, 47, 45, 43, 41, 39, 37, 35, 33, 31, 29, 27, 25, 23, 21, 19, 17, 15, 13, 11, 9, 7, 5, 3, 1

Sizes (43, 49, 53)" only

Cont in patt, inc for front and back raglans without working any sleeve incs as foll:

NEXT ROW: (WS) Work 1 WS row even as established.

NEXT ROW: (RS) Work next row of Left Front chart to m, sl m, *k1tbl, knit to next m, sl m, work next row of Sleeve chart over 19 sts, sl m, knit to 1 st before next m, k1tbl, sl m,* work next row of Back chart to m, sl m; rep from * to * once more for second sleeve, work next row of Right Front chart to end—4 sts inc'd: 1 st each front, 2 back sts, no change to sleeve sts.

Rep the last 2 rows (2, 0, 1) more time(s), ending with RS Row (53, 61, 65) of front and back charts—(339, 415, 427) sts total: (49, 62, 64) sts each front, (73,

SLEEVE

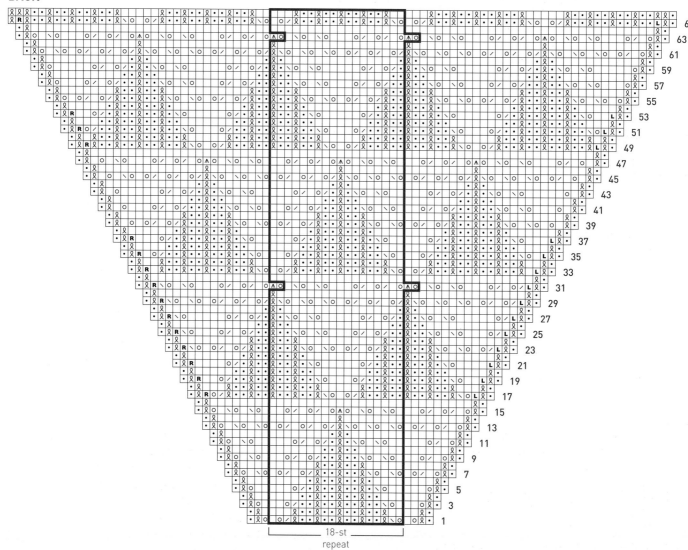

knit on RS rows and all rnds; purl on WS rows

· purl on RS rows and all rnds; knit on WS rows

Ⴙ k1tbl on RS rows and all rnds; p1tbl on WS rows

O yo

∕ k2tog

∖ ssk

Λ sl 2, k1, p2sso (see Stitch Guide)

R M1R (see Glossary)

L M1L (see Glossary)

+ cast-on st

no stitch

pattern repeat

BACK

18-st repeat
work 2 (2, 2, 2, 3, 3, 3) times

RIGHT FRONT—SIZES 35", 37", 41", 43"

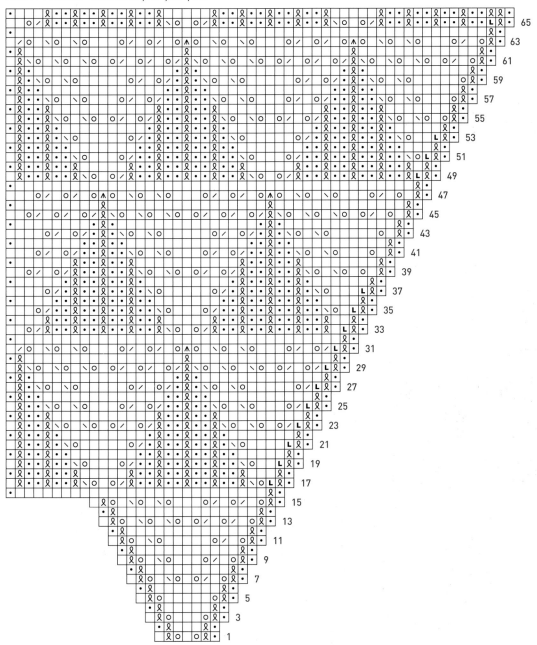

Divide for Body and Sleeves

85, 87) sts each sleeve, (95, 121, 125) back sts; piece measures (6¼, 7¼, 7¾)" (16 [18.5, 19.5] cm) from CO.

DIVIDING ROW: (WS; Row 48 [50, 52, 54, 58, 62, 66] of front and back charts) Working next WS chart row as established, work 46 (47, 48, 49, 60, 62, 64) right front

sts, put next 73 (75, 77, 73, 83, 85, 87) sleeve sts onto waste yarn or holder leaving Sleeve chart m in place, use the knitted method to CO 6 (8, 13, 15, 10, 11, 15) underarm sts, pm for side "seam," CO 7 (9, 14, 16, 11, 12, 16) more underarm sts, work 89 (91, 93, 95, 117, 121, 125) back sts, put next 73 (75, 77, 73, 83, 85, 87) sleeve sts onto waste yarn or holder leaving sleeve chart m in place, CO 7 (9, 14, 16, 11, 12, 16) underarm sts, pm for side "seam," CO 6 (8, 13, 15, 10, 11, 15) underarm sts, work 46 (47, 48, 49, 60, 62, 64) right front sts—207 (219,

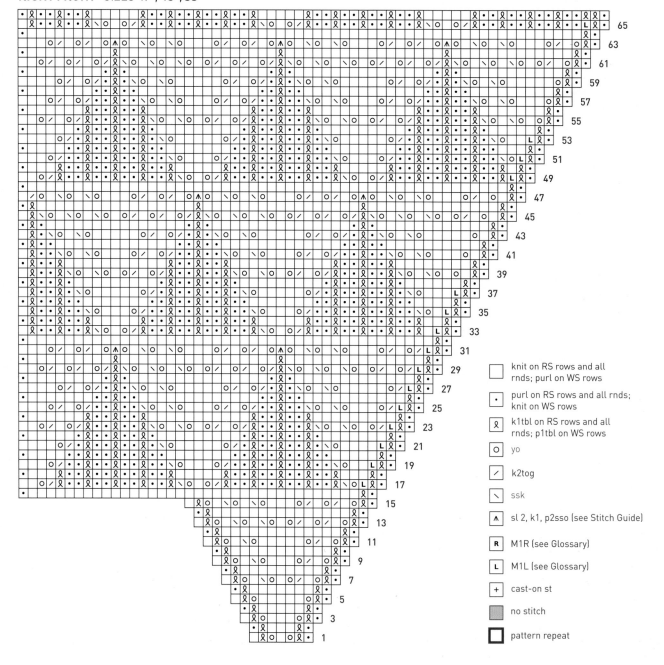

Chart legend:

- ☐ knit on RS rows and all rnds; purl on WS rows
- · purl on RS rows and all rnds; knit on WS rows
- ℛ k1tbl on RS rows and all rnds; p1tbl on WS rows
- ○ yo
- ╱ k2tog
- ╲ ssk
- ⋀ sl 2, k1, p2sso (see Stitch Guide)
- R M1R (see Glossary)
- L M1L (see Glossary)
- + cast-on st
- ▨ no stitch
- ☐ pattern repeat

243, 255, 279, 291, 315) sts total: 52 (55, 61, 64, 70, 73, 79) sts each front, 103 (109, 121, 127, 139, 145, 157) back sts.

Note: *Record the WS row of the Sleeve chart just completed so you can resume the patt with the correct row later.*

Body

Work for your size as foll:

Sizes 35 (41, 47, 53)" only

NEXT ROW: (RS) K1 (selvedge st; knit every row as established), beg and ending as indicated for your size, work Row 17 (21, 27, 3) of Chandelier chart over 46 (55, 64, 73) left front sts, *place new m, work Row 1 of Side Insert chart over 11 sts removing side m, then

CHANDELIER

*31, 29, 27, 25, 23, 21, 19, 17, 15, 13, 11, 9, 7, 5, 3, 1

18-st
repeat

*See Notes
for Row 31.

end
35" left front
35" back
47" right front
49" body
53" left &
right front
53" back

end
35" right front
37" body
41" left & right front
41" back
43" body
47" left front
47" back

beg
35" left front
37" body
41" left & right front
41" back
43" body
47" back
47" right front

beg
35" back
35" right front
47" left front
49" body
53" left
& right front
53" back

SIDE INSERT

3, 1

place new m,* work Row 17 (21, 27, 3) of Chandelier chart over 91 (109, 127, 145) back sts beg and ending where indicated for your size; rep from * to * once more for second side panel, work Row 17 (21, 27, 3) of Chandelier chart over 46 (55, 64, 73) right front sts beg and ending where indicated for your size, k1 (selvedge st; knit every row as established).

Work even in established patts until piece measures 6" (15 cm) from dividing row. Change to smaller cir needle. Work even in patts until 79 (75, 85, 77) lower body rows total have been completed, ending with Row 31 (31, 15, 15) of Chandelier chart—piece measures about 9¼ (8¾, 10, 9)" (23.5 [22, 25.5, 23] cm) from dividing row.

Sizes (37, 43, 49)" only

NEXT ROW: K1 (selvedge st; knit every row as established), beg and ending as indicated for your sizes, work Row (19, 23, 31) of Chandelier chart over center

(217, 253, 289) sts, k1 (selvedge st, knit every row as established).

Work even in established patts until piece measures 6" (15 cm) from dividing row. Change to smaller cir needle. Work even in patts until (77, 73, 81) lower body rows total have been completed, ending with Row (31, 31, 15) of Chandelier chart—piece measures about (9, 8½, 9½)" ([23, 21.5, 24] cm) from dividing row.

All sizes

NEXT ROW: (WS) Purl and *at the same time* dec 3 sts evenly spaced—204 (216, 240, 252, 276, 288, 312) sts rem.

Change to larger cir needle and work in k2, p2 rib (see Stitch Guide) beg with RS Row 2 until piece measures 13½" (34.5 cm) from dividing row for all sizes, ending with a WS row. With RS facing, BO all sts in patt.

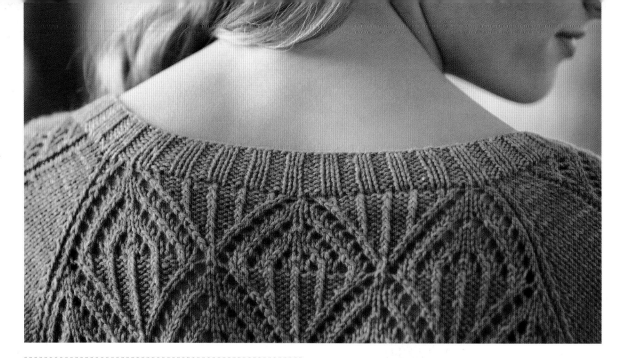

Sleeves

Note: *The sleeves are worked in rnds, beg with the next odd-numbered chart row after the WS dividing row. When working in rnds, read all even-numbered chart rows as right-side (RS) rnds.*

With shorter cir needle in larger size and RS facing, join yarn to center of underarm CO sts, then pick up and knit 6 (8, 13, 15, 10, 11, 15) sts along first half of CO sts, M1 (see Glossary) in corner between CO sts and held sts, work 73 (75, 77, 73, 83, 85, 87) held sleeve sts as established, M1 in corner between sleeve sts and CO sts, pick up and knit 7 (9, 14, 16, 11, 12, 16) sts along other half of CO sts—88 (94, 106, 106, 106, 110, 120) sts total. Pm and join for working in rnds.

NEXT RND: K5 (7, 12, 14, 9, 10, 14), k2tog, work in patt to last 8 (10, 15, 17, 12, 13, 17) sts, k2tog, k6 (8, 13, 15, 10, 11, 15)—86 (92, 104, 104, 104, 108, 118) sts rem

Work 1 rnd even in patt, working sts outside chart section in St st.

DEC RND: K2, k2tog, work in patt to last 4 sts, ssk, k2—2 sts dec'd.

Cont in patt, rep the dec rnd every other rnd 0 (0, 0, 4, 4, 6) more times, then every 4th rnd 9 (9, 14, 14, 10, 12, 11) times, then every 6th rnd 3 (3, 0, 0, 0, 0, 0) times, changing to dpn in larger size when sts no longer fit comfortably on cir needle—60 (66, 74, 74, 74, 74, 82) sts rem.

Work even in patt until sleeve measures about 11" (28 cm) from dividing row for all sizes, ending with Rnd 6 of Sleeve chart.

Cuff

Knit 6 rnds, purl 1 rnd for hem fold line—sleeve measures about 11¾" (30 cm) from dividing rnd. Change to smaller dpn and knit 6 more rnds for facing.

BO all sts.

Fold facing to WS along fold line and, with yarn threaded on a tapestry needle, whipstitch (see Glossary) in place.

Finishing

Block pieces to measurements.

Neckband

With longer cir needle in larger size and RS facing, pick up and knit 140 (140, 140, 140, 172, 172, 172) sts evenly spaced around neck opening. Do not join. Beg and ending with a WS row, work in k2, p2 rib until piece measures 1" (2.5 cm) from pick-up row.

With RS facing, BO all sts in patt.

Buttonband

With longer cir needle in larger size and RS facing, pick up and knit 120 (120, 120, 124, 128, 128, 132) sts evenly spaced along left front edge. Beg and ending with a WS row, work 5 rows in k2, p2 rib.

With RS facing, BO all sts in patt.

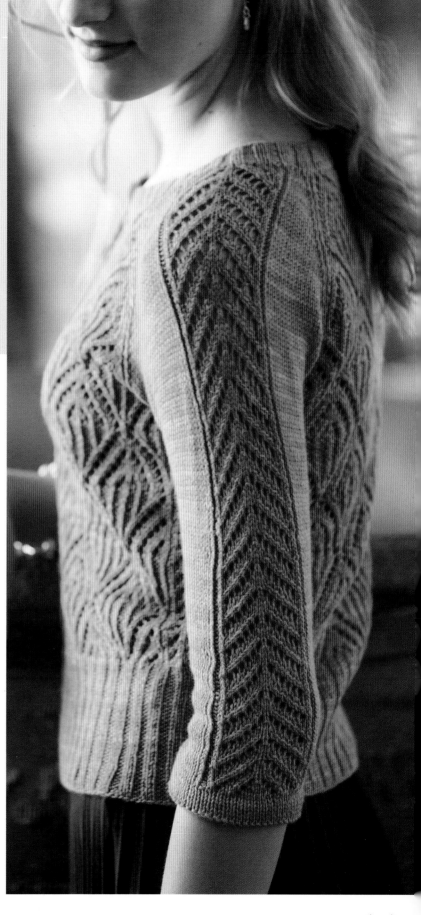

Make It Yours

Stitch pattern breakdown:

Main body: Multiple of 18 stitches plus 1 balancing stitch.

Side insert: 11-stitch panel.

◇ Choose any pattern with a multiple of 18 stitches plus 1 to substitute for the chandelier lace pattern used here. You can also use a pattern with a multiple of 9 stitches plus 1, repeating the 9-stitch pattern twice for every 18-stitch repeat in the original.

◇ For an even better custom fit, substitute a wider or narrower lace panel for the 11-stitch side insert used here.

Buttonhole Band

Mark placement of 9 buttonholes on right front, one ½" (1.3 cm) up from lower edge, one ½" (1.3 cm) down from neck edge, and the others evenly spaced in between. With longer cir needle in larger size and RS facing, pick up and knit 120 (120, 120, 124, 128, 128, 132) sts evenly spaced along right front edge. Work 2 rows in k2, p2 rib, ending with a RS row.

BUTTONHOLE ROW: (WS) Cont in patt, use the one-row method (see Glossary), to make a 2-st buttonhole opposite each marked buttonhole position.

Work in patt for 2 more rows, ending with a WS row.

With RS facing, BO all sts in patt.

Weave in loose ends. Block again, if desired. Sew buttons to buttonband, opposite buttonholes.

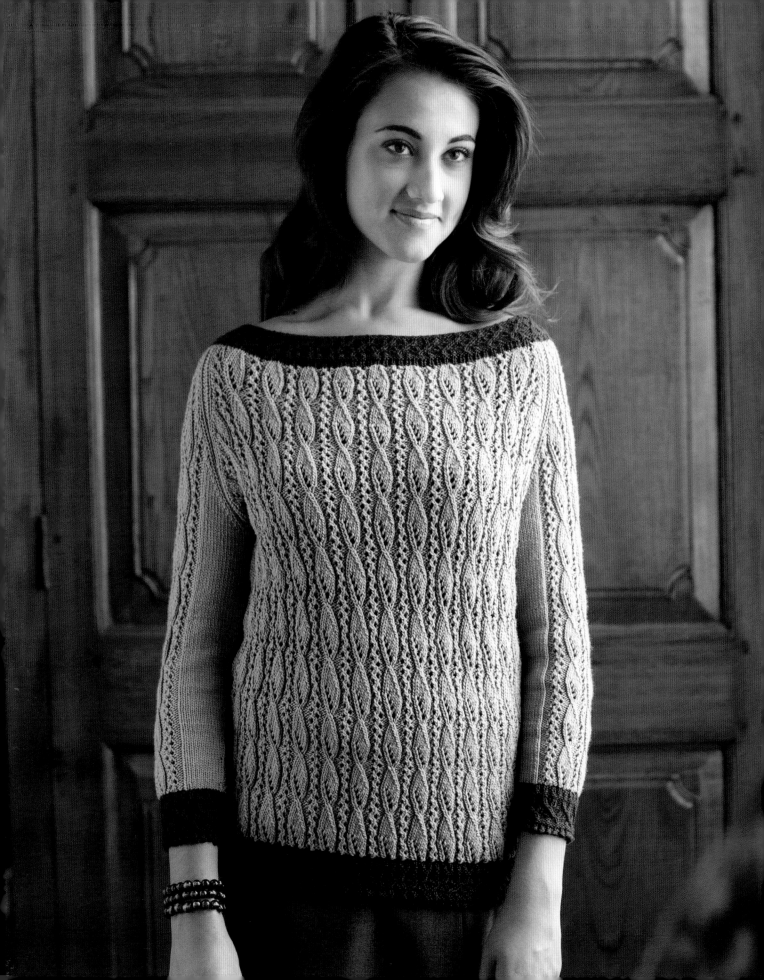

Lace Pullover

In this sophisticated and flattering pullover, you will learn a decorative dewdrop cast-on, how to shape your knitting without decreases or increases, and how to transition between colors and between stitch patterns. Worked from the bottom to the armholes, the waist shaping is achieved by changing needle size. The raglan yoke is worked in a single piece from the armholes to the neck. This project allows for easy stitch substitution and the length of the sleeves and body can be adjusted for very different looks.

designed by **FAINA GOBERSTEIN**

FINISHED SIZE

About 35½ (40½, 44¾, 49½, 54, 58¾)" (90 [103, 113.5, 125.5, 137, 149] cm) bust circumference.

Pullover shown measures 35½" (90 cm).

YARN

Sportweight (#2 Fine).

Shown here: Cascade Venezia Sport (70% merino, 30% mulberry silk; 307.5 yd [281 m]/100 g): #177 orchid haze (MC), 4 (5, 6, 7, 8, 9) skeins; #192, royal purple (CC), 2 skeins for all sizes.

NEEDLES

Body and sleeves: size U.S. 4 (3.5 mm): 24" or 32" (60 or 80 cm) circular (cir) and set of 5 double-pointed (dpn).

Waist: size U.S. 3 (3.25 mm): 24" or 32" (60 or 80 cm) cir and size U.S. 2 (2.75 mm): 24" or 32" (60 or 80 cm) cir.

Adjust needle sizes if necessary to obtain the correct gauge.

NOTIONS

Markers (m); two cable needles (cn); stitch holders; tapestry needle.

GAUGE

5 patt repeats (varies from 8 to 12 sts) measure 5¾" (14.5 cm) wide (unstretched) and 36 rnds = 4" (10 cm) high in patt from Eyelet and Lace chart on largest needles.

29 sts and 35 rnds = 4" (10 cm) in right and left traveling rib patts on largest needles.

27 sts and 36 rnds = 4" (10 cm) in St st on largest needles.

Design Techniques

Raglan construction worked in rounds from the bottom up, page 7.

Shaping in lace patterns, page 41.

Self-standing patterns, page 17.

Dewdrop cast-on, page 172.

Combining lace with other stitch patterns, page 47.

TIPS & TRICKS

- When working the decorative dewdrop cast-on, be sure to maintain uniform tension. If you work it too tightly, the "dewdrop" will not be apparent.

- Place markers to separate pattern repeats.

- The stitch count in the main pattern repeat of the Eyelet and Lace chart varies from 8 to 12 stitches. Each repeat is made up of two pattern sections that are indicated on the chart: a 6-stitch eyelet section that remains constant throughout, and a lace section that begins as 2 stitches, increases to 6 stitches, then decreases back to 2 stitches.

- During shaping, if there are not enough stitches in an eyelet section of the Eyelet and Lace chart to work both the decrease and its companion yarnover, work the remaining stitch in stockinette instead.

- During shaping, continue the lace sections of the Eyelet and Lace chart as well as possible. Check to make sure that the overall raglan shaping removes about the same number of repeats from each side of all pieces to preserve the symmetry of the pattern; if not, make any necessary adjustments.

- If one of the two stitches included in a raglan decrease is a yarnover, work the yarnover through its back loop to twist it. If necessary, remove the yarnover and replace it on the left needle in its twisted position before working the decrease.

STITCH GUIDE

1/1LC
Sl 1 st onto cn and hold in front of work, k1, then k1 from cn.

1/2/1LC
Sl 1 st onto first cn and hold in front of work, sl next 2 sts onto second cn and hold in back of work, k1, return 2 purl sts from second cn onto left needle and work them as p2, then k1 from first cn.

1/2/1RC
Sl 3 sts onto cn and hold in back of work, k1, return 2 purl sts from cn onto left needle and work them as p2, then k1 from cn.

LEFT TRAVELING RIB: (MULTIPLE OF 6 STS)
RNDS 1–3: *K1, p2; rep from *.

RND 4: *1/2/1LC, p2; rep from *.

RNDS 5 AND 6: Rep Rnd 1.

RND 7: *K1, p2; rep from * to last 3 sts and stop, leaving last 3 sts unworked.

RND 8: Sl 1 unworked st onto first cn and hold in front of work, sl next 2 sts onto second cn and hold in back of work, k1, return 2 purl sts from second cn onto left needle and work them as p2, replace end-of-rnd m, k1 from first cn, p1, *1/2/1LC, p2; rep from * to 3 sts before end-of-rnd m, k1, p2.

RNDS 9–11: Rep Rnds 1–3.

RIGHT TRAVELING RIB: (MULTIPLE OF 6 STS)
RNDS 1–3: *K1, p2; rep from *.

RND 4: *1/2/1RC, p2; rep from *.

RNDS 5 AND 6: Rep Rnd 1.

RND 7: *K1, p2; rep from * to last 3 sts and stop, leaving last 3 sts unworked.

RND 8: Sl last 3 unworked sts of Rnd 7 onto cn and hold in back of work, remove end-of-rnd m, k1, return 2 purl sts from cn onto left needle and work them as p2, replace end-of-rnd m, k1 from cn, p2, *1/2/1RC, p2; rep from * to 3 sts before end-of-rnd m, k1, p2.

RNDS 9–11: Rep Rnds 1–3.

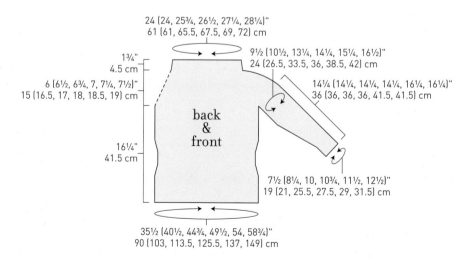

24 (24, 25¾, 26½, 27¼, 28¼)"
61 (61, 65.5, 67.5, 69, 72) cm

9½ (10½, 13¼, 14¼, 15¼, 16½)"
24 (26.5, 33.5, 36, 38.5, 42) cm

1¾"
4.5 cm

6 (6½, 6¾, 7, 7¼, 7½)"
15 (16.5, 17, 18, 18.5, 19) cm

14¼ (14¼, 14¼, 14¼, 16¼, 16¼)"
36 (36, 36, 36, 41.5, 41.5) cm

back & front

16¼"
41.5 cm

7½ (8¼, 10, 10¾, 11½, 12½)"
19 (21, 25.5, 27.5, 29, 31.5) cm

35½ (40½, 44¾, 49½, 54, 58¾)"
90 (103, 113.5, 125.5, 137, 149) cm

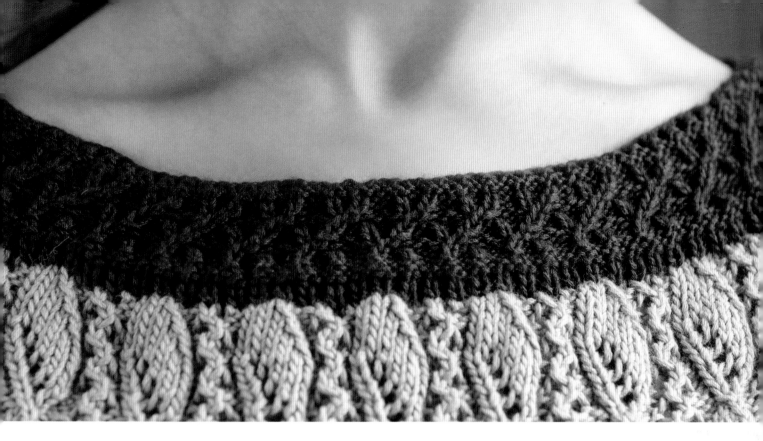

Sleeves

Cuff Border

With CC, dpn, and using the dewdrop method (see Glossary), CO 54 (60, 72, 78, 84, 90) sts. Place marker pm) and join for working in rnds, being careful not to twist sts.

Work in k1, p1 rib for 2 rnds.

Purl 2 rnds.

Work Rnds 1–11 of left traveling rib patt (see Stitch Guide).

Purl 2 rnds.

Work in k1, p1 rib for 2 rnds.

Knit 1 rnd—piece measures about 2¼" (5.5 cm) from CO.

Shape Sleeve

Change to MC. Knit 1 rnd and *at the same time* inc 2 (2, 4, 4, 4, 4) sts evenly spaced—56 (62, 76, 82, 88, 94) sts.

SET-UP RND: Work only the first 6 sts from Rnd 1 of Eyelet and Lace chart over first 6 sleeve sts, pm, work 10 (13, 20, 23, 26, 29) sts in St st, pm, beg and end as indicated for center sleeve panel, work Rnd 1 of Eyelet and Lace chart over 30 sts, pm, work 10 (13, 20, 23, 26, 29) sts in St st.

Note: *Cont to work the first 6 sts of the chart over the first 6 sts of each rnd for a decorative sleeve detail.*

Slipping markers (sl m) every rnd as you come to them, work 2 rnds even in established patts.

INC RND: Work 6 sts in patt, sl m, k1, M1L (see Glossary), work in patt to last st, M1R (see Glossary), k1—2 sts inc'd: 1 st after the first St st and 1 st before the last St st.

Cont in patt, rep inc rnd every 12th rnd 2 (3, 0, 0, 0, 0) times, then every 10th rnd 2 (1, 0, 0, 0, 0) time(s), then every 8th rnd 0 (0, 6, 2, 3, 4) times, then every 6th rnd 0 (0, 0, 6, 5, 4) times, working new sts in St st—66 (72, 90, 100, 106, 112) sts, counting the center sleeve panel as 30 sts (see Notes); 15 (18, 27, 32, 35, 38) sts in each marked St st section; 6-st sleeve detail at beg of rnd.

Work even as established until 107 (107, 107, 107, 125, 125) chart rnds have been completed, ending with Rnd 35 (35, 35, 35, 17, 17) of chart—piece measures about 14¼ (14¼, 14¼, 14¼, 16¼, 16¼)" (36 [36, 36, 36, 41.5, 41.5] cm) from CO.

NEXT RND: (Rnd 36 [36, 36, 36, 18, 18] of chart) Work in patt to last 4 (4, 5, 6, 7, 7) sts, BO next 14 (14, 16, 18, 20, 20) sts, removing end-of-rnd m as you come to it; the

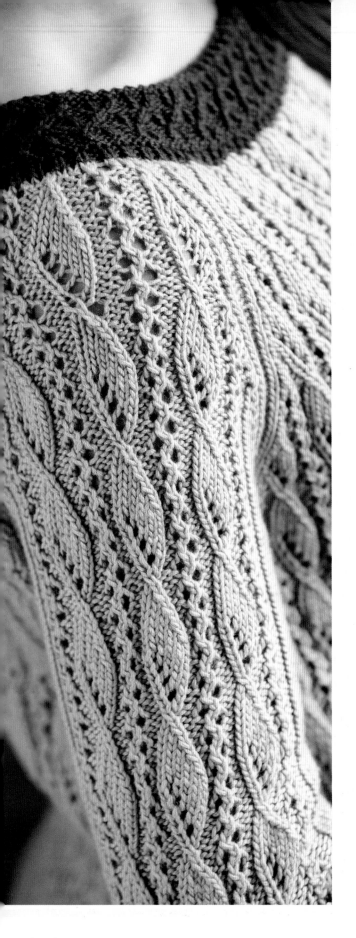

EYELET AND LACE

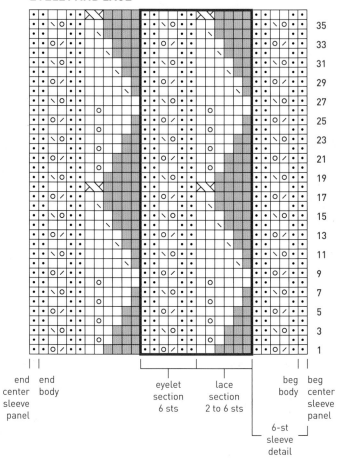

end center sleeve panel | end body | eyelet section 6 sts | lace section 2 to 6 sts | 6-st sleeve detail | beg body | beg center sleeve panel

Row numbers: 35, 33, 31, 29, 27, 25, 23, 21, 19, 17, 15, 13, 11, 9, 7, 5, 3, 1

☐ knit

· purl

○ yo

╱ k2tog

╲ ssk

▨ no stitch

☐ pattern repeat

⟋⟍ 1/1 LC (see Stitch Guide)

6-st sleeve detail will be in the center of the BO sts—52 (58, 74, 82, 86, 92) sts rem; 30 sts in center sleeve panel; 11 (14, 22, 26, 28, 31) sts in each marked St st section; 108 (108, 108, 108, 126, 126) chart rnds completed.

Place sts onto holder.

Body

Hemline Border

With CC, largest cir needle, and using the dewdrop method, CO 246 (276, 312, 342, 372, 408) sts. Pm and join for working in rnds, being careful not to twist sts.

Work in k1, p1 rib for 2 rnds.

Purl 2 rnds.

Work Rnds 1–11 of Right Traveling Rib patt (see Stitch Guide).

Purl 2 rnds.

Work in k1, p1 rib for 2 rnds.

Knit 1 rnd—piece measures about 2¼" (5.5 cm) from CO.

Shape Hip to Waist

Change to MC. Knit 1 rnd and *at the same time* inc 2 (4, 0, 2, 4, 0) sts evenly spaced—248 (280, 312, 344, 376, 408) sts.

Note: *The chart patt is worked the same on the back and front to center the patt.*

SET-UP RND: Beg and ending where indicated for body work Rnd 1 of Eyelet and Lace chart as foll: *Work 5 sts before patt rep once, rep 8-st patt 14 (16, 18, 20, 22, 24) times, work 7 sts after patt rep once,* pm for right side; rep from * to * once more for back—124 (140, 156, 172, 188, 204) sts each for front and back. Rnd begins at start of front sts.

Cont in patt as established until piece measures 4½ (4½, 4½, 4¾, 5, 5)" (11.5 [11.5, 11.5, 12, 12.5, 12.5] cm) from CO.

Shape Waist

Change to middle-size cir needle and work even in patt for 2 (2, 2, 2¼, 2½, 2½)" (5 [5, 5, 5.5, 6.5, 6.5] cm).

Change to smallest cir needle and work even for 2" (5 cm) for all sizes.

Change to middle-sized cir needle and work even for 2 (2, 2, 2¼, 2½, 2½)" (5 [5, 5, 5.5, 6.5, 6.5] cm)—piece measures about 10½ (10½, 10½, 11¼, 12, 12)" (26.5 [26.5, 26.5, 28.5, 30.5, 30.5] cm) from CO.

Shape Waist to Bust

Change to largest cir needle and work even in patt until 125 chart rnds have been completed for all sizes, ending with Rnd 17 of chart and ending last rnd 7 (7, 8, 9, 10, 10) sts before end-of-rnd m—piece measures about 16¼" (41.5 cm) from CO.

NEXT RND: (Rnd 18 of chart) Removing m as you come to them, BO last 7 (7, 8, 9, 10, 10) sts of previous rnd and first 7 (7, 8, 9, 10, 10) sts of next rnd for left armhole, work front sts in patt to 7 (7, 8, 9, 10, 10) sts before side m, BO 14 (14, 16, 18, 20, 20) sts for right armhole, work in patt to end of back sts—220 (252, 280, 308, 336, 368) sts rem; 110 (126, 140, 154, 168, 184) sts each for front and back.

Join Sleeves and Body

Note: *In the following rnd, cont the chart patt as established with Rnd 19 for the body sts and Rnd 1 (1, 1, 1, 19, 19) for the sleeve sts.*

NEXT RND: With yarn attached to end of back sts and keeping in patt (see Notes), for left sleeve *work the first sts as p1, k1, pm, work in patt to last 2 sts, pm, k1, p1;* rep from * to * for the front, right sleeve, and back, then

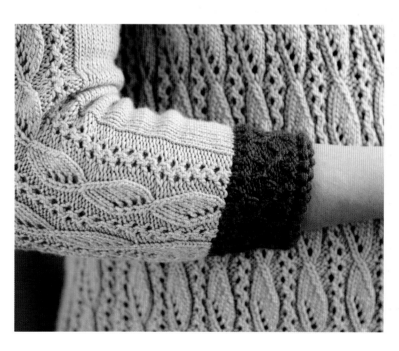

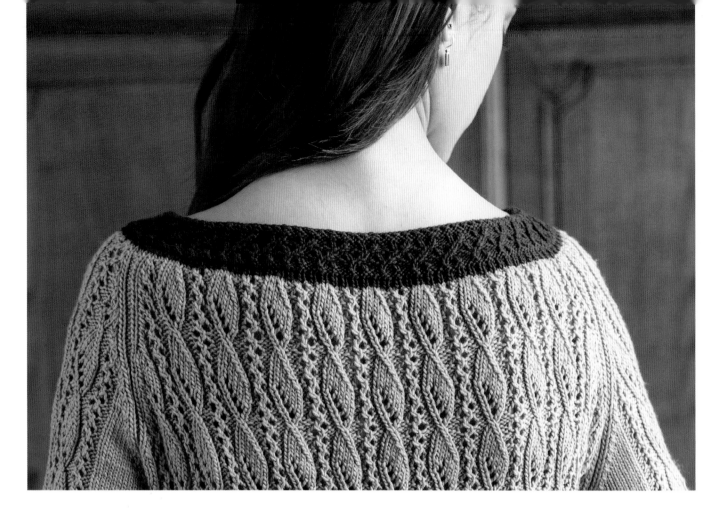

work first 2 left sleeve sts again as p1, k1, to end at the marker (now the end-of-rnd)—324 (368, 428, 472, 508, 552) sts total; 106 (122, 136, 150, 164, 180) sts each for front and back, 48 (54, 70, 78, 82, 88) sts each sleeve, and 4 marked 4-st raglan sections.

Rnd begins after left back raglan sts, at start of left sleeve sts.

Work 1 rnd even in patt, working each 4-st raglan section as k1, p2, k1.

Shape Raglan

Note: *If you reach the desired number of reps before the desired length of the raglan, work even until the raglan is the correct height. If too many reps rem when the raglan has reached the correct height, stop; the extra sts can be decreased away in the next few rnds. Because the number of sts in each rep and the number of balancing sts vary depending on the last chart rnd completed, exact stitch counts cannot be determined at this point.*

DEC RND: (see Notes) Keeping in patt, *k2tog, work to 2 sts before raglan m, ssk, sl m, k1, p2, k1, sl m; rep from * 3 more times—8 sts dec'd.

NEXT RND: Work even in established patts, working each 4-st raglan section as k1, p2, k1.

Cont in patt, rep the last 2 rnds until the front and back contain about 9 (11, 13, 13, 15, 17) patt reps with a few sts at each side as necessary to balance and center the patt, each sleeve contains a single rep with a few sts at each side as necessary to balance and center the patt, and the raglan measures about 5¾ (6¼, 6½, 6¾, 7, 7¼)" (14.5 [16, 16.5, 17, 18, 18.5] cm) from joining rnd.

Count the number of sts in each full patt rep and cont as foll according to your patt arrangement:

8 sts rem in each repeat (2 sts in each lace section)

Knit 2 rnds, removing raglan m. Knit 1 rnd, dec evenly to 178 (196, 228, 244, 272, 288) sts—raglan measures about 6 (6½, 6¾, 7, 7¼, 7½)" (15 [16.5, 17, 18, 18.5, 19] cm) from joining rnd.

*9 or 10 sts rem in each repeat
(3 or 4 sts in each lace section)*

Knit 1 rnd, removing raglan m. Knit 1 rnd, dec the lace section of each rep to 2 sts. Knit 1 rnd, dec evenly to 178 (196, 228, 244, 272, 288) sts—raglan measures about 6 (6½, 6¾, 7, 7¼, 7½)" (15 [16.5, 17, 18, 18.5, 19] cm) from joining rnd.

*11 or 12 sts rem in each repeat
(5 or 6 sts in each lace section)*

Knit 1 rnd, removing raglan m and dec the lace section of each rep to 4 sts. Knit 1 rnd, dec the lace section of each rep to 2 sts. Knit 1 rnd, dec evenly to 178 (196, 228, 244, 272, 288) sts—raglan measures about 6 (6½, 6¾, 7, 7¼, 7½)" (15 [16.5, 17, 18, 18.5, 19] cm) from joining rnd.

Neck Border

NEXT RND: Change to CC and knit 1 rnd and *at the same time* dec 0 (0, 14, 12, 28, 30) sts evenly spaced—178 (196, 214, 232, 244, 258) sts rem.

Work in k1, p1 rib for 2 rnds.

NEXT RND: Purl and *at the same time* dec 0 (12, 18, 24, 26, 26) sts by working evenly spaced p2tog decs—178 (184, 196, 208, 218, 232) sts rem.

NEXT RND: Purl and *at the same time* dec 4 (4, 10, 16, 20, 28) sts by working evenly spaced p2tog decs—174 (180, 186, 192, 198, 204) sts rem.

Work Rnds 1–4 of right traveling rib patt. Change to middle-size needle. Work Rnds 5–8 of patt. Change to smallest needle. Work Rnds 9–11 of patt.

Purl 1 rnd.

NEXT RND: Purl and *at the same time* dec 0 (6, 0, 0, 0, 0) sts by working evenly spaced p2tog decs —174 (174, 186, 192, 198, 204) sts rem.

Work in k1, p1 rib for 2 rnds—neck border measures about 1¾" (4.5 cm).

BO all sts in rib patt.

Finishing

Block to measurements. Weave in loose ends.

Make It Yours

Stitch pattern breakdown:

Overall stitch pattern: 8-stitch repeat, plus 6 stitches to balance the sleeve pattern or plus 4 stitches to balance the body pattern.

◊ Choose any pattern that is a multiple of 4 or 8 stitches to substitute for the main pattern. Add 4 balancing stitches to center the pattern symmetrically for the front and back. This is also helpful with the placement of pattern at the raglan lines.

◊ For each sleeve, place the desired number of repeats of the 8-stitch pattern plus 6 balancing stitches in the center and work the stitches at each side of the pattern section in stockinette.

◊ For a nice detail, work a small 2- to 6-stitch panel in pattern along the invisible sleeve "seam" and increase stitches on each side of this panel to shape the sleeve.

◊ Check the gauge of your new patterns and adjust needle size if necessary to achieve the correct measurements.

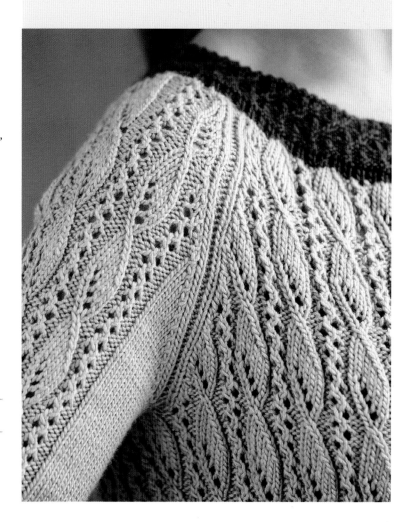

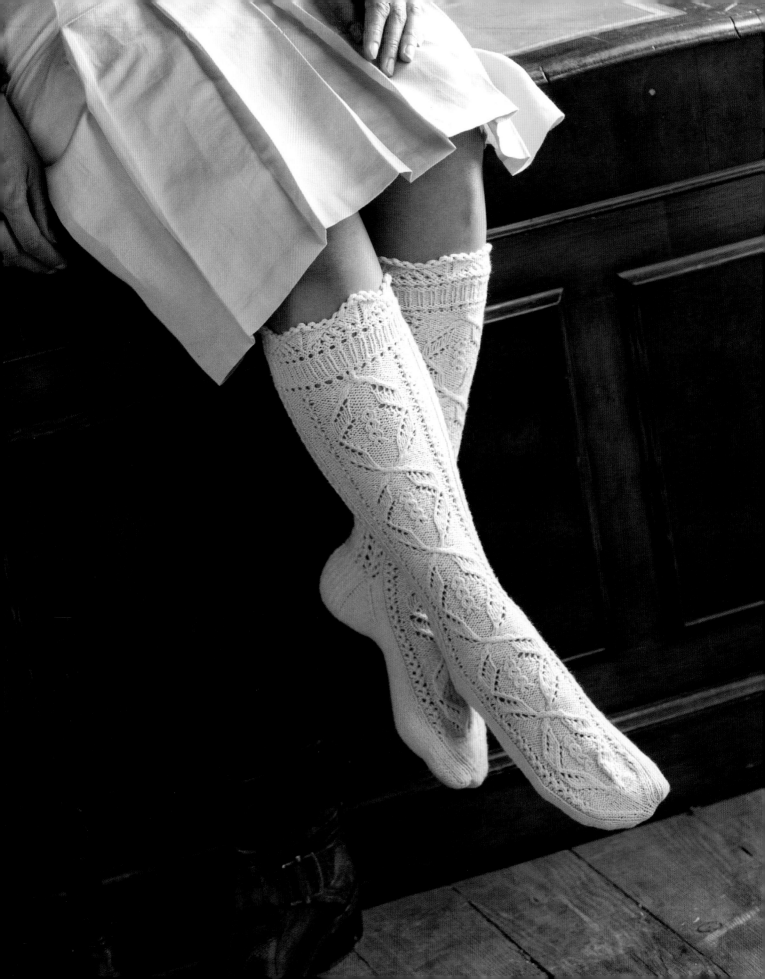

Lace Stockings

Knitted from the top down, these stockings begin with a decorative dewdrop cast-on and a small geometric lace cuff that includes a strand of elastic thread (to help keep the stockings in place) and is bordered with eyelets. Two beautiful and somewhat geometric lace patterns are combined for the main part of the leg, with the larger pattern continuing along the top of the foot. Decreases between the patterns shape the leg "invisibly." The vintage look of these knee-high stockings will add romantic flavor to any outfit.

designed by **FAINA GOBERSTEIN**

FINISHED SIZE

About 7¾ (8¼, 9¼)" (19.5 [21, 23.5] cm) foot circumference, 9 (10½, 12)" (23 [26.5, 30.5] cm) calf circumference, and 9 (9¾, 10¼)" (23 [25, 26] cm) foot length from back of heel to tip of toe (length is adjustable).

Socks shown measure 8¼" (21 cm) foot circumference.

YARN

Fingering Weight (#1 Super Fine).

Shown here: Bijou Ranch Basin Bijou Spun Tibetan Dream (85% yak down, 15% nylon; 440 yd [402 m]/4 oz [114 g]): #02 natural cream, 2 skeins for all sizes.

NEEDLES

Size U.S. 2 (2.75 mm): set of 5 double-pointed (dpn).

Adjust needle size if necessary to obtain the correct gauge.

NOTIONS

Markers (m); cable needle (cn); stitch holder or waste yarn; tapestry needle; Gutermann elastic thread in white.

GAUGE

31 sts and 46 rnds = 4" (10 cm) in St st, worked in rnds.

23 sts of Lace and Cables chart measure 3" (7.5 cm) wide.

7 sts of Little Arrows chart measure 1" (2.5 cm) wide.

Design Techniques

Dewdrop cast-on, page 172.

Self-standing patterns, page 17.

Combining lace with other stitch patterns, page 47.

Kitchener stitch, page 174.

STITCH GUIDE

2/1/2 LC

Sl 3 sts onto cn and hold in front of work, k2, sl third st from cn back onto left needle and work it as p1, then k2 from cn.

PASS 1, K1, YO, K1

Skip the first 2 sts on left needle, use the right needle tip to lift the third st on left needle up and over the first 2 sts and off the needle to wrap them, then work the first 2 sts on the left needle as k1, yo, k1—3 sts made from 3 sts.

Cuff

Using the dewdrop method (see Glossary), CO 66 (77, 88) sts. Arrange sts as evenly as possible on 4 dpn, place marker (pm), and join for working in rnds, being careful not to twist sts.

Purl 1 rnd, then work Rnds 1–10 of Diamond Dangles chart.

NEXT RND: Purl to last 4 (2, 0) sts, [p2tog] 2 (1, 0) time(s)—64 (76, 88) sts rem.

Purl 1 rnd.

EYELET RND: *K2tog, yo; rep from *.

Purl 2 rnds.

Join elastic thread and, with elastic held tog with working yarn, work k1, p1 rib for 9 rnds.

Cut elastic thread and cont with working yarn only.

Purl 2 rnds, then rep eyelet rnd.

Purl 2 rnds, ending the second rnd 11 sts before the end-of-rnd m—piece measures about 2½" (6.5 cm) from CO.

Leg

SET-UP RND: Removing old m as you come to it, work *k2, p19, k2, pm, p1 (4, 7), pm, k7, pm, p1 (4, 7), pm; rep from * once more; the last m placed is the new end-of-rnd m.

NEXT RND: *Work Rnd 1 of Lace and Cables chart over 23 sts, slip marker (sl m), p1 (4, 7), sl m, work Rnd 1 of Little Arrows chart over 7 sts, sl m, p1 (4, 7), sl m; rep from * once more.

Slip markers on all foll rnds as you come to them.

Cont in established patts, purling the sts between the charts every rnd, until leg measures 9 (4, 6)" (23 [10, 15] cm) from CO.

Taper Leg

Cont for your size as foll:

Size 7¾" only

DEC RND: *Work Lace and Cables chart as established over 23 sts, k2tog (next st tog with first st of Little Arrows chart) removing m, work next 5 sts of chart, ssk (last st of Little Arrows tog with st after it) removing m; rep from * once more—60 sts rem; no purl sts rem between chart patts.

Size 8¼" only

DEC RND 1: *Work Lace and Cables chart as established over 23 sts, sl m, p2tog, p2, sl m, work Little Arrows chart as established over 7 sts, sl m, p2tog, p2, sl m; rep from * once more—72 sts rem; 3 purl sts rem between chart patts.

Work 31 rnds even.

DEC RND 2: *Work Lace and Cables chart as established over 23 sts, sl m, p2tog, p1, sl m, work Little Arrows chart as established over 7 sts, sl m, p2tog, p1, sl m; rep from * once more—68 sts rem; 2 purl sts rem between chart patts.

LACE AND CABLES

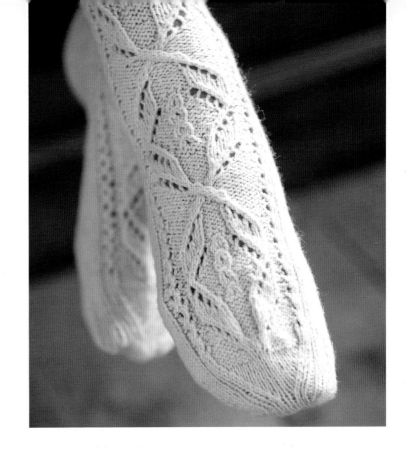

(chart rows, odd numbers: 75, 73, 71, 69, 67, 65, 63, 61, 59, 57, 55, 53, 51, 49, 47, 45, 43, 41, 39, 37, 35, 33, 31, 29, 27, 25, 23, 21, 19, 17, 15, 13, 11, 9, 7, 5, 3, 1)

Legend

	
☐	knit
•	purl
O	yo
╱	k2tog
╲	ssk
⋀	sl 2 sts as if to k2tog, k1, p2sso
☐	pattern repeat
	pass 1, k1, yo, k1 (see Stitch Guide)
	sl 2 sts onto cn and hold in front, p2, k2 from cn
	sl 2 sts onto cn and hold in back, k2, p2 from cn
╳╳	2/1/2 LC (see Stitch Guide)

DIAMOND DANGLES

(chart rows: 9, 7, 5, 3, 1)

LITTLE ARROWS

(chart rows: 3, 1)

Work 31 rnds even.

DEC RND 3: *Work Lace and Cables chart as established over 23 sts, sl m, p2tog, sl m, work Little Arrows chart as established over 7 sts, sl m, p2tog, sl m; rep from * once more—64 sts rem; 1 purl st rem between chart patts.

Size 9¼" only

DEC RND 1: *Work Lace and Cables chart as established over 23 sts, sl m, p2tog, p5, sl m, work Little Arrows chart as established over 7 sts, sl m, p2tog, p5, sl m; rep from * once more—84 sts rem; 6 purl sts rem between chart patts.

Work 19 rnds even.

DEC RND 2: *Work Lace and Cables chart as established over 23 sts, sl m, p2tog, p4, sl m, work Little Arrows chart as established over 7 sts, sl m, p2tog, p4, sl m; rep from * once more—80 sts rem; 5 purl sts rem between chart patts.

Work 19 rnds even.

DEC RND 3: *Work Lace and Cables chart as established over 23 sts, sl m, p2tog, p3, sl m, work Little Arrows chart as established over 7 sts, sl m, p2tog, p3, sl m; rep from * once more—76 sts rem; 4 purl sts rem between chart patts.

Work 19 rnds even.

DEC RND 4: *Work Lace and Cables chart as established over 23 sts, sl m, p2tog, p2, sl m, work Little Arrows chart as established over 7 sts, sl m, p2tog, p2, sl m; rep from * once more—72 sts rem; 3 purl sts rem between chart patts.

All sizes

Cont even in established patts until a total 114 rnds of Lace and Cables chart have been worked, ending with Rnd 38 of chart.

NEXT RND: (Rnd 39 of Lace and Cables chart; Rnd 3 of Little Arrows chart) Work in patt to last 7 (8, 10) sts, work first 3 sts of Little Arrows patt as k3, and stop here, leaving last 4 sts of Little Arrows and the 0 (1, 3) purl st(s) after them unworked—leg measures about 14" (35.5 cm) from CO.

Shape Heel

SET-UP ROW: With RS still facing and removing markers as you come to them, k1, [sl 1 purlwise with yarn in back, k1] 15 (16, 18) times, then place next 29 (31, 35) sts on waste yarn or holder to work later for instep; the 23 sts of the Lace and Cables chart should be in the center of the held sts—31 (33, 37) sts rem for heel.

Heel Flap

Work 31 (33, 37) heel sts back and forth in rows as foll:

ROW 1: (WS) Sl 1 purlwise with yarn in front (pwise wyf), purl to last st, k1.

ROW 2: (RS) Sl 1 pwise wyf, k1, *sl 1 pwise with yarn in back (wyb), k1; rep from * to last st, k1.

Rep the last 2 rows 14 more times, then work WS Row 1 once more—31 rows total; flap measures about 2¼" (5.5 cm).

Heel Turn

Work heel sts in short-rows as foll:

ROW 1: (RS) Sl 1 kwise, k1, [sl 1 wyb, k1] 9 (9, 11) times, sl 1 wyb 0 (1, 0) time, ssk, turn work—9 (10, 11) unworked sts at end of row.

ROW 2: (WS) Sl 1 wyf, p9 (9, 11), p2tog, turn work—9 (10, 11) unworked sts at end of row.

ROW 3: Sl 1 kwise, k1, [sl 1 wyb, k1] 4 (4, 5) times, ssk (1 st each side of gap), turn work.

ROW 4: Sl 1 wyf, p9 (9, 11), p2tog (1 st each side of gap), turn work.

Rep Rows 3 and 4 eight (nine, ten) more times—all sts have been worked; 11 (11, 13) center heel sts rem.

Shape Gussets

RND 1: (RS) Sl 1 wyf, k10 (10, 12) heel sts, pick up and knit 15 sts along side of heel flap, pm, pick up and knit 1 st between flap and instep sts; work 29 (31, 35) held instep sts as k2 (3, 5), p1, 23 sts in patt from Rnd 40 of Lace and Cable chart, p1, k2 (3, 5); pick up and knit 1 st between flap and instep sts, pm, pick up and knit 15 sts along side of heel flap, pm for new beg of rnd—72 (74, 80) sts total; 31 (33, 37) sts between markers for instep; rnd begins at start of heel sts.

RND 2: K26 (26, 28), sl m, k3 (4, 6), p1, work 23 sts of Lace and Cable chart, p1, k3 (4, 6), sl m, knit to end.

RND 3: (dec rnd) Knit to 2 sts before first instep m, k2tog, sl m, k3 (4, 6), p1, work 23 sts of Lace and Cable chart, p1, k3 (4, 6), sl m, ssk, knit to end—2 sts dec'd.

RND 4: Work even as established, working sts outside chart patt as they appear (knit the knits and purl the purls).

Rep Rnds 3 and 4 five (four, three) more times—60 (64, 72) sts rem; 31 (33, 37) sts between markers for instep; 29 (31, 35) St sts for sole.

Foot

Work even in established patts until foot measures 7¼ (7¾, 8)" (18.5 [19.5, 20.5] cm) from back of heel or about 1¾ (2, 2¼)" (4.5 [5, 5.5] cm) less than desired finished length.

Note: *The socks shown have a 9¾" (25 cm) foot length, contain 190 total rnds of the Lace and Cables chart from the beg; the foot ends with Rnd 38 of the third rep.*

Toe

RND 1: Knit to 2 sts before first m, k2tog, sl m, k3 (4, 6), p1, k2, p8, k3tog, p8, k2, p1, k3 (4, 6), sl m, ssk, knit to end—56 (60, 68) sts rem; 29 (31, 35) sts between markers for top of foot; 27 (29, 33) sts for bottom of foot.

RND 2: Knit to first m, sl m, k3 (4, 6), p1, k2, p2tog, p6, k1, p6, p2tog, k2, p1, k3 (4, 6), sl m, knit to end—54 (58, 66) sts rem; 27 (29, 33) sts each for top and bottom of foot.

RND 3: Knit.

RND 4: Knit to 2 sts before first m, k2tog, sl m, k3 (4, 6), p1, k1, ssk, knit to 7 (8, 10) sts before next m, k2tog, k1, p1, k3 (4, 6), sl m, ssk, knit to end—4 sts dec'd.

Rep the last 2 rnds 6 more times—26 (30, 38) sts rem; 13 (15, 19) sts each for top and bottom of foot; 1 st rem between decs on top of foot.

NEXT RND: Knit.

NEXT RND: Knit to 2 sts before first m, k2tog, sl m, ssk, work sts as they appear to 2 sts before next m, k2tog, sl m, ssk, knit to end—4 sts dec'd.

Make It Yours

Stitch pattern breakdown:
Diamond dangles: Multiple of 11 stitches.
Lace and cables pattern: Panel of 23 stitches.
Little arrows pattern: Panel of 7 stitches.

◊ When substituting other stitch patterns, work the ribbing and eyelet rounds at the top of the leg, the heel, and the gusset and toe shaping the same as in the instructions.

◊ The main lace and cable pattern can be replaced with another 23-stitch panel or a different combination of stitches that adds up to 23 stitches. For example, you could choose a 19-stitch panel and add 2 purl stitches to each side for 23 stitches total. Using a panel with fewer than 19 stitches is not recommended, because it would be too narrow to match the proportions of the original design.

◊ The little arrows pattern can be replaced by a different 7-stitch panel or a 5-stitch panel with a purl stitch added to each side to make 7 stitches total.

◊ Check the gauge of your new patterns and adjust needle size if necessary to achieve the correct measurements.

Rep the last 2 rnds 1 (2, 4) more time(s)—18 sts rem for all sizes.

Arrange sts with 9 sts for top of foot on one needle and 9 sts for bottom of foot on a second needle, with the working yarn between the two needles.

Finishing

Cut yarn, leaving a 14" (35.5 cm) tail. Use the Kitchener st (see Glossary) to graft rem sts tog.

Weave in loose ends. Lightly steam-block, being careful not to flatten the stitch patts.

Cable Patterns

Cables are formed by crossing two (or more) groups of stitches—in essence, knitting them out of order. The first group is held on a separate cable needle while the second group is worked, then the first group is worked.

Depending on whether the first stitches are held to front or back as the other group is worked, the resulting cable is said to cross to the left or right. By varying the number of stitches in each group, frequency of crossing rows, direction of cross, and even the type of crossed stitches, you can produce a variety of intricate three-dimensional fabrics.

Typically, cables are crossed on right-side rows—where it's easier to see the groups of stitches to be crossed—so there is always an even number of rows between the crossings. When knitting in rounds, you're always looking at the right side of the work and every round is a "right-side row." This makes for more consistent tension and it makes it easier to see the cables form and to know when it's time to cross them. However, it can be more difficult to keep track of how many rounds have been worked between crossings. It is therefore a good idea to use a row counter.

When blocking a cable swatch, stretch the knitted fabric to achieve the look you desire for your finished garment. Use the blocking method that works best for the yarn you've used. When blocking, be careful not to press too hard on cables—doing so will flatten the cables and eliminate their three-dimensionality.

Designing with Cable Patterns

Cables look most pronounced if they are worked against a background of contrasting stitches, such as stockinette cable stitches against a purl background; they will be less prominent if worked against stockinette, garter, seed, or other patterns with small stitch repeats. Each texture has its own charm and the preference of one over another depends on the look you're after. It's always a good idea to knit a generous swatch to ensure

that there is sufficient contrast between the cable and background stitches for your purposes. To get the best stitch definition in cables, use a smooth yarn that has some natural elasticity.

Note that cable crossings will draw in the knitted fabric and make it considerably denser than the same number of stitches worked in stockinette. The density depends on the width and frequency of the cable crosses. Many narrow cables that involve just two or four stitches will result in a more rigid fabric than wider cables. Also, be aware that the more cables there are, the more the fabric will draw in. You can offset some of this denseness by choosing to work with thinner and softer yarns.

When worked in seamless garments, cables can travel freely from the front to the back without interruption. It's best to plan for the beginning of the round to occur between cables, so you won't have

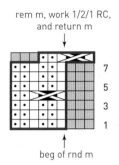

rem m, work 1/2/1 RC,
and return m

beg of rnd m

Figure 1
*When a cable cross occurs across the
beginning of the round, temporarily remove
the marker, cross the cable, then replace
the marker in its original position.*

← 5 sts decreased at once
to make a sharp corner

Figure 2
*On Row 23 of the cable pattern
used in the Cabled Top (page 106),
5 stitches are abruptly decreased
to create a sharp corner; 5 stitches
are reinstated on Rows 27 and 28.*

	knit on RS; purl on WS
·	purl on RS; knit on WS
⑤	5-into-1 dec (see Stitch Guide)
	sl 1 st onto cn and hold in front, k1, k1 from cn
③	1-into-3 inc (see Stitch Guide)
	sl 1 st onto cn and hold in back, k2, p1 from cn
	sl 2 sts onto cn and hold in front, p1, k2 from cn
	sl 2 sts onto cn and hold in back, k2, k2 from cn

	sl 2 sts onto cn and hold in front, k2, k2 from cn
	sl 2 sts onto cn and hold in back, k2, p2 from cn
	sl 2 sts onto cn and hold in front, p2, k2 from cn
	2/1/2 RC (see Stitch Guide)
	2/1/2 LC (see Stitch Guide)
	1/2/1 RC (see Stitch Guide)
	no stitch
	pattern repeat

Working Cables Without a Cable Needle

When working with wool or other sticky yarns that are less likely to ravel, it's possible to twist stitches for cables without using a cable needle. The instructions here are for cables that consist of two stitches but the principles are the same no matter how many stitches are crossed. Be aware that the chances of dropped stitches increase with the number of stitches involved in a cable.

Slip the first stitch (or group of stitches) off the left-hand needle and let it drop temporarily to the front (shown) or back of the work as specified in the instructions **(Figure 1)**. Slip the next stitch (or group of stitches) onto the right-hand needle, keeping the dropped stitch(es) in front or back. Return the dropped stitch(es) onto the left-hand needle, then return the held stitch(es) from the right-hand needle onto the left-hand needle **(Figure 2)**. Knit these stitches (or groups of stitches) in their new order **(Figure 3)**.

Figure 1

Figure 2

Figure 3

be lost to draw-in. At a gauge of 5 stitches/inch, you'd lose close to 2" (5 cm) in width in these areas. For this type of cable, you'll want to knit a generous swatch and measure the width-wise (stitch) gauge in a number of places and use the average in your calculations.

Shaping in Cable Patterns

There are a number of ways to make slight changes in the width of a garment worked in a cable pattern, even if the cables are used as an allover pattern. The shaping option depends on the type of cables involved: simple vertical columns of cables or more intricate intertwined cables.

If the cables are worked side by side in an allover pattern without any background stitches, you will be forced to interrupt the established pattern to shape the hips, waist, or bust. In these cases, you might want to work a few "plain" stitches at each side "seam", along which you can work increases and decreases without disturbing the cables.

If there are panels of background stitches that separate the cables, however, you can add or remove these background stitches without interfering with the cables themselves. Depending on how much the width needs to change, you can adjust the number of stitches in the background sections. For example, if four-stitch cables are separated by two purl stitches, you can decrease to a single purl stitch between cables or you could increase to three purl stitches between cables. You can make these decreases or increases in any number of panels. Just be sure to do so in a symmetrical fashion across the width or circumference of the piece.

In patterns made up of cables that travel across the fabric to form

to cross cables between the end of one round and the beginning of the next. But this is not always possible, especially if the cable pattern travels diagonally around the circumference of the garment. If you do find that you need to cross a cable across the end-of-round marker, temporarily remove the marker to cross the cable stitches, then replace the marker in its original position after the cable has been crossed, as shown in **Figure 1** (see page 75) and demonstrated in the Cabled Cowl on page 116.

Some showcase cables, such as Celtic knots, can make stunning design accents against plain

backgrounds. At the same time, they can be tricky in the design process due to the draw-in the cables cause. For example, the central cable in the Cabled Top on page 106, and shown in **Figure 2** (see page 75) changes in stitch count from 37 to 41 stitches, then back to 37 stitches in one pattern repeat. In this pattern, the cable is used as a central panel that is framed by small ropes on each side. In the case of a single four-stitch cable (in which two stitches cross over two), the remaining stitches can stretch to accommodate the two-stitch draw-in caused by the twist. But, if there were 6 such cables, a total of 12 stitches would

isolated cells of background or textured stitches, make the stitch adjustments within the cells. When doing so, be careful to preserve the integrity of the original pattern. If more than two stitches are increased or decreased within a cell, you might want to add or subtract two rows between the cable twists in order to maintain the same proportions of the original cable pattern. This is most easily done by marking the changes on a copy of the charted pattern. If the desired width changes are substantial, you might want to add or subtract background stitches as described above at the same time.

If you want to decrease along the edges of a cable, use directional left- and right-leaning decreases on non-cable rows/rounds to emphasize the direction of the cable twist, as shown in **Figure 3**. The directions of the decreases should match the directions that the stitches will lean after the cable

is crossed. In the chart shown in **Figure 4**, left-leaning decreases are centered within the cable stitches to emphasize the left-crossing cable. Although the placement and types of decreases are different between the two charts, in both cases the 4/4LC at the base becomes a 3/3LC, then a 2/2LC, then a 1/1LC, and finally, a single stitch.

Another way to shape invisibly is to work decreases simultaneously with the cable crossings, as shown in the chart in **Figure 5** and the accompanying swatch (see page 79). On each cable cross, one stitch is decreased from the group of stitches that fall behind the crossing stitches. For example, on Row 6, two 4/4 cables (eight stitches each) are worked in sequence. On Row 12, one stitch in the group that is held in back of each cable is decreased to result in seven stitches in each cable. On Row 18, one stitch is again decreased to form 3/3 cables (six stitches each). The look of the

cables is preserved throughout the series of decreases. This is a good strategy to use for the crown of a hat or yoke of a sweater worked from the bottom up.

Combining Cable Patterns

The amount of draw-in in cabled fabric varies according to the number of stitches that are crossed and the frequency of the crossings. An allover pattern of four-stitch cables (two stitches cross over two stitches) can narrow fabric width by as much as 30 percent in comparison to the number of stitches worked in stockinette. Therefore, if you want to combine multiple cable patterns, you'll need to measure the gauge of each cable pattern (before and after blocking) and calculate the number of stitches you'll need in each pattern in order to end up with the desired circumference.

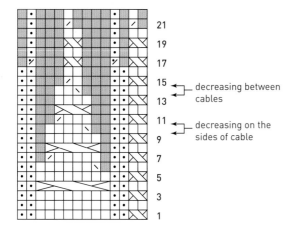

Figure 3

Decreases are worked at the edges of the cable to taper it from 8 stitches wide at the base to a single stitch at the top. Additional shaping is worked in the background stitches as well.

decreasing between cables

decreasing on the sides of cable

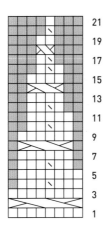

Figure 4

Decreases are worked within the center of the cable to taper it from 8 stitches wide at the base to a single stitch at the top.

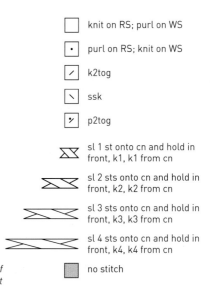

	knit on RS; purl on WS
•	purl on RS; knit on WS
/	k2tog
\	ssk
⅄	p2tog

sl 1 st onto cn and hold in front, k1, k1 from cn

sl 2 sts onto cn and hold in front, k2, k2 from cn

sl 3 sts onto cn and hold in front, k3, k3 from cn

sl 4 sts onto cn and hold in front, k4, k4 from cn

no stitch

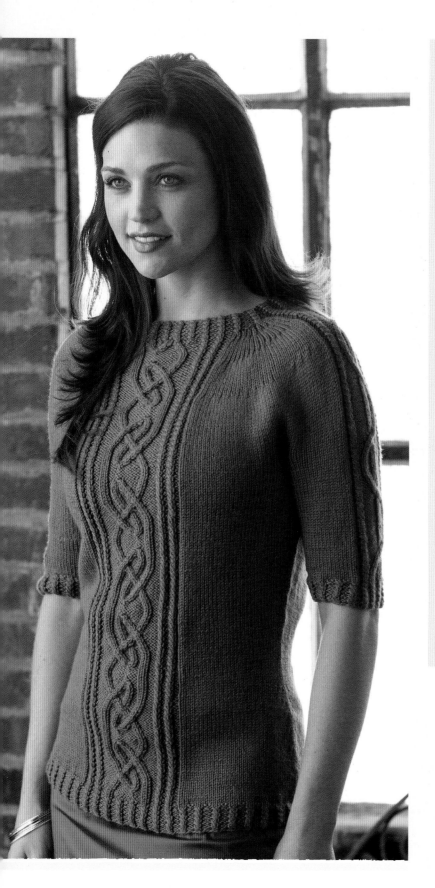

Tips for Working with Cables

CABLE NEEDLE: A short cable needle that is tapered on both ends will help make fast work of cable crossings. Cable needles come in a variety of shapes and sizes—for the best results, choose one that is smaller in diameter than the needles you're knitting with.

STITCH MARKERS: Use stitch markers to isolate different cable patterns, especially if there are different numbers of rows in the repeats.

TIGHTEN STITCHES: To prevent gaps from forming between the cable and background stitches, try to work the background stitch just before the cable and the one just after the cable a little tighter than normal.

COUNT ROWS: It can be tricky to count the number of rows that have been worked since the stitches were last crossed, so you might want to use a row counter. If your design involves cables that repeat over different numbers of rows, try using a separate counter for each pattern. Alternatively, place a removable marker in the background pattern on a crossing row. It will be easier to count rows in an area that doesn't include cable crosses.

DIVIDING FOR ARMHOLES: When working a pullover in rounds, divide the fronts and back at the armholes on a round that will become a right-side row when you switch to knitting back and forth in rows. This will ensure that the cable crossings will continue on right-side rows as established.

This tapered tulip cable is produced by nearly invisible decreases that are worked in conjunction with each cable cross. The charted pattern is shown at right.

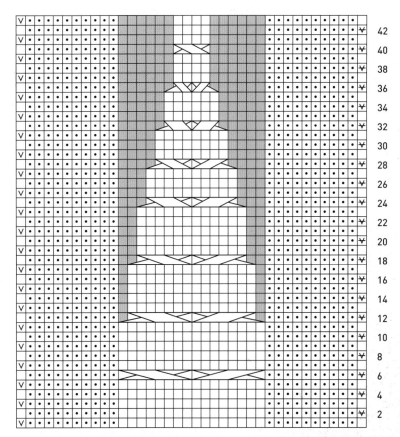

Figure 5

Chart for the tapered tulip cable shown above left.

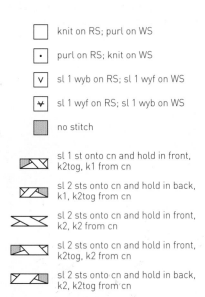

☐ knit on RS; purl on WS

· purl on RS; knit on WS

V sl 1 wyb on RS; sl 1 wyf on WS

↓ sl 1 wyf on RS; sl 1 wyb on WS

▨ no stitch

sl 1 st onto cn and hold in front, k2tog, k1 from cn

sl 2 sts onto cn and hold in back, k1, k2tog from cn

sl 2 sts onto cn and hold in front, k2, k2 from cn

sl 2 sts onto cn and hold in front, k2tog, k2 from cn

sl 2 sts onto cn and hold in back, k2, k2tog from cn

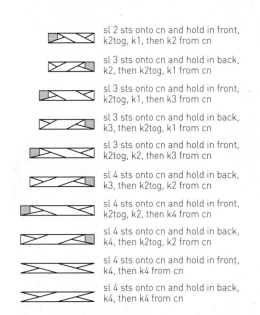

sl 2 sts onto cn and hold in front, k2tog, k1, then k2 from cn

sl 3 sts onto cn and hold in back, k2, then k2tog, k1 from cn

sl 3 sts onto cn and hold in front, k2tog, k1, then k3 from cn

sl 3 sts onto cn and hold in back, k3, then k2tog, k1 from cn

sl 3 sts onto cn and hold in front, k2tog, k2, then k3 from cn

sl 4 sts onto cn and hold in back, k3, then k2tog, k2 from cn

sl 4 sts onto cn and hold in front, k2tog, k2, then k4 from cn

sl 4 sts onto cn and hold in back, k4, then k2tog, k2 from cn

sl 4 sts onto cn and hold in front, k4, then k4 from cn

sl 4 sts onto cn and hold in back, k4, then k4 from cn

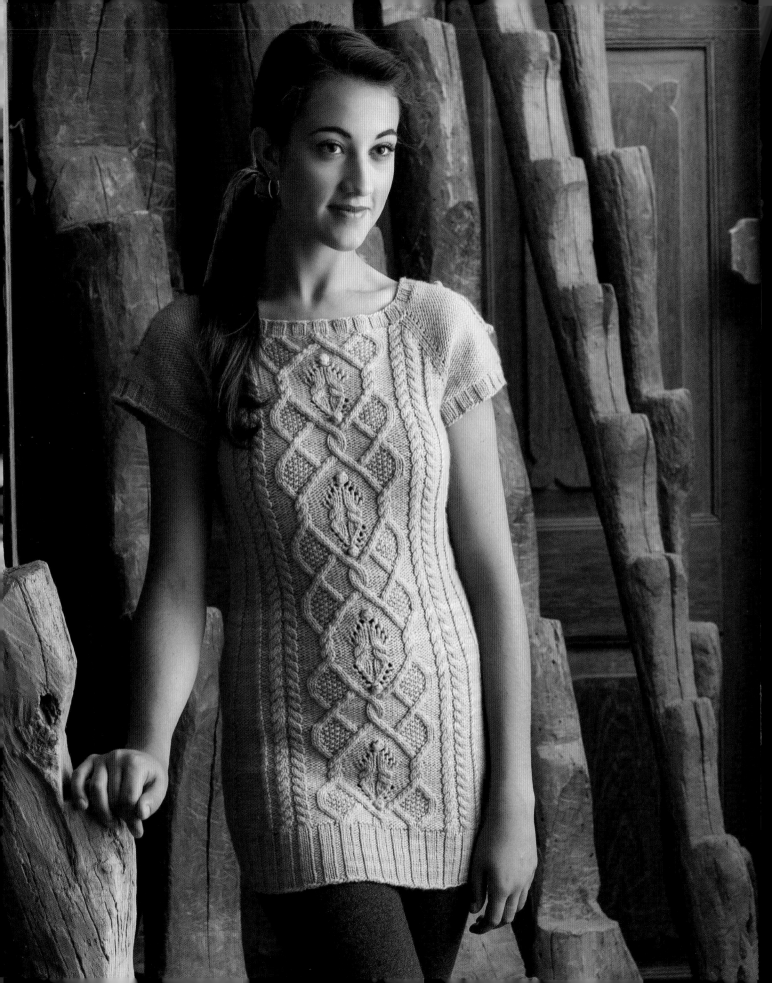

Cabled Tunic

This versatile tunic follows classic top-down construction—beginning at the neck, the yoke is worked downward to the armholes, with cable patterns centered on the front and back. A small motif from the front, centered on the reverse-stockinette background of the sleeves, ties the elements together in pleasing overall balance. Waist and hip shaping worked in the reverse-stockinette sections between cables results in a slimming hourglass silhouette. For the three largest sizes, there is an option for introducing additional cable patterns to fill in what would otherwise be large expanses of reverse stockinette.

designed by **SIMONA MERCHANT-DEST**

FINISHED SIZE

About 32¾ (37, 40¼, 43¾, 48¾, 52¼, 56¼)" (83 [94, 102, 111, 124, 132.5, 143] cm) bust circumference.

Tunic shown measures 32¾" (83 cm).

YARN

Worsted weight (#4 Medium).

Shown here: Malabrigo Merino Worsted (100% pure merino wool; 210 yd [192 m]/100 g): #35 frank ochre, 5 (6, 6, 7, 8, 8, 9) skeins.

NEEDLES

Body and sleeves: size 7 (4.5 mm): 24" and 32" (60 and 80 cm) circular (cir) and 16" (40 cm) cir or set of 5 double-pointed (dpn).

Ribbing: size 6 (4 mm): 24" and 32" (60 and 80 cm) cir, and 16" (40 cm) cir or set of 5 dpn.

Adjust needle sizes if necessary to obtain the correct gauge.

NOTIONS

Markers (m) in three different colors; cable needle (cn); stitch holders or waste yarn; tapestry needle.

GAUGE

19 sts and 32 rnds = 4" (10 cm) in rev St st on larger needles.

61 sts from Back and Front charts measure 9¼" (23.5 cm) wide on larger needles.

Design Techniques

Raglan construction worked in rounds from the top down, page 11.

Shaping in cable patterns, page 76.

Self-standing patterns, page 17.

Backward-loop cast-on, page 171.

Knitted cast-on, page 173.

Pick up stitches purlwise, page 177.

TIPS & TRICKS

• The yoke is worked in the round from the neckline to the underarms, then the sleeve stitches are placed on holders and the body is worked in the round to the lower edge. The sleeves are also finished by working in the round.

• Three different marker colors are used for this project: one color for the end of the round, a second color to mark the raglan increase lines, and a third to indicate the placement of the center sleeve motif. Slip the markers every round as you come to them.

STITCH GUIDE

RIB PATTERN (MULTIPLE OF 5 STS)
ALL RNDS: P1, *k3, p2; rep from * last 4 sts, k3, p1.

BOBBLE
With RS facing, work ([k1, p1] 2 times, k1) all in same st—5 sts made from 1 st. Turn work so WS is facing, p5, turn work again so RS is facing, and k5tog through back loops (tbl)—5 sts dec'd to 1 st.

1/1RC
Sl 1 st onto cable needle (cn) and hold in back of work, k1, then k1 from cn.

2/1/2LC
Sl 3 sts onto cn and hold in front of work, k2, sl third st from cn back onto left needle and work it as p1, then k2 from cn.

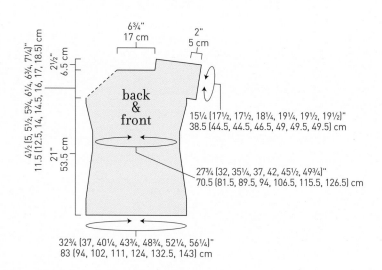

6¾" 17 cm

2" 5 cm

back & front

4½ (5, 5½, 5¾, 6¼, 6¾, 7¼)" 11.5 (12.5, 14, 14.5, 16, 17, 18.5) cm

2½" 6.5 cm

21" 53.5 cm

15¼ (17½, 17½, 18¼, 19¼, 19½, 19½)" 38.5 (44.5, 44.5, 46.5, 49, 49.5, 49.5) cm

27¾ (32, 35¼, 37, 42, 45½, 49¾)" 70.5 (81.5, 89.5, 94, 106.5, 115.5, 126.5) cm

32¾ (37, 40¼, 43¾, 48¾, 52¼, 56¼)" 83 (94, 102, 111, 124, 132.5, 143) cm

Neckband

With smaller 24" cir needle, CO 130 sts. Place marker (pm) for beg of rnd, and join for working in rnds, being careful not to twist sts. Work 6 rnds in rib patt (see Stitch Guide)—piece measures 1" (2.5 cm) from CO.

Yoke

NEXT RND: (inc rnd) Knit and *at the same time* inc 6 sts evenly spaced—136 sts.

NEXT RND: P45 back sts, pm in raglan color (see Notes), p23 right sleeve sts, pm in raglan color, p45 front sts, pm in raglan color, p23 left sleeve sts.

Change to larger 24" (60 cm) cir needle.

SET-UP RND: K1, work set-up rnd of Back chart (page 84) over 43 sts, k1, sl m, k1, p21, k1, sl m, k1,

work set-up rnd of Front chart (page 85) over 43 sts, k1, sl m, k1, p21, k1.

INC RND: K1, work next rnd of Back chart and inc as shown, k1, *sl m, k1, M1L pwise (see Glossary), purl to 1 st before raglan m, M1R pwise (see Glossary), k1, sl m,* k1, work next rnd of Front chart and inc as shown, k1; rep from * to * for second sleeve—8 sts inc'd; 2 sts inc'd each for back, front, and each sleeve.

NEXT RND: Work even in established patts, working new sleeve sts in Rev St st.

Cont as established, rep the shaping of the last 2 rnds 2 more times, ending with Rnd 6 of charts—160 sts; 51 sts each for back and front, 29 sts for each sleeve.

NEXT RND: K1, work next rnd of Back chart and inc as shown, k1, *sl m, k1, M1L pwise, p8, pm in sleeve motif color, work Rnd 1 of Sleeve chart (page 87) over 11 sts,

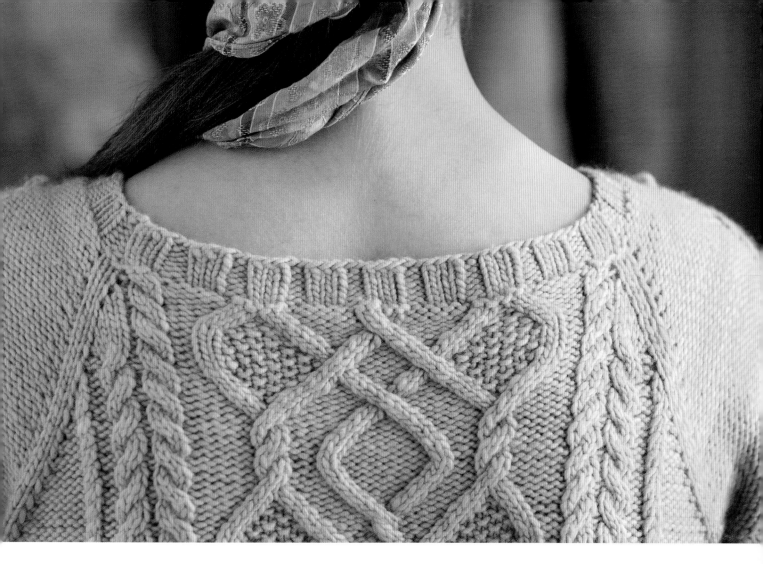

pm in sleeve motif color, p8, M1R pwise, k1, sl m,* k1, work next rnd of Front chart and inc as shown, k1; rep from * to * for second sleeve—8 sts inc'd; 2 sts inc'd each for back, front, and each sleeve.

NEXT RND: Work even in established patts, working new sleeve sts in Rev St st.

Cont as established, rep the shaping of the last 2 rnds 5 more times, ending with Rnd 18 of Back and Front charts and Rnd 12 of Sleeve chart, and changing to larger 32" (80 cm) cir needle when there are too many sts to fit comfortably on short needle—208 sts; 63 sts each for back and front, 41 sts each sleeve.

NEXT RND: (inc rnd) K1, M1L pwise, work next rnd of Back chart over 61 sts, M1R pwise, k1, *sl m, k1, M1L pwise, purl to sleeve motif m, sl m, work next rnd of Sleeve chart over 11 sts, sl m, purl to 1 st before raglan m, M1R pwise, k1, sl m,* k1, M1L pwise, work next rnd of Front chart over 61 sts, M1R pwise, k1; rep from * to * for second sleeve—8 sts inc'd; 2 inc'd sts each for back, front, and each sleeve.

NEXT RND: Work even in established patts, working new sts for back, front, and sleeves in rev St st.

Notes: *Cont the Back and Front charts on the center 61 sts of the back and front until Rnd 66 has been completed, then rep Rnds 19–66 of charts to the end. After Rnd 28 of the Sleeve chart has been completed, remove the sleeve motif markers and resume working the center 11 sleeve sts in Rev St st. For both the body and sleeves, work the new stitches of the following yoke shaping in reverse stockinette. See the box (page 86) for an alternate way of working the new stitches beginning in Rnd 21 for the three largest sizes.*

Cont as established, rep the shaping of the last 2 rnds 8 (10, 10, 10, 9, 10, 5) more times—280 (296, 296, 296, 288, 296, 256) sts; 81 (85, 85, 85, 83, 85, 75) sts each for back and front, 59 (63, 63, 63, 61, 63, 53) sts for each sleeve. Cont for your size as foll:

BACK

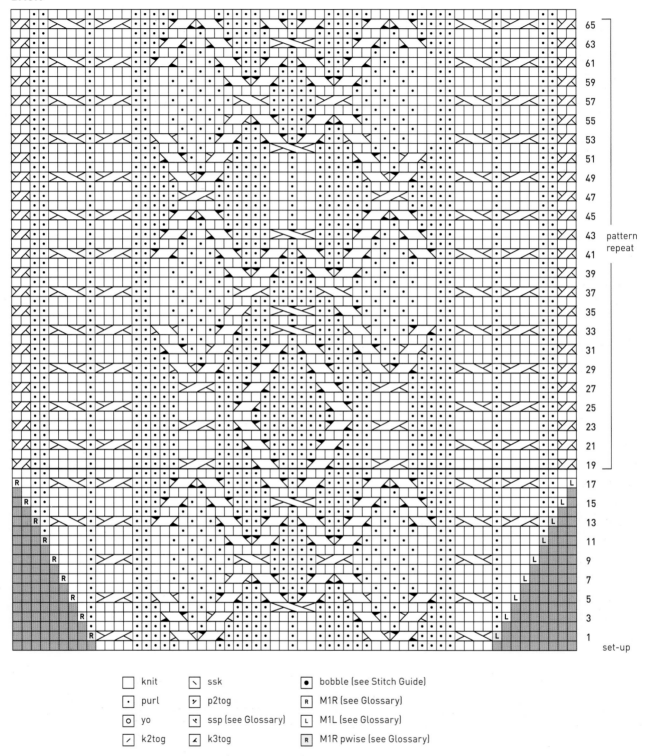

65
63
61
59
57
55
53
51
49
47
45
43 — pattern repeat
41
39
37
35
33
31
29
27
25
23
21
19
17
15
13
11
9
7
5
3
1 — set-up

	knit		ssk		bobble (see Stitch Guide)
	purl		p2tog		M1R (see Glossary)
	yo		ssp (see Glossary)		M1L (see Glossary)
	k2tog		k3tog		M1R pwise (see Glossary)

FRONT

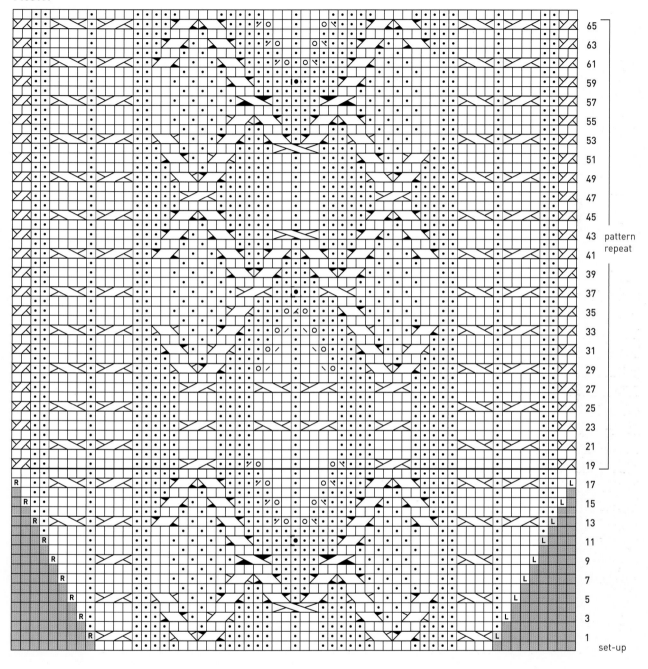

pattern
repeat

65
63
61
59
57
55
53
51
49
47
45
43
41
39
37
35
33
31
29
27
25
23
21
19
17
15
13
11
9
7
5
3
1

set-up

 M1L pwise (see Glossary)

sl 2 sts onto cn and hold in front, p1, k2 from cn

1/1 RC (see see Stitch Guide)

sl 2 sts onto cn and hold in back, k2, k2 from cn

sl 1 st onto cn and hold in back, k2, k1 from cn

sl 2 sts onto cn and hold in front, k2, k2 from cn

sl 2 sts onto cn and hold in front, k1, k2 from cn

sl 2 sts onto cn and hold in back, k2, p2 from cn

sl 1 st onto cn and hold in back, k2, p1 from cn

sl 2 sts onto cn and hold in front, p2, k2 from cn

2/1/2 LC (see Stitch Guide)

no stitch

Using the Right and Left Option Charts

For sizes 48¾" (52¼, 56¼)", you can work the new stitches outside the Back and Front charts in reverse stockinette, as given in the main instructions, or you can work them according to the Right and Left Option charts to extend the cable patterning at each side.

After completing Rnd 20, there will be 216 sts for all three sizes: 65 sts each for back and front, and 43 sts for each sleeve. The back and front sts consist of 61 chart sts with 1 purl st and 1 raglan knit st at each side.

Work Rnd 21 as follows to set-up the optional charts: *K1, work 2 sts from Rnd 21 of Right Option chart as M1L pwise, p1 (note that the inc symbols are not shown on this row of the chart because they occur at different places for the different sizes; but you do want to work the inc anyway); work in patt to last 2 back sts, work 2 sts from Rnd 21 of Left Option chart as p1, M1R pwise (again, this inc is not shown on the chart), k1;* work sleeve sts as k1, M1L pwise, purl to sleeve marker, work 11 sts from chart as established, purl to last sleeve st, M1R pwise, k1; rep from * for front and second sleeve—224 sts for all three sizes; 67 sts each for front and back, 45 sts each sleeve. The back and front sts consist of 61 main chart sts, with 2 optional chart sts and 1 raglan knit st at each side.

Working inc'd sts into the optional chart patts, inc 2 sts each for back, front, and each sleeve every other rnd (8, 9, 4) more times—(288, 296, 256) sts; (83, 85, 75) sts each for front and back, (61, 63, 53) sts each sleeve. Inc 2 sts each for front and back only (no sleeve incs) on the next 3 rnds, then inc 2 sts each for front, back and both sleeves on the foll rnd—20 sts inc'd; 8 sts each for back and front, 2 sts each sleeve. Rep the shaping of the last 4 rnds (1, 1, 5) more time(s)—(328, 336, 376) sts; (99, 101, 123) sts each for front and back, (65, 67, 65) sts each sleeve. Inc 2 sts each for front and back only (no sleeve incs) on the next (4, 6, 0) rnds—(344, 360, 376) sts; (107, 113, 123) sts each for front and back, (65, 67, 65) sts each sleeve. Work (1, 1, 5) rnds even to end with Rnd 50 (54, 58) of main charts.

The back and front sts consist of 61 main chart sts in the center plus a 16-st optional chart, (6, 9, 14) rev St sts, and 1 raglan knit st on each side of the main chart.

Resume working from the project instructions, beginning with the dividing round. Continue the optional charts into the lower body, working the waist decreases and hip increases outside the 1/1 RC cable at the outer edge of each chart. After completing Rnd 98 of the optional charts, repeat Rnds 51–98 of these charts for pattern. For the sleeves, position the 1/1 RC cables so they correspond to the 1/1 RC cables in the optional charts.

Note: *At the cable gauge, each 16-stitch optional chart measures about 2½" (6.5 cm) wide. If worked in reverse stockinette, these 16 stitches would measure about 3¼" (8.5 cm) wide. Because of this gauge difference, using the optional charts will produce bust, waist, and hip measurements about 3" (7.5 cm) smaller around than given in Finished Sizes or shown on the schematic.*

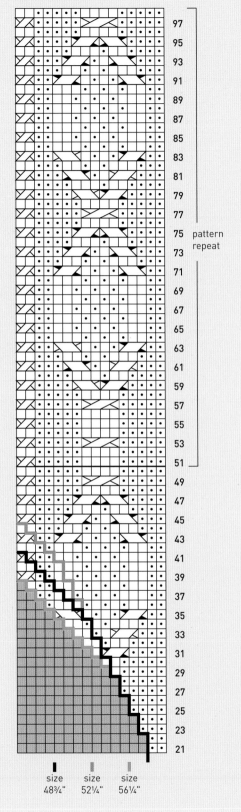

LEFT OPTION

pattern repeat

97 95 93 91 89 87 85 83 81 79 77 75 73 71 69 67 65 63 61 59 57 55 53 51 49 47 45 43 41 39 37 35 33 31 29 27 25 23 21

size 48¾" size 52¼" size 56¼"

RIGHT OPTION

97
95
93
91
89
87
85
83
81
79
77
75 pattern repeat
73
71
69
67
65
63
61
59
57
55
53
51
49
47
45
43
41
39
37
35
33
31
29
27
25
23
21

size 48¾" size 52¼" size 56¼"

SLEEVE

27
25
23
21
19
17
15
13
11
9
7
5
3
1

☐ knit

· purl

⊙ yo

╱ k2tog

╲ ssk

⊼ p2tog

⊻ ssp (see Glossary)

⊼ k3tog

● bobble (see see Stitch Guide)

⤢ 1/1 RC (see see Stitch Guide)

⤢ sl 1 st onto cn and hold in back, k2, k1 from cn

⤢ sl 2 sts onto cn and hold in front, k1, k2 from cn

⤢ sl 1 st onto cn and hold in back, k2, p1 from cn

⤢ sl 2 sts onto cn and hold in front, p1, k2 from cn

⤢ sl 2 sts onto cn and hold in back, k2, k2 from cn

⤢ sl 2 sts onto cn and hold in front, k2, k2 from cn

▨ no stitch

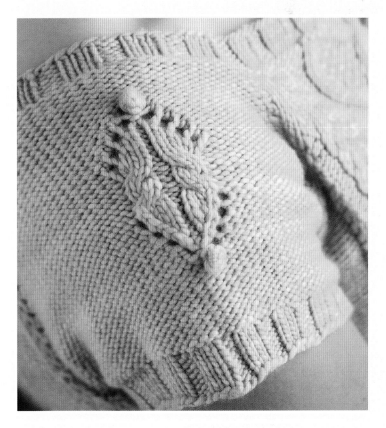

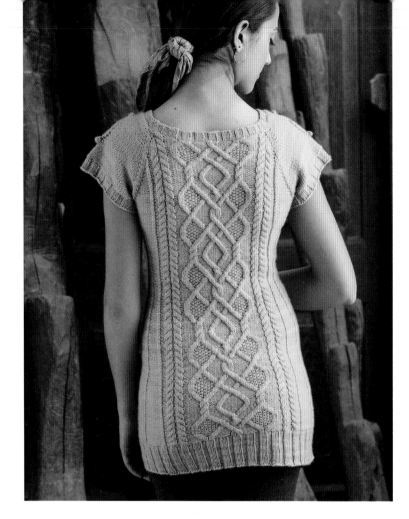

Cont in patt, inc 1 st at each side of the back and front, without inc any sleeve sts, on the next (4, 6, 0) rnds, then work (0, 0, 4) rnds even, ending with Rnd (50, 54, 58) of charts—(344, 360, 376) sts; (107, 113, 123) sts each for back and front, (65, 67, 65) sts each sleeve; yoke measures (6¼, 6¾, 7¼)" (16 [17, 18.5] cm) from end of neckband and 1" (2.5 cm) longer from CO.

Divide for Body and Sleeves

Cont in patt, removing raglan m as you come to them, use the backward-loop method (see Glossary) to CO 7 (10, 10, 12, 13, 14, 14) sts onto left needle before back sts, work 81 (85, 93, 97, 107, 113, 123) back sts, place next 59 (63, 63, 63, 65, 67, 65) right sleeve sts onto holder, use the backward-loop method (see Glossary) to CO 7 (10, 10, 12, 13, 14, 14) sts, pm for right side "seam," use the backward-loop method to CO 7 (10, 10, 12, 13, 14, 14) sts, work 81 (85, 93, 97, 107, 113, 123) front sts, place next 59 (63, 63, 63, 65, 67, 65) left sleeve sts onto holder, use the backward-loop method to CO 7 (10, 10, 12, 13, 14, 14) sts, pm for left side "seam" and end-of- rnd—190 (210, 226, 242, 266, 282, 302) sts rem; 95 (105, 113, 121, 133, 141, 151) sts each for back and front; 61 center sts in charted patt and 17 (22, 26, 30, 36, 40, 45) sts at each side.

Lower Body

NEXT RND: *P6 (9, 9, 11, 12, 12, 13), k2, p9 (11, 15, 17, 22, 26, 30), work 61 chart sts as established, p9 (11, 15, 17, 22, 26, 30), k2, p6 (9, 9, 11, 12, 12, 13), sl m; rep from * once more.

NEXT RND: *P6 (9, 9, 11, 12, 12, 13), 1/1RC (see Stitch Guide), p9 (11, 15, 17, 22, 26, 30), work 61 chart sts as established, p9 (11, 15, 17, 22, 26, 30), 1/1RC, p6 (9, 9, 11, 12, 12, 13), sl m; rep from * once more.

Cont in patt, rep the last 2 rnds 2 more times—piece measures about ¾" (2 cm) from dividing rnd.

Shape Waist

DEC RND: *P6 (9, 9, 11, 12, 12, 13), k2, p2tog, purl to chart section, work 61 chart sts as established, purl to 2 sts before next 2-st cable column, p2tog, k2, p6 (9, 9, 11, 12, 12, 13), sl m; rep from * once more—4 sts dec'd, 1 st at each side of front and back between center chart and new 2-st cable column.

Sizes 32¾ (37)" only

Yoke shaping is complete, ending with Rnd 36 (40) of charts—piece measures 4½ (5)" (11.5 [12.5] cm) from end of neckband and 1" (2.5 cm) longer from CO.

Sizes (40¼, 43¾)" only

Cont in patt, inc 1 st at each side of the back and front, without inc any sleeve sts, on the next (4, 6) rnds, ending with Rnd (44, 46) of charts—(312, 320) sts; (93, 97) sts each for back and front, (63, 63) sts each sleeve; yoke measures (5½, 5¾)" (14 [14.5] cm) from end of neckband and 1" (2.5 cm) longer from CO.

Sizes (48¾, 52¼, 56¼)" only

NEXT 3 RNDS: Cont in patt, inc 1 st at each side of the back and front, without inc any sleeve sts—12 sts total inc'd over 3 rnds.

NEXT RND: Cont in patt, inc 1 st at each side of the back, front, and both sleeves—8 sts inc'd.

Rep the last 4 rnds (1, 1, 5) more time(s)—(328, 336, 376) sts; (99, 101, 123) sts each for back and front, (65, 67, 65) sts each sleeve.

Cont in patt, rep the dec rnd every 8 (8, 8, 6, 6, 6, 6)th rnd 5 (5, 5, 7, 7, 7, 7) more times—166 (186, 202, 210, 234, 250, 270) sts rem; 83 (93, 101, 105, 117, 125, 135) sts each for back and front; piece measures about 6 (6, 6, 6¼, 6¼, 6¼, 6¼)" (15 [15, 15, 16, 16, 16, 16] cm) from dividing rnd.

Work even in patt until piece measures 9" (23 cm) from dividing rnd, ending with an odd-numbered chart rnd.

Shape Hips

INC RND: *P6 (9, 9, 11, 12, 12, 13), k2, p1, M1P (see Glossary), purl to chart section, work 61 chart sts as established, purl to 1 st before next 2-st cable column, M1P, p1, k2, p6 (9, 9, 11, 12, 12, 13), sl m; rep from * once more—4 sts inc'd, 1 st at each side of front and back between center chart and new 2-st cable column.

Cont in patt, rep the inc rnd every 14 (14, 14, 10, 10, 10, 10)th rnd 5 (5, 5, 7, 7, 7, 7) more times, working new sts in Rev St st—190 (210, 226, 242, 266, 282, 302) sts; 95 (105, 113, 121, 133, 141, 151) sts each for back and front; piece measures about 18" (45.5 cm) from dividing rnd for all sizes.

Note: If desired, work a few more rnds even here to end the charts at a point that is visually pleasing to you before starting the rib. For example, end the cable charts after finishing a complete lace motif in the center of the front chart or after a rnd that crosses the center 5-st cable. The tunic shown ends with Rnd 47 of the charts.

Lower Edging

Change to smaller 32" (80 cm) cir needle.

NEXT RND: Knit and *at the same time* dec 0 (0, 1, 2, 1, 2, 2) st(s) evenly spaced—190 (210, 225, 240, 265, 280, 300) sts rem.

Work even in rib patt (see Stitch Guide) for 3" (7.5 cm)— piece measures 21" (53.5 cm) from dividing rnd. BO all sts in patt.

Sleeves

Place 59 (63, 63, 63, 65, 67, 65) held sleeve sts onto larger dpn or 16" (40 cm) cir needle and join yarn to center of underarm CO sts. Pick up and purl (see Glossary) 6 (9, 9, 11, 12, 12, 13) sts from half of underarm, pick up and knit 1 st, work 59 (63, 63, 63, 65, 67, 65) sleeve sts in Rev St st, pick up and knit 1 st, pick up and purl 6 (9, 9, 11, 12, 12, 13) sts from other half

Make It Yours

Stitch pattern breakdown:

Main pattern: Panel of 61 stitches.

◊ If you want to substitute your own pattern for the central front and back stitch panels, choose a pattern (or patterns) that take up about one-half to two-thirds of the bust width stitches for your main chart. Select elements from this chart for the sleeve motif and optional side panels.

◊ For beginners, use the charts from these directions as templates to create your own chart blanks, filling in the templates with your own stitch patterns.

◊ To attain the finished size provided, make sure that your new center cable pattern is about 9¼" (23.5 cm) wide.

◊ Check the gauge of your new patterns and adjust needle size if necessary to achieve the correct measurements.

of underarm, pm, and join for working in rnds—73 (83, 83, 87, 91, 93, 93) sts.

NEXT RND: *P6 (9, 9, 11, 12, 12, 13), k2, p57 (61, 61, 61, 63, 65, 63), k2, p6 (9, 9, 11, 12, 12, 13).

NEXT RND: *P6 (9, 9, 11, 12, 12, 13), 1/1 RC, p57 (61, 61, 61, 63, 65, 63), 1/1 RC, p6 (9, 9, 11, 12, 12, 13).

Rep the last 2 rnds until piece measures 1" from underarm.

NEXT RND: Knit and *at the same time* inc 2 (inc 2, inc 2, inc 3, dec 1, dec 3, inc 2) st(s) evenly spaced—75 (85, 85, 90, 90, 90, 95) sts.

Change to smaller 16" cir needle or dpn.

Work even in rib patt for 7 rnds—piece measures 2" (5 cm) from underarm. BO all sts in rib patt.

Finishing

Weave in loose ends. Block to measurements.

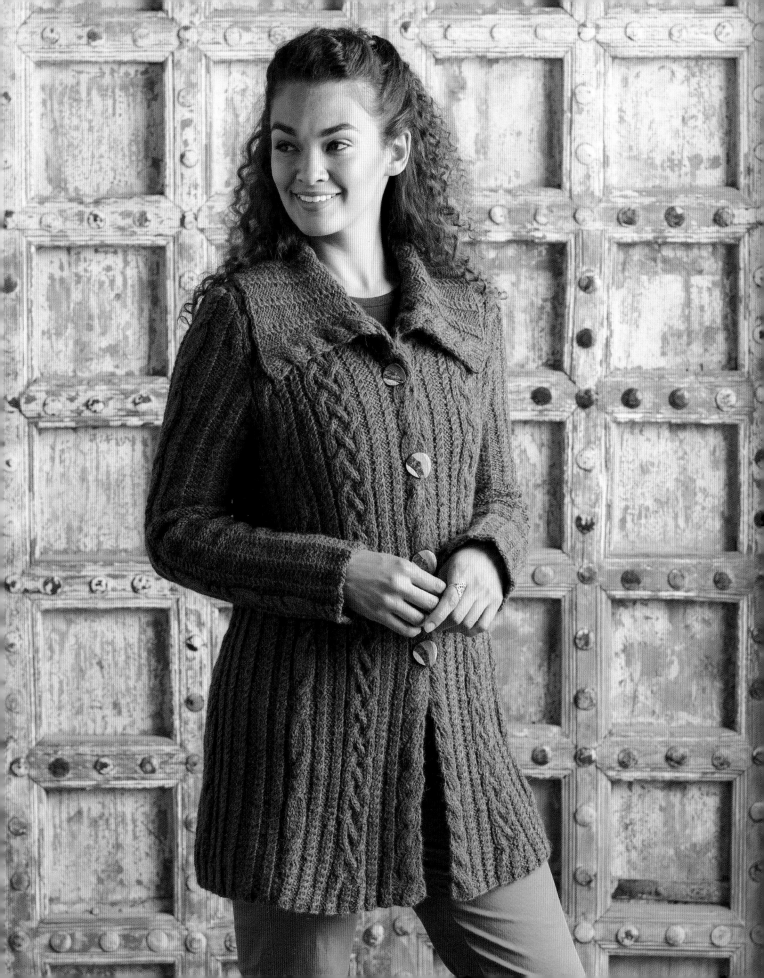

Cabled Cardigan

This cardigan demonstrates how to scale a cable pattern by decreasing invisibly in the crossing rows of cables, as well as how to work reversible cables. The lower body is worked in one piece to the armholes, then the fronts and back are worked separately to the shoulders. The sleeves are worked in rounds to the start of the cap shaping, which is worked back and forth in rows. For a refined fit, the sleeves are rotated a bit in the armholes. The natural holes formed by the cable crossings in the front band serve as hidden buttonholes.

designed by **FAINA GOBERSTEIN**

FINISHED SIZE
About 34¼ (37, 39½, 42¼, 45, 47½, 50¼)" (87 [94, 100.5, 1007.5, 114.5, 120.5, 127.5] cm) bust circumference, buttoned, with fronts overlapped 1¼" (3.2 cm).

Cardigan shown measures 37" (94 cm).

YARN
Worsted weight (#4 Medium).

Shown here: Cascade Lana D'Oro (50% alpaca, 50% wool; 219 yd [200 m]/100 g): #1060 Rainier heather, 10 (11, 12, 12, 13, 14, 15) skeins.

NEEDLES
Size U.S. 7 (4.5 mm): 32" (80 cm) circular (cir) and set of 5 double-pointed (dpn).

Adjust needle size if necessary to obtain the correct gauge.

NOTIONS
Markers (m); removable markers; cable needle (cn); stitch holders; tapestry needle; four 1¼" (3.2 cm) buttons.

GAUGE
24 sts and 25 rows = 4" (10 cm) in cabled rib patt.

17 sts of side rib patt measure 2¾" (7 cm) wide.

6 sts of Oval Cable chart measure 1" (2.5 cm) wide.

48 sts from Rows 1–7 of Right and Left Front chart measure 6½" (16.5 cm) wide.

43 sts from Rows 9–36 of Right and Left Front chart measure 5¾" (14.5 cm) wide.

70 sts from Rows 9–54 of Large Back chart measure 10½" (26.5 cm) wide.

34 sts from Rows 137–152 of Small Back chart measure 5½" (14 cm) wide.

Design Techniques

Set-in sleeve construction worked in rows from the bottom up, page 11.

Shaping in cable patterns, page 76.

Self-standing patterns, page 17.

Short rows, page 178.

Three-needle bind-off, page 171.

TIPS & TRICKS

- Place markers between the different patterns. Slip the markers every row as you come to them.

- Use a separate row counter for each cable pattern or use another method to track the different cables; the charts do not all repeat over the same number of rows.

- The sleeve cap is rotated in the armhole so that the center of the cap falls about ¼" (6 mm) to the front of the shoulder seam. This insures a better fit at the armhole.

STITCH GUIDE

1/2RC
Sl 2 sts onto cable needle (cn) and hold in back of work, k1, then k2 from cn.

2/1/2RC
Sl 3 sts onto cn and hold in back of work, k2, sl third st from cn back onto left needle and work it as p1, then k2 from cn.

2/1/2LC
Sl 3 sts onto cn and hold in front of work, k2, sl third st from cn back onto left needle and work it as p1, then k2 from cn.

6/6RC RIBBED
Sl 6 sts onto cn and hold in back of work, [k1, p1] 3 times, then work 6 sts from cn as [k1, p1] 3 times.

6/6LC RIBBED
Sl 6 sts onto cn and hold in back of work, [p1, k1] 3 times, then work 6 sts from cn as [p1, k1] 3 times.

CABLED RIB IN ROWS (MULTIPLE OF 6 STS + 3)
SET-UP ROW 1: (WS) K3, *p3, k3; rep from *.

SET-UP ROW 2: (RS) P3, *k3, p3; rep from *.

SET-UP ROW 3: Rep Set-up Row 1.

ROW 1: (RS) *P3, 1/2RC (see above); rep from * to last 3 sts, p3.

ROW 2: K3 *p3, k3; rep from *.

Rep Rows 1 and 2 for patt; do not rep the set-up rows.

CABLED RIB IN ROUNDS (MULTIPLE OF 6 STS + 3)
RND 1: P3, *1/2RC, p3; rep from *.

RND 2: P3, *k3, p3; rep from *.

Rep Rnds 1 and 2 for patt.

SIDE RIB (WORKED OVER 17 STS)
SET-UP ROW 1: (WS) P3, k4, p1, p1 and mark this st with a removable marker for side "seam" st, p1, k4, p3.

SET-UP ROW 2: (RS) [K3, p4] 2 times, k3.

SET-UP ROW 3: [P3, k4] 2 times, p3.

ROW 1: (RS) [1/2RC, p4] 2 times, 1/2RC.

ROW 2: [P3, k4] 2 times, p3.

Rep Rows 1 and 2 for patt; do not rep the set-up rows.

Move the marker in the center st up as you work so you can always identify this st for the body side "seam."

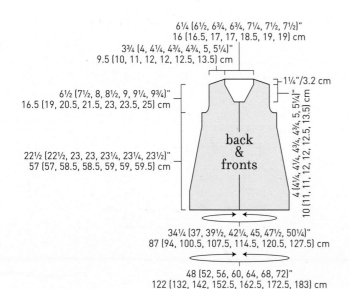

6¼ (6½, 6¾, 6¾, 7¼, 7½, 7½)"
16 (16.5, 17, 17, 18.5, 19, 19) cm

3¾ (4, 4¼, 4¾, 4¾, 5, 5¼)"
9.5 (10, 11, 12, 12, 12.5, 13.5) cm

1¼"/3.2 cm

6½ (7½, 8, 8½, 9, 9¼, 9¾)"
16.5 (19, 20.5, 21.5, 23, 23.5, 25) cm

4 (4¼, 4¼, 4¾, 4¾, 5, 5¼)"
10 (11, 11, 12, 12, 12.5, 13.5) cm

22½ (22½, 23, 23, 23¼, 23¼, 23½)"
57 (57, 58.5, 58.5, 59, 59, 59.5) cm

back & fronts

34¼ (37, 39½, 42¼, 45, 47½, 50¼)"
87 (94, 100.5, 107.5, 114.5, 120.5, 127.5) cm

48 (52, 56, 60, 64, 68, 72)"
122 (132, 142, 152.5, 162.5, 172.5, 183) cm

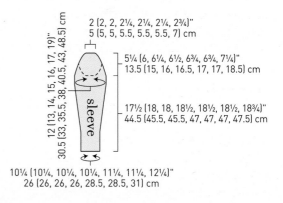

2 (2, 2, 2¼, 2¼, 2¼, 2¾)"
5 (5, 5, 5.5, 5.5, 5.5, 7) cm

5¼ (6, 6¼, 6½, 6¾, 6¾, 7¼)"
13.5 (15, 16, 16.5, 17, 17, 18.5) cm

17½ (18, 18, 18½, 18½, 18½, 18¾)"
44.5 (45.5, 45.5, 47, 47, 47, 47.5) cm

12 (13, 14, 15, 16, 17, 19)"
30.5 (33, 35.5, 38, 40.5, 43, 48.5) cm

sleeve

10¼ (10¼, 10¼, 10¼, 11¼, 11¼, 12¼)"
26 (26, 26, 26, 28.5, 28.5, 31) cm

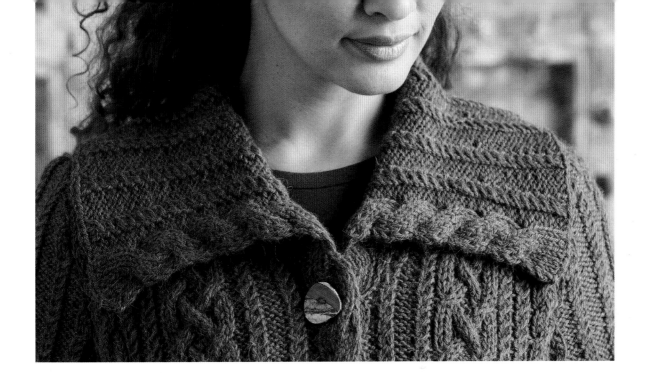

Body

With cir needle, CO 308 (332, 356, 380, 404, 428, 452) sts. Working back and forth in rows, work next row for your size as foll:

Size 34¼" only

With WS facing, work Set-up Row 1 for all patts (see Stitch Guide) and charts as foll: Work 48 sts in Left Front chart, pm, k3 for rev St st (knit on WS rows, purl on RS rows), work 3 sts in Oval Cable chart, 9 sts in cabled rib, pm, 17 sts in side rib, pm, 9 sts in cabled rib, 3 sts in Oval Cable chart, 9 sts in cabled rib, 3 sts in Oval Cable chart, 9 sts in cabled rib, pm, 82 sts in Large Back chart, pm, 9 sts in cabled rib, 3 sts in Oval Cable chart, 9 sts in cabled rib, 3 sts in Oval Cable chart, 9 sts in cabled rib, pm, 17 sts in side rib, pm, 9 sts in cabled rib, 3 sts in Oval Cable chart, k3 for rev St st, pm, 48 sts in Right Front chart.

For this size, cont the 3 sts next to each front chart in Rev St st (knit WS rows; purl RS rows).

Sizes (37, 39½, 42¼, 45, 47½, 50¼)"

With WS facing, work Set-up Row 1 for all patts (see Stitch Guide) and charts as foll: Work 48 sts in Left Front chart, pm, 9 sts in cabled rib, 3 sts in Oval Cable chart, (9, 15, 21, 27, 33, 39) sts in cabled rib, pm, 17 sts in side rib, pm, (9, 15, 15, 15, 21, 21) sts in cabled rib, 3 sts in Oval Cable chart, (15, 9, 15, 21, 15, 21) sts in cabled rib, 3 sts in Oval Cable chart, (9, 15, 15, 15, 21, 21) sts in cabled rib, pm, 82 sts in Large Back chart, pm, (9, 15, 15, 15, 21, 21) sts in cabled rib, 3 sts in Oval Cable chart, (15, 9, 15, 21, 15, 21) sts in cabled rib, 3 sts in Oval Cable chart, (9, 15, 15, 15, 21, 21) sts in cabled rib, pm, 17 sts in side rib, pm, (9, 15, 21, 27, 33, 39) sts in cabled rib, 3 sts in Oval Cable chart, 9 sts in cabled rib, pm, 48 sts in Right Front chart.

All Sizes

Cont sts outside charts as established, for charts work Set-up Rows 2 and 3, then work Rows 1–26. The st count remains unchanged at 308 (332, 356, 380, 404, 428, 452) because the 12 sts dec'd in the Large Back chart and 3 sts dec'd in each front chart have been offset by the 3 sts inc'd in each of the 6 Oval Cable charts; piece measures 4¼" (11 cm) from CO.

With RS facing the patts are as foll: 45 sts in Right Front chart, 3 (9, 9, 9, 9, 9, 9) sts in either Rev St st or cabled rib depending on your size, 6 sts in Oval Cable chart, 9 (9, 15, 21, 27, 33, 39) sts in cabled rib, 17 sts in side rib, 9 (9, 15, 15, 15, 21, 21) sts in cabled rib, 6 sts in Oval Cable chart, 9 (15, 9, 15, 21, 15, 21) sts in cabled rib, 6 sts in Oval Cable chart, 9 (9, 15, 15, 15, 21, 21) sts in cabled rib, 70 sts in Large Back chart, 9 (9, 15, 15, 15, 21, 21) sts in cabled rib, 6 sts in Oval Cable chart, 9 (15, 9, 15, 21, 15, 21) sts in cabled rib, 6 sts in Oval Cable chart, 9 (9, 15, 15, 15, 21, 21) sts in cabled rib, 17 sts in side rib, 9 (9, 15, 21, 27, 33, 39) sts in cabled rib, 6 sts in Oval cable chart, 3 (9, 9, 9, 9, 9, 9) sts in either Rev St st or cabled rib, 45 sts in Left Front chart.

LEFT FRONT

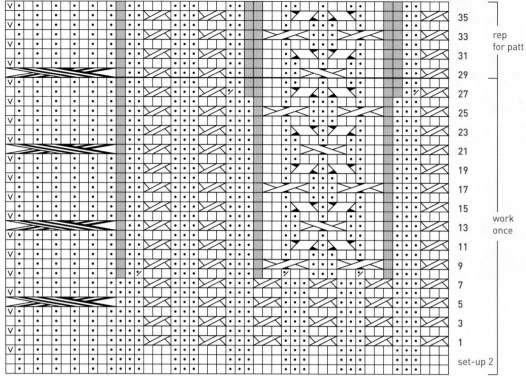

set-up 3
set-up 1
set-up 2

35 — rep for patt
33
31
29
27 — work once
25
23
21
19
17
15
13
11
9
7
5
3
1

OVAL CABLE

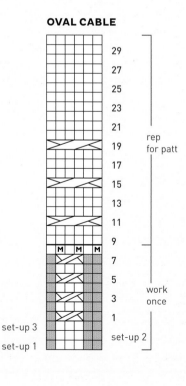

29
27
25
23
21
19 — rep for patt
17
15
13
11
9
7 — work once
5
3
1

set-up 3
set-up 1
set-up 2

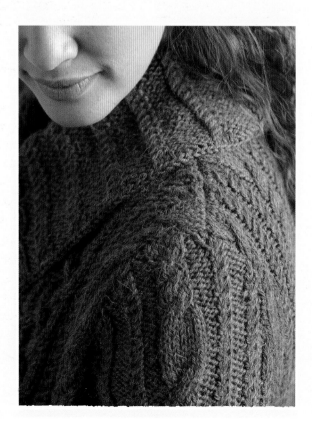

LARGE BACK

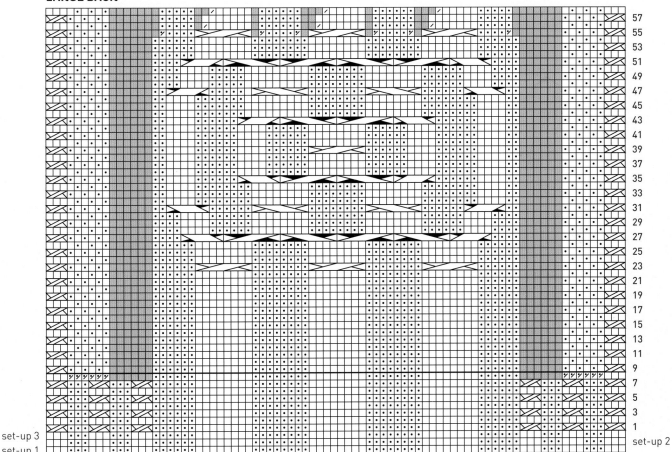

57
55
53
51
49
47
45
43
41
39
37
35
33
31
29
27
25
23
21
19
17
15
13
11
9
7
5
3
1

set-up 3
set-up 1

set-up 2

☐ knit on RS rows and all rnds; purl on WS rows	⊠ sl 3 sts onto cn and hold in front, p2, k3 from cn
• purl on RS rows and all rnds; knit on WS rows	⊠ 2/1/2 RC (see Stitch Guide)
⟋ k2tog on RS; p2tog on WS	⊠ 2/1/2 LC (see Stitch Guide)
⋋ p2tog on RS; k2tog on WS	⊠ sl 3 sts onto cn and hold in back, k3, k3 from cn
M M1 pwise on WS (see Glossary)	⊠ sl 3 sts onto cn and hold in front, k3, k3 from cn
V sl 1 kwise on RS; sl 1 pwise on WS	⊠ sl 3 sts onto cn and hold in back, k3, p3 from cn
⊠ 1/2 RC (see Stitch Guide)	⊠ sl 3 sts onto cn and hold in front, p3, k3 from cn
⊠ sl 1 st onto cn and hold in back, k2, p1 from cn	⊠ sl 2 sts onto cn and hold in back, k4, p2 from cn
⊠ sl 2 sts onto cn and hold in front, p1, k2 from cn	⊠ sl 4 sts onto cn and hold in front, p2, k4 from cn
⊠ sl 2 sts onto cn and hold in back, k2, k2 from cn	⊠ sl 4 sts onto cn and hold in back, k4, k4 from cn
⊠ sl 2 sts onto cn and hold in front, k2, k2 from cn	⊠ sl 4 sts onto cn and hold in front, k4, k4 from cn
⊠ sl 2 sts onto cn and hold in back, k2, p2 from cn	⊠ sl 4 sts onto cn and hold in back, k4, p4 from cn
⊠ sl 2 sts onto cn and hold in front, p2, k2 from cn	⊠ sl 4 sts onto cn and hold in front, p4, k4 from cn
⊠ sl 1 st onto cn and hold in back, k3, p1 from cn	⊠ 6/6 RC ribbed (see Stitch Guide)
⊠ sl 3 sts onto cn and hold in front, p1, k3 from cn	⊠ 6/6 LC ribbed (see Stitch Guide)
⊠ sl 2 sts onto cn and hold in back, k3, p2 from cn	▨ no stitch

RIGHT FRONT

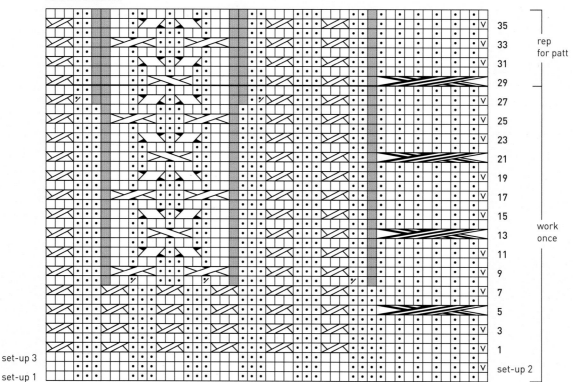

set-up 3

set-up 1

35

33

rep
for patt

31

29

27

25

23

21

19

17

15

13

11

9

7

5

3

1

set-up 2

work
once

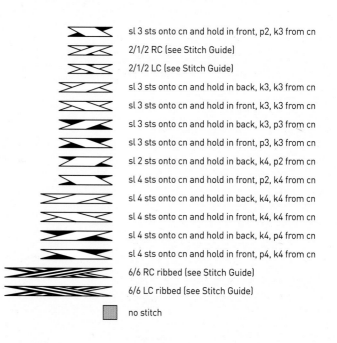

	knit on RS rows and all rnds; purl on WS rows
•	purl on RS rows and all rnds; knit on WS rows
/	k2tog on RS; p2tog on WS
⟍	p2tog on RS; k2tog on WS
M	M1 pwise on WS (see Glossary)
V	sl 1 kwise on RS; sl 1 pwise on WS

1/2 RC (see Stitch Guide)

sl 1 st onto cn and hold in back, k2, p1 from cn

sl 2 sts onto cn and hold in front, p1, k2 from cn

sl 2 sts onto cn and hold in back, k2, k2 from cn

sl 2 sts onto cn and hold in front, k2, k2 from cn

sl 2 sts onto cn and hold in back, k2, p2 from cn

sl 2 sts onto cn and hold in front, p2, k2 from cn

sl 1 st onto cn and hold in back, k3, p1 from cn

sl 3 sts onto cn and hold in front, p1, k3 from cn

sl 2 sts onto cn and hold in back, k3, p2 from cn

sl 3 sts onto cn and hold in front, p2, k3 from cn

2/1/2 RC (see Stitch Guide)

2/1/2 LC (see Stitch Guide)

sl 3 sts onto cn and hold in back, k3, k3 from cn

sl 3 sts onto cn and hold in front, k3, k3 from cn

sl 3 sts onto cn and hold in back, k3, p3 from cn

sl 3 sts onto cn and hold in front, p3, k3 from cn

sl 2 sts onto cn and hold in back, k4, p2 from cn

sl 4 sts onto cn and hold in front, p2, k4 from cn

sl 4 sts onto cn and hold in back, k4, k4 from cn

sl 4 sts onto cn and hold in front, k4, k4 from cn

sl 4 sts onto cn and hold in back, k4, p4 from cn

sl 4 sts onto cn and hold in front, p4, k4 from cn

6/6 RC ribbed (see Stitch Guide)

6/6 LC ribbed (see Stitch Guide)

no stitch

There will be 71 (77, 83, 89, 95, 101, 107) front sts at each end of the row outside the marked center st of the side rib section and 164 (176, 188, 200, 212, 224, 236) back sts between the marked center side rib sts.

Note: *As you work the following instructions, after completing Row 30 of the Oval Cable chart, rep Rows 9–30 for patt; do not rep Rows 1–8 for this chart.*

First Decrease Set

Note: *Beg on the next RS row, specific 3-st purl columns in the cable rib sections will be dec'd to 2 sts. Cont the patt as established during the decs, working the sts on each side of the 1/2RC cables as they appear. Do not work any decs in the 17-st marked side rib sections; these sections cont unchanged with 17 sts until the dividing row.*

Counting only the 3-st purl columns in the cabled rib (and also Rev St st for the smallest size), the foll number of p3 columns will be converted to p2 columns:

Between each front chart and side rib section: 3 (4, 5, 6, 7, 8, 9) columns.

Between each side rib section and back chart: 6 (7, 8, 9, 10, 11, 12) columns.

Total p3 columns to dec: 9 (11, 13, 15, 17, 19, 21) on each side of back section.

NEXT ROW: (RS; Row 27 of Large Back chart) In this row, the purl columns to be dec'd are the two p3 columns before the back section and the two p3 columns after the back section; each front chart also decreases from 45 to 43 sts in this row as foll:

Work in patt to 9 sts before back section, p2tog, p1, 1/2RC, p2tog, p1, work Large Back chart over 70 sts, p1, p2tog, 1/2RC, p1, p2tog, work in patt to end—8 sts dec'd; 1 st each from four p3 columns and 2 sts from each front chart.

Work 11 (9, 7, 7, 5, 5, 3) rows even, ending with a WS row.

NEXT ROW: (RS) In this row, the purl columns to be dec'd are the two p3 columns before the first p2 column created in the previous decrease row and the two p3 columns after the last p2 column created in the previous decrease row as foll:

Work in patt, working the two p3 columns before the back section as [p2tog, p1] and the two p3 columns after the back section as [p1, p2tog]—4 sts dec'd, 1 st each from four p3 columns.

Cont in patt, rep the shaping of the last 12 (10, 8, 8, 6, 6, 4) rows 2 (3, 4, 5, 6, 7, 8) more times, changing to Medium Back chart after completing Row 58 of the Large Back chart—8 (12, 16, 20, 24, 28, 32) additional sts dec'd in p3 columns; the back chart has dec'd 14 sts from 70 sts to 56 sts.

Work 11 (9, 7, 7, 5, 5, 3) rows even, ending with a WS row.

NEXT ROW: (RS) In this row, the purl columns to be dec'd are the rem two p3 columns, one next to the front chart at each side as foll: ·

Work in patt, working each of the first p3 column as [p2tog, p1] and the last p3 column as [p1, p2tog]—2 additional sts dec'd; all targeted p3 columns have been converted to p2 columns.

The last RS row completed is Row 75 (77, 75, 83, 75, 81, 67) of the Medium Back chart, which now contains 56 sts.

There will be 272 (292, 312, 332, 352, 372, 392) sts arranged as foll with RS facing: 43 sts in Right Front chart, 2 (7, 7, 7, 7, 7, 7) sts in either Rev St st or cabled rib depending on your size, 6 sts in Oval Cable chart, 7 (7, 12, 17, 22, 27, 32) sts in cabled rib, 17 sts in side rib, 7 (7, 12, 12, 12, 17, 17) sts in cabled rib, 6 sts in Oval Cable chart, 7 (12, 7, 12, 17, 12, 17) sts in cabled rib, 6 sts in Oval Cable, 7 (7, 12, 12, 12, 17, 17) sts in cabled rib, 56 sts in Medium Back chart, 7 (7, 12, 12, 12, 17, 17) sts in cabled rib, 6 sts in Oval Cable chart, 7 (12, 7, 12, 17, 12, 17) sts in cabled rib, 6 sts in Oval Cable chart, 7 (7, 12, 12, 12, 17, 17) sts in cabled rib, 17 sts in side rib, 7 (7, 12, 17, 22, 27, 32) sts in cabled rib, 6 sts in Oval cable chart, 2 (7, 7, 7, 7, 7, 7) sts in either Rev St st or cabled rib, 43 sts in Left Front chart.

There will be 66 (71, 76, 81, 86, 91, 96) front sts at each end of row outside the marked center st of the side rib section and 138 (148, 158, 168, 178, 188, 198) back sts between the marked center side rib sts.

Work 1 WS row even, ending with Row 76 (78, 76, 84, 76, 82, 68) of Medium Back chart—piece measures 12¾ (13, 12¾, 14, 12¾, 13½, 11¼)" (32.5 [33, 32.5, 35.5, 32.5, 34.5, 28.5] cm) from CO.

MEDIUM BACK

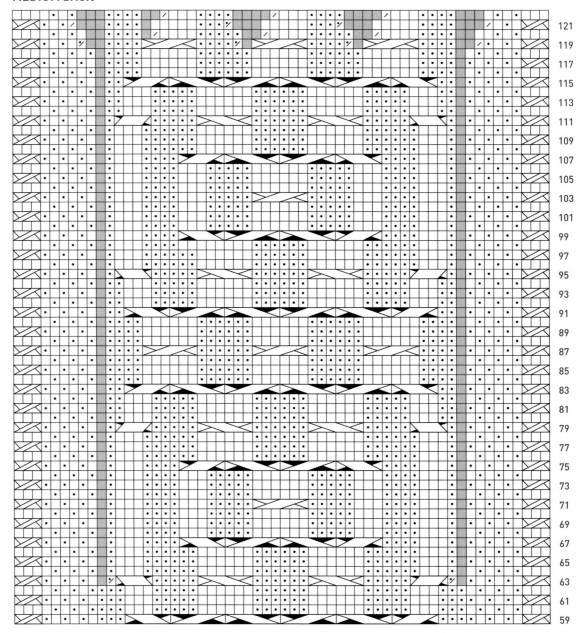

121
119
117
115
113
111
109
107
105
103
101
99
97
95
93
91
89
87
85
83
81
79
77
75
73
71
69
67
65
63
61
59

SMALL BACK

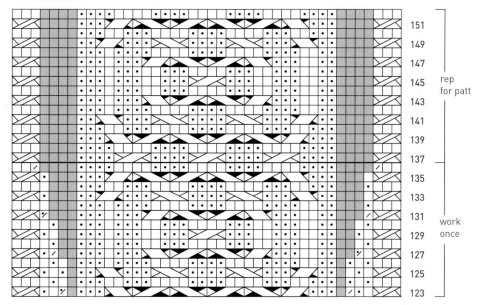

151
149
147
145 rep
143 for patt
141
139
137
135
133
131 work
129 once
127
125
123

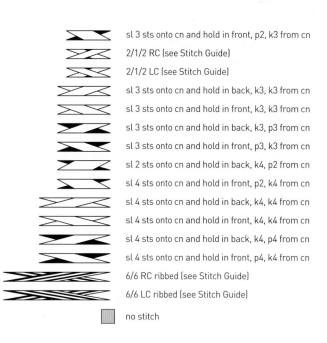

	knit on RS rows and all rnds; purl on WS rows
	purl on RS rows and all rnds; knit on WS rows
	k2tog on RS; p2tog on WS
	p2tog on RS; k2tog on WS
M	M1 pwise on WS (see Glossary)
V	sl 1 kwise on RS; sl 1 pwise on WS
	1/2 RC (see Stitch Guide)
	sl 1 st onto cn and hold in back, k2, p1 from cn
	sl 2 sts onto cn and hold in front, p1, k2 from cn
	sl 2 sts onto cn and hold in back, k2, k2 from cn
	sl 2 sts onto cn and hold in front, k2, k2 from cn
	sl 2 sts onto cn and hold in back, k2, p2 from cn
	sl 2 sts onto cn and hold in front, p2, k2 from cn
	sl 1 st onto cn and hold in back, k3, p1 from cn
	sl 3 sts onto cn and hold in front, p1, k3 from cn
	sl 2 sts onto cn and hold in back, k3, p2 from cn

	sl 3 sts onto cn and hold in front, p2, k3 from cn
	2/1/2 RC (see Stitch Guide)
	2/1/2 LC (see Stitch Guide)
	sl 3 sts onto cn and hold in back, k3, k3 from cn
	sl 3 sts onto cn and hold in front, k3, k3 from cn
	sl 3 sts onto cn and hold in back, k3, p3 from cn
	sl 3 sts onto cn and hold in front, p3, k3 from cn
	sl 2 sts onto cn and hold in back, k4, p2 from cn
	sl 4 sts onto cn and hold in front, p2, k4 from cn
	sl 4 sts onto cn and hold in back, k4, k4 from cn
	sl 4 sts onto cn and hold in front, k4, k4 from cn
	sl 4 sts onto cn and hold in back, k4, p4 from cn
	sl 4 sts onto cn and hold in front, p4, k4 from cn
	6/6 RC ribbed (see Stitch Guide)
	6/6 LC ribbed (see Stitch Guide)
	no stitch

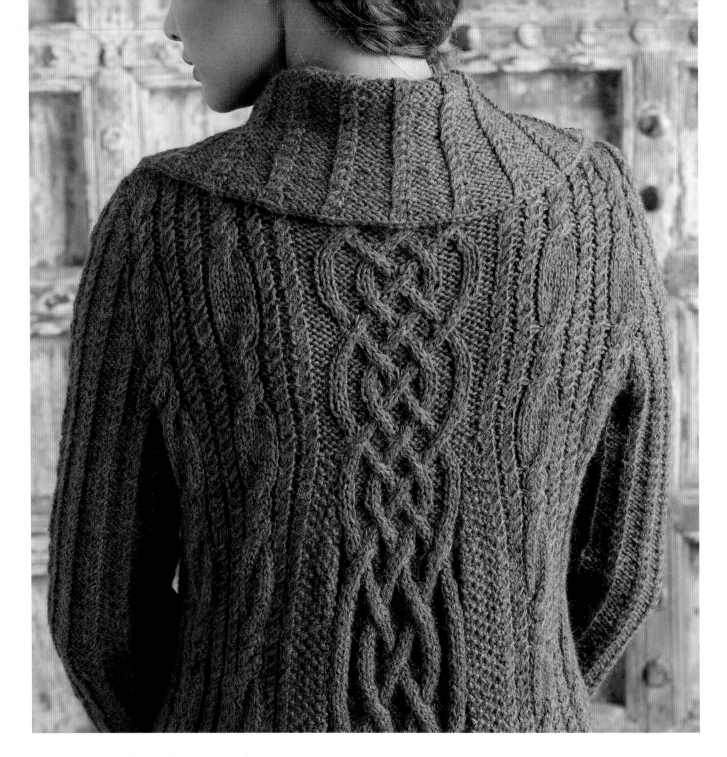

Second Decrease Set

Note: *Beg on the next RS row, specific 2-st purl columns in the cable rib sections will be dec'd to 1 st. Cont in patt as established during the decs, working the sts on each side of the 1/2RC cables as they appear. As before, do not work any decs in the 17-st marked side rib sections.*

Counting only the 2-st purl columns in the cabled rib (and also Rev St st for the smallest size), the foll number of p2 columns will be converted to p1 columns:

Between each front chart and side rib section: 3 (4, 5, 6, 7, 8, 9) columns.

Between each side rib section and back chart: 6 (7, 8, 9, 10, 11, 12) columns.

Total p2 columns to dec: 9 (11, 13, 15, 17, 19, 21) on each side of back section.

NEXT ROW: (RS) In this row, the purl columns to be dec'd are the two p2 columns before the back section and the two p2 columns after the back section as foll:

Work in patt to 7 sts before back section, p2tog, 1/2RC, p2tog, work Medium Back chart, p2tog, 1/2RC, p2tog, work in patt to end—4 sts dec'd; 1 st each from four p2 columns.

Work 9 (7, 5, 3, 3, 3, 3) rows even, ending with a WS row.

NEXT ROW: (RS) In this row, the purl columns to be dec'd are the two p2 columns before first p1 column created in the previous dec row and the two p2 columns after the last p1 column created in the previous dec row as foll:

Work in patt, working each of the four p2 columns targeted for dec as p2tog—4 sts dec'd, 1 st each from four p2 columns.

Cont in patt, rep the shaping of the last 10 (8, 6, 6, 4, 4, 4) rows 2 (3, 4, 5, 6, 7, 8) more times—8 (12, 16, 20, 24, 28, 32) additional sts dec'd in p2 columns.

Work 9 (7, 5, 5, 3, 3, 3) rows even, ending with a WS row.

NEXT ROW: (RS) In this row, the purl columns to be dec'd are the rem two p2 columns, one next to the front chart at each side as foll:

Work in patt, working the first p2 column as p2tog and the last p2 column as p2tog—2 additional sts dec'd; all targeted p2 columns have been converted to p1 columns.

The last RS row completed is Row 117 (119, 115, 115, 111, 119, 106) of the Medium Back chart. Work 5 (3, 7, 7, 11, 3, 13) row(s) even to end with Row 122 of chart for all sizes—Medium Back chart now contains 42 sts; piece measures 20" (51 cm) from CO for all sizes.

There will be 240 (256, 272, 288, 304, 320, 336) sts arranged as foll with RS facing: 43 sts in Right Front chart, 1 (5, 5, 5, 5, 5, 5) st(s) in either Rev St st or cabled rib depending on your size, 6 sts in Oval Cable chart, 5 (5, 9, 13, 17, 21, 25) sts in cabled rib, 17 sts in side rib, 5 (5, 9, 9, 9, 13, 13) sts in cabled rib, 6 sts in Oval Cable chart, 5 (9, 5, 9, 13, 9, 13) sts in cabled rib, 6 sts in Oval Cable chart, 5 (5, 9, 9, 9, 13, 13) sts in cabled rib, 42 sts in Medium Back chart, 5 (5, 9, 9, 9, 13, 13) sts in cabled rib, 6 sts in Oval Cable chart, 5 (9, 5, 9, 13, 9, 13) sts in cabled rib, 6 sts in Oval Cable chart, 5 (5, 9, 9, 9, 13, 13) sts in cabled rib, 17 sts in side rib, 5 (5, 9, 13, 17, 21, 25) sts in cabled rib, 6 sts in Oval cable chart, 1 (5, 5, 5, 5, 5, 5) st(s) in either Rev St st or cabled rib, 43 sts in Left Front chart.

There will be 63 (67, 71, 75, 79, 83, 87) front sts at each end of row outside the marked center st of the side rib section and 112 (120, 128, 136, 144, 152, 160) back sts between the marked center side rib sts.

Change to working the back section according to the Small Back chart. Work even in patt until Row 137 (137, 141, 141, 143, 143, 145) of Small Back chart has been completed, ending with a RS row—piece measures 22½ (22½, 23, 23, 23¼, 23¼, 23½)" (57 [57, 58.5, 58.5, 59, 59, 59.5] cm) from CO; 232 (248, 264, 280, 296, 312, 328) sts total; 63 (67, 71, 75, 79, 83, 87) sts each front, 104, 112, 120, 128, 136, 144, 152) back sts, 2 marked center side rib sts.

Divide for Back and Front

NEXT ROW: (WS) Cont in patt, work 60 (63, 67, 71, 75, 79, 79, 82) sts, BO center 7 (9, 9, 9, 9, 9, 11) sts of side rib removing marker from center st, work in patt until there are 98 (104, 112, 120, 128, 136, 142) back sts on needle after BO gap, BO center 7 (9, 9, 9, 9, 9, 11) sts of side rib removing marker from center st, work to end for right front.

Cut yarn. Place 60 (63, 67, 71, 75, 79, 82) sts of right and left fronts onto separate holders, leaving 98 (104, 112, 120, 128, 136, 142) back sts on needle.

Back

Shape Armholes

Rejoin yarn to back sts with RS facing. BO 3 sts at beg of next 2 rows, then BO 2 sts at the beg of foll 4 (4, 2, 2, 4, 4, 6) rows—84 (90, 102, 110, 114, 122, 124) sts rem.

DEC ROW: (RS) Sl 1 kwise, ssk, work in patt to last 3 sts, k2tog, k1—2 sts dec'd.

NEXT ROW: (WS) Sl 1 pwise, work in patt to last st, p1.

Rep the last 2 rows 0 (0, 4, 4, 5, 7, 7) more time(s)—82 (88, 92, 100, 102, 106, 108) sts rem.

Cont even in patt, working selvedge sts as for last 2 rows, until armholes measure 6½ (7½, 8, 8½, 9, 9¼, 9¾)" (16.5 [19, 20.5, 21.5, 23, 23.5, 25] cm), ending with a RS row.

Shape Shoulders

Work in short-rows (see Glossary) as foll:

SHORT-ROW 1: (RS) Work in patt to last 6 sts, wrap next st, turn work.

SHORT-ROW 2: (WS) Work in patt to last 6 sts, wrap next st, turn work.

SHORT-ROWS 3 AND 4: Work in patt to last 12 sts, wrap next st, turn work.

SHORT-ROWS 5 AND 6: Work in patt to last 18 sts, wrap next st, turn work.

NEXT 2 ROWS: Work in patt to end of row, working wraps tog with wrapped sts when you come to them.

Place 22 (24, 25, 29, 29, 30, 31) sts onto one holder for right shoulder, place next 38 (40, 42, 42, 44, 46, 46) sts onto a second holder for neck, place rem 22 (24, 25, 29, 29, 30, 31) sts onto a third holder for left shoulder.

Right Front

Return 60 (63, 67, 71, 75, 79, 82) held right front sts onto needle and rejoin yarn at armhole edge with WS facing.

Shape Armhole

Keeping in patt, BO 3 sts at beg of next WS row, then BO 2 sts at beg of foll 2 (2, 1, 1, 2, 2, 3) WS row(s)—53 (56, 62, 66, 68, 72, 73) sts rem. Work 1 RS row even after last WS BO row.

DEC ROW: (WS) Sl 1 pwise, p2tog, work in patt to last st, p1—1 st dec'd.

NEXT ROW: (RS) Sl 1 kwise, work in patt to last st, k1.

Rep the last 2 rows 0 (0, 4, 4, 5, 7, 7) more time(s)—52 (55, 57, 61, 62, 64, 65) sts rem.

Working selvedge sts as for last 2 rows, cont in patt if necessary until armhole measures 1½ (1½, 2½, 2½, 3, 3¾, 4)" (3.8 [3.8, 6.5, 6.5, 7.5, 9.5, 10] cm), ending with a WS row.

NEXT ROW: (RS) Dec the p2 columns on each side of the braid cable section of the Right Front chart to 1 st as foll: Work first 23 chart sts, p2tog, work 13 sts in patt, p2tog, work rem 3 chart sts in patt, work to end—50 (53, 55, 59, 60, 62, 63) sts rem; 41 Right Front chart sts rem.

Shape Neck

Work short-rows as foll:

SHORT-ROW 1: (WS) Work in patt to last 13 sts, wrap next st, turn work.

SHORT-ROWS 2 AND 4: (RS) Work in patt end.

SHORT-ROW 3: Work in patt to last 14 sts, wrap next st, turn work.

SHORT-ROW 5: Work in patt to 1 st before previously wrapped st, wrap next st, turn work.

SHORT-ROW 6: Work to end.

Rep the last 2 rows 9 (10, 10, 11, 11, 12, 13) more times.

NEXT ROW: (WS) Work to end, working wraps tog with wrapped sts as you come to them—piece measures about 5¾ (6, 7, 7¼, 7¾, 8¾, 9½)" (14.5 [15, 18, 18.5, 19.5, 22, 24] cm) from dividing row at armhole edge (end of RS rows) and 4 (4¼, 4¼, 4¾, 4¾, 5, 5¼)" (10 [11, 11, 12, 12, 12.5, 13.5] cm) less at neck edge (beg of RS rows).

Cont even in patt until armhole measures 6½ (7½, 8, 8½, 9, 9¼, 9¾)" (16.5 [19, 20.5, 21.5, 23, 23.5, 25] cm), at armhole edge, ending with a WS row.

Shape Shoulder

SHORT-ROW 1: (RS) Work in patt to last 6 sts, wrap next st, turn work.

SHORT-ROWS 2 AND 4: (WS) Work to end.

SHORT-ROW 3: Work in patt to last 12 sts, wrap next st, turn work.

SHORT-ROW 5: Work in patt to last 18 sts, wrap next st, turn work.

SHORT-ROW 6: Work to end.

NEXT 2 ROWS: Work in patt across all sts, working wraps tog with wrapped sts when you come to them.

Place 22 (24, 25, 29, 29, 30, 31) sts at armhole edge onto holder for right shoulder and place rem 28 (29, 30, 30, 31, 32, 32) sts at right front edge onto a second holder.

Left Front

Return 60 (63, 67, 71, 75, 79, 82) held left front sts onto needle and rejoin yarn at neck edge with WS facing. Work 1 WS row even.

Shape Armhole

Keeping in patt, BO 3 sts at beg of next RS row, then BO 2 sts at beg of foll 2 (2, 1, 1, 2, 2, 3) RS row(s)—53 (56, 62, 66, 68, 72, 73) sts rem.

DEC ROW: (RS) Sl 1 kwise, ssk, work in patt to last st, k1—1 st dec'd.

NEXT ROW: (WS) Sl 1 pwise, work in patt to last st, p1.

Rep the last 2 rows 0 (0, 4, 4, 5, 7, 7) more time(s)—52 (55, 57, 61, 62, 64, 65) sts rem.

Working selvedge sts as for last 2 rows, cont in patt if necessary until armhole measures 1½ (1½, 2½, 2½, 3, 3¾, 4)" (3.8 [3.8, 6.5, 6.5, 7.5, 9.5, 10] cm), ending with a WS row.

NEXT ROW: (RS) Dec the p2 columns on each side of the braid cable section of the Left Front chart to 1 st as foll: Work in patt to Left Front chart sts, work first 3 chart sts, p2tog, work 13 sts in patt, p2tog, work rem 23 chart sts in patt—50 (53, 55, 59, 60, 62, 63) sts rem; 41 Left Front chart sts rem.

Work 1 WS row even.

Shape Neck

Work short-rows as foll:

SHORT-ROW 1: (RS) Work in patt to last 13 sts, wrap next st, turn work.

SHORT-ROWS 2 AND 4: (WS) Work in patt end.

SHORT-ROW 3: Work in patt to last 14 sts, wrap next st, turn work.

SHORT-ROW 5: Work in patt to 1 st before previously wrapped st, wrap next st, turn work.

SHORT-ROW 6: Work to end.

Rep the last 2 rows 9 (10, 10, 11, 11, 12, 13) more times.

NEXT ROW: (RS) Work to end, working wraps tog with wrapped sts as you come to them—piece measures about 5¾ (6, 7, 7¼, 7¾, 8¾, 9½)" (14.5 [15, 18, 18.5, 19.5, 22, 24] cm) from dividing row at armhole edge (beg of RS rows) and 4 (4¼, 4¼, 4¾, 4¾, 5, 5¼)" (10 [11, 11, 12, 12, 12.5, 13.5] cm) less at neck edge (end of RS rows).

Cont even in patt until armhole measures 6½ (7½, 8, 8½, 9, 9¼, 9¾)" (16.5 [19, 20.5, 21.5, 23, 23.5, 25] cm) at armhole edge, ending with a RS row.

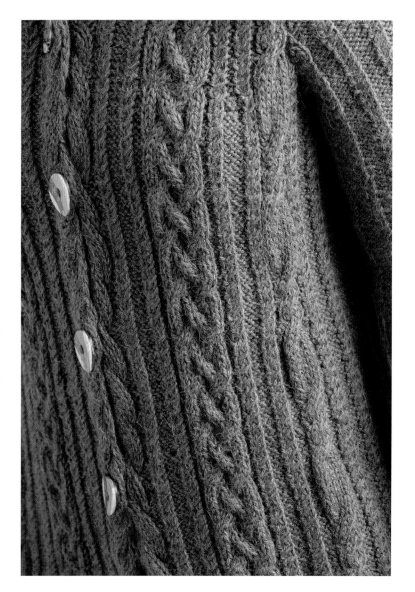

Shape Shoulder

SHORT-ROW 1: (WS) Work in patt to last 6 sts, wrap next st, turn work.

SHORT-ROWS 2 AND 4: (RS) Work to end.

SHORT-ROW 3: Work in patt to last 12 sts, wrap next st, turn work.

SHORT-ROW 5: Work in patt to last 18 sts, wrap next st, turn work.

SHORT-ROW 6: Work to end.

NEXT 2 ROWS: Work in patt across all sts, working wraps tog with wrapped sts when you come to them.

Place 22 (24, 25, 29, 29, 30, 31) sts at armhole edge onto holder for left shoulder and place rem 28 (29, 30, 30, 31, 32, 32) sts at left front edge onto a second holder.

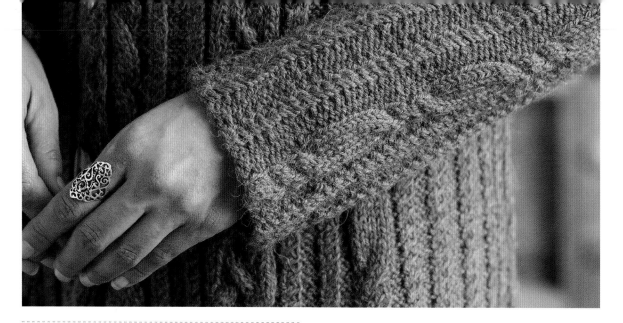

Sleeves

With dpn, CO 61 (61, 61, 61, 67, 67, 73) sts. Pm and join for working in rnds, being careful not to twist sts.

NEXT RND: K1 (1, 1, 1, 4, 4, 1), work Rnd 2 of cabled rib in rnds over 27 (27, 27, 27, 27, 27, 33) sts, k6, work Rnd 2 of cabled rib in rnds over 27 (27, 27, 27, 27, 27, 33) sts, k0 (0, 0, 0, 3, 3, 0).

NEXT RND: K1, work 1/2RC 0 (0, 0, 0, 1, 1, 0) time, work Rnd 1 of cabled rib over 27 (27, 27, 27, 27, 27, 33) sts, k6, work Rnd 1 of cabled rib over 27 (27, 27, 27, 27, 27, 33) sts, work 1/2RC 0 (0, 0, 0, 1, 1, 0) time.

NEXT 2 RNDS: Rep the last 2 rnds once more.

NEXT RND: Work in patt to center 6 sts, pm, work Rnd 10 of Oval Cable chart over center 6 sts, pm, work in patt to end.

Note: *During the following instructions, work the Oval Cable chart until Rnd 30 has been completed, then rep Rnds 9–30 for patt.*

Knitting the first st of every rnd, work even in established patts until piece measures 4½" (11.5 cm) from CO.

INC RND: K1, M1R (see Glossary), work in patt to end, M1L (see Glossary)—2 sts inc'd.

Cont in patt, rep the inc rnd every 12th rnd 5 (0, 0, 0, 0, 0, 0) times, then every 10th rnd 0 (6, 0, 0, 0, 0, 0) times, then every 8th rnd 0 (2, 8, 0, 0, 0, 0) times, then every 6th rnd 0 (0, 2, 13, 11, 3, 0) times, then every 4th rnd 0 (0, 0, 0, 3, 14, 19) times, working new sts into cabled rib patt—73 (79, 83, 89, 97, 103, 113) sts.

Work even until piece measures about 17½ (18, 18, 18½, 18½, 18½, 18¾)" (44.5 [45.5, 45.5, 47, 47, 47, 47.5] cm) from CO, ending with an even-numbered rnd and ending last rnd 3 (4, 4, 4, 4, 4, 5) sts before end-of-rnd m.

NEXT RND: (odd-numbered rnd) BO 7 (9, 9, 9, 9, 9, 11) sts removing end-of-rnd m, work in patt to end—66 (70, 74, 80, 88, 94, 102) sts rem.

Shape Cap

Change to working back and forth in rows; even-numbered rows are WS and odd-numbered rows are RS.

Beg with a WS row, BO 3 sts at beg of next 4 rows, then BO 2 sts at beg of foll 6 rows—42 (46, 50, 56, 64, 70, 78) sts rem. Work 1 WS row even.

DEC ROW: (RS) Sl 1, ssk, work to last 3 sts, k2tog, k1—2 sts dec'd.

Rep dec row every RS row 6 (8, 5, 8, 9, 9, 8) times, then every 4th row (i.e., every other RS row) 0 (0, 2, 1, 1, 1, 2) time(s)—28 (28, 34, 36, 42, 48, 56) sts rem.

BO 2 (2, 3, 3, 4, 5, 6) sts at beg of next 6 rows—16 (16, 16, 18, 18, 18, 20) sts rem.

Rep dec row every RS row 2 times—12 (12, 12, 14, 14, 14, 16) sts rem.

BO rem sts.

Finishing

Block pieces to measurements, taking care not to flatten cables.

Join Shoulders

Place 22 (24, 25, 29, 29, 30, 31) held left front shoulder sts on one needle and corresponding held left back shoulder sts onto another needle. Hold needles parallel with RS of fabric touching and WS facing out and use the three-needle method (see Glossary) to BO all sts tog. Rep for right shoulder.

With yarn threaded on a tapestry needle, sew sleeves into armholes, matching center of sleeve cap cable to about ¼" (6 mm) to the front of the shoulder line (see Tips and Tricks on page 92).

Collar

With RS facing, place 28 (29, 30, 30, 31, 32, 32) held right front sts, 38 (40, 42, 42, 44, 46, 46) held back sts, and 28 (29, 30, 30, 31, 32, 32) held left front sts on cir needle—94 (98, 102, 102, 106, 110, 110) sts total. Join yarn with WS facing to left front edge.

Note: *The RS of the collar corresponds to the WS of the garment so the RS of the collar will show when the collar is folded back. Because the 12 sts at each front edge are reversible cables that look the same on both the right and wrong sides, you can cont to work these sts as established for the collar. To make it easier to keep track of the patterns, work an extra row or skip one row in the patt of the reversible cables so they cross on the same row as the 1/2RC cables in the rest of the collar.*

SET-UP ROW: (RS of collar; WS of garment) Work 12 left front edge sts in established patt, [k5, M1] 3 (3, 3, 3, 3, 4, 4) times, k1 (2, 3, 3, 4, 0, 0), pick up and knit 2 (3, 1, 1, 2, 2, 2) st(s) at left shoulder join, [k8, M1] 4 (5, 5, 5, 5, 5, 5) times, k6 (0, 2, 2, 4, 6, 6), pick up and knit 3 (3, 1, 1, 2, 2, 2) st(s) at right shoulder join, [k5, M1] 3 (3, 3, 3, 3, 4, 4) times, k1 (2, 3, 3, 4, 0, 0), work 12 right front edge sts as established—109 (115, 115, 115, 121, 127, 127) sts total.

NEXT ROW: (WS of collar; RS of garment) Work 12 edge sts, k2, *p3, k3; rep from * to last 17 sts, p3, k2, work 12 edge sts.

NEXT ROW: (RS of collar) Work 12 edge sts, p2, *1/2RC, p3; rep from * to last 17 sts, 1/2RC, p2, work 12 edge sts.

Rep the last 2 rows until collar measures 3" (7.5 cm) from pick-up row, ending with a WS collar row.

INC ROW: (RS of collar) Inc the center 5 (6, 6, 6, 7, 8, 8) p3 columns to p4 as foll: Work 12 edge sts, p2, [1/2RC, p3] 4 times for all sizes, [1/2RC, p1, M1P (see Glossary), p2] 5 (6, 6, 6, 7, 8, 8) times, [1/2RC, p3] 4 times for all sizes, 1/2RC, p2, work 12 edge sts—114 (121, 121, 128, 135, 135) sts.

Working new sts as they appear, cont in patt until collar measures 5" (12.5 cm) from pick-up row, ending with a WS collar row.

INC ROW: (RS of collar) Inc the rem p3 columns to p4 as foll: Work 12 edge sts, p2, [1/2RC, p1, M1P, p2] 4 times for all sizes, [1/2RC, p4] 5 (6, 6, 6, 7, 8, 8) times, [1/2RC, p1, M1P, p2] 4 times for all sizes, 1/2RC, p2, work 12 edge sts—122 (129, 129, 129, 136, 143, 143) sts.

Working new sts as they appear, cont in patt until collar measures 6" (15 cm) from pick-up row, ending with a WS collar row.

NEXT ROW: (RS of collar) Inc the center 7 (8, 8, 8, 9, 10, 10) p4 columns to p5 as foll: Work 12 edge sts, p2, [1/2RC, p4] 3 times for all sizes, [1/2RC, p2, M1P, p2] 7 (8, 8, 8, 9, 10, 10) times, [1/2RC, p4] 3 times for all sizes, 1/2RC, p2, work 12 edge sts—129 (137, 137, 137, 145, 153, 153) sts.

Working new sts as they appear, cont in patt until collar measures 8" (20.5 cm) from pick-up row, ending with a WS collar row. BO all sts loosely in patt with RS of collar facing.

Block collar and all seams. Weave in loose ends.

Sew buttons to left front reversible cable band, opposite cable crossing rows in the right front so the natural holes of the crossing rows can be used as buttonholes. For the cardigan shown, the highest button is about 1" (2.5 cm) below the start of the neck shaping short-rows, the lowest is 12" (30.5 cm) up from the CO edge, and the rem two are evenly spaced in between.

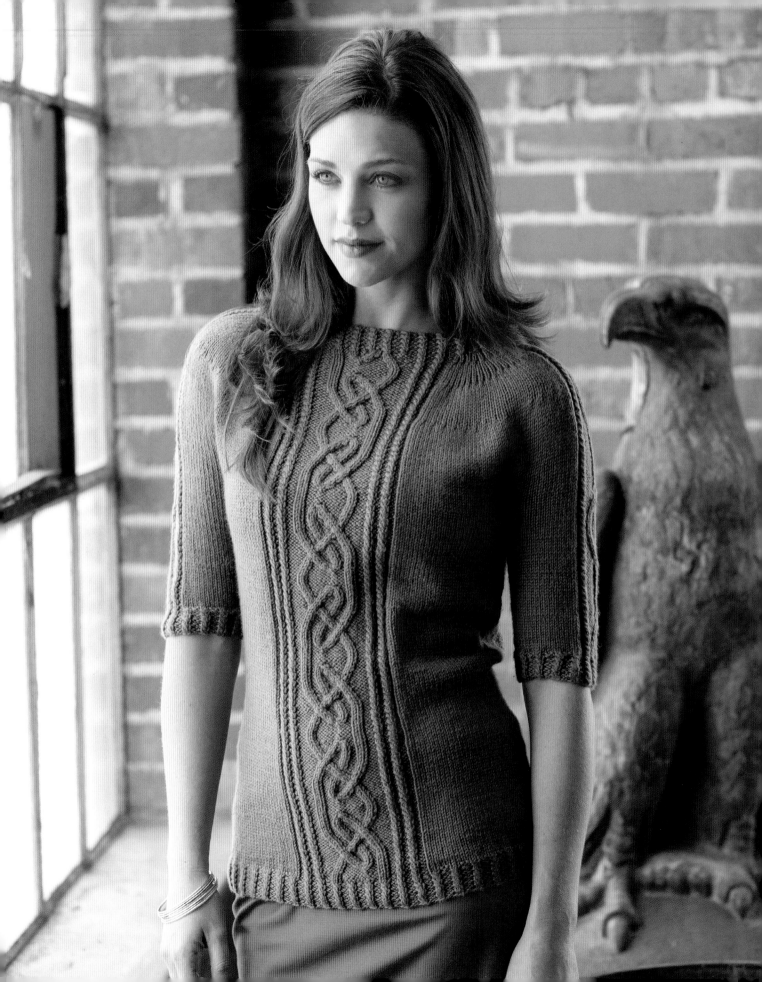

Cabled Top

This top is knitted in the round from the bottom up with a Celtic-inspired cable panel along the center front, as well as waist shaping for a flattering silhouette. A complementary cable panel adorns each sleeve, which is also worked in rounds to the underarm. The sleeves and body are joined at the yoke and worked in a single piece to the neck, while the sleeve cables continue into the yoke for an interesting design feature. A portion of the front cable is repeated on the back of the yoke for a tattoo-like "surprise."

designed by **FAINA GOBERSTEIN**

FINISHED SIZE

About 35¾ (41½, 44½, 50¼, 53¼, 59)" (91 [105.5, 113, 127.5, 135.5, 150] cm) bust circumference.

Top shown measures 35¾" (91 cm).

YARN

DK weight (#3 Light).

Shown here: Debbie Bliss Cashmerino DK (55% merino wool, 33% microfiber, 12% cashmere; 121 yd [110 m]/50 g): #44 denim, 9 (10, 12, 13, 14, 16) balls.

NEEDLES

Size U.S. 6 (4 mm): 28" to 32" (70 to 80 cm) circular (cir) and set of 5 double-pointed (dpn).

Adjust needle size if necessary to obtain the correct gauge.

NOTIONS

Markers (m); cable needle (cn); stitch holders or waste yarn; tapestry needle.

GAUGE

22 sts and 32 rows/rnds = 4" (10 cm) in St st.

37–41 sts of Front chart measure 5½" (14 cm) wide.

22 sts of Right and Left Sleeve charts measure 3" (7.5 cm) wide.

17–21 sts of Back chart measure 3¼" (8.5 cm) wide.

Design Techniques

Circular yoke construction worked in rounds from the bottom up, page 8.

Shaping in cable patterns, page 76.

Self-standing patterns, page 17.

Short-rows, page 178.

TIPS & TRICKS

• The stitch counts of the charts used for the front and back do not remain constant throughout. The Front chart varies from 37 to 41 stitches; always count the front chart section as 37 stitches, even if it is on a round where the count has temporarily increased. The Back chart varies from 17 to 21 stitches and should always be counted as 17 stitches.

• To work the twists in Rnd 2 of the Twisted Rib pattern more easily, turn the point of the left needle toward your body so you can see the backs of the stitches more easily, then insert the tip of the right needle into the back of the second stitch on the left needle to begin the twist.

• When using short-rows to raise the back of the neck, work the chart patterns back and forth in rows, reading all even-numbered chart rounds as WS rows.

• Whenever the directions call for an ssk decrease, use the modified ssk (at right) to produce a flatter left-leaning decrease.

STITCH GUIDE

TW2 (TWIST 2)

Skip the first st on the left needle, and insert the right needle tip into the back of the second st on left needle and knit it through the back loop (tbl) without removing any sts from the left needle. Knit the first st on the left needle through its front loop in the usual manner, then slip both sts from the left needle.

TWISTED RIB: (MULTIPLE OF 4 STS)

RND 1: P1, *k2, p2; rep from * to last 3 sts, k2, p1.

RND 2: P1, *Tw2 (see above), p2; rep from * to last 3 sts, Tw2, p1.

Rep Rnds 1 and 2 for patt.

MODIFIED SSK

Sl 1 knitwise, k1 tbl, psso—1 st dec'd.

1-INTO-3 INC

On RS rows and all rnds, knit into the back and front of same st, insert left needle tip from left to right into the vertical bar formed between the 2 new sts, and knit the bar through its back loop—3 sts made from 1 st.

On WS rows, knit into the back and front of same st, insert left needle tip from left to right into the vertical bar formed between the 2 new sts, and purl the bar through its back loop—3 sts made from 1 st.

5-INTO-1 DEC

Temporarily drop working yarn in back of work. Sl 3 sts individually kwise to right needle (try not to stretch the sts), *use the left needle tip to lift the second st on the right needle up and over the first st and off the needle. Transfer the resulting st to the left needle. Use the right needle tip to lift the second st on the left needle up and over the first st and off the needle. Transfer the resulting st to the right needle. Rep from * once more. Return the st from the right needle to the left needle,

pick up the working yarn, and knit the st through its back loop—5 sts dec'd to 1 st.

2/1/2 RC

Sl 3 sts onto cn and hold in back of work, k2, sl third st from cn back onto left needle and work it as p1, then k2 from cn.

2/1/2 LC

Sl 3 sts onto cn and hold in front of work, k2, sl third st from cn back onto left needle and work it as p1, then k2 from cn.

WRAP STITCH

Bring yarn to front between needles, slip next st purlwise to right needle, bring yarn to back between the needles, return slipped st to left needle, turn work.

WORK WRAP TOGETHER WITH WRAPPED STITCH

On RS rows, insert the right needle tip into the wrap from front to back, lift it onto the left needle, then knit the wrap together with the wrapped st.

On WS rows, insert the right needle tip into the wrap from back to front, lift it onto the left needle, then purl the wrap together with the wrapped st.

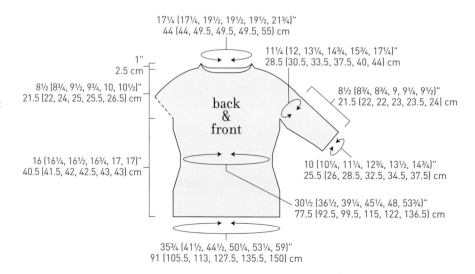

17¼ (17¼, 19½, 19½, 19½, 21¾)"
44 (44, 49.5, 49.5, 49.5, 55) cm

11¼ (12, 13¼, 14¾, 15¾, 17¼)"
28.5 (30.5, 33.5, 37.5, 40, 44) cm

1"
2.5 cm

8½ (8¾, 9½, 9¾, 10, 10½)"
21.5 (22, 24, 25, 25.5, 26.5) cm

8½ (8¾, 8¾, 9, 9¼, 9½)"
21.5 (22, 22, 23, 23.5, 24) cm

back & front

16 (16¼, 16½, 16¾, 17, 17)"
40.5 (41.5, 42, 42.5, 43, 43) cm

10 (10¼, 11¼, 12¾, 13½, 14¾)"
25.5 (26, 28.5, 32.5, 34.5, 37.5) cm

30½ (36¼, 39¼, 45¼, 48, 53¾)"
77.5 (92.5, 99.5, 115, 122, 136.5) cm

35¾ (41½, 44½, 50¼, 53¼, 59)"
91 (105.5, 113, 127.5, 135.5, 150) cm

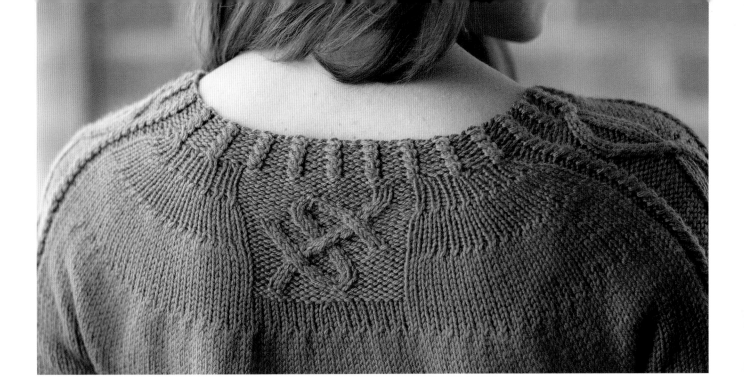

Left Sleeve

With dpn, CO 60 (60, 68, 76, 76, 84) sts. Divide sts as evenly as possible onto 4 needles, place marker (pm), and join for working in rnds, being careful not to twist sts.

Work twisted rib (see Stitch Guide) for 10 rnds, ending with Rnd 2 of patt—piece measures 1" (2.5 cm).

SET-UP RND: K1, [M1 (see Glossary)] 0 (0, 0, 0, 1, 0) time, k18 (18, 22, 26, 26, 30), [M1] 0 (1, 0, 0, 1, 1) time, pm, work set-up rnd of Left Sleeve chart (page 110)over center 22 sts, pm, [M1] 0 (1, 0, 0, 1, 1) time, k18 (18, 22, 26, 26, 30), [M1] 0 (0, 0, 0, 1, 0) time, k1—60 (62, 68, 76, 80, 86) sts.

NEXT RND: K19 (20, 23, 27, 29, 32), slip marker (sl m), work Rnd 1 of Left Sleeve chart over center 22 sts, sl m, k19 (20, 23, 27, 29, 32).

Working sts outside chart patt in St st, cont in established patts for 3 more rnds, ending with Rnd 4 of chart.

INC RND: K1, M1L (see Glossary), knit to m, sl m, work 22 chart sts, sl m, knit to last st, M1R (see Glossary), k1—2 sts inc'd.

Note: During the foll shaping, after completing Rnd 40 of the chart, rep Rnds 1–40 for patt; do not rep the set-up rnd.

Cont in patt, rep the inc rnd every 8th rnd 0 (2, 0, 0, 2, 6) time(s), then every 10th rnd 0 (2, 4, 2, 3, 0) times(s), then every 12th rnd 3 (0, 0, 2, 0, 0) time(s), working new sts in St st—68 (72, 78, 86, 92, 100) sts.

Work even as established until piece measures 8½ (8¾, 8¾, 9, 9¼, 9½)" (21.5 [22, 22, 23, 23.5, 24] cm) from CO, ending with an odd-numbered rnd and ending last rnd 6 (6, 8, 8, 8, 9) sts before end-of-rnd m. Make a note of the last chart rnd completed so you can work the other sleeve to match.

NEXT RND: (even-numbered rnd) Removing end-of-rnd m as you come to it, BO 6 (6, 8, 8, 8, 9) sts from end of previous rnd and 6 (6, 8, 8, 8, 9) sts at beg of next rnd, work in patt to end, leaving chart m in place—56 (60, 62, 70, 76, 82) sts rem.

Place sts onto holder or waste yarn.

Right Sleeve

With dpn, CO 60 (60, 68, 76, 76, 84) sts. Divide sts as evenly as possible onto 4 needles, pm and join for working in rnds, being careful not to twist sts.

Work twisted rib for 10 rnds, ending with Rnd 2 of patt—piece measures 1" (2.5 cm).

SET-UP RND: K1, [M1] 0 (0, 0, 0, 1, 0) time, k18 (18, 22, 26, 26, 30), [M1] 0 (1, 0, 0, 1, 1) time, pm, work set-up rnd of Right Sleeve chart (page 110) over center 22 sts, pm, [M1] 0 (1, 0, 0, 1, 1) time, k18 (18, 22, 26, 26, 30), [M1] 0 (0, 0, 0, 1, 0) time, k1—60 (62, 68, 76, 80, 86) sts.

LEFT SLEEVE

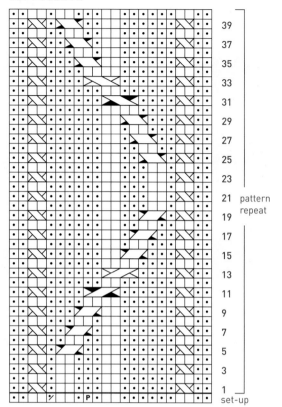

39
37
35
33
31
29
27
25
23
21 pattern
 repeat
19
17
15
13
11
9
7
5
3
1 set-up

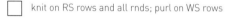

RIGHT SLEEVE

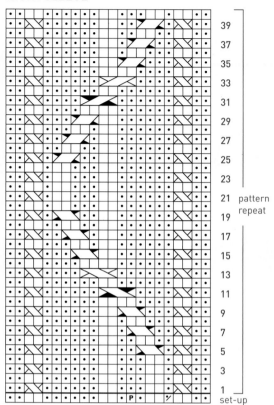

39
37
35
33
31
29
27
25
23
21 pattern
 repeat
19
17
15
13
11
9
7
5
3
1 set-up

	knit on RS rows and all rnds; purl on WS rows
	purl on RS rows and all rnds; knit on WS rows
	p2tog
P	M1 pwise (see Glossary)
	5-into-1 dec (see Stitch Guide)
	Tw2 (see Stitch Guide)
	1-into-3 inc (see Stitch Guide)
	sl 1 st to cn and hold in back, k2, p1 from cn

	sl 2 sts to cn and hold in front, p1, k2 from cn
	sl 2 sts to cn and hold in back, k2, k2 from cn
	sl 2 sts to cn and hold in front, k2, k2 from cn
	sl 2 sts to cn and hold in back, k2, p2 from cn
	sl 2 sts to cn and hold in front, p2, k2 from cn
	2/1/2 RC (see Stitch Guide)
	2/1/2 LC (see Stitch Guide)
	no stitch

FRONT

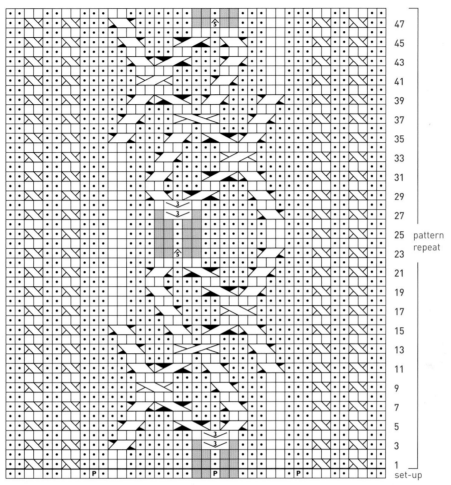

47
45
43
41
39
37
35
33
31
29
27
25 pattern repeat
23
21
19
17
15
13
11
9
7
5
3
1
set-up

BACK

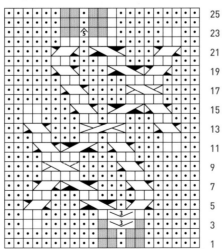

25
23
21
19
17
15
13
11
9
7
5
3
1

NEXT RND: K19 (20, 23, 27, 29, 32), sl m, work Rnd 1of Right Sleeve chart over center 22 sts, sl m, k19 (20, 23, 27, 29, 32).

Note: *As for left sleeve, after completing Rnd 40 of the chart, rep Rnds 1-40 for patt; do not rep the set-up rnd.*

Work as for left sleeve, ending with an even-numbered rnd—56 (60, 62, 70, 76, 82) sts rem. Place sts onto holder or waste yarn.

Body

With cir needle, CO 200 (232, 248, 280, 296, 328) sts. Pm and join for working in rnds, being careful not to twist sts.

Work in twisted rib patt for 10 rnds, ending with Rnd 2 of patt—piece measures 1" (2.5 cm) from CO.

SET-UP RND: K33 (41, 45, 53, 57, 65), pm, work set-up rnd of Front chart over 34 sts and inc them to 37 sts as shown, pm, k33 (41, 45, 53, 57, 65), pm for right side "seam," knit to end—203 (235, 251, 283, 299, 331) sts total; 103 (119, 127, 143, 151, 167) front sts, 100 (116, 124, 140, 148, 164) back sts.

Working sts outside chart patt in St st, cont in established patts until piece measures 4¼ (4¼, 4¾, 5, 5¼, 5½)" (11 [11, 12, 12.5, 13.5, 14] cm) from CO.

Shape Waist

Note: *During the foll shaping, after completing Rnd 48 of the Front chart, rep Rnds 1–48 for patt; do not rep the set-up rnd. Where the directions call for an ssk dec, use the modified ssk method (see Stitch Guide).*

DEC RND: *K1, k2tog, work in patt to 3 sts before side m, ssk, k1, sl m; rep from * once more—4 sts dec'd.

Cont in patt, rep dec rnd every 6th rnd 4 times, then every 4th rnd 2 times—175 (207, 223, 255, 271, 303) sts rem; 89 (105, 113, 129, 137, 153) front sts (see Tips & Tricks for how to count chart sts), 86 (102, 110, 126, 134, 150) back sts; piece measures 8¼ (8¼, 8¾, 9, 9¼, 9½)" (21 [21, 22, 23, 23.5, 24] cm) from CO.

Work even in patt for 2" (5 cm).

INC RND: *K1, M1L, work in patt to 1 st before side m, M1R, k1, sl m; rep from * once more—4 sts inc'd.

Rep inc rnd every 4th rnd 2 times, then every 6th rnd 4 times—203 (235, 251, 283, 299, 331) sts; 103 (119,

127, 143, 151, 167) front sts, 100 (116, 124, 140, 148, 164) back sts.

Work even in patt until piece measures 16 (16¼, 16½, 16¾, 17, 17)" (40.5 [41.5, 42, 42.5, 43, 43] cm) from CO, ending with an odd-numbered rnd and ending the last rnd 6 (6, 8, 8, 8, 9) sts before end-of-rnd m.

Divide for Front and Back

DIVIDING RND: (even-numbered rnd) Removing end-of-rnd m as you come to it, BO 6 (6, 8, 8, 8, 9) sts from end of previous rnd and 6 (6, 8, 8, 8, 9) sts at beg of next rnd; leaving chart m in place work in patt to 6 (6, 8, 8, 8, 9) sts before side m, BO 12 (12, 16, 16, 16, 18) sts removing side m, knit to end—91 (107, 111, 127, 135, 149) front sts rem and 88 (104, 108, 124, 132, 146) back sts rem. Cut yarn and leave sts on cir needle.

Yoke

With RS facing, rejoin yarn to start of front sts.

JOINING RND: (odd-numbered rnd) Work 91 (107, 111, 127, 135, 149) front sts in patt; return 56 (60, 62, 70, 76, 82) held right sleeve sts to left needle and work them in patt; k88 (104, 108, 124, 132, 146) back sts, return 56 (60, 62, 70, 76, 82) held left sleeve sts to left needle and work them in patt—291 (331, 343, 391, 419, 459) sts total.

NEXT RND: Reposition the end-of-rnd m by working a partial rnd as foll: K27 (35, 37, 45, 49, 56), sl m, work 37 sts according to Front chart, sl m, k44 (54, 57, 69, 76, 86), sl m, work 22 sts according to Right Sleeve chart, sl m, k60 (70, 73, 85, 92, 102), pm, k2tog at center back, pm, k60 (70, 73, 85, 92, 102), sl m, work 22 sts according to Left Sleeve chart—m at end of Left Sleeve chart is now the new end-of-rnd m; 290 (330, 342, 390, 418, 458) sts rem; 44 (54, 57, 69, 76, 86) sts before Front chart, 37 sts of Front chart, 44 (54, 57, 69, 76, 86) sts between Front and Right Sleeve charts, 22 sts of Right Sleeve chart, 121 (141, 147, 171, 185, 205) back sts between sleeve charts, 22 sts of Left Sleeve chart at end of rnd.

Work even in established patts until yoke measures 2¾ (3, 3¾, 4, 4¼, 4¾)" (7 [7.5, 9.5, 10, 11, 12] cm) from joining rnd, ending with an even-numbered rnd.

DEC RND 1: K2 (0, 0, 0, 1, 2), [k2tog, k1] 14 (18, 19, 23, 25, 28) times, sl m, work 37 sts of Front chart, sl m, [k2tog, k1] 14 (18, 19, 23, 25, 28) times, k2 (0, 0, 0, 1,

2), sl m, work 22 sts of Right Sleeve chart, sl m, k1 (2, 2, 2, 0, 1), [k2tog, k1] 17 (20, 21, 25, 28, 31) times, k8, sl m, k1 (center back), sl m, k8, [k1, k2tog] 17 (20, 21, 25, 28, 31) times, k1 (2, 2, 2, 0, 1), sl m, work 22 sts of Left Sleeve chart—228 (254, 262, 294, 312, 340) sts rem; 30 (36, 38, 46, 51, 58) sts before Front chart, 37 sts of Front chart, 30 (36, 38, 46, 51, 58) sts between Front and Right Sleeve charts, 22 sts of Right Sleeve chart, 87 (101, 105, 121, 129, 143) back sts between sleeve charts, 22 sts of Left Sleeve chart.

Cont in established patts, work 5 rnds even, beg and ending with an even-numbered rnd.

NEXT RND: K30 (36, 38, 46, 51, 58), sl m, work 37 sts Front chart, sl m, k30 (36, 38, 46, 51, 58), sl m, work 22 sts of Right Sleeve chart, sl m, k35 (42, 44, 52, 56, 63), pm, work Rnd 1 of Back chart over next 17 sts removing m on each side of center st, pm, k35 (42, 44, 52, 56, 63), sl m, work 22 sts of Left Sleeve chart.

Cont in established patts, work 11 rnds even, ending with Rnd 12 of Back chart.

DEC RND 2: K0 (0, 0, 0, 1, 0), [k2tog] 15 (18, 19, 23, 25, 29) times, sl m, work 37 sts of Front chart, sl m, [k2tog] 15 (18, 19, 23, 25, 29) times, k0 (0, 0, 0, 1, 0), sl m, work 22 sts of Right Sleeve chart, sl m, k1 (0, 0, 0, 0, 1), [k2tog] 17 (21, 22, 26, 28, 31) times, sl m, work 17 sts of Back chart, sl m, [k2tog] 17 (21, 22, 26, 28, 31) times, k1 (0, 0, 0, 0, 1), sl m, work 22 sts of Left Sleeve chart—164 (176, 180, 196, 206, 220) sts rem; 15 (18, 19, 23, 26, 29) sts before Front chart, 37 sts of Front chart, 15 (18, 19, 23, 26, 29) sts between Front and Right Sleeve charts, 22 sts of Right Sleeve chart, 18 (21, 22, 26, 28, 32) sts between Right Sleeve and Back charts, 17 sts of Back chart, 18 (21, 22, 26, 28, 32) sts between Back and Left Sleeve charts, 22 sts of Left Sleeve chart.

Cont in established patts, work 9 rnds even, ending with Rnd 22 of Back chart.

DEC RND 3: K1 (0, 1, 1, 0, 1], [k2tog] 7 (9, 9, 11, 13, 14) times, sl m, work 37 sts of Front chart, sl m, [k2tog] 7 (9, 9, 11, 13, 14) times, k1 (0, 1, 1, 0, 1), sl m, work 22 sts of Right Sleeve chart, sl m, k0 (1, 0, 0, 0, 0), [k2tog] 9 (10, 11, 13, 14, 16) times, sl m, work 17 sts of Back chart, sl m, [k2tog] 9 (10, 11, 13, 14, 16) times, k0 (1, 0, 0, 0, 0), sl m, work 22 sts of Left Sleeve chart—132 (138, 140, 148, 152, 160) sts rem; 8 (9, 10, 12, 13, 15) sts before Front chart, 37 sts of Front chart, 8 (9, 10, 12, 13, 15) sts between Front and Right Sleeve charts, 22 sts of Right Sleeve chart, 9 (11, 11, 13, 14, 16) sts between

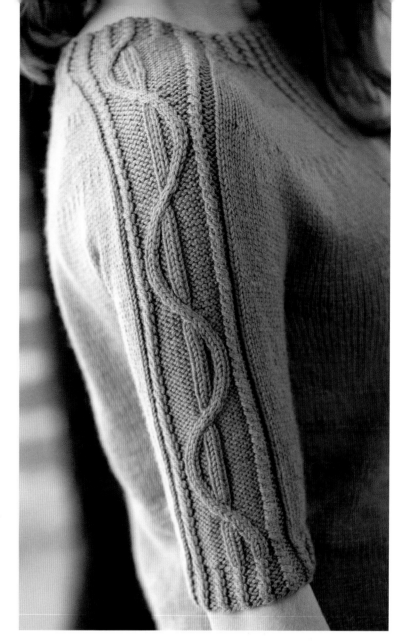

Right Sleeve and Back charts, 17 sts of Back chart, 9 (11, 11, 13, 14, 16) sts between Back and Left Sleeve charts, 22 sts of Left Sleeve chart.

Work 1 rnd even in patt, ending with Rnd 24 of Back chart—yoke measures about 6½ (6¾, 7½, 7¾, 8, 8½)" (16.5 [17, 19, 19.5, 20.5, 21.5] cm) from dividing rnd.

Shape Back Neck

Note: *During the foll shaping, after completing Rnd 25 of the Back chart, work the 17 Back chart sts in reverse stockinette (purl RS rows and all rnds; knit WS rows).*

Cont patts as established (see Notes), work back and forth in short-rows (see Glossary) as foll:

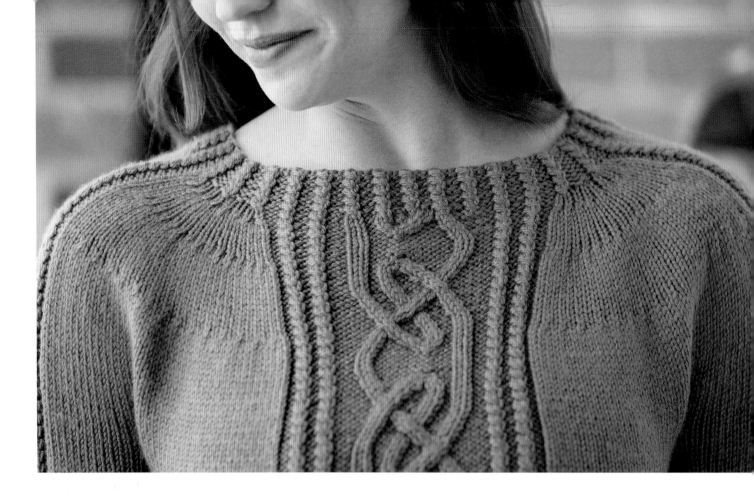

SHORT-ROW 1: (RS; odd-numbered chart row) Work in patt to 3 (3, 3, 4, 4, 5) sts before Left Sleeve chart, wrap next st, turn work.

SHORT-ROW 2: (WS; even-numbered chart row) Work in patt to 3 (3, 3, 4, 4, 5) sts before Right Sleeve chart, wrap next st, turn work.

SHORT-ROW 3: Work in patt to 6 (6, 6, 8, 8, 10) sts before Left Sleeve chart, wrap next st, turn work.

SHORT-ROW 4: Work in patt to 6 (6, 6, 8, 8, 10) sts before Right Sleeve chart, wrap next st, turn work.

SHORT-ROW 5: Work in patt to 8 (8, 8, 10, 12, 14) sts before Left Sleeve chart, wrap next st, turn work.

SHORT-ROW 6: Work in patt to 8 (8, 8, 10, 12, 14) sts before Right Sleeve chart, wrap next st, turn work.

SHORT-ROW 7: Work in patt to end-of-rnd m, working wraps tog with wrapped sts when you come to them, turn work.

NEXT ROW: (WS) Work across all sts in patt to end-of-rnd m, working rem wraps tog with wrapped sts when you come to them, turn work—2 rows added at each

end of row; 8 rows added at center back; yoke measures 7½ (7¾, 8½, 8¾, 9, 9½)" (19 [19.5, 21.5, 22, 23, 24] cm) from dividing rnd at center back and ¾" (2 cm) less at center front.

Resume working all sts in the rnd with an odd-numbered chart rnd and cont as foll:

DEC RND 4: [K2tog] 2 (3, 0, 2, 3, 1) time(s), k4 (3, 10, 8, 7, 13), sl m, work 37 sts of Front chart, sl m, k4 (3, 10, 8, 7, 13), [k2tog] 2 (3, 0, 2, 3, 1) time(s), sl m, work 22 sts of Right Sleeve chart, sl m, k5 (5, 11, 9, 8, 14), [k2tog] 2 (3, 0, 2, 3, 1) time(s), sl m, work 17 sts of Back chart, sl m, [k2tog] 2 (3, 0, 2, 3, 1) time(s), k5 (5, 11, 9, 8, 14), sl m, work 22 sts of Left Sleeve chart—124 (126, 140, 140, 140, 156) sts rem; 6 (6, 10, 10, 10, 14) sts before Front chart, 37 sts of Front chart, 6 (6, 10, 10, 10, 14) sts between Front and Right Sleeve charts, 22 sts of Right Sleeve chart, 7 (8, 11, 11, 11, 15) sts between Right Sleeve and Back charts, 17 sts of Back chart, 7 (8, 11, 11, 11, 15) sts between Back and Left Sleeve charts, 22 sts of Left Sleeve chart.

Notes: *At this point, the yoke is about 1" (2.5 cm) shorter than its intended height and it is time to start planning how to make the chart patterns flow "seamlessly" into the neckband pattern. Here are some guidelines for deciding where to end the charts:*

For the front chart, identify the center sts of the chart that form the main cable patt; these are the 15 to 19 sts in between the 3-st purl columns of the chart. Cont in patt until the next rnd that has 2 knit sts next to the 3-st purl column on each side (for example, Rnd 1, 23, 25, or 47). There should be 37 sts in the Front chart section. Cont the 2-st twists at each side, work the center sts as they appear (knit the knits and purl the purls) to the end of the yoke, without working any more traveling cables.

For the sleeve charts, cont in patt until the next rnd where the 2-st traveling column is separated from the 2-st stationary column by exactly 2 purl sts (for example, Rnd 5, 17, 25, or 37), or where the traveling column is exactly on top of the 2-st stationary column (for example, Rnd 11 or 31). Cont the 2-st twists at each side, work the center 14 sts of the sleeve charts as they appear (knit the knits and purl the purls) to the end of the yoke, without working any more traveling cables.

Cont patts until the yoke measures 8½ (8¾, 9½, 9¾, 10, 10½)" (21.5 [22, 24, 25, 25.5, 26.5] cm) from dividing rnd at center back, ending with an odd-numbered rnd.

Neckband

NEXT RND: [K2, p2] 1 (1, 2, 2, 2, 3) time(s), k2, sl m, work 37 sts of Front chart sts as [p2, k2] 2 times, p2tog, p1, k2, p4, p2tog, p5, k2, p1, p2tog, [k2, p2] 2 times, sl m, [k2, p2] 1 (1, 2, 2, 2, 3) time(s), k2, sl m, work 22 sts of Right Sleeve chart as [p2, k2] 5 times, p2, sl m, [k2, p2] 1 (1, 2, 2, 2, 3) time(s), [k2tog] 1 (2, 1, 1, 1, 1) time(s), k1 (0, 1, 1, 1, 1), sl m, work 17 sts of Back chart as [p2, k2] 2 times, M1 pwise, p1, [k2, p2] 2 times, sl m, k1 (0, 1, 1, 1, 1), [k2tog] 1 (2, 1, 1, 1, 1) time(s), [p2, k2] 1 (1, 2, 2, 2, 3) time(s), sl m, work 22 sts of Left Sleeve chart as [p2, k2] 5 times, p2—120 (120, 136, 136, 136, 152) sts rem; 6 (6, 10, 10, 10, 14) sts between every pair of charts, 34 sts of Front chart, 22 sts of Right and Left Sleeve charts, 18 sts of Back chart.

Removing chart m in first rnd, work twisted rib for neckband as foll:

RND 1: *Tw2, p2; rep from *.

RND 2: *K2, p2; rep from *.

Make It Yours

Stitch pattern breakdown:
Front chart: Panel of 37 to 41 stitches that measures about 5½" (14 cm) wide.
Sleeve charts: Panels of 22 stitches that measures about 3" (7.5 cm) wide.
Back chart: Panel of 17 to 21 stitches that measures about 3¼" (8.5 cm) wide.

◊ You can substitute panels of different stitch patterns that have about the same gauges and widths as the ones used here without altering the shaping, which is worked between the panels, not within them.

◊ Because the cable panels and stockinette have different gauges, calculate the number of stitches to cast on for each pattern separately, then add them together.

◊ For example, the front cable used in this project measures 5½" (14 cm) wide and the sample sweater shown measure 35¾" (91 cm) at the hips and bust. To determine the number of cast-on stitches, subtract 5½" (14 cm) for the cable panel from the total circumference to find how much of the circumference is in stockinette—30¼" (77 cm). Multiply the stockinette measurement by the stockinette gauge of 5½ stitches per inch—about 166 stitches. Add 34 stitches for the set-up round of the Front chart to the stockinette stitches—200 cast-on stitches. This number is a multiple of 4 stitches that will accommodate the twisted rib pattern, so no further adjustment is required.

Rep these 2 rnds 4 more times—10 rnds total.

Loosely BO all sts—neckband measures 1" (2.5 cm).

Finishing

Weave in loose ends. Block to measurements, being careful not to flatten cable patts.

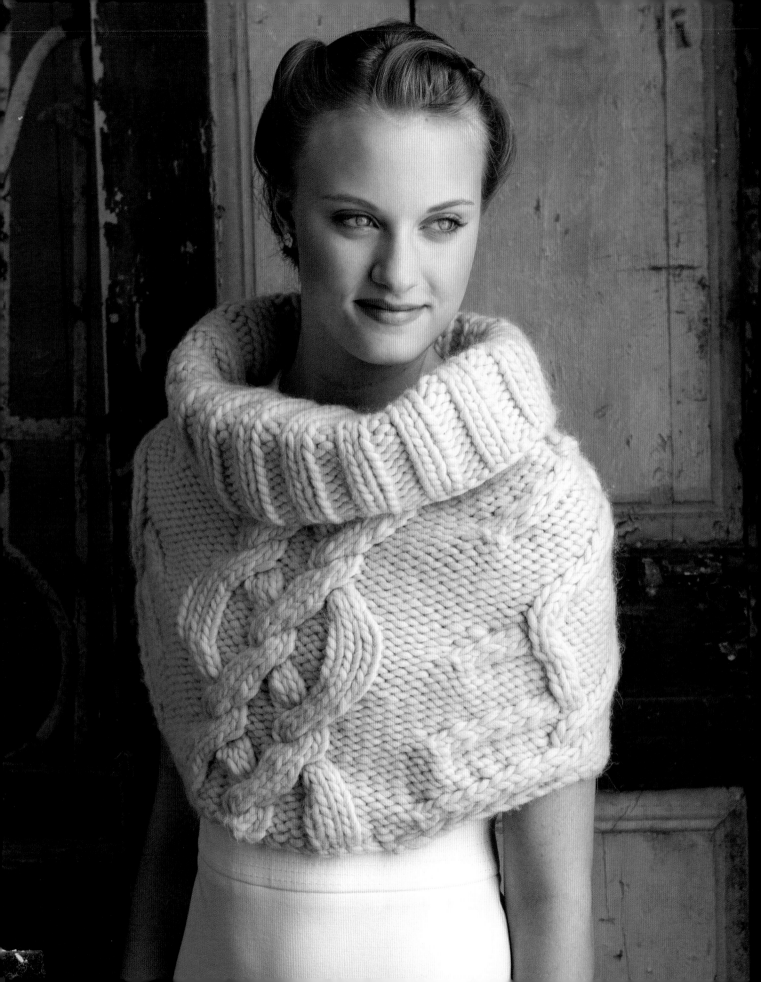

Cabled Cowl

A great project for working cables seamlessly, this simple cowl offers lessons in working cable patterns that cross the boundary from one round to the next, transitioning between working in rows and rounds, and decreasing "invisibly" within the purl-stitch background. The bulky yarn creates a soft and cozy neck wrap that knits up quickly—knit it over the weekend and head to work in style Monday morning. Reveal your inner designer by substituting different cables of your own choosing. You can create countless new looks!

designed by **SIMONA MERCHANT-DEST**

FINISHED SIZE

About 31¾ (36¼, 40¾, 45¼, 49¾, 54¼)" (80.5 [92, 103.5, 115, 126.5, 138] cm) lower edge circumference and 21¼ (21½, 21½, 21½, 21½, 21½)" (54 [54.5, 54.5, 54.5, 54.5, 54.5] cm) long from lowest point of body to neck bind-off.

Cowl shown measures 36¼" (92 cm) at lower edge.

YARN

Bulky Weight (#6 Super Bulky).

Shown here: Blue Sky Alpacas Bulky (50% alpaca, 50% wool; 45 yd [41 m]/100 g): #1211 frost, 6 (7, 7, 8, 9, 10) skeins.

NEEDLES

Size U.S. 15 (10 mm): 32" (80 cm) circular (cir).

Adjust needle sizes if necessary to obtain the correct gauge.

NOTIONS

Markers (m); cable needle (cn); tapestry needle.

GAUGE

8 sts and 13 rows/rnds = 4" (10 cm) in St st.

18-st main cable from chart measures 6¼" (16 cm) wide.

One 12-st cable repeat from chart measures 4½" (11.5 cm) wide.

Design Techniques

Cable cast-on, page 172.

Cables worked across end of round, page 76.

Raised (make-one) increases, page 175.

TIPS & TRICKS

• The lower body extension is worked back and forth in rows. After completing the lower body shaping, stitches are cast-on for the rest of the cowl, which is then worked in rounds to the end.

• When a cable is worked using stitches on both sides of the end-of-round marker, end the round before the cable crossing at the start of the cable stitches.

• For example, in this project end Rnd 22 of the Cable chart 2 stitches before the end-of-round marker. At the start of Rnd 23, temporarily slip the last 2 stitches of the round to the right needle, remove the marker, return the slipped stitches to the left needle, and replace the marker on the right needle. Work the cable at the beginning of Rnd 23 over the 2 slipped stitches and the first 2 stitches of the original round. Work in pattern to the end-of-round marker, temporarily remove the marker, and work the last 2 stitches of Rnd 23 in pattern (the first 2 stitches of the cable), then replace the marker in its original position. The marker is repositioned in the same manner in Rnds 38 and 39.

STITCH GUIDE

K2, P2 RIB: (MULTIPLE OF 4 STS)
ALL RNDS: *K2, p2; rep from *.

Rep this rnd for patt.

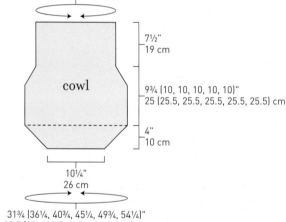

27¼ (28¾, 30½, 33½, 35¼, 38½)"
69 (73, 77.5, 85, 89.5, 98) cm

cowl

7½"
19 cm

9¾ (10, 10, 10, 10, 10)"
25 (25.5, 25.5, 25.5, 25.5, 25.5) cm

4"
10 cm

10¼"
26 cm

31¾ (36¼, 40¾, 45¼, 49¾, 54¼)"
80.5 (92, 103.5, 115, 126.5, 138) cm

Cowl

Using the cable method (see Glossary), CO 26 sts.

Lower Body Extension

NEXT ROW: (RS) Work Row 1 of Cable chart (page 120) over 26 sts, using M1P incs (see Glossary) to inc to 28 sts as shown.

Work Rows 2–13 of Cable chart back and forth in rows, beg and ending with a RS row—52 sts; piece measures about 4" (10 cm) from CO.

Yoke

Turn work so WS is facing and the needle holding the sts is in your left hand. Use the cable method to CO 32 (44, 56, 68, 80, 92) sts—84 (96, 108, 120, 132, 144) sts total. With RS facing, place marker (pm) and join for working in rnds, being careful not to twist sts.

NEXT RND: (Rnd 14 of chart) Work first 56 sts once, work the 12-st patt rep 2 (3, 4, 5, 6, 7) times, then work 4 sts after last patt rep once.

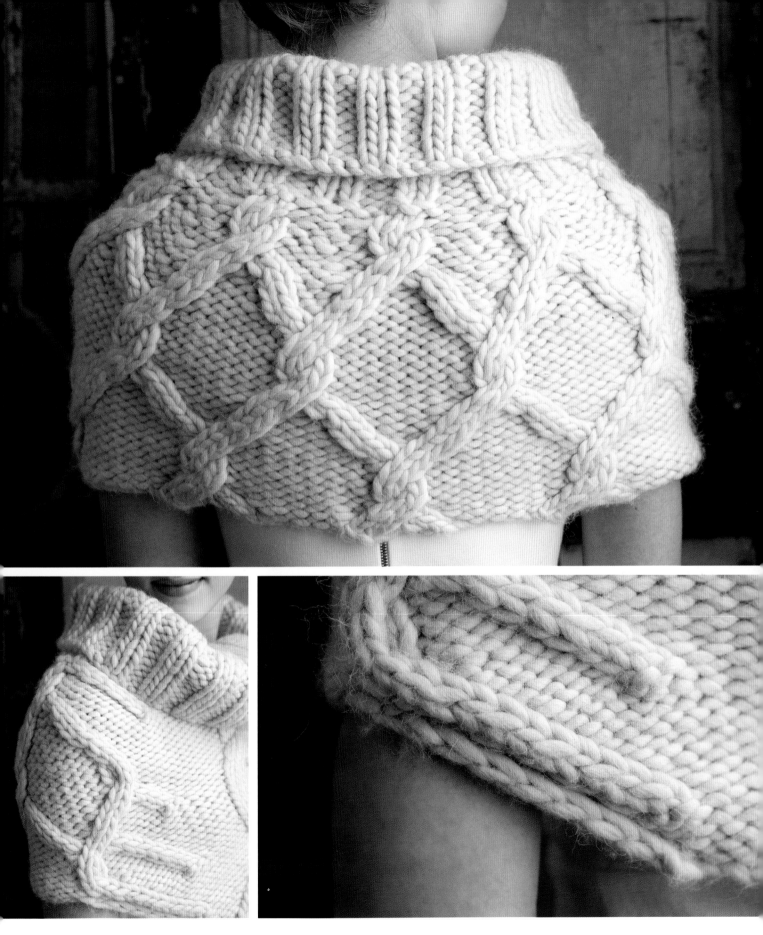

CABLE

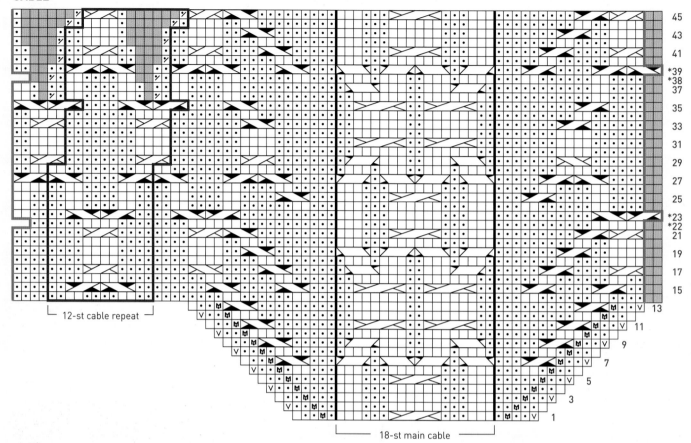

45
43
41
*39
*38
37
35
33
31
29
27
25
*23
*22
21
19
17
15
13
11
9
7
5
3
1

└ 12-st cable repeat ┘

└───── 18-st main cable ─────┘

*See Tips & Tricks for repositioning marker on these rounds (page 118).

⬜	knit on RS rows and all rnds; p on WS rows	
•	purl on RS rows and all rnds; k on WS rows	
⅄	p2tog	
M	M1P	
V	sl 1 kwise on RS rows; sl 1 pwise on WS rows	
│	end-of-rnd marker position	
⤬	sl 2 sts to cn and hold in front, k2, k2 from cn	

sl 2 sts to cn and hold in back, k2, k2 from cn
sl 2 sts to cn and hold in front, p2, k2 from cn
sl 2 sts to cn and hold in back, k2, p2 from cn
sl 3 sts to cn and hold in front, p1, k3 from cn
sl 1 st to cn and hold in back, k3, p1 from cn
sl 3 sts to cn and hold in back, k3, k3 from cn
⬛ no stitch
⬜ pattern repeat

Cont in this manner, work Rnds 15–44 of chart, dec as shown—69 (76, 83, 90, 97, 104) sts rem: 52 sts before the first patt rep, 2 (3, 4, 5, 6, 7) patt reps with 7 sts each, and 3 sts after last patt rep.

Cont for the 5 largest sizes as foll:

Sizes (36¼, 40¾, 45¼, 49¾, 54¼)" only

Work Rnd 45 of chart, dec as shown—(72, 78, 84, 90, 96) sts rem: 52 sts at start of rnd, (3, 4, 5, 6, 7) patt reps with 6 sts each, and 2 sts after last patt rep.

All sizes

Purl 1 rnd, dec 1 (0, 2, 0, 2, 0) st(s) evenly spaced—68 (72, 76, 84, 88, 96) sts rem; piece measures about 13¾ (14, 14, 14, 14, 14)" (35 [35.5, 35.5, 35.5, 35.5, 35.5] cm) from lower body CO and 4" (10 cm) less than that from yoke CO.

Neck

Work even in k2, p2 rib for 7½" (19 cm)—piece measures about 21¼ (21½, 21½, 21½, 21½, 21½)" (54 [54.5, 54.5, 54.5, 54.5, 54.5] cm) from lower body CO and 4" (10 cm) less than that from yoke CO.

BO all sts in patt.

Finishing

Block to measurements.

Weave in loose ends.

Make It Yours

Stitch pattern breakdown:

Center panel: Begins with 26 stitches consisting of an 18-stitch main cable with 4 stitches on each side and increases to 52 stitches consisting of the 18-stitch main cable with 17 stitches on each side. The increased stitches create a transition between the main cable and the repeating cable pattern.

Cable pattern: Multiple of 12 stitches plus 4 balancing stitches.

◊ When substituting other stitch patterns, work the neck the same as in the instructions and adjust your stitch count at the end of the yoke to be a multiple of 4 stitches to accommodate the k2, p2 rib pattern.

◊ You can replace the main cable pattern with another 18-stitch cable or a combination of cables that adds up to 18 stitches at the same gauge.

◊ The repeating cable pattern can be replaced by a different 12-stitch cable or a narrower cable with purl stitches added to each side to make a 12-stitch repeat of the same width. You may need to adjust the number of stitches between the repeating cable and the main cable to achieve a smooth transition in the areas between the cable patterns.

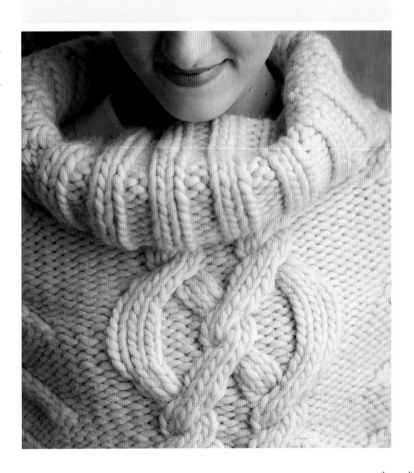

Textured Stitch Patterns

Textured patterns have a raised, three-dimensional look. They are produced by various arrangements of knit and purl stitches that may or may not be combined with other simple techniques, such as slip stitches or abrupt increases paired with abrupt decreases, to name a couple.

Designing with Textured Stitch Patterns

Textured stitches add depth and complexity to a knitted garment. For example, ribs form vertical patterns that draw in the fabric widthwise, brioche patterns form lofty textures, cluster stitches form three-dimensional embossed textures, and slip stitches can give the impression of complicated colorwork, but involve just working one color per row.

Each type of textured stitch pattern has its own considerations when it comes to planning a garment design. The most popular types of patterns are included here.

Ribbed Patterns

The strong vertical nature of ribs results from the transitions between stacked knit and purl stitches. Such patterns lend themselves well to seamless circular knitting because the beginning of the round can be positioned at the break between columns, so that the pattern appears uninterrupted between the end of one round and the beginning of the next.

When designing with ribbed patterns, make sure that the ribs appear symmetrical across the front and back of a garment. For seamless cardigans, you'll want the same portion of the rib pattern to appear at each side of the center-front opening. This will likely involve adding "balancing" stitches to the overall pattern repeat. For pullovers knitted in rounds, on the other hand, you'll want to work with full pattern repeats only so that the pattern appears continuous around the entire circumference. In either case, it may be necessary to adjust the number of body stitches to accommodate the number of stitches in your choice of patterns.

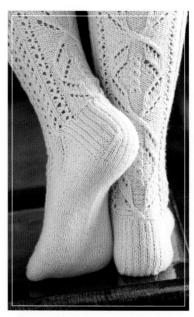

Slipped stitches from the reinforced heel stitch used on the Lace Stockings (page 68).

Tips for Working with Textured Stitch Patterns

RIBS: If the rib pattern is composed of an equal number of knit and purl stitches (such as k2, p2 rib), there is no need to work a gauge swatch in the round—it will be the same whether you work in rows or rounds.

If you place a rib pattern along the brim of a hat, use a firm cast-on and needles one or two sizes smaller that what you use to get gauge to prevent the ribbing from stretching too much.

SLIP-STITCH PATTERNS: Experiment with the same slip-stitch pattern alternating solid and multicolored yarns.

BRIOCHE STITCH: Use needles two or three sizes smaller than you would use for a regular rib pattern.

Because brioche forms a stretchy fabric, it is a good idea to begin with a few rows of regular rib to ensure that the edge will maintain the proper amount of elasticity. This is especially important for hats, but works well for cuffs and hems, too. If you do not want to add a few rows of regular rib, work the first few rows with elastic thread held together with the working yarn.

CLUSTER PATTERNS: Be sure to grab all the loops when you decrease a cluster back to one stitch. If you miss a loop, it will stretch and make a very loose and sloppy stitch.

You can modify any cluster stitch by changing the number of decreases and increases within the cluster pair when working paired clusters, or by changing the way that the increases and decreases are worked when working stitches for simultaneous clusters.

AVOIDING JOGS: Many texture stitch patterns create visible jogs at the boundary between one round and the next. Whenever possible, you'll want to minimize these jogs. When working seed stitch in rounds, use an odd number of stitches. If the round begins and ends with a knit (or purl), the pattern will appear continuous across the boundary. It's more difficult to hide jogs in moss stitch, garter stitch, and other patterns that repeat over two rounds. In these cases, it's advisable to use two balls of yarn and the "helix" method as described on page 24.

Slip-Stitch Patterns

Slip-stitch patterns are deceptively easy to work—simply slip certain stitches (purlwise) from the left needle onto the right needle without knitting or purling them. The working yarn is typically held in the back (wrong side) of the work when a stitch is slipped, creating a horizontal "float." Stitches can be slipped over several rows for deep three-dimensional effects. The draw-in caused by a slipped stitch can affect the gauge, both horizontally (stitches/inch) and vertically (rows or rounds/inch). Knit a generous swatch and measure it in several places both widthwise and vertically to get an accurate reading.

When the floats occur on the back of the work, the slipped stitches appear elongated and raised in comparison to the background stitches. Vertical ridges form when slipped stitches are stacked every other row (or round), as for the traditional heel stitch pattern used to reinforce sock heels (see the Lace Stockings on page 68). By varying the number of slipped stitches and the distance between them, you can produce all sorts of pattern variations. If you hold the yarn in front of the work (i.e., along the right side) as stitches are slipped, you'll produce a fabric with a woven appearance. By varying the lengths of these floats and positioning them in a deliberate order, you can produce a variety of interesting patterns.

To produce a diagonal pattern, simply cross a slipped stitch over a neighboring stitch, much like a cable. If you repeat this maneuver over a number of rows, the slipped stitches will form a diagonal line. If you reverse the direction of the crossings, you can create zigzags, diamonds, triangles, and other shapes. Such slipped stitches pull the other stitches together to produce a firm fabric that holds its shape, but be aware that they can cause significant widthwise draw-in as well.

When working slip-stitch patterns, be careful not to carry the floats too tightly—they should be just long enough to cover the distance between the adjacent worked stitches. It is easiest to maintain uniform tension if the pattern is worked in rounds when there is no need to switch between right- and wrong-side rows.

When worked with two or more colors, slip-stitch patterns can have the appearance of complicated Fair Isle designs. Typically, colors are changed every two rows or rounds, but some patterns involve changing colors every row/round. This type

of colorwork pattern is best worked in rounds so that right side always faces you and all of the colors are available at the beginning of every round. Be aware that jogs can appear at the boundaries between rounds—use one of the methods for eliminating jogs (see page 23).

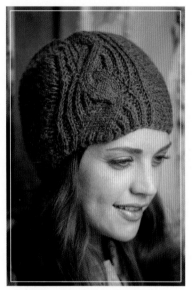

Brioche stitches give soft three-dimensional loft to the Brioche Hat (page 162).

Brioche Patterns

The brioche family of patterns involves slipped stitches worked in tandem with yarnovers. But unlike the way yarnovers are paired with decreases to form openwork lace patterns (see Chapter Three), the yarnovers in brioche patterns add bulk to the slipped stitches to form a denser fabric that is soft and three-dimensional. The basic brioche rib looks like raised columns of knit stitches that alternate with purl-like stitches that recede into the background. Because many brioche patterns are reversible, they are ideal for cowls and neck warmers.

It's important to note that brioche patterns require about 30 to 50 percent more yarn than the same

number of stitches worked in stockinette. Because it tends to be stretchy, avoid heavy yarns that may stretch and lengthen over time. Wool (but not superwash, which is less elastic) and wool blends work best for large projects because their inherent resiliency helps preventing the stitches from stretching out of shape.

When working brioche seamlessly in rows, it's important to work the edge stitches tightly. Knit a generous swatch, but before measuring it for gauge, lightly steam-block it (or spray water over a relaxed swatch that has been placed on a flat surface). Allow the swatch to air-dry thoroughly before moving it—a wet swatch will stretch lengthwise quite a bit and won't return to its original dimensions. Measure both the stitch and row gauge in several places.

When worked in rows, right- and wrong-side rows are worked the same way (see sidebar on page 125)—a brioche knit stitch (brk1) worked on the side facing you will appear as brioche purl stitch (brp1) on the other side of the fabric, and vice versa. When worked in rounds, the first round is worked just the same as for working in rows. On the following round, each slipped stitch/yarnover pair is worked as brp1. Be sure to mark the beginning of the round so you'll know when to switch from brk1 to brp1 stitches.

Once you have mastered basic brioche stitch, you can go on to add color for more interesting patterns. For single-color brioche worked in rows, the brioche knit stitch is worked on both right- and wrong-side rows. To get the same effect with two colors, both brioche knit and brioche purl stitches are used in each row. When working two-color brioche in rounds, brioche knit and brioche purl stitches are alternated each round, just as for working single-color brioche

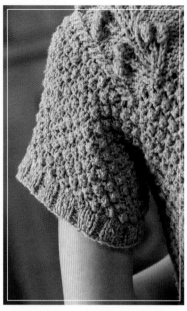

A cluster-stitch pattern gives a highly textured appearance to the Textured Jacket (page 128).

in rounds. For the best results, always pick up the new color from under the old and tighten the first stitch at every color change.

Cluster-Stitch Patterns

Cluster-stitch patterns are highly textural (see the Textured Jacket on page 128). A cluster is made by working a number of increases into a single stitch then decreasing to the original stitch. For example, on one row or round you might work knit, then purl, then knit (i.e., k1, p1, k1) all into the same stitch to increase that one stitch to three stitches. On a following row, you would decrease those three stitches back to one stitch by knitting them together (i.e., k3tog). Typically, every cluster increase is paired with a cluster decrease to maintain a consistent fabric width.

When choosing a cluster-stitch pattern, begin by swatching with different needle sizes to get fabrics with different densities. Holes will form between the increases

and decreases in some patterns and you'll want to experiment to determine the size hole that is most acceptable for the project you have in mind. As always, knit a generous swatch and measure your gauge several times. The increased and decreased stitches can be difficult to count, so it's a good idea to calculate your gauge based on the full width of the swatch.

Shaping in Textured Stitch Patterns

When it comes to shaping textured patterns, you'll want to place increases and decreases as invisibly as possible. In some patterns, such

Brioche Stitch Primer

The instructions given here use the symbols and terminology that Nancy Marchant introduced in her pivotal book *Knitting Brioche*.

Basic Brioche in Rows (even number of stitches)

SET-UP ROW: Sl 1 purlwise with yarn in front (pwise wyf), k1, *yfsl1yo, k1; rep from * to last 2 sts, sl 1 purlwise with yarn in back (pwise wyb), k1 through back loop (tbl).

ROW 1: (RS) Sl 1 pwise wyf, k1, *yfsl1yo, brk1; rep from * to last 2 sts, sl 1 pwise wyb, k1tbl.

ROW 2: (WS) Sl 1 pwise wyf, k1, *yfsl1yo, brk1; rep from * to last 2 sts, sl 1 pwise wyb, k1tbl.

Repeat Rows 1 and 2 for pattern; do not rep set-up row.

SET-UP RND: *Yfsl1yo, k1; rep from *.

RND 1: *Brk1, yfsl1yo; rep from *.

RND 2: *Yfsl1yo, brp1; rep from *.

Repeat Rnds 1 and 2 for pattern; do not rep set-up rnd.

☐	knit on RS rows and all rnds; purl on WS rows
·	purl on RS rows and all rnds; knit on WS rows
⅄	k1tbl on RS rows and all rnds; knit on WS rows
⅄	p1tbl on RS rows and all rnds; k1tbl on WS rows
V	sl 1wyb on RS; sl 1 wyf on WS
ⱴ	sl 1 wyf on RS; sl 1 wyb on WS

☐	pattern repeat
‖	yfsl1yo
⋒	brk1 on RS rows and all rnds; brp1 on WS rows
А	brp1 on RS rows and all rnds; brk1 on WS rows

See Stitch Guide on page 164 for brioche symbols.

BASIC BRIOCHE WORKED IN ROWS

WS Row 2
WS set-up rnd
RS Row 1

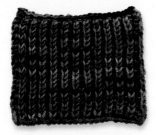

Swatch of basic brioche worked in rows.

BASIC BRIOCHE WORKED IN ROUNDS

Rnd 2
Rnd 1
set-up rnd

Swatch of basic brioche worked in rounds.

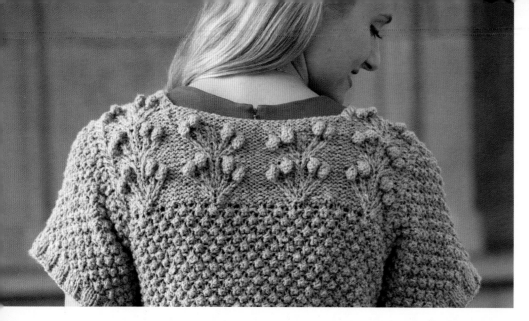

as ribs, the elastic nature of the stitches may create all the shaping you need. In complicated patterns such as brioche and lace, it may be best to simply change the size of the needle to affect widthwise changes. Patterns that are not very elastic, such as slip-stitch patterns, require traditional increases and decreases to change the widths.

Increasing and Decreasing in Rib Patterns

In many rib patterns, it isn't necessary to increase or decrease to shape the hips, waist, and bust because the stitch patterns are so elastic that they will stretch and shrink around body without any necessary shaping required. On the other hand, if ribs are worked as an allover pattern in a garment or small accessory, stacked increases or decreases can produce an interesting visual design element by creating diagonal lines that "travel" across the fabric. This type of shaping was used for the oversized collar of the Cabled Cardigan (page 90). The best way to increase or decrease in rib pattern is to place the increases/decreases in the purl portion of the rib so that the raised knit columns remain intact and preserve the visual integrity of the pattern.

Increasing and Decreasing in Slip-Stitch Patterns

Slip-stitch patterns follow the same rules as other textured techniques when shaping is concerned and you'll want to preserve the integrity of the pattern by working the shaping increases and decreases as invisibly as possible. The slipped stitches should always be worked at least one stitch in from the selvedge. Choose between ssk or k2tog decreases as necessary so that the slipped stitch is always on top of the background stitch for the most invisible shaping. Conversely, if you want the shaping to be prominent—such as along a raglan—choose the decrease that will put the slipped stitch behind the background stitch.

When working invisible shaping with multiple colors, be sure to place the increases or decreases in non-color-change rows or rounds. If you're using a slipped-stitch pattern that involves multiple colors throughout, it may be best to establish an intentionally visible shaping line. This line will visually "frame" the stitch pattern, producing a tailored and finished look.

Increasing and Decreasing in Brioche Patterns

To preserve the integrity of brioche stitch, you may want to use the method of changing needle sizes to increase or decrease the widths of fabrics. But there is a limit to how much shaping can be achieved this way without affecting the look of the fabric. If you do choose to increase and decrease stitches in a traditional way, remember that you should work stitches in pairs to maintain pattern continuity. When working a garment seamlessly in rows, place the decreases or increases along the faux side "seams."

For simplicity, we'll explain decreasing and increasing stitches in basic brioche only. If there is a stitch that is not paired with a yarnover, you can work it together with the stitch that is paired with a yarnover (working these three loops as k3tog) to decrease one stitch. This type of decrease slants to the right and is called "brk2tog." To decrease two stitches at a time, work a brk2tog, then pass the next stitch over the decreased stitch. Called "brk3tog," this type of decrease also forms a right slant in which the last stitch is on top of the other two. If the decreases are worked every row or round, you might need to alternate between the regular k2tog and brk2tog because there won't always be a yarnover paired with the stitch to be decreased.

To increase two stitches, you can work (brk1, brp1, brk1) all into the same stitch. Another option is work (brk1, yo, brk1) into the same stitch. Both methods will preserve the look of the brioche pattern.

Increasing and Decreasing in Cluster-Stitch Patterns

Cluster stitches make great allover patterns with dramatic looks, as

shown in the Textured Jacket on page 128. But it can be tricky to work increases and decreases invisibly in these types of patterns, so you may want to begin by using them just as a panel or border on a garment. Make sure you're comfortable with the way the stitches correlate to each other as they expand and contract before you add the complexity of shaping.

For shaping cluster-stitch patterns, it's important to understand that each pattern repeat already involves both increases and decreases. Read more about how to impose shaping on patterns with fluctuating stitch counts (page 20) and patterns with changing number of stitches (page 22).

Combining Textured Stitch Patterns

The textured patterns mentioned here are lovely alone or worked in combination. If you do choose to combine different patterns in a garment, be sure to measure the gauge of each pattern separately and pay close attention to the differences. Some stitch patterns are quite compatible. For example, garter, seed, brioche, and some slip-stitch patterns have similar gauges and, therefore, can be worked side by side without affecting the overall gauge. On the other hand, stitch patterns such as single (knit 1, purl 1) rib and cables can draw in a fabric and will cause narrowing if worked in horizontal bands with other stitch patterns. Of course, these types of gauge differences can be intentional design elements. For example, see the Brioche Hat and Fingerless Gloves on page 162, which combine ribs, brioche stitch, a cable, and a textured stitch pattern, all in perfect harmony.

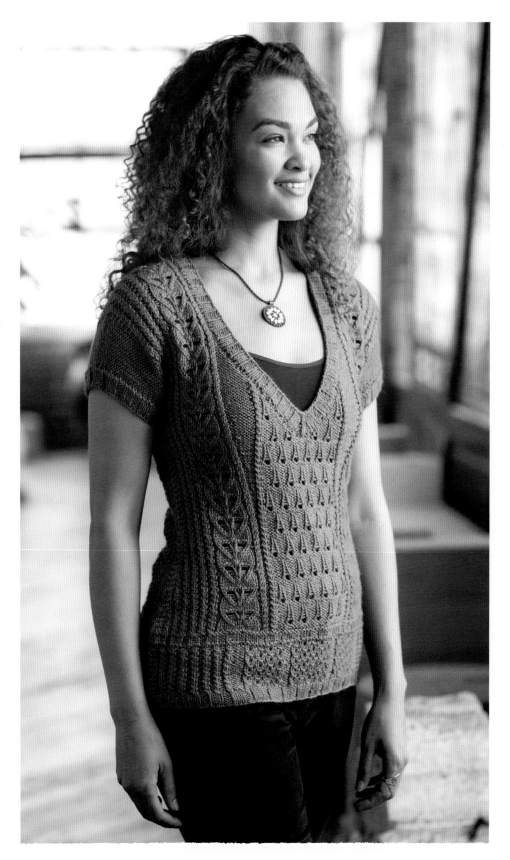

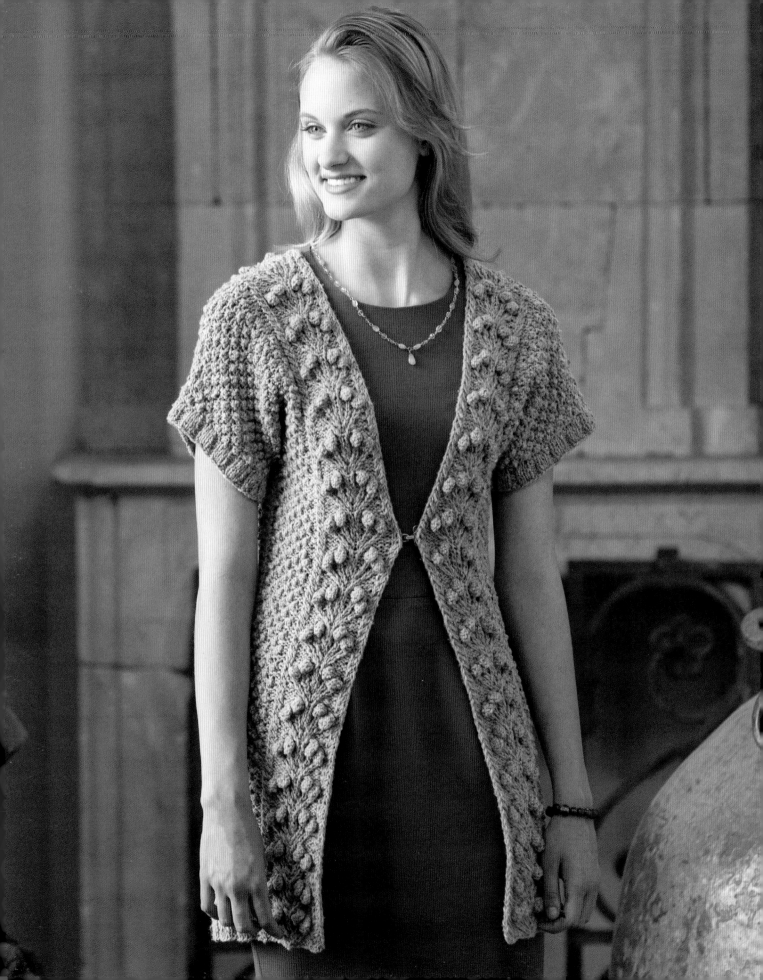

Textured Jacket

Knitted in a tweedy blend of merino, silk, and cashmere, this casual jacket is exceptionally soft, luxurious, and lofty. It is worked from the lower edge to the neck, with hourglass waist shaping along the way. The main trinity stitch pattern has a four-stitch repeat that consists of one-into-three increases paired with three-into-one decreases. While careful attention is necessary to keep the stitch counts correct during shaping, the stitch pattern is quite easy to master.

designed by **SIMONA MERCHANT-DEST**

FINISHED SIZE

About 33½ (36½, 39½, 45¼, 48¼, 51, 54)" (85 [92.5, 100.5, 115, 122.5, 129.5, 137] cm) bust circumference, with fronts meeting at center.

Jacket shown measures 33½" (85 cm).

YARN

Aran weight (#4 Medium).

Shown here: Queensland Collection Kathmandu Aran (85% merino wool, 10% silk, 5% cashmere; 104 yd [95 m]/50 g): #144 lime, 10 (11, 12, 14, 15, 16, 18) balls.

NEEDLES

Size 8 (5 mm): 32" (80 cm) circular (cir) and 16" (40 cm) cir or set of 5 double-pointed (dpn).

Adjust needle sizes if necessary to obtain the correct gauge.

NOTIONS

Markers (m; two colors recommended); stitch holders or waste yarn; cable needle (cn); tapestry needle; one large hook-and-eye closure.

GAUGE

22 sts and 26½ rows = 4" (10 cm) in trinity stitch patt.

20 sts of Tree Panel chart measure 3½" (9 cm) wide.

6 sts of side cable patt measure 1" (2.5 cm) wide.

Design Techniques

Dolman construction worked from the bottom up, page 10.

Shaping in textured stitch patterns, page 125.

Patterns with fluctuating stitch counts, page 20.

Knitted cast-on, page 173.

Increasing stitches evenly spaced, page 175.

Short-rows, page 178.

TIPS & TRICKS

- The jacket's lower body is worked in one piece to the underarms, then stitches are cast on at each side for the sleeves and the back and fronts are worked separately to the shoulders.

- Use markers of different colors to set off the patterns—a "tree" color to mark the edge of the tree panels and a "cable" color separating the trinity stitch sections from the side cables. Slip the markers every row.

- The gold shading on the charts calls attention to stitches that affect the stitch count during shaping. When decreasing in pattern, the shading indicates a p2tog decrease or a place where a 3-into-1 increase has been omitted. When increasing in pattern, the shading indicates an M1L or M1R increase or a place where a newly-added stitch is first worked into the established pattern as a 1-into-3 increase. Cast-on stitches are not shaded.

STITCH GUIDE

TRINITY STITCH (MULTIPLE OF 4 STS + 2)

ROW 1: (RS) Purl.

ROW 2: (WS) K1, *work [k1, p1, k1] all in next st, p3tog; rep from * to last st, k1.

ROW 3: Purl.

ROW 4: K1, *p3tog, work [k1, p1, k1] all in next st; rep from * to last st, k1.

Rep Rows 1–4 for pattern.

1/1RC

Sl 1 st onto cable needle (cn) and hold in back of work, k1, then k1 from cn.

BOBBLE

(RS) Work ([k1, p1] 2 times, k1) all in the same st—5 sts made from 1 st. Turn work, k5 with WS facing, turn work, p5 with RS facing, turn work, k5 with WS facing, turn work so RS is facing, then knit the 5 bobble sts tog through their back loops (tbl)—5 sts dec'd to 1 st again.

3×2 RIB WORKED IN ROWS (MULTIPLE OF 5 STS + 2)

SET-UP ROW: (WS) K2, *p3, k2; rep from *.

ROW 1: (RS) P2, *k3, p2; rep from *.

ROW 2: K2, *p3, k2; rep from *.

Rep Rows 1 and 2 for patt; do not rep the set-up row.

3×2 RIB WORKED IN ROUNDS (MULTIPLE OF 5 STS)

ALL RNDS: P1, *k3, p2; rep from * to last 4 sts, k3, p1.

Rep this rnd for patt.

SIDE CABLE (WORKED OVER 6 STS)

ROW 1: (RS) 1/1RC (see above), k2, 1/1RC.

ROW 2: P2, k2, p2.

Rep Rows 1 and 2 for patt.

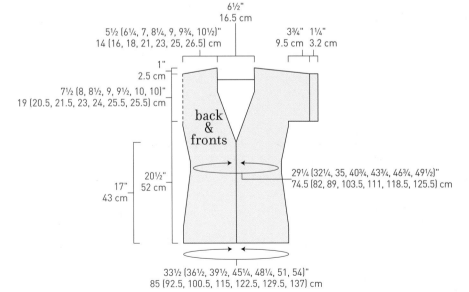

6½"
16.5 cm

5½ (6¼, 7, 8¼, 9, 9¾, 10½)"
14 (16, 18, 21, 23, 25, 26.5) cm

3¾" 1¼"
9.5 cm 3.2 cm

1"
2.5 cm

7½ (8, 8½, 9, 9½, 10, 10)"
19 (20.5, 21.5, 23, 24, 25.5, 25.5) cm

back
&
fronts

20½"
52 cm

17"
43 cm

29¼ (32¼, 35, 40¾, 43¾, 46¾, 49½)"
74.5 (82, 89, 103.5, 111, 118.5, 125.5) cm

33½ (36½, 39½, 45¼, 48¼, 51, 54)"
85 (92.5, 100.5, 115, 122.5, 129.5, 137) cm

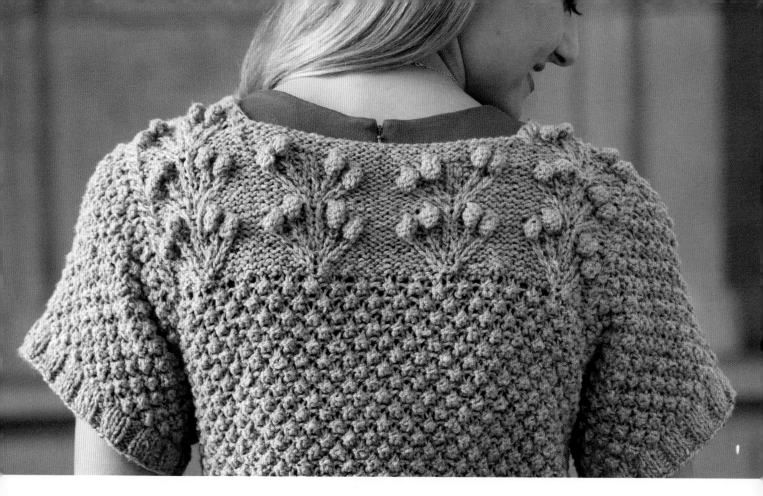

Body

With longer cir needle, CO 174 (189, 204, 234, 249, 264, 279) sts. Do not join for working in rnds.

Note: *For the tree panels on the fronts, work the entire 20-st Tree Panel chart; the separate cable and tree sections of the chart are for working the patt on the back neck later.*

SET-UP ROW: (WS) P1 (selvedge st), work set-up row of Tree Panel chart (page 133) over 20 sts, pm in tree color (see Notes), work set-up row of 3x2 rib in rows (see Stitch Guide) over 132 (147, 162, 192, 207, 222, 237) sts, pm in tree color, work set-up row of Tree Panel chart over 20 sts, p1 (selvedge st).

NEXT ROW: (RS) Sl 1 knitwise (selvedge st), work Row 1 of Tree Panel over 20 sts, sl m, work Row 1 of 3×2 rib to last 21 sts, sl m, work Row 1 of Tree Panel over 20 sts, k1 (selvedge st).

Note: *For selvedge sts, on RS rows slip the first st knitwise and knit the last st; on WS rows, slip the first st purlwise and purl the last st.*

Slipping markers every row, cont even in patts for 4 more rows, ending with a RS row—piece measures 1" (2.5 cm) from CO, ending with a RS row.

INC ROW: (WS) Sl 1 purlwise, work 20 sts of Tree Panel chart, sl m, k2, purl to 2 sts before next tree m and *at the same time* inc 14 (15, 16, 18, 19, 20, 21) sts evenly spaced (see page 175), k2, sl m, work 20 sts of Tree Panel, p1—188 (204, 220, 252, 268, 284, 300) sts.

NEXT ROW: (RS) Sl 1 knitwise, work 20 sts of Tree Panel chart, sl m, work Row 1 of Right Front Decrease chart over 22 (26, 30, 38, 42, 46, 50) sts working 4-st patt rep 3 (4, 5, 7, 8, 9, 10) times, pm in cable color, work Row 1 of side cable patt (see Stitch Guide) over 6 sts, pm in cable color, work Row 1 of Back Decrease chart over 90 (98, 106, 122, 130, 138, 146) sts working 4-st patt rep 18 (20, 22, 26, 28, 30, 32) times, pm in cable color, work Row 1 of side cable patt over 6 sts, pm in cable color, work Row 1 of Left Front Decrease chart over 22 (26, 30, 38, 42, 46, 50) sts working 4-st patt rep 3 (4, 5, 7, 8, 9, 10) times, sl m, work 20 sts of Tree Panel, k1.

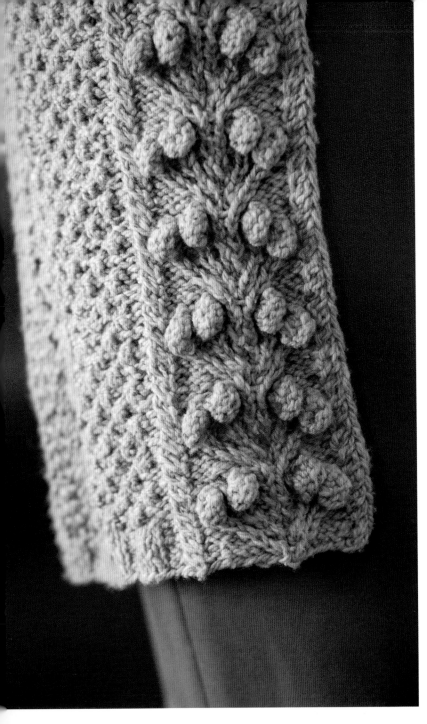

cables, 78 (86, 94, 110, 118, 126, 134) back trinity sts, 17 (21, 25, 33, 37, 41, 45) right front trinity sts, 15 (19, 23, 31, 35, 39, 43) left front trinity sts; 73 rows total above rib including inc row; piece measures 12" (30.5 cm) from CO.

Note: *The right and left front charts do not contain the same number of sts in Row 72 because the right front has a (k1, p1, k1) inc outside the patt rep and the left front ended with a p3tog dec outside the patt rep.*

NEXT ROW: (RS) Sl 1 knitwise, work 20 sts of Tree Panel, sl m, work Row 1 of Right Front Increase and Neck chart over 17 (21, 25, 33, 37, 41, 45) sts working 4-st patt rep 1 (2, 3, 5, 6, 7, 8) time(s), sl m, work 6 sts of side cable, sl m, work Row 1 of Back Increase chart over 78 (86, 94, 110, 118, 126, 134) sts working 4-st patt rep 18 (20, 22, 26, 28, 30, 32) times, sl m, work 6 sts of side cable, sl m, work Row 1 of Left Front Increase and Neck chart over 15 (19, 23, 31, 35, 39, 43) sts working 4-st patt rep 1 (2, 3, 5, 6, 7, 8) time(s), sl m, work 20 sts of Tree Panel, k1.

Cont as established, work Rows 73–76 of back and front charts once, then work Rows 72–76 two more times—piece measures 13¾" (35 cm) from CO.

Cont in patt, work Rows 85–127 of back and front charts once—172 (188, 204, 236, 252, 268, 284) sts total; 1 selvedge st and 20 Tree Panel sts at each end of row, two 6-st side cables, 14 (18, 22, 30, 34, 38, 42) trinity sts each front, 90 (98, 106, 122, 130, 138, 146) back trinity sts.

Divide for Fronts and Back

NEXT ROW: (WS, Row 128 of back and front charts) Sl 1 purlwise, work 20 sts of Tree Panel, sl m, 14 (18, 22, 30, 34, 38, 42) left front trinity sts, remove m, work first 3 side cable sts as p2, k1 to end in center of side cable, place 38 (42, 46, 54, 58, 62, 66) sts just worked onto holder for left front; work rem 3 side cable sts as k1, p2, remove m, work 90 (98, 106, 122, 130, 138, 146) back trinity sts, remove m, work first 3 sts of side cable as p2, k1 to end in center of cable, place 96 (104, 112, 128, 136, 144, 152) sts just worked onto holder for back; work rem 3 side cable sts as k1, p2, remove m, work 14 (18, 22, 30, 34, 38, 42) right front trinity sts, sl m, work 20 sts of Tree Panel, p1, place 38 (42, 46, 54, 58, 62, 66) sts just worked onto holder for right front—piece measures 20½" (52 cm) from CO.

Note: *During the foll instructions, after working Row 10 of the Tree Panel chart, rep Rows 1–10 for patt; do not rep the set-up row.*

Cont as established, work Rows 2–4 of back and front decrease charts once, then work Rows 1–4 once more—8 back and front chart rows total. Cont in patt, work Rows 9–72 of back and front charts once—164 (180, 196, 228, 244, 260, 276) sts total; 1 selvedge st and 20 Tree Panel sts at each end of row, two 6-st side

TREE PANEL

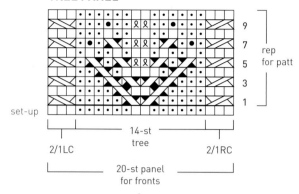

rep
for patt

set-up

2/1LC 14-st
tree 2/1RC

20-st panel
for fronts

RIGHT FRONT DECREASE

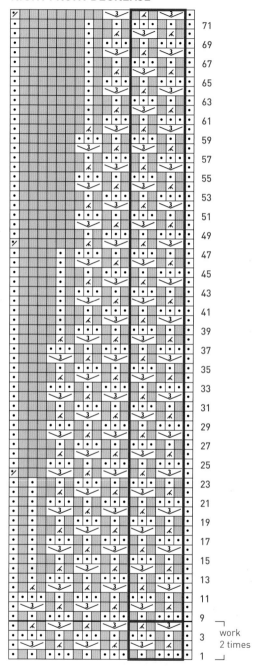

work
2 times

	k on RS; p on WS
•	p on RS, k on WS
ℛ	k1 tbl
↗	k2tog on WS
↘	ssk on WS
⋏	p3tog on WS
L	M1L (see Glossary)
R	M1R (see Glossary)
●	bobble (see Stitch Guide)
▨	no stitch
	sts that affect stitch count (see Notes)
▢	pattern repeat
⧄	RS and WS: sl 2 sts onto cn and hold in back, k1, k2 from cn
⧅	RS and WS: sl 1 st onto cn and hold in front, p1, k1 from cn
3	work [k1, p1, k1] all in same st
⤬	1/2 RC: sl 2 sts onto cn and hold in back, k1, k2 from cn
⤬	1/2 LC: sl 1 st onto cn and hold in front, k2, k1 from cn

BACK DECREASE

LEFT FRONT DECREASE

71
69
67
65
63
61
59
57
55
53
51
49
47
45
43
41
39
37
35
33
31
29
27
25
23
21
19
17
15
13
11
9
3
1

work
2 times

71
69
67
65
63
61
59
57
55
53
51
49
47
45
43
41
39
37
35
33
31
29
27
25
23
21
19
17
15
13
11
9
3
1

work
2 times

RIGHT FRONT INCREASE AND NECK

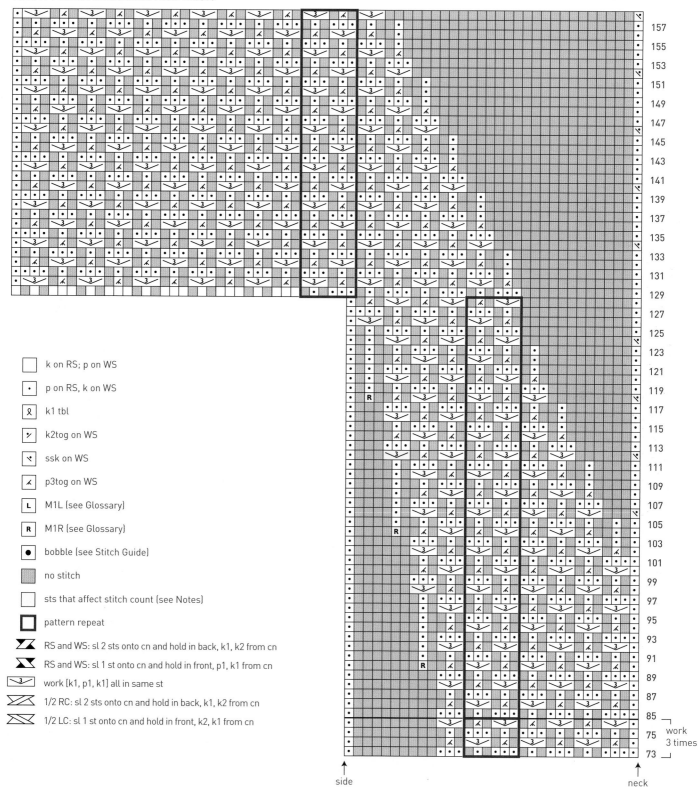

☐	k on RS; p on WS
•	p on RS, k on WS
ℓ	k1 tbl
↘	k2tog on WS
↙	ssk on WS
⅄	p3tog on WS
L	M1L (see Glossary)
R	M1R (see Glossary)
●	bobble (see Stitch Guide)
▨	no stitch
☐	sts that affect stitch count (see Notes)
☐	pattern repeat

✕ RS and WS: sl 2 sts onto cn and hold in back, k1, k2 from cn

✕ RS and WS: sl 1 st onto cn and hold in front, p1, k1 from cn

〰3 work [k1, p1, k1] all in same st

✕ 1/2 RC: sl 2 sts onto cn and hold in back, k1, k2 from cn

✕ 1/2 LC: sl 1 st onto cn and hold in front, k2, k1 from cn

BACK INCREASE

☐	k on RS; p on WS
•	p on RS, k on WS
℞	k1 tbl
↘	k2tog on WS
↘	ssk on WS
⋏	p3tog on WS
L	M1L (see Glossary)
R	M1R (see Glossary)
●	bobble (see Stitch Guide)
▨	no stitch
☐	sts that affect stitch count (see Notes)
☐	pattern repeat
⤬	RS and WS: sl 2 sts onto cn and hold in back, k1, k2 from cn
⤬	RS and WS: sl 1 st onto cn and hold in front, p1, k1 from cn
⌣	work [k1, p1, k1] all in same st
⤬	1/2 RC: sl 2 sts onto cn and hold in back, k1, k2 from cn
⤬	1/2 LC: sl 1 st onto cn and hold in front, k2, k1 from cn

LEFT FRONT INCREASE AND NECK

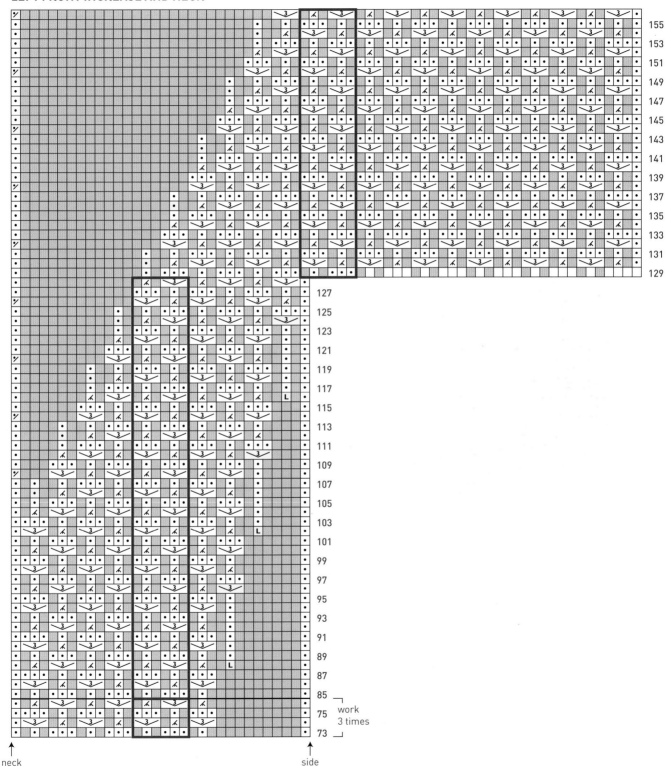

neck side

work
3 times

Back

Return 96 (104, 112, 128, 136, 144, 152) held back sts to longer cir needle and rejoin yarn with RS facing.

Shape Sleeves

NEXT ROW: (RS; counts as Row 1 of trinity st) Use the knitted method (see Glossary) to CO 21 sts at beg of row and, starting with new CO sts, purl to end—117 (125, 133, 149, 157, 165, 173) sts.

NEXT ROW: (WS) Use the knitted method to CO 21 sts at beg of row and, starting with new CO sts, work all sts in established trinity st patt to end—138 (146, 154, 170, 178, 186, 194) sts.

Cont in patt until piece measures 2½ (3, 3½, 4, 4½, 5, 5)" (6.5 [7.5, 9, 10, 11.5, 12.5, 12.5] cm) from sleeve CO, ending with a WS row.

Back Neck

NEXT ROW: (RS) Work 29 (33, 37, 45, 49, 53, 57) sts in established patt, pm, knit the next 80 sts and *at the same time* dec 9 sts evenly spaced (see page 175), pm, work 29 (33, 37, 45, 49, 53, 57) sts in patt —129 (137, 145, 161, 169, 177, 185) sts; 71 sts in marked center section.

SET-UP ROW: (WS) Work trinity st patt to m, sl m, p3, knit to 3 sts before m, p3, sl m, work trinity st patt to end.

Cont in trinity st patt at each side, work sections of Tree Panel chart over marked center sts as foll:

ROW 1: (RS; Row 1 of Tree Panel chart) Work trinity st patt to m, sl m, work cable at beg of chart over 3 sts, [work 14-st tree section, p3] 3 times, work 14-st tree section once, work 1/2LC cable at end of chart once, sl m, work trinity st patt to end.

ROWS 2–19: Cont in patts as established, work Rows 2–10 of Tree Panel chart, then work Rows 1–9 once more, ending with a RS row.

ROW 20: (Row 10 of tree chart) Work trinity st patt to m, sl m, p3 for cable, work 14-st tree section once, k37, work 14-st tree section once, p3 for cable, sl m, work trinity st patt to end.

ROW 21: (Row 1 of chart) Work trinity st patt to m, sl m, work 1/2RC over 3 sts, work 14-st tree section once, p37, work 14-st tree section once, work 1/2LC over 3 sts, sl m, work trinity st patt to end.

ROW 22: (Row 2 of chart) Rep Row 20—piece measures 6¼ (6¾, 7¼, 7¾, 8¼, 8¾, 8¾)" (16 [17, 18.5, 19.5, 21, 22, 22] cm) from sleeve CO.

ROW 23: (Row 3 of chart) Work trinity st patt to m, sl m, work 1/2RC over 3 sts, work 14-st tree section once, k4, join a second ball of yarn and BO center 29 sts, knit until there are 4 sts on right needle after BO gap, work 14-st tree section once, work 1/2LC over 3 sts, sl m, work trinity st patt to end—50 (54, 58, 66, 70, 74, 78) sts each side.

ROW 24: (Row 4 of chart) For first group of sts (left sleeve and shoulder), work trinity st patt to m, sl m, p3 for cable, work 14-st tree section once, p3, p1 (neck selvedge st); for second group of sts (right sleeve and shoulder), sl 1 purlwise (neck selvedge), p3, work 14-st tree section once, p3 for cable, sl m, work trinity st patt to end.

ROW 25: (Row 5 of chart) For first group of sts (right sleeve and shoulder), work trinity st patt to m, sl m, work 1/2RC over 3 sts, work 14-st tree section once, work 1/2LC cable over 3 sts, k1 (neck selvedge st); for second group of sts (left sleeve and shoulder), sl 1 knitwise (neck selvedge), work 1/2RC over 3 sts, work 14-st tree section once, work 1/2LC over 3 sts, sl m, work trinity st patt to end.

ROW 26: (Row 6 of chart) Work even in established patts.

ROWS 27–32: Cont cables and trinity st as established, work Tree Panel sts as they appeared in Row 6 every row (knit the knits and purl the purls), ending with a WS row—piece measures 7½ (8, 8½, 9, 9½, 10, 10)" (19 [20.5, 21.5, 23, 24, 25.5, 25.5] cm) from sleeve CO.

Shape Shoulders

Note: *The shoulder shaping is worked over the trinity st sections only; maintain the patt as well as possible during the shaping.*

Working each shoulder separately using short-rows (see Glossary) as foll:

Right back shoulder

SHORT-ROW 1: (RS) Work trinity st patt to 8 (8, 8, 12, 12, 16, 16) sts before tree m, wrap next st, turn work.

SHORT-ROWS 2 AND 4: (WS) Work in patt to end, turn work.

SHORT-ROW 3: Work trinity st patt to 16 (16, 16, 24, 24, 32, 32) sts before tree m, wrap next st, turn work.

SHORT-ROW 5: Work trinity st patt to 24 (24, 24, 36, 36, 48, 48) sts before tree m, wrap next st, turn work.

SHORT-ROW 6: Work in patt to end, turn work.

NEXT ROW: (RS) Work all sts in patt, working wraps tog with wrapped sts as you come to them—piece measures 1" (2.5 cm) higher at neck edge than at armhole edge.

Place sts onto holder.

Left back shoulder

Rejoin yarn to neck edge with RS facing.

SHORT-ROW 1: (RS) Work in patt to end, turn work.

SHORT-ROW 2: (WS) Work trinity st patt to 8 (8, 8, 12, 12, 16, 16) sts before tree m, wrap next st, turn work.

SHORT-ROWS 3 AND 5: (RS) Work in patt to end, turn work.

SHORT-ROW 4: Work trinity st patt to 16 (16, 16, 24, 24, 32, 32) sts before tree m, wrap next st, turn work.

SHORT-ROW 6: Work trinity st patt to 24 (24, 24, 36, 36, 48, 48) sts before tree m, wrap next st, turn work.

NEXT ROW: (WS) Work all sts in patt, working wraps tog with wrapped sts as you come to them—piece measures 1" (2.5 cm) higher at neck edge than at armhole edge.

Place sts onto holder.

Left Front

NEXT ROW: (RS) With RS facing, pick up and knit 21 sts from base of sts CO for left back sleeve (these sts count as the first 21 knit sts from Row 129 of Left Front Increase and Neck chart), return 38 (42, 46, 54, 58, 62, 66) held left front sts to longer cir needle and rejoin yarn with RS facing, work the next 17 (21, 25, 33, 37, 41, 45) sts from Row 129 of chart working 4-st patt rep 1 (2, 3, 5, 6, 7, 8) time(s), sl m, work 20 sts of Tree Panel, k1—59 (63, 67, 75, 79, 83, 87) sts total.

Cont selvedge st at front edge (end of RS rows; beg of WS rows) as established, work in patts until Row 156 of front chart has been completed—50 (54, 58, 66, 70, 74, 78) sts; 29 (33, 37, 45, 49, 53, 57) trinity patt sts, 20 Tree Panel sts, 1 selvedge st; piece measure 4¼" (11 cm) from sleeve CO.

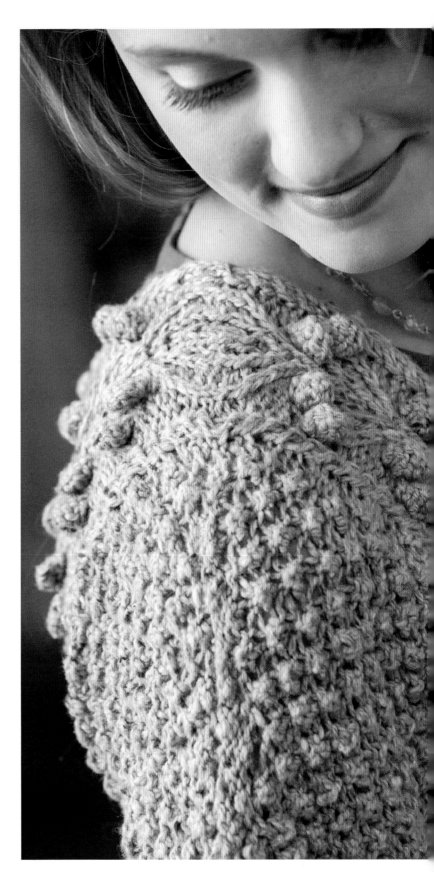

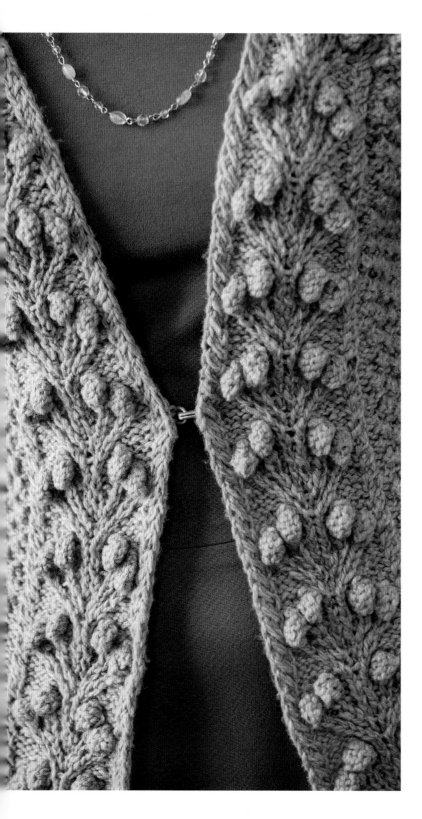

Cont in established patts until piece measures 7½ (8, 8½, 9, 9½, 10, 10)" (19 [20.5, 21.5, 23, 24, 25.5, 25.5] cm) from sleeve CO, ending with a WS row.

Note: *In order to avoid having a partial tree motif, work the Tree Panel until you have completed Row 6, then check the length; if the piece is 2" (5 cm) or less shorter than the desired length, stop working the patt in the tree section of the Tree Panel chart and work the 14 tree sts as they appear in Row 6 to the end.*

Left front shoulder

Work as for right back shoulder—piece measures 1" (2.5 cm) higher at neck edge than at armhole edge.

Place sts onto holder.

Right Front

Return 38 (42, 46, 54, 58, 62, 66) held right front sts to longer cir needle and rejoin yarn with RS facing.

NEXT ROW: (RS) Sl 1 knitwise, work 20 sts of Tree Panel, sl m, work the first 17 (21, 25, 33, 37, 41, 45) sts from Row 129 of Right Front Increase and Neck chart working 4-st patt rep 1 (2, 3, 5, 6, 7, 8) time(s), then pick up and knit 21 sts from base of sts CO for right back sleeve; these sts count as the last 21 sts of Row 129—59 (63, 67, 75, 79, 83, 87) sts total.

Cont selvedge st at front edge (beg of RS rows) as established, work in patts until Row 158 of front chart has been completed—50 (54, 58, 66, 70, 74, 78) sts; 29 (33, 37, 45, 49, 53, 57) trinity patt sts, 20 Tree Panel sts, 1 selvedge st; piece measure 4½" (11.5 cm) from sleeve CO. The right front has 2 more rows than the left front; the neck shaping is offset from the left front neck by 2 rows.

Cont in established patts until piece measures 7½ (8, 8½, 9, 9½, 10, 10)" (19 [20.5, 21.5, 23, 24, 25.5, 25.5] cm) from sleeve CO, working the end of the Tree Panel sts the same as for left front, and ending with a WS row.

Right front shoulder

Work as for left back shoulder—piece measures 1" (2.5 cm) higher at neck edge than at armhole edge.

Place sts onto holder.

Finishing

Join fronts to back at shoulders using the Kitchener st or 3-needle bind-off method (see Glossary).

Sleeve Edging

With shorter cir needle or dpn, RS facing, and beg in center of underarm, pick up and knit 65 (70, 75, 75, 80, 85, 85) sts evenly spaced around sleeve opening. Pm and join for working in rnds. Work 3x2 rib in rnds (see Stitch Guide) for 1¼" (3.2 cm). BO all sts in rib patt.

Sew hook half of hook-and-eye closure to WS of left front at start of V-neck shaping, about 17" (43 cm) up from CO edge. Sew eye half of closure to corresponding position on right front so that the hook is concealed when the fronts are closed.

Weave in loose ends. Block to measurements.

Make it Yours

Stitch pattern breakdown:
Tree pattern: Panel of 14 stitches.
Main pattern: Multiple of 4 stitches plus 2 balancing stitches (1 purl stitch at each side).

◊ If you substitute other patterns, make sure you get the same gauge.

◊ The 14-stitch tree pattern on the front is the easiest pattern to replace with another.

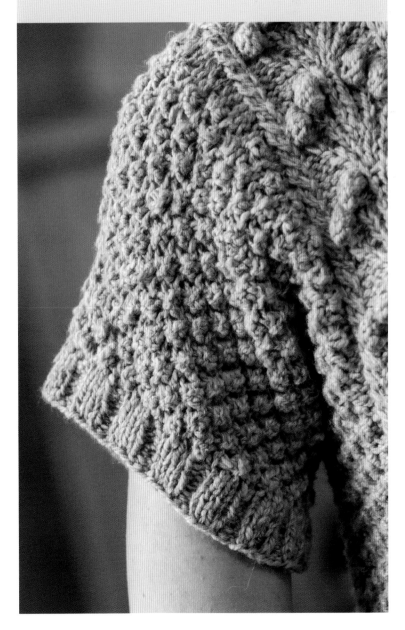

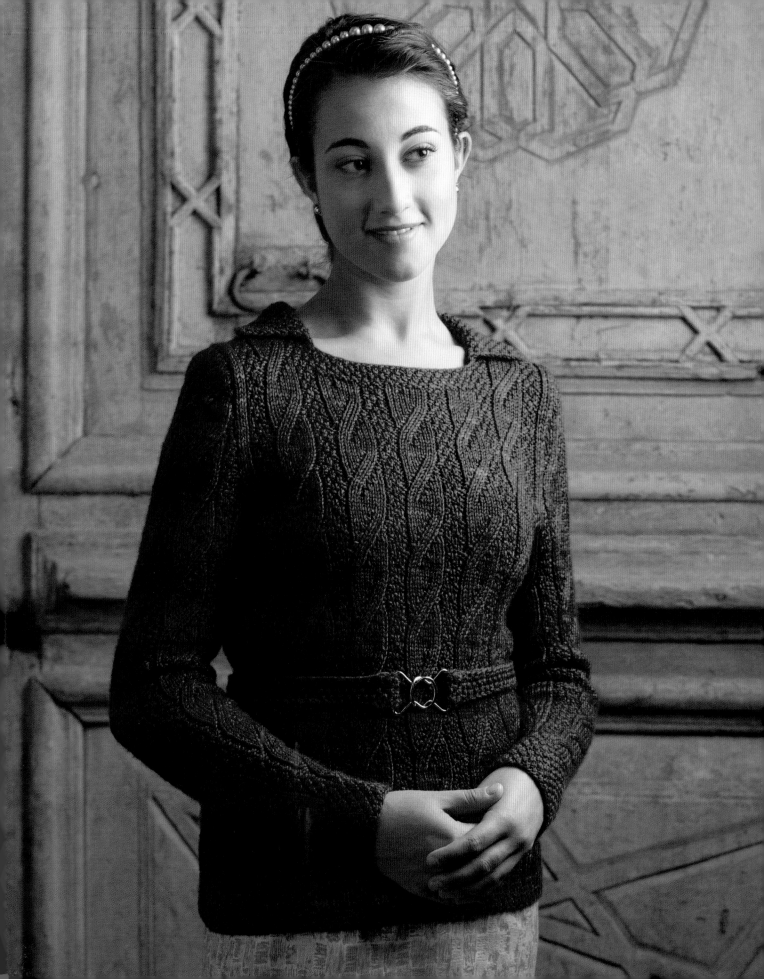

Textured Pullover

This slimming pullover is worked in rounds from the lower edge to the armholes (and shaped along the way), at which point the front and back are worked separately in rows to the shoulders. Beginning with mitered cuffs, the sleeves are worked in rounds to the armholes, and then the caps are worked in rows. The square neckline is finished with a collar; the sleeve caps are rotated in the armholes for a refined fit. The optional narrow belt is worked in seed stitch.

designed by **FAINA GOBERSTEIN**

FINISHED SIZE

About 34¾ (39, 43¼, 47¼, 51½, 55¾)" (88.5 [99, 110, 120, 131, 141.5] cm) bust circumference.

Pullover shown measures 34¾" (88.5 cm).

YARN

Worsted weight (#4 Medium).

Shown here: Claudia Hand Painted Yarns Worsted Weight (100% merino, 168 yd [154 m]/100 g): Brick House Music Co., 8 (9, 10, 11, 12, 13) skeins.

NEEDLES

Size U.S. 7 (4.5 mm): 32" (80 cm) circular (cir) and set of 5 double-pointed (dpn).

Adjust needle size if necessary to obtain the correct gauge.

NOTIONS

Markers (m); stitch holders; tapestry needle; 1½" (3.8 cm) buckle (optional; shown is Fashion Cinch Buckle by Dritz); sharp-point sewing needle and matching thread (optional for buckle); waste yarn (optional for buckle).

GAUGE

23 sts and 28 rows/rnds = 4" (10 cm) in Textured Stitch patt from chart.

22 sts and 28 rows/rnds = 4" (10 cm) in moss st.

Design Techniques

Set-in sleeve construction worked in rounds from the bottom up, page 8.

Self-standing patterns, page 17.

Short rows, page 178.

Three-needle bind-off, page 171.

TIPS & TRICKS

- The textured stitch pattern is worked in the round for the lower body and sleeves and it is worked back and forth in rows for the upper body and the sleeve caps. When working in rows, the even-numbered rounds are worked as WS rows.

- The end-of-round marker and the markers between the chart patterns need to be repositioned on rounds marked with an asterisk (*). At the start of a * round, remove the end-of-round marker, slip the first stitch purlwise to the right needle, then replace the marker—the end-of-round marker has moved one stitch to the left. For the marker separating the chart patterns, work in pattern to one stitch before the marker, temporarily slip the next stitch to the right needle, remove the marker, return the slipped stitch to the left needle, work the p2tog at the end of the pattern section, then replace the marker on the right needle after the p2tog. At the end of the round, the final p2tog is worked on the last stitch of the round and the slipped stitch from the beginning of the round. The important thing to remember is to keep the 1-stitch purl columns and the 3- and 5-stitch moss columns between them aligned.

- The sleeve cap is rotated in the armhole so that the center of the cap falls about ¼" (6 mm) to the front of the shoulder seam. This insures a better fit at the armhole.

- Use markers to separate stitch pattern repeats.

STITCH GUIDE

MOSS STITCH WORKED IN ROUNDS ON AN EVEN NUMBER OF STITCHES

RNDS 1 AND 2: *K1, p1; rep from *.

RNDS 3 AND 4: *P1, k1; rep from *.

Rep Rnds 1–4 for patt.

MOSS STITCH WORKED IN ROUNDS ON AN ODD NUMBER OF STITCHES

RNDS 1 AND 2: K1 *p1, k1; rep from *.

RNDS 3 AND 4: P1, *k1, p1; rep from *.

Rep Rnds 1–4 for patt.

MOSS STITCH WORKED IN ROWS (ODD NUMBER OF STS)

ROW 1: (RS) K1, *p1, k1; rep from *.

ROWS 2 AND 3: P1, *k1, p1; rep from *.

ROW 4: K1, *p1, k1; rep from *.

Rep Rows 1–4 for patt.

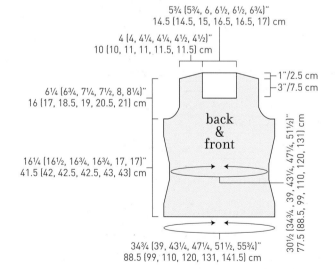

5¾ (5¾, 6, 6½, 6½, 6¾)"
14.5 (14.5, 15, 16.5, 16.5, 17) cm

4 (4, 4¼, 4¼, 4½, 4½)"
10 (10, 11, 11, 11.5, 11.5) cm

6¼ (6¾, 7¼, 7½, 8, 8¼)"
16 (17, 18.5, 19, 20.5, 21) cm

1"/2.5 cm
3"/7.5 cm

back & front

16¼ (16½, 16¾, 16¾, 17, 17)"
41.5 (42, 42.5, 42.5, 43, 43) cm

30½ (34¾, 39, 43¼, 47¼, 51½)"
77.5 (88.5, 99, 110, 120, 131) cm

34¾ (39, 43¼, 47¼, 51½, 55¾)"
88.5 (99, 110, 120, 131, 141.5) cm

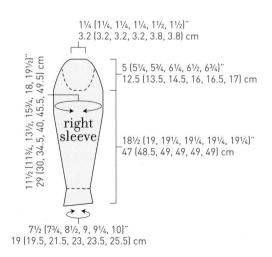

1¼ (1¼, 1¼, 1¼, 1½, 1½)"
3.2 (3.2, 3.2, 3.2, 3.8, 3.8) cm

5 (5¼, 5¾, 6¼, 6½, 6¾)"
12.5 (13.5, 14.5, 16, 16.5, 17) cm

right sleeve

11½ (11¾, 13½, 15¾, 18, 19½)"
29 (30, 34.5, 40, 45.5, 49.5) cm

18½ (19, 19¼, 19¼, 19¼, 19¼)"
47 (48.5, 49, 49, 49, 49) cm

7½ (7¾, 8½, 9, 9¼, 10)"
19 (19.5, 21.5, 23, 23.5, 25.5) cm

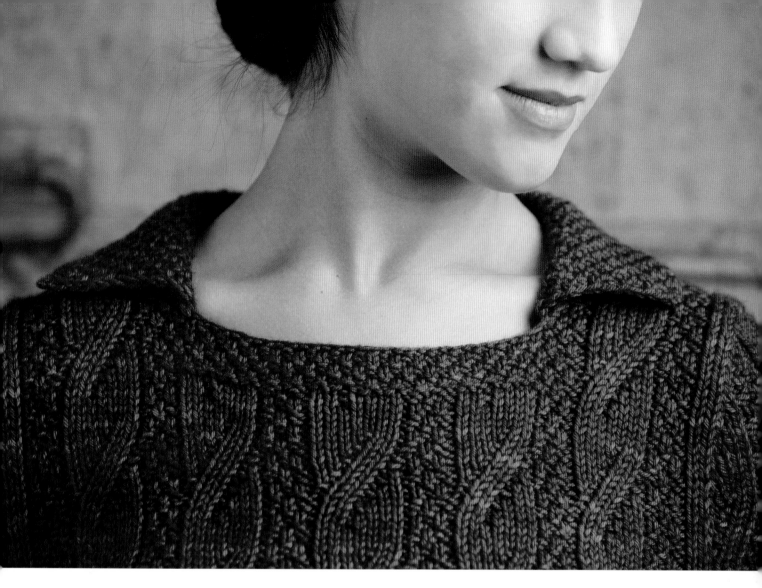

Body

CO 200 (224, 248, 272, 296, 320) sts. Place marker (pm) and join for working in rnds, being careful not to twist sts.

Work moss st in the rnd for an even number of sts (see Stitch Guide) for 8 rnds—piece measures about 1¼" (3.2 cm) from CO.

Note: *For a nice detail, adjust the patt of the 3- and 5-st moss columns of the charts, if necessary, so they cont the established moss st.*

SET-UP RND: *Work Rnd 1 of Waist Shaping chart over 45 sts, pm, work Rnd 1 of Textured Stitch chart over 55 (67, 79, 91, 103, 115) sts, beg and ending where indicated for body; rep from * once more.

Work in established patts for 5 more rnds, ending with Rnd 6 of charts.

Shape Waist

Work 31 rnds in established patts, dec in each side panel as shown in Waist Shaping chart and ending with Rnd 5 of Textured Stitch chart and Rnd 37 of Waist Shaping chart—176 (200, 224, 248, 272, 296) sts rem; 33 sts in each side panel; piece measures 6½" (16.5 cm) from CO.

Work 17 rnds even in patt, ending with Rnd 6 of Textured Stitch chart and Rnd 54 of Waist Shaping chart—piece measures 9" (23 cm) from CO.

Work 31 rnds in patt, inc in each side panel as shown and ending with Rnd 5 of Textured Stitch chart and Rnd 85 of Waist Shaping chart—200 (224, 248, 272, 296, 320) sts; 45 sts in each side panel; piece measures 13½" (34.5 cm) from CO.

Work 11 rnds even in patt, ending with Rnd 16 of Textured Stitch chart and Rnd 96 of Waist Shaping chart.

WAIST SHAPING

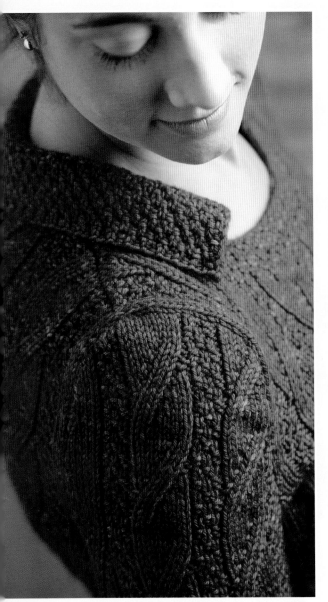

Row numbers (right side of chart, bottom to top): 1, 3, 5, 7, 9, 11, 13, *15, 17, 19, 21, 23, 25, 27, 29, *31, 33, 35, 37, 39, 41, 43, 45, *47, 49, 51, 53, 55, 57, 59, 61, *63, 65, 67, 69, 71, 73, 75, 77, *79, 81, 83, 85, 87, 89, 91, 93, *95

*See Notes for moving markers.

TEXTURED STITCH

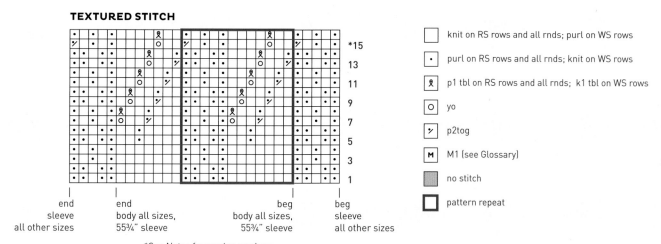

	knit on RS rows and all rnds; purl on WS rows
	purl on RS rows and all rnds; knit on WS rows
	p1 tbl on RS rows and all rnds; k1 tbl on WS rows
	yo
	p2tog
	M1 (see Glossary)
	no stitch
	pattern repeat

end
sleeve
all other sizes

end
body all sizes,
55¾" sleeve

beg
body all sizes,
55¾" sleeve

beg
sleeve
all other sizes

See Notes for moving markers.

SIDE PANEL

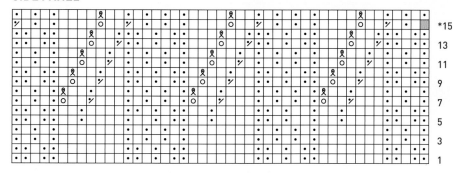

See Notes for moving markers.

NEXT RND: *Work Rnd 1 of Side Panel chart over 45 sts, sl m, work Rnd 1 of Textured Stitch chart over 55 (67, 79, 91, 103, 115) sts; rep from * once more.

Cont in established patts until piece measures 16¼ (16½, 16¾, 16¾, 17, 17)" (41.5 [42, 42.5, 42.5, 43, 43] cm) from CO, ending with an even-numbered rnd.

Divide for Back and Front

Cut yarn. Slip the first 18 (16, 15, 14, 14, 13) side panel sts to right needle without working them. Rejoin yarn.

DIVIDING RND: BO the center 9 (13, 15, 17, 17, 19) side panel sts for left underarm, work to end of side panel, work 55 (67, 79, 91, 103, 115) center front sts, work the first 18 (16, 15, 14, 14, 13) sts of next side panel, BO the center 9 (13, 15, 17, 17, 19) side panel sts for right underarm, work to end of side panel, work 55 (67, 79, 91, 103, 115) back sts, work the 18 (16, 15, 14, 14, 13) slipped side panel sts in patt to end at underarm

gap—91 (99, 109, 119, 131, 141) sts rem each for front and back.

Place front sts onto holder.

Back

Change to working Textured Stitch in rows (see Notes). Work 1 WS row even.

Shape Armholes

BO 3 sts at beg of next 0 (2, 4, 4, 6, 6) rows—91 (93, 97, 107, 113, 123) sts rem. BO 2 sts at beg of next 4 (4, 4, 6, 8, 10) rows—83 (85, 89, 95, 97, 103) sts rem.

DEC ROW: (RS) Sl 1 with yarn in front (wyf), ssk, work in patt to last 3 sts, k2tog, k1—2 sts dec'd.

NEXT ROW: (WS) Sl 1 wyf, work in patt to end.

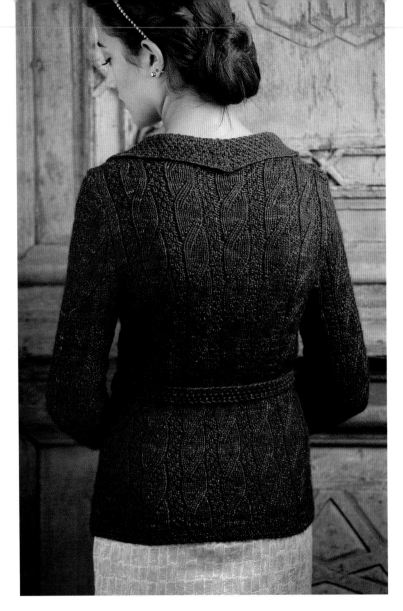

Cont in patt, rep the shaping of the last 2 rows 1 (2, 2, 4, 4, 6) more time(s)—79 (79, 83, 85, 87, 89) sts rem.

NEXT ROW: (RS) Sl 1 wyf, k2, work in patt to last 3 sts, k3.

NEXT ROW: (WS) Sl 1 wyf, p2, work in patt to last 3 sts, p2, k1.

Cont in patt, rep the last 2 rows until armholes measure 6 (6½, 7, 7¼, 7¾, 8)" (15 [16.5, 18, 18.5, 19.5, 20.5] cm) from dividing rnd, ending with a WS row (see Notes).

Shape Shoulders

Keeping in patt, work short-rows (see Glossary) as foll:

SHORT-ROW 1: (RS) Work in patt to last 5 (5, 6, 6, 7, 7) sts, wrap next st, turn work.

SHORT-ROW 2: (WS) Work in patt to last 5 (5, 6, 6, 7, 7) sts, wrap next st, turn work.

SHORT-ROWS 3 AND 4: Work in patt to last 10 (10, 12, 12, 14, 14) sts, wrap next st, turn work.

SHORT-ROWS 5 AND 6: Work in patt to last 15 (15, 18, 18, 21, 21) sts, wrap next st, turn work.

NEXT 2 ROWS: Work in patt to end of row, working wraps tog with wrapped sts as you come to them—armholes measure 6¼ (6¾, 7¼, 7½, 8, 8¼)" (16 [17, 18.5, 19, 20.5, 21] cm) at each side; do not measure at center.

Cut yarn and place 23 (23, 24, 24, 25, 25) sts at each side onto separate holders for shoulders—33 (33, 35, 37, 37, 39) back neck sts rem. Rejoin yarn and BO back neck sts.

Front

Return 91 (99, 109, 119, 131, 141) held front sts to needle and join yarn with WS facing. Change to working Textured Stitch in rows. Work 1 WS row even.

Shape Armholes

Work armhole shaping as for back—79 (79, 83, 85, 87, 89) sts rem.

Cont as for back until armholes measure 2¼ (2¾, 3¼, 3½, 4, 4¼)" (5.5 [7, 8.5, 9, 10, 11] cm) from dividing rnd, ending with a WS row.

Shape Front Neck

SET-UP ROW: (RS) Work 17 (17, 18, 18, 19, 19) sts in patt, pm, work Row 1 of moss st in rows (see Stitch Guide) over center 45 (45, 47, 49, 49, 51) sts, pm, work 17 (17, 18, 18, 19, 19) sts in patt.

Working marked center sts in moss st, cont in patt for 5 more rows, ending with WS Row 2 of moss st—armholes measure about 3¼ (3¾, 4¼, 4½, 5, 5¼)" (8.5 [9.5, 11, 11.5, 12.5, 13.5] cm).

NEXT ROW: (RS) Work 17 (17, 18, 18, 19, 19) sts in patt, work 6 sts in established moss st, place 23 (23, 24, 24, 25, 25) sts just worked onto holder for left neck, BO center 33 (33, 35, 37, 37, 39) sts, work in established moss st until there are 6 moss sts on right needle after BO gap, work 17 (17, 18, 18, 19, 19) sts in patt for right neck—23 (23, 24, 24, 25, 25) right neck sts rem on needle.

Right Neck and Shoulder

Keeping 6 sts at neck edge in established moss st, work even in patt until armhole measures 6 (6½, 7, 7¼, 7¾, 8)" (15 [16.5, 18, 18.5, 19.5, 20.5] cm) from dividing rnd, ending with a WS row.

Keeping in patt, work short-rows as foll:

SHORT-ROW 1: (RS) Work in patt to last 5 (5, 6, 6, 7, 7) sts, wrap next st, turn work.

SHORT-ROWS 2 AND 4: (WS) Work in patt to end.

SHORT-ROW 3: Work in patt to last 10 (10, 12, 12, 14, 14) sts, wrap next st, turn work.

SHORT-ROW 5: Work in patt to last 15 (15, 18, 18, 21, 21) sts, wrap next st, turn work.

SHORT-ROW 6: Work in patt to end.

NEXT 2 ROWS: Work in patt across all sts, working wraps tog with wrapped sts as you come to them—armhole measures 6¼ (6¾, 7¼, 7½, 8, 8¼)" (16 [17, 18.5, 19, 20.5, 21] cm) at end of RS rows.

Place 23 (23, 24, 24, 25, 25) sts onto holder for right shoulder.

Left Neck and Shoulder

Return 23 (23, 24, 24, 25, 25) held left neck sts onto needle and join yarn with WS facing.

Keeping 6 sts at neck edge in established moss st, work even in patt until armhole measures 6 (6½, 7, 7¼, 7¾, 8)" (15 [16.5, 18, 18.5, 19.5, 20.5] cm) from dividing rnd, ending with a RS row.

Keeping in patt, work short-rows as foll:

SHORT-ROW 1: (WS) Work in patt to last 5 (5, 6, 6, 7, 7) sts, wrap next st, turn work.

SHORT-ROWS 2 AND 4: (RS) Work in patt to end.

SHORT-ROW 3: Work in patt to last 10 (10, 12, 12, 14, 14) sts, wrap next st, turn work.

SHORT-ROW 5: Work in patt to last 15 (15, 18, 18, 21, 21) sts, wrap next st, turn work.

SHORT-ROW 6: Work in patt to end.

NEXT 2 ROWS: Work in patt across all sts, working wraps tog with wrapped sts as you come to them—armhole measures 6¼ (6¾, 7¼, 7½, 8, 8¼)" (16 [17, 18.5, 19, 20.5, 21] cm) at beg of RS rows.

Place 23 (23, 24, 24, 25, 25) sts onto holder for left shoulder.

Sleeves

Note: *The sleeve cuffs are worked differently for the right and left sleeves, so that the mitered cuff detail will be positioned over the back of each hand. After working its individual cuff, each sleeve is worked according to the same instructions. Take care to make both a right and left sleeve.*

Right Cuff

With dpn, CO 37 (39, 42, 43, 45, 48) sts, pm, CO 1 st (miter st), pm, then CO 13 (13, 14, 15, 15, 16) more sts—51 (53, 57, 59, 61, 65) sts total. Pm and join for working in rnds, being careful not to twist sts; miter st is about one-quarter of the way from the end of the rnd.

RNDS 1 AND 2: Work moss st in the rnd (for odd or even number of sts as necessary for your size) to m, sl m, k1 (miter st), sl m, work moss st in the rnd to end.

RND 3: (dec rnd) Work in established patt to 2 sts before m, p2tog, sl m, k1, sl m, p2tog, work in established patt to end—2 sts dec'd.

Cont in moss st as established, rep the shaping of the last 3 rnds 4 more times, then work 3 rnds even, ending with Rnd 2 of moss st—41 (43, 47, 49, 51, 55) sts rem; piece measures 2½" (6.5 cm) from CO at beg of rnd, measured straight up from the CO edge (do not measure along the miter st).

Left Cuff

With dpn, CO 13 (13, 14, 15, 15, 16) sts, pm, CO 1 st (miter st), pm, then CO 37 (39, 42, 43, 45, 48) more sts —51 (53, 57, 59, 61, 65) sts total. Pm and join for working in rnds, being careful not to twist sts; miter st is about one-quarter of the way from the beginning of the rnd.

Work as for right cuff—41 (43, 47, 49, 51, 55) sts rem; piece measures 2½" (6.5 cm) from CO at beg of rnd.

Both Right and Left Sleeves

Note: *As for the lower body, adjust the patt of the 3-st moss columns from the chart if necessary so that they cont the moss st established in the cuff.*

SET-UP RND: M1P (see Glossary) for "seam" st, work 0 (1, 3, 4, 5, 0) st(s) in St st, work Rnd 1 of Textured Stitch chart over 41 (41, 41, 41, 41, 55) sts beg and ending

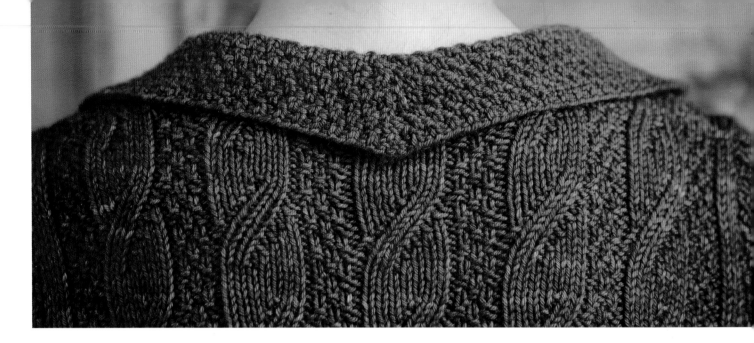

where indicated for your size, work 0 (1, 3, 4, 5, 0) st(s) in St st—1 st inc'd.

NEXT RND: Working sts outside chart in St st and purling "seam" st, work 1 rnd even in patt.

Note: *When increasing for the sleeve, do not work any partial faux cables. Work these sts in stockinette until they have increased to 7 sts, then introduce the faux cable patt on the next rnd. Work new sts in patt for the 1-st purl columns and 3-st moss columns of the chart as soon as they appear. In Rnd 15, work the p2tog end of the Textured St chart as p1 until enough new sts have been added to provide a companion yo for this dec.*

INC RND: P1 ("seam" st), M1 (see Glossary), work in patt to end, M1—2 sts inc'd.

Working new sts into patt, rep the inc rnd every 4th rnd 0 (0, 0, 9, 25, 27) times, then every 6th rnd 1 (1, 10, 10, 0, 0) time(s), then every 8th rnd 10 (10, 4, 0, 0, 0) times—66 (68, 78, 90, 104, 112) sts.

Work even until piece measures 18½ (19, 19¼, 19¼, 19¼, 19¼)" (47 [48.5, 49, 49, 49, 49] cm) from CO, ending with an even-numbered rnd and ending last rnd 4 (6, 7, 8, 8, 9) sts before end-of-rnd m.

Shape Cap

Change to working Textured Stitch in rows and beg with an odd-numbered row, work as foll:

NEXT ROW: (RS) BO 9 (13, 15, 17, 17, 19) sts with "seam" st in the center of BO sts, work in patt to end—57 (55, 63, 73, 87, 93) sts rem.

BO 3 sts at beg of next 2 (2, 4, 4, 6, 6) rows, then BO 2 sts at beg of the foll 4 (4, 4, 10, 10, 12) rows—43 (41, 43, 41, 49, 51) sts rem.

DEC ROW: (RS) Sl 1 wyf, ssk, work in patt to last 3 sts, k2tog, k1—2 sts dec'd.

NEXT ROW: (WS) Sl 1 wyf, work in patt to end.

Cont in patt, rep the shaping of the last 2 rows 8 (5, 6, 6, 7, 9) more times—25 (29, 29, 27, 33, 31) sts rem.

Working edge sts as established, work the dec row every 4th row 1 (3, 3, 2, 1, 0) time(s)—23 (23, 23, 23, 31, 31) sts rem.

BO 3 sts at beg of next 4 (4, 4, 4, 6, 6) rows, then BO 2 sts at beg of next 2 rows—7 (7, 7, 7, 9, 9) sts rem. BO rem sts.

Finishing

Block pieces to measurements.

Join Shoulders

Place 23 (23, 24, 24, 25, 25) held right front sts onto one dpn and 23 (23, 24, 24, 25, 25) held right back sts onto another dpn. Hold the needles parallel with RS of fabric touching and WS facing out and use the three-needle method (see Glossary) to BO the sts tog. Rep for left shoulder sts.

Collar

Note: *The collar sts are picked up with the WS facing; the pick-up welt on the RS of the garment will be covered by the collar when the collar is folded back.*

Join yarn in left front neck corner. With WS facing, pick up and knit 20 sts along left neck to shoulder join, 18 (18, 19, 20, 20, 21) sts from first half of back neck to center, pm to denote center, pick up and knit 18 (18, 19, 20, 20, 21) sts along second half of back neck to shoulder join, and 20 sts along right neck to corner—76 (76, 78, 80, 80, 82) sts total.

Do not join. Work moss st with slipped edge sts back and forth in rows as foll:

ROWS 1 (RS) AND 2 (WS): Sl 1 wyf, *k1, p1; rep from * to last st, k1.

ROWS 3 AND 4: Sl 1 wyf, *p1, k1; rep from * to last st, k1.

Rep these 4 rows until piece measures 2" (5 cm) from pick-up row, ending with a WS row.

INC ROW: (RS) Work in established patt to 1 st before m, M1, work 1 st in patt, sl m, work 1 st in patt, M1, work in patt to end—2 sts inc'd.

Working new sts into moss st patt, rep inc row on the next 3 (3, 3, 4, 5, 5) RS rows—84 (84, 86, 90, 92, 94) sts.

Work even in patt for 3 more rows after the final inc row, beg and ending with a WS row—collar measures 3¼ (3¼, 3¼, 3½, 3¾, 3¾)" (8.5 [8.5, 8.5, 9, 9.5, 9.5] cm) from pick-up row.

NEXT ROW: (RS) BO loosely in patt to m, remove m, M1, BO loosely in patt to end.

With yarn threaded on a tapestry needle, sew sleeves into armholes, matching center of sleeve cap to about ¼" (6 mm) in front of the shoulder line. Block collar and all seams. Weave in loose ends.

Belt (optional)

With waste yarn CO 7 sts. Knit 1 row. Change to main yarn. Work 3 rows in St st, beg and ending with a RS (knit) row. Knit the next WS row for turning ridge. Work in seed st as foll:

NEXT 3 ROWS: Sl 1 wyf, [k1, p1] 2 times, k2.

NEXT ROW: Sl 1 wyb, k1, psso, [p1, k1] 2 times, k1—6 sts rem.

NEXT ROW: Sl 1 wyb, k1, psso, [p1, k1] 2 times—5 sts rem.

NEXT ROW: Sl 1 wyf, [p1, k1] 2 times.

Make It Yours

Stitch Pattern breakdown:
Main overall stitch pattern: 12-stitch repeat, plus 7 stitches to balance the pattern.

◇ Choose any pattern that is a multiple of 2, 4, 6, or 12 stitches to substitute for the main pattern, adding balancing stitches as necessary to center the pattern symmetrically on the front, back, and sleeves.

◇ Chart two or three repeats of the pattern, plus balancing stitches, to use for the side panels, then plot the placement of the waist shaping on this chart.

◇ Check the gauge of your new patterns and adjust needle size if necessary to achieve the correct measurements.

◇ If you want to add 1" (2.5 cm) or less to the body length, add extra rounds to the lower body below the waist shaping so that the extra length is added between the cast-on and the start of the waist decreases. For a longer body, calculate the number of extra rounds you'll need and distribute that number evenly between the existing decreases.

◇ In addition to choosing your own stitch patterns, you can also modify this project by omitting the sleeves to make a vest, omitting the collar or cuffs, or by working shorter sleeves.

Rep the last row until piece measures 29 (33, 38, 42, 46, 50)" (73.5 [84, 96.5, 106.5, 117, 127] cm) from CO, ending with a WS row.

NEXT ROW: Sl 1 wyf, M1, [p1, k1] 2 times—6 sts.

NEXT ROW: Sl 1 wyf, M1, [p1, k1] 2 times, k1—7 sts.

NEXT 3 ROWS: Sl 1 wyf, [k1, p1] 2 times, k2.

Knit the next WS row for turning ridge. Work 3 rows in St st, beg and ending with a RS row. Change to waste yarn and work 2 more rows in St st.

Place sts onto holder if desired, and block belt. Wrap the St st section around one half of buckle, folding along the turning ridge. Carefully remove the waste yarn, and use yarn threaded on a tapestry needle to sew live sts to WS of belt. Rep for other half of buckle. Weave in loose ends.

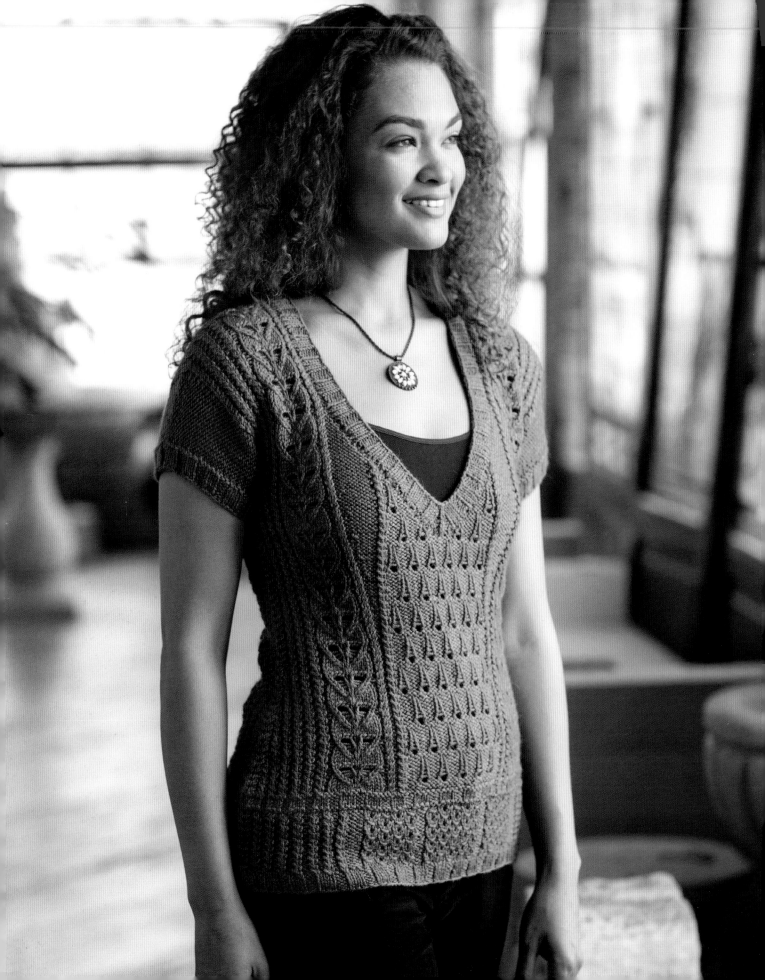

Textured V-Neck Top

This top demonstrates ways to adjust stitch counts between patterns that have different gauges and two ways to achieve waist shaping. Beginning directly above the ribbing, the lower border is a combination of drops and twist patterns that maintain a constant width. Decreases worked along the sides shape the section between the hips and waist; increases restricted to reverse-stockinette areas shape the section between the waist and bust. The twisted rib pattern contours female curves artfully and adds a slimming element.

designed by **SIMONA MERCHANT-DEST**

FINISHED SIZE
About 34½ (38½, 42, 46, 51½, 56)" (87.5 [98, 106.5, 117, 131, 142] cm) bust circumference.

Top shown measures 34½" (87.5 cm).

YARN
Worsted weight (#4 Medium).

Shown here: The Fibre Company Canopy Worsted (50% baby alpaca, 30% merino, 20% viscose bamboo; 100 yd [91 m]/50 g): acai, 9 (10, 11, 13, 14, 15) skeins.

NEEDLES
Size U.S. 7 (4.5 mm): 32" (80 cm) circular (cir) and set of 5 double-pointed (dpn) or 16" (40 cm) cir.

Adjust needle size if necessary to obtain the correct gauge.

NOTIONS
Markers (m; one in a different color to mark end of rnd); removable markers; two cable needles (cn); stitch holders; spare needles same size as main needles or smaller for three-needle bind-off; tapestry needle.

GAUGE
20 sts and 28 rows/rnds = 4" (10 cm) in Rev St st.

23 sts and 28 rows/rnds = 4" (10 cm) in right and left twisted rib patts.

22 sts = 4" (10 cm) in drops patt.

9–17 sts of Heart chart (see Notes) measure 2¾" (7 cm) wide.

19½ sts = 4" (10 cm) in patt from Eiffel Tower chart.

Design Techniques

Dolman construction worked in rounds from the bottom up, page 8.

Shaping in textured stitch patterns, page 125.

Patterns with fluctuating stitch counts, page 20.

Backward-loop cast-on, page 171.

Provisional cast-on, page 172.

Short rows, page 178.

Kitchener stitch, page 174.

Three-needle BO, page 171.

TIPS & TRICKS

- The body is worked in the round from the lower edge to the base of the V-neck, then divided for working back and forth in rows to the underarms. At the armholes, the two sides of the front and the back are divided and worked separately to the shoulders. The shoulders are shaped with short-rows.

- When the chart patterns change from working in rounds to working back and forth in rows, work the even-numbered rounds as WS rows.

- The Heart chart varies from 9 to 17 stitches; always count the chart as 17 stitches, even if it is on a row or round where the count has temporarily decreased.

- The drops patterns requires a 6-stitch repeat or a 6-stitch repeat plus 3 stitches to begin. After completing Rnd 1, the pattern decreases to a 5-stitch repeat, or a 5-stitch repeat plus 2. After Rnd 3, the pattern decreases to a 5-stitch repeat, or a 5-stitch repeat plus 3. After completing Rnds 2 and 4, the pattern increases back to a 6-stitch repeat or a 6-stitch repeat plus 3 again.

- When working the waist decreases, maintain the twisted rib patterns as well as possible. If there are not enough stitches to work a complete RT or LT, work the remaining stitch in stockinette instead.

STITCH GUIDE

3×2 RIB (MULTIPLE OF 5 STS)

ALL RNDS: P1, *k3, p2; rep from * to last 4 sts, k3, p1.

LT (LEFT TWIST; WORKED OVER 2 STS)

Odd-numbered rnds and RS rows: Skip the first st on left needle, knit the second st through the back loop (tbl) but do not remove the st from the left needle, then knit the first st, and slip both sts from the left needle tog.

Even-numbered rnds and WS rows: Work sts as they appear (k2 on RS rnds and rows; p2 on WS rows).

RT (RIGHT TWIST; WORKED OVER 2 STS)

Odd-numbered rnds and RS rows: Skip the first st on left needle, knit the second st through its front loop in the normal manner but do not remove the st from the left needle, then knit the first st, and slip both sts from the left needle tog.

Even-numbered rnds and WS rows: Work sts as they appear (k2 on RS rnds and rows; p2 on WS rows).

RIGHT TWISTED RIB (MULTIPLE OF 3 STS + 2)

IN RNDS:

RND 1: RT (see above), *p1, RT; rep from *.

RND 2: K2, *p1, k2; rep from *.

IN ROWS:

ROW 1: (RS) RT, *p1, RT; rep from *.

ROW 2: (WS) P2, *k1, p2; rep from *.

Rep Rows/Rnds 1 and 2 for patt.

LEFT TWISTED RIB (MULTIPLE OF 3 STS + 2)

IN RNDS:

RND 1: LT (see above), *p1, LT; rep from *.

RND 2: K2, *p1, k2; rep from *.

IN ROWS:

ROW 1: (RS) LT, *p1, LT; rep from *.

ROW 2: (WS) P2, *k1, p2; rep from *.

Rep Rows/Rnds 1 and 2 for patt.

DROPS PATTERN (MULTIPLE OF 6 STS)

RND 1: *K3, pass third st on right needle over first 2 sts, k3; rep from *—1 st dec'd per rep; patt is a multiple of 5 sts.

RND 2: *K1, yo, k4; rep from *—1 sts inc'd per rep; patt is a multiple of 6 sts.

RND 3: *K6, pass third st on right needle over first 2 sts; rep from *—1 st dec'd per rep; patt is a multiple of 5 sts.

RND 4: *K4, yo, k1; rep from *—1 st inc'd per rep; patt is a multiple of 6 sts.

Rep Rnds 1–4 for patt.

DROPS PATTERN (MULTIPLE OF 6 STS + 3)

RND 1: *K3, pass third st on right needle over first 2 sts, k3; rep from * to last 3 sts, k3, pass third st on right needle over first 2 sts—1 st dec'd per rep; patt is a multiple of 5 sts plus 2.

RND 2: *K1, yo, k4; rep from * to last 2 sts, k1, yo, k1—1 st inc'd per rep; patt is a multiple of 6 sts plus 3.

RND 3: *K6, pass third st on right needle over first 2 sts; rep from * to last 3 sts, k3—1 st dec'd per rep; patt is a multiple of 5 sts plus 3.

RND 4: *K4, yo, k1; rep from * to last 3 sts, k3—1 st inc'd per rep; patt is a multiple of 6 sts plus 3.

Rep Rnds 1–4 for patt.

LTDEC (LT DECREASE)

Sl 1 st onto cn needle (cn) and hold in front of work, k1, then return st from cn onto left needle and work it tog with the st after it as ssk—1 st dec'd.

RTDEC (RT DECREASE)

Sl the st before the RT onto right needle, sl next st onto cn and hold in back of work, return the slipped st from right needle onto left needle and work it tog with the st after it as k2tog, then k1 from cn—1 st dec'd.

MODLTDEC (MODIFIED LT DECREASE)

Sl 1 st onto cn and hold in front of work, k1, sl next st onto another cn and hold in back of work, return st from front cn onto left needle and work it tog with st after it as ssk, then k1 from back cn—1 st dec'd.

MODRTDEC (MODIFIED RT DECREASE)

Sl 1 st onto cn and hold in front of work, k1, sl next st onto another cn and hold in back of work, return st from front cn onto left needle and work it tog with st after it as k2tog, then k1 from back cn—1 st dec'd.

SL 1 WITH YOS

Bring yarn to front, sl the next st pwise along with any yarnovers lying on top of it, bring yarn to back over the top of the right needle to add another yarnover on top of the slipped st. After creating the new yarnover on top of the needle, leave the yarn in back on RS rows and all rounds; bring the yarn to the front again between the needles on WS rows.

Note: In Rnd/Row 2 of the Heart chart, there won't be a yarnover on top of the slipped stitch yet; simply, slip the stitch pwise, then bring the yarn to the back over the top of the right needle to create the first yarnover.

K1 TOG WITH 5 YOS

Insert the right needle tip under all 5 yarnovers on top of the needle and into the slipped st under them, then knit all 5 loops and the slipped st tog.

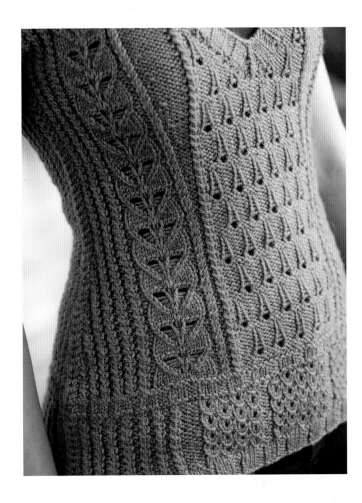

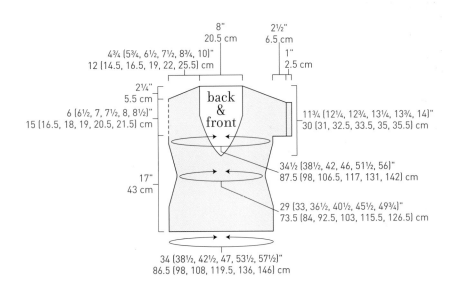

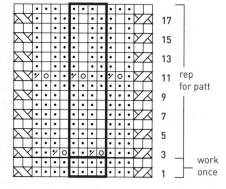

HEART

EIFFEL TOWER

	knit on RS rows and all rnds; purl on WS rows
·	purl on RS rows and all rnds; knit on WS rows
/	k2tog on RS rows and all rnds; p2tog on WS rows
\	ssk on RS rows and all rnds; ssp on WS rows
⋎	p2tog
o	yo
+	CO 1 st with backward-loop method (see Glossary)
‖	sl 1 with yos (see Stitch Guide)
∩	k1 tog with 5 yos (see Stitch Guide)
⋈	RT (see Stitch Guide)
⋊	LT (see Stitch Guide)
▨	no stitch
☐	pattern repeat

Lower Border

With longer cir needle, CO 180 (200, 220, 240, 265, 285) sts. Place marker (pm) in the end-of-rnd color and join for working in rnds, being careful not to twist sts. Rnd begs at left side "seam" at start of front sts.

Work in 3×2 rib patt (see Stitch Guide) for 6 rnds—piece measures ¾" (2 cm) from CO.

NEXT RND: Knit and *at the same time* inc 10 (14, 18, 22, 33, 37) sts evenly spaced (see page 175)—190 (214, 238, 262, 298, 322) sts.

SET-UP RND: *LT (see Stitch Guide), p1, work Rnd 1 of right twisted rib (see Stitch Guide) over 20 (23, 26, 29, 35, 38) sts, p3, work Rnd 1 of drops patt (see Stitch Guide) over 12 (12, 15, 15, 18, 18) sts, p2, work Rnd 1 of drops patt over center 15 (21, 21, 27, 27, 33) sts, p2, work Rnd 1 of drops patt over 12 (12, 15, 15, 18, 18) sts, p3, work Rnd 1 of left twisted rib (see Stitch Guide) over 20 (23, 26, 29, 35, 38) sts, p1, RT (see Stitch Guide),* pm for right side "seam," rep from * to * once more for back.

Working the purl sts between patts in Rev St st (purl every rnd), work 16 rnds even in established patts, ending with Rnd 1 of twisted rib and drops patts—piece measures 3¼" (8.5 cm) from CO.

Note: *Because each drops patt is now either a multiple of 5 sts or a multiple of 5 sts plus 2, the actual stitch count has been decreased to 176 (198, 218, 240, 276, 298,) sts total; 88 (99, 109, 120, 138, 149) sts each for front and back. We will take advantage of this natural reduction in sts to transition to the next section.*

Cont for your size as foll:

Sizes 34½ (38½, 42, 46)" only

NEXT RND: Knit and *at the same time* inc 4 (2, 2, 0) sts evenly spaced—180 (200, 220, 240) sts.

Sizes (51½, 56)" only

NEXT RND: Knit and *at the same time* dec (11, 13) sts evenly spaced—(265, 285) sts.

All sizes

Purl 1 rnd, work 3 rnds in 3×2 rib, purl 1 rnd.

NEXT RND: Knit and *at the same time* inc 18 (18, 18, 18, 21, 21) sts evenly spaced—198 (218, 238, 258, 286, 306) sts; 99 (109, 119, 129, 143, 153) sts each for front and back; piece measures about 4" (10 cm) from CO.

Re-position right side "seam" marker if necessary to have the same number of sts on front and back.

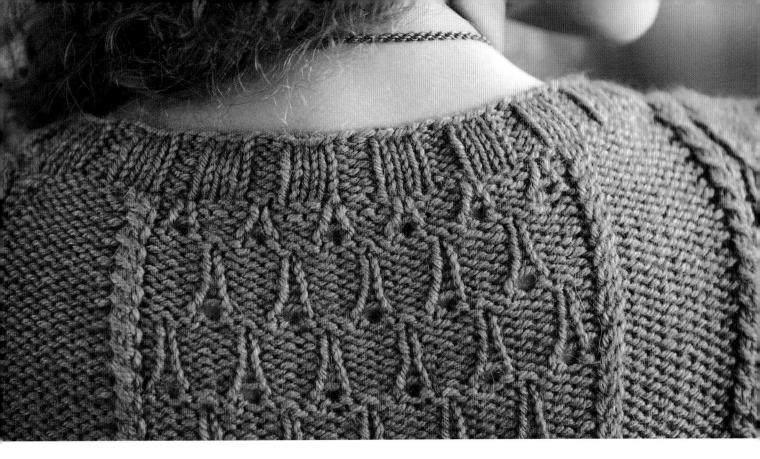

Body

SET-UP RND: *LT, p1, work Rnd 1 of right twisted rib over 14 (17, 20, 23, 26, 29) sts, p1, work Rnd 1 of Heart chart over 17 sts, p1, work Rnd 1 of Eiffel Tower chart over center 27 (31, 35, 39, 47, 51) sts, p1, work Rnd 1 of Heart chart over 17 sts, p1, work Rnd 1 of left twisted rib over 14 (17, 20, 23, 26, 29) sts, p1, RT,* pm for right side "seam." rep from * to * once more for back.

Working the purl sts between patts in Rev St st, work 3 rnds even in established patts, ending with Rnd 4 of both charts and Rnd 2 of twisted rib patts—piece measures 4½" (11.5 cm) from CO.

Note: As you work the foll shaping, work the Eiffel Tower chart until Rnd 18 has been completed, then rep Rnds 3–18 for patt; do not rep Rnds 1 and 2. For the Heart chart, work until Rnd 8 has been completed, then rep Rnds 1–8 for patt.

Shape Waist

Note: The waist decreases are worked inside the 2-st twists on each side of the markers. When there is a k1 or p1 next to the side twist, use LTdec or RTdec (see Stitch Guide) to remove the single st. When there is a full 2-st twist next to the side twist, use modLTdec and modRTdec (see Stitch Guide) to remove 1 of the 2 twist sts. On the foll dec rnd, you can use LTdec or RTdec again because only a single k1 will rem next to each side twist.

RND 1: *LTdec, work in patt to 3 sts before next m, RTdec; rep from *—4 sts dec'd.

RNDS 2–4: Work 3 rnds even in patt.

RND 5: *modLTdec, work in patt to 4 sts before next m, modRTdec; rep from *—4 sts dec'd.

RNDS 6–8: Work 3 rnds even in patt.

RND 9: Rep Rnd 1—4 sts dec'd.

RNDS 10–12: Work 3 rnds even in patt.

Cont in patt, rep the shaping of the last 12 rnds 2 more times—162 (182, 202, 222, 250, 270) sts rem; 81 (91, 101, 111, 125, 135) sts each for front and back; piece measures about 9¾" (25 cm) from CO.

Work even in patt until piece measures 10" (25.5 cm) from CO, ending with an even-numbered rnd.

Shape Bust and Front Neck

If you do not already have the Heart charts set off with markers, place a removable m at the end of the first Heart chart and at the beg of the second Heart chart on both the front and back—29 (33, 37, 41, 49, 53) center

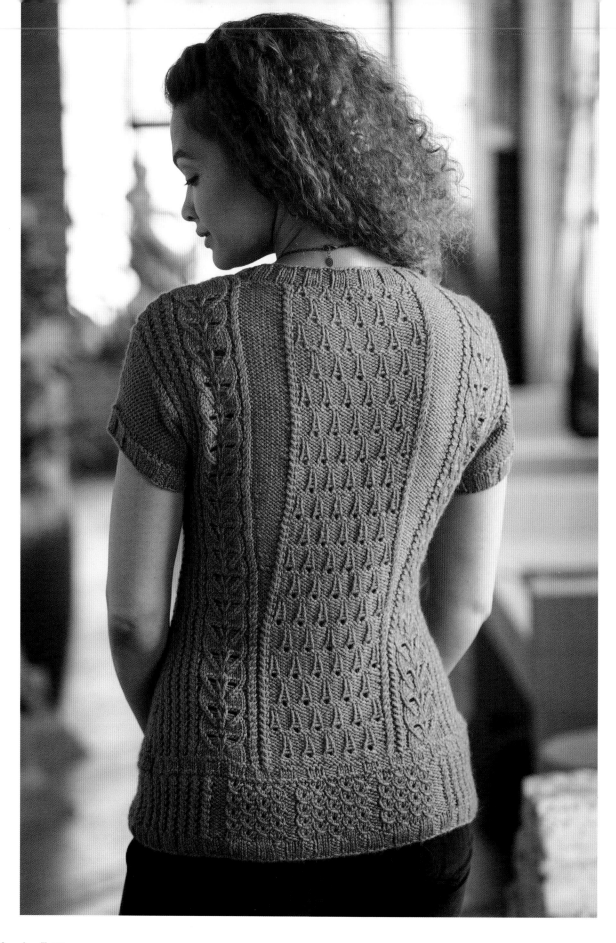

sts between m; 27 (31, 35, 39, 47, 51) Eiffel Tower sts; 1 purl st on each side of Eiffel Tower section.

INC RND: *Work in patt to beg of marked center section, slip marker (sl m), M1P (see Glossary), purl to Eiffel Tower chart, work chart as established, purl to end of marked center section, M1P, sl m, work in patt to side m; rep from * once more for back—4 sts inc'd, 1 st in each of 4 Rev St st sections next to Eiffel Tower charts.

Inc 4 sts in this manner every 8th rnd 2 (2, 2, 2, 2, 0) more times, then every 6th rnd 1 (1, 1, 1, 1, 4) time(s), working new sts in Rev St st and ending with an odd-numbered inc rnd—178 (198, 218, 238, 266, 290) sts; 89 (99, 109, 119, 133, 145) sts each for front and back; 5 (5, 5, 5, 5, 6) sts in each of 4 Rev St st sections next to Eiffel Tower charts.

Work 1 even-numbered rnd after last inc rnd—piece measures 13½ (13½, 13½, 13½, 13½, 13¾)" (34.5 [34.5, 34.5, 34.5, 34.5, 35] cm) from CO.

Shape Front Neck

Mark center front st with removable m—44 (49, 54, 59, 66, 72) front sts each side of center front.

Cut yarn. With RS facing, sl the first 44 (49, 54, 59, 66, 72) front sts pwise without working them to end at marked center front st. Rejoin yarn.

V-NECK DIVIDING ROW: (RS) Keeping in patts, BO 1 st at center front, work to end of right front, work across back sts, work to end of left front—44 (49, 54, 59, 66, 72) sts each for right and left front, 89 (99, 109, 119, 133, 145) back sts.

Change to working back and forth in rows, beg and ending at neck edges. Work 1 WS row even in patt.

Note: Neck shaping is worked at the same time as bust shaping continues; read the next sections all the way through before proceeding.

NECK DEC ROW: (RS) P1, ssp (see Glossary), work in patt to last 3 sts, p2tog, p1—1 st dec'd at each neck edge.

Rep the neck dec row on the next 11 (11, 11, 11, 11, 10) RS rows, ending with a RS inc row—12 (12, 12, 12, 12, 11) sts total dec'd at each neck edge, including the first neck dec row.

At the same time inc 4 bust sts as established beg on the 6th row after the previous bust inc rnd, then every 6th row 2 more times—3 bust sts inc'd each front; 6 bust sts inc'd for back; 8 (8, 8, 8, 8, 9) sts in each Rev St st section

next to Eiffel Tower charts—35 (40, 45, 50, 57, 64) sts rem each front after all shaping is complete; 95 (105, 115, 125, 139, 151) back sts; piece measures 17" (43 cm) from CO for all sizes.

Cut yarn and place front sts onto separate holders or waste yarn—95 (105, 115, 125, 139, 151) back sts rem on needle.

Back

Rejoin yarn to back sts with WS facing.

CO sleeve sts at each side as foll:

NEXT ROW: (WS) Using a provisional method (see Glossary), CO 12 sts at beg of row, knit across 12 new sts, work in patt to end, then use a provisional method to CO 12 sts at end of row—119 (129, 139, 149, 163, 175) sts total.

Working 12 sleeve sts at each end of row in Rev St st, work even in patts until armholes measure 6 (6½, 7, 7½, 8, 8½)" (15 [16.5, 18, 19, 20.5, 21.5] cm) from sts CO at start of sleeves, ending with WS Row 8 of Heart chart.

Shape Shoulders

Note: During short-row shaping, after completing Row 7 of the Heart chart, work the center 11 sts of the chart in St st to the end so there will be no partial heart motifs at the shoulders.

Work short-rows (see Glossary) as foll:

SHORT-ROW 1: (RS) Work in patt to last 5 (6, 6, 7, 8, 9) sts, wrap next st, turn work.

SHORT-ROW 2: (WS) Work in patt to last 5 (6, 6, 7, 8, 9) sts, wrap next st, turn work.

SHORT-ROWS 3–12: Work in patt to 5 (6, 6, 7, 8, 9) sts before previously wrapped st, wrap next st, turn work—last wrapped st at each side is the 30 (36, 36, 42, 48, 54)th st from end of the row; 59 (57, 67, 65, 67, 67) center sts between last pair of wrapped sts.

SHORT-ROWS 13 AND 14: Work in patt to 10 (9, 14, 13, 14, 14) sts before last wrapped st, wrap next st, turn work—last wrapped st at each side is the 40 (45, 50, 55, 62, 68)th st from end of row; 39 sts rem between last pair of wrapped sts for all sizes.

NEXT ROW: (RS) Work 39 back neck sts, work in patt to end, working wraps tog with wrapped sts when you come to them.

NEXT ROW: (WS) Keeping in patt, work 40 (45, 50, 55, 62, 68) sts for left back shoulder and place sts just worked onto holder, BO center 39 sts for back neck, work in patt to end, working rem wraps tog with wrapped sts when you come to them—40 (45, 50, 55, 62, 68) right back shoulder sts rem. Place right shoulder sts onto separate holder.

Fronts

Return 35 (40, 45, 50, 57, 64) sts for each front onto needle and join a separate ball of yarn to each group with WS facing. Last row completed on each front was a RS neck dec row.

Working each front separately, cont neck shaping while picking up sts for sleeves as foll:

NEXT ROW: (WS) On right front, pick up and knit 12 sts from base of provisional CO sts of right back sleeve, work to end of right front sts; on left front, work to end of left front sts, then pick up and knit 12 sts from base of provisional CO sts of left back sleeve—47 (52, 57, 62, 69, 76) sts each side.

Working 12 sleeve sts at each end of row in Rev St st, dec 1 st at each neck edge on the next RS row, then every other RS row (i.e., every 4th row) 6 (6, 6, 6, 6, 7) more times—40 (45, 50, 55, 62, 68) sts rem each side. Work even in patts until armholes measure 6 (6½, 7, 7½, 8, 8½)" (15 [16.5, 18, 19, 20.5, 21.5] cm) from sts CO at start of sleeves, ending with the same WS of Heart chart as for back.

Shape Shoulders

Note: *As for the back, work the center 11 sts of each Heart chart in St st to avoid having any partial heart motifs at the shoulders. Each shoulder is worked separately, beginning with the left front shoulder; the right shoulder sts can be placed on a holder or allowed to rest on the cable portion of the cir needle while working the left shoulder.*

Left front shoulder

Working sts of left front shoulder only, work short-rows as foll:

SHORT-ROW 1: (RS) Work in patt to neck edge, turn work.

SHORT-ROW 2: (WS) Work in patt to last 5 (6, 6, 7, 8, 9) sts, wrap next st, turn work.

SHORT-ROWS 3, 5, 7, 9, AND 11: Work in patt to neck edge, turn work.

SHORT-ROWS 4, 6, 8, 10, AND 12: Work in patt to 5 (6, 6, 7, 8, 9) sts before previously wrapped st, wrap next st, turn work—last wrapped st is the 30 (36, 36, 42, 48, 54)th st from the armhole edge

SHORT-ROW 13: Work in patt to neck edge.

SHORT-ROW 14: Work in patt to end, working wraps tog with wrapped sts when you come to them.

Work 2 rows even in patt across all sts, ending with a WS row. Place sts onto holder.

Right front shoulder

Return 40 (45, 50, 55, 62, 68) right shoulder sts to needle with RS facing if they are not already on the needle.

Work short-rows as foll:

SHORT-ROW 1: (RS) Work in patt to last 5 (6, 6, 7, 8, 9) sts, wrap next st, turn work.

SHORT-ROW 2: (WS) Work in patt to neck edge, turn work.

SHORT-ROWS 3, 5, 7, 9, AND 11: Work in patt to 5 (6, 6, 7, 8, 9) sts before previously wrapped st, wrap next st, turn work—last wrapped st is the 30 (36, 36, 42, 48, 54)th st from the armhole edge.

SHORT-ROWS 4, 6, 8, 10, AND 12: Work in patt to neck edge, turn work.

SHORT-ROW 13: Work in patt to end, working wraps tog with wrapped sts when you come to them.

Work 3 rows even in patt across all sts, ending with a WS row. Place sts onto holder.

Finishing

Join Shoulders

Place 40 (45, 50, 55, 62, 68) held front and back right shoulder sts onto separate spare needles. Hold the needles parallel with RS of fabric touching and WS facing out, and use the three-needle method (see Glossary) to BO the sts tog. Rep for left shoulder.

Sleeve Edging

With shorter cir needle or dpn, RS facing, and beg at sleeve seam, pick up and knit 60 (65, 70, 75, 80, 90) sts evenly spaced around sleeve opening. Pm and join for working in rnds. Purl 1 rnd. Work 3×2 rib for 6 rnds—edging measures 1" (2.5 cm) from pick-up rnd. BO all sts in rib patt

Neck Edging

With shorter cir needle or dpn, RS facing, and beg at right shoulder join, pick up and knit 40 sts across back neck edge, 62 (62, 67, 67, 72, 72) sts along left front edge, 1 st in center front (place removable marker in this st), and 62 (62, 67, 67, 72, 72) sts along right front edge—165 (165, 175, 175, 185, 185) sts total. Pm and join for working in rnds. If necessary, move the removable marker up as you work so you can readily identify the center st.

SET-UP RND: P1, [k3, p2] 20 (20, 21, 21, 22, 22) times, k1, k1 (marked center st), k1, [p2, k3] 12 (12, 13, 13, 14, 14) times, p1.

DEC RND: Work sts as they appear to 1 st before marked center front st, sl 2 sts tog kwise, k1, p2sso, work sts as they appear to end—2 sts dec'd.

NEXT RND: Work sts as they appear.

Cont in patt as established, rep the last 2 rnds 2 more times, then work the dec rnd once more—7 rnds completed from pick-up rnd; 157 (157, 167, 167, 177, 177) sts rem. BO all sts in rib patt.

Weave in loose ends. Block to measurements.

Note: *The sleeve edgings are shown on schematic but neck edging is not shown for clarity.*

Make It Yours

Stitch pattern breakdown:
Drops pattern: Multiple of 6 stitches.
Heart pattern: Panel of 17 stitches.
Eiffel Tower pattern: Multiple of 4 plus 11 stitches.

◊ You can substitute your own patterns for the Drops, Heart, and Eiffel Tower patterns, but do not substitute for the cables along the sides.

◊ If you substitute another pattern for the Drops pattern, it must be one where the center 6 stitches can be divided into two groups of 3 stitches on each side of the base of the V-neck shaping.

◊ Check the gauge of your new patterns and adjust needle size if necessary to achieve the correct measurements.

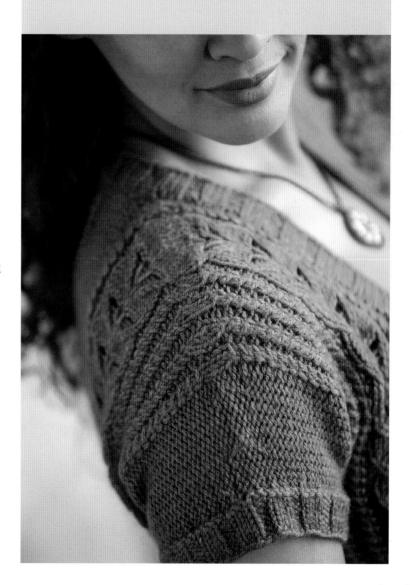

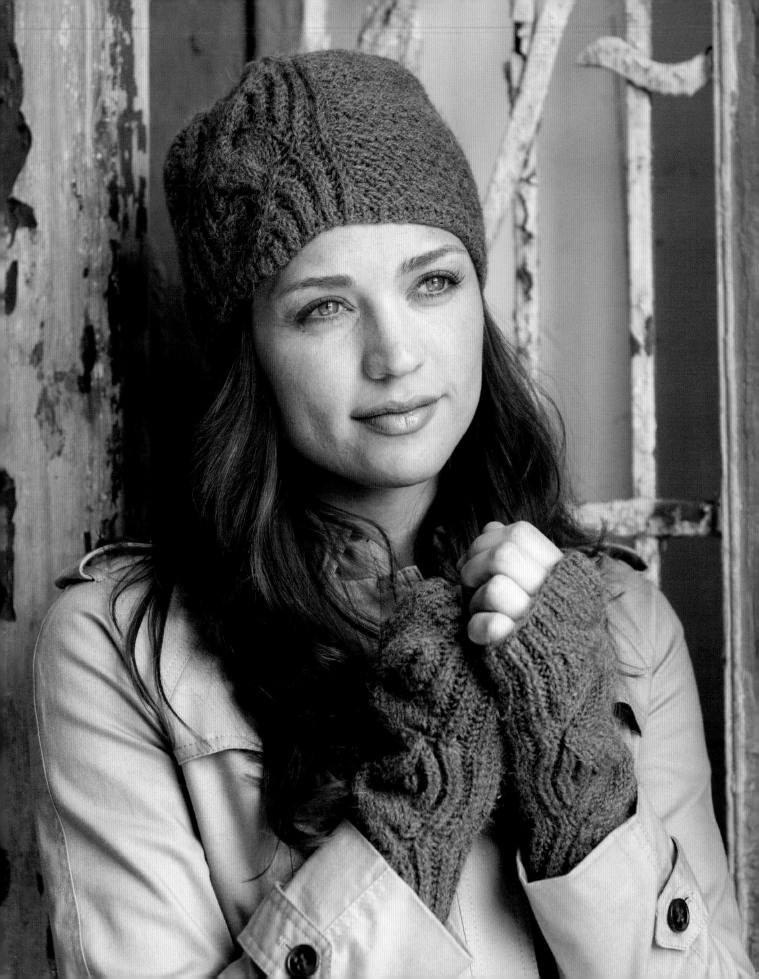

Brioche Hat and Fingerless Gloves

The combination of three stitch patterns—textured little waves, brioche, and a stockinette cable—makes this hat and fingerless gloves interesting to knit and stylish to wear. Because there is a difference in row gauges, the cable pattern is a bit longer and forms an attractive "dip" along the edge. This design demonstrates how to adapt multiple patterns for working harmoniously in the round. Pay close attention to the details and be sure to work separate charts for the two gloves.

designed by **FAINA GOBERSTEIN**

FINISHED SIZE

Hat: about 18¼ (20, 22¼)" (46.5 [51, 56.5] cm) circumference.

Hat shown measures 20" (51 cm).

Gloves: about 7½" (19 cm) hand circumference, 7½" (19 cm) long on palm side of hand, and 9" (23 cm) long on back of hand.

YARN

Worsted weight (#4 Medium).

Shown here: Berroco Ultra Alpaca (50% alpaca, 50% wool; 215 yd [196 m]/100 g): #6287 denim mix, 1 skein each for hat and gloves.

NEEDLES

Hat and gloves: size U.S. 7 (4.5 mm): 16" (40 cm) circular (cir) and set of 5 double-pointed (dpn).

Ribbing: size U.S. 6 (4 mm): 16" (40 cm) cir.

Adjust needle size if necessary to obtain the correct gauge.

NOTIONS

Markers (m); cable needle (cn); 12" (30.5 cm) of smooth waste yarn for gloves; tapestry needle.

GAUGE

20 sts and 32 rnds = 4" (10 cm) in little waves patt on larger needle, worked in rnds.

22 sts of Brioche Cable chart measure 4¼" (11 cm) wide on larger needle, worked in rnds.

18 sts and 46 rnds = 4" (10 cm) in basic brioche patt on larger needles, worked in rnds.

10-st marked cable sections average about 1¾" (4.5 cm) wide on larger needles, worked in rnds.

38 rnds = 4" (10 cm) in cable section of Left Glove and Right Glove charts on larger needles, worked in rnds.

Design Techniques

Designing with cables, page 74.

Brioche stitch patterns, page 124.

Three-needle bind-off, page 171.

TIPS & TRICKS

- The stitch patterns are presented for working in the round; work your gauge swatch in the round.

- Use markers to set off the brioche and cable panel.

- To tighten the yarnovers and minimize holes adjacent to the cables, work the yarnovers by inserting the right needle through the back loop of the yarnover but do not slip the yarnover off the left needle. Then use the right needle tip to make a circular motion going down and up clockwise to the starting point to twist the back loop of the yarnover. Slip the twisted yarnover to the right needle, then return it to the left needle and work in pattern.

- Waste yarn is used to mark the thumb openings while the hand of the glove is knitted. The thumbs are worked later on the waste-yarn stitches along with stitches picked up from the top and sides of the thumb opening.

- All length measurements are taken in the brioche pattern on the palm side of glove; do not measure along the cable pattern on the back of the hand.

- The purl columns of the brioche pattern are shaded in blue on the charts to better distinguish them from the brioche knit columns.

- To avoid ladders of loose stitches at the breaks between needles, shift the stitches periodically by working two or three stitches from one needle onto the next needle, keeping all markers in place.

- Instead of double-pointed needles, these gloves can be worked using the magic-loop method or with two circular needles, if desired.

STITCH GUIDE

YOP1P

Yo, p1, pass yo over purl st—1 st made from 1 st.

YOP2P

Yo, p2, pass yo over 2 purled sts—2 sts made from 2 sts.

YOP2TOGP

Yo, p2tog, pass yo over decreased st—2 sts dec'd to 1 st.

YFSL1YO (YARN FORWARD, SL 1, YARN OVER)

Sl 1 st purlwise with yarn in front (pwise wyf), then bring the yarn over the right needle and over the slipped st to the back (if the next st is s knit), or to the back and between the needles to the front again (if the next st is a purl), in position to work the following st—the slipped st/yo pair counts as 1 st.

BRK1 (BRIOCHE KNIT)

Knit the st that was slipped in the previous rnd tog with its yarnover—counts as 1 st.

BRP1 (BRIOCHE PURL)

Purl the st that was slipped in the previous rnd tog with its yarnover— counts as 1 st.

LITTLE WAVES IN THE ROUND FOR SWATCH (EVEN NUMBER OF STS)

RND 1: *Yop2p (see above); rep from * to end.

RND 2: Knit to last st, temporarily sl last st to right needle, remove end-of-rnd marker, return slipped st to left needle, replace marker on right needle—end-of-rnd has moved 1 st to the right.

RND 3: *Yop2p; rep from * to end.

RND 4: Knit to end, remove end-of-rnd marker, k1, replace marker on right needle—end-of-rnd has moved 1 st to the left to its original position.

Rep Rnds 1–4 for patt.

BASIC BRIOCHE (EVEN NUMBER OF STS)

SET-UP RND: *Yfsl1yo (see Stitch Guide), k1; rep from *.

RND 1: *Brk1 (see Stitch Guide), yfsl1yo; rep from *

RND 2: *Yfsl1yo, brp1 (see Stitch Guide); rep from *.

Rep Rnds 1 and 2 for patt; do not rep set-up rnd.

Hat

With smaller cir needle, CO 42 (48, 54) sts, place marker (pm), CO 22 more sts for cable panel, pm, then CO 28 (32, 36) more sts—92 (102, 112) sts total. Pm for end-of-rnd and join for working in rnds, being careful not to twist sts.

RND 1: *K1, p1; rep from * to end.

RND 2: Work 42 (48, 54) sts as they appear (knit the knits and purl the purls), slip marker (sl m), [k1, yfsl1yo (see Stitch Guide)] 11 times, sl m, work 28 (32, 36) sts as they appear.

RND 3: [Yop2p] (see Stitch Guide) 21 (24, 27) times, sl m, work Rnd 1 of Brioche Cable chart (page 166) over 22 sts, sl m, [yop2p] 14 (16, 18) times.

RND 4: Knit to m, sl m, work Rnd 2 of chart over 22 sts, sl m, knit to last st, temporarily sl last st to right needle, remove end-of-rnd marker, return slipped st to left needle, replace marker on right needle—end-of-rnd has moved 1 st to the right.

Change to larger cir needle.

RND 5: [Yop2p] 21 (24, 27) times, yop1p (see Stitch Guide), sl m, work next rnd of chart over 22 sts, sl m, yop1p, [yop2p] (13, 15, 17) times.

RND 6: Knit to m, sl m, work next rnd of chart over 22 sts, sl m, knit to end, remove end-of-rnd marker, k1, replace marker on right needle—end-of-rnd has moved 1 st to the left, back to its original position.

RND 7: [Yop2p] 21 (24, 27) times, sl m, work next rnd of chart over 22 sts, sl m, [yop2p] 14 (16, 18) times.

RND 8: Knit to m, sl m, work next rnd of chart over 22 sts, sl m, knit to last st, temporarily sl last st to right needle, remove end-of-rnd marker, return slipped st to left needle, replace marker on right needle—end-of-rnd has moved 1 st to the right.

Cont chart patt as established, rep Rnds 5–8 eleven more times, then work Rnd 5 once more, ending with Rnd 51 of Brioche Cable chart—end-of rnd m is 1 st to the right of its original position; 90 (100, 110) sts total; 43 (49, 55) sts before marked cable section, 20 cable panel sts, 27 (31, 35) sts after cable section; piece measures about 6½" (16.5) from CO.

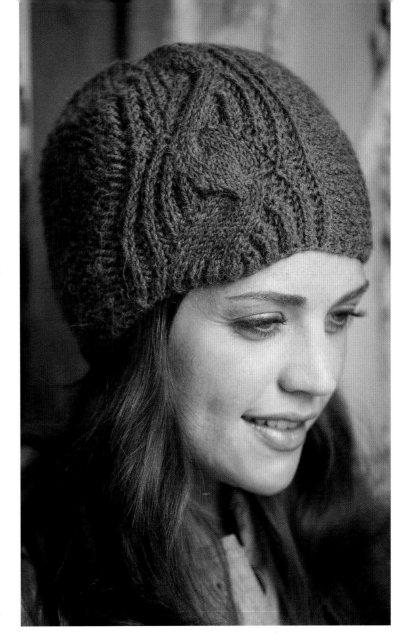

Shape Crown

Note: *Change to dpn when there are too few sts to fit comfortably on cir needle.*

SET-UP RND: K1, [k14 (16, 18), pm] 3 times, sl m, work Rnd 52 of chart, sl m, k14 (16, 18), pm, k13 (15, 17), remove end-of-rnd marker, k1, replace marker on right needle—14 (16, 18) sts each in 5 marked sections, 3 marked sections before cable panel, 20 cable sts, 2 marked sections after cable panel; end-of-rnd has moved 1 st to the left, back to its original position.

Dec as foll, working the sts next to the decs tightly to prevent holes:

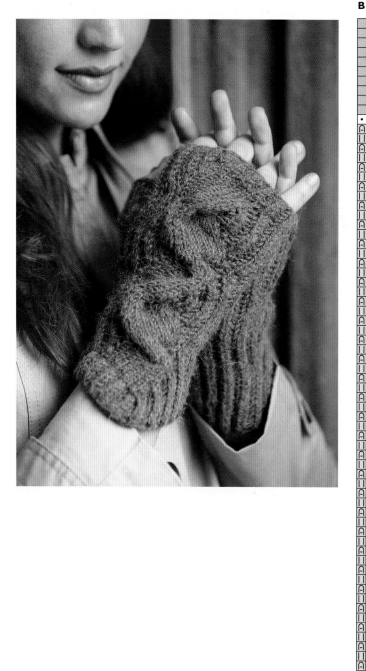

BRIOCHE CABLE

RIGHT GLOVE

29
27
25
23
21
19
17
15
13
11
9
7
5
3
1

LEFT GLOVE

29
27
25
23
21
19
17
15
13
11
9
7
5
3
1

		knit
		purl
		k1tbl
		yo
		k2tog
		ssk
		yfsl1yo (see Stitch Guide and Notes)
		brk1 (see Stitch Guide)
		brp1 (see Stitch Guide and Notes)
		stitch marker
		sl 4 sts onto cn, hold in back, k4, k4 from cn
		sl 4 sts onto cn, hold in front, k4, k4 from cn

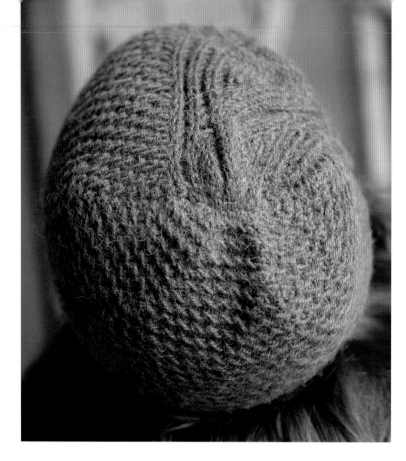

RND 1: *[Yop2p] 6 (7, 8) times, yop2togp (see Stitch Guide), sl m; rep from * 2 more times, work Rnd 53 of chart over 20 sts dec them to 19 sts as shown, sl m, **[yop2p] 6 (7, 8) times, yop2togp, sl m; rep from ** once more—13 (15, 17) sts each in 5 marked sections, 19 cable sts.

RND 2: [K2tog, knit to m, sl m] 3 times, work Rnd 54 of chart over 19 sts, sl m, [k2tog, knit to m, sl m] 2 times—12 (14, 16) sts each in 5 marked sections, 19 cable sts.

RND 3: *Rep [yop2p] to 2 sts before m, yop2togp, sl m; rep from * 2 more times, work next chart rnd to m, sl m, **rep [yop2p] to 2 sts before m, yop2togp, sl m; rep from ** once more—1 st dec'd in each of 5 marked sections, cable st count varies according to chart rnd.

RND 4: [K2tog, knit to m, sl m] 3 times, sl m, work next rnd of chart to m, sl m, [k2tog, knit to m, sl m] 2 times—1 st dec'd in each of 5 marked sections, cable st count varies according to chart rnd.

Cont chart patt as established, rep the shaping of the last 2 rnds 4 (5, 6) more times, ending with Rnd 64 (66, 68) of chart and removing m as you come to them in the last rnd—20 sts rem; 2 sts each in 5 marked sections for little wave patt; 10 brioche cable sts from chart.

Finishing

Place the last 4 sts of the rnd on one dpn, knit the first 6 sts of the rnd onto the same needle, then place rem 10 cable sts on another dpn—10 little wave sts on one dpn, 10 brioche cable sts on other dpn.

Turn hat inside out. Use the three-needle method (see Glossary) to BO all sts.

Weave in loose ends.

Gloves

Left Glove

CO 36 sts. Divide sts evenly onto 4 dpn. Place marker (pm) and join for working in rnds, being careful not to twist sts.

Work basic brioche patt (see Stitch Guide) for 8 rnds, including set-up rnd, ending with Rnd 1 of patt—piece measures about ¾" (2 cm).

SET-UP RND: [Yfsl1yo, brp1] 6 times, pm for beg of brioche cable, [k1, brk1] 5 times, pm, [yfsl1yo, brp1] 7 times.

Rep Rnds 1–30 of Left Glove chart until piece measures about 5½" (14 cm) from CO on palm side of hand (see Tips & Tricks), ending with an even-numbered rnd.

MARK THUMB: Work 3 sts in established patt, then, with waste yarn, work the next 5 sts as [k1, brk1] 2 times, k1, return the 5 sts just worked to left needle, change to working yarn and knit these 5 sts again, work in patt to end.

NEXT RND: Work 3 sts in patt, work 5 thumb sts as [p1, yfsl1yo] 2 times, p1, work in patt to end.

Cont in patts as established until piece measures about 6¾" (17 cm) from CO on palm side of hand.

Work all sts in basic brioche patt as established for 8 rnds—piece measures about 7½" (19 cm) from CO.

BO all sts in k1, p1 rib patt.

Thumb

Carefully remove waste yarn from thumb sts and place 5 sts onto dpn. Slip another dpn into the 4 loops along the base of the 5 sts above the thumb opening—9 sts total.

Join yarn with RS facing to beg of thumb sts.

NEXT RND: K5, use an empty dpn to pick up and knit 3 sts from side of thumb opening, k4 sts from above the thumb opening, then use another empty dpn to pick up and knit 3 sts from other side of thumb opening—15 sts.

Pm, and join for working in rnds. Work even in St st until thumb measures about 1½" (3.8 cm) from pick-up rnd. BO all sts.

Right Glove

CO 36 sts. Divide sts evenly onto 4 dpn. Pm and join for working in rnds, being careful not to twist sts.

Work basic brioche patt for 8 rnds, including set-up rnd, ending with Rnd 1 of patt—piece measures about ¾" (2 cm).

SET-UP RND: [Yfsl1yo, brp1] 7 times, pm for beg of brioche cable, [k1, brk1] 5 times, pm, [yfsl1yo, brp1] 6 times.

Rep Rnds 1–30 of Right Glove chart until piece measures about 5½" (14 cm) from CO on palm side of hand, ending with an even-numbered rnd.

MARK THUMB: Work in established patt to last 8 sts, then, with waste yarn, work the next 5 sts as [brk1, k1] 2 times, brk1, return the 5 sts just worked to left needle, change to working yarn and knit these 5 sts again, work in patt to end.

NEXT RND: Work in patt to last 8 sts, work 5 thumb sts as [yfsl1yo, p1] 2 times, yfsl1yo, work in patt to end.

Complete hand and thumb as for left glove.

Finishing

Weave in loose ends. Block lightly, being careful not to flatten patterns.

Make It Yours

Stitch Pattern Breakdown:
Basic Brioche: Even number of stitches.
Traveling Cable: Panel of 8 stitches.

◊ You can substitute the cable with your choice of pattern that has the same gauge over 8 stitches or works out to be about 1¾" (4.5 cm) wide.

◊ To simplify the design, omit the cable pattern and work the gloves entirely in basic brioche stitch.

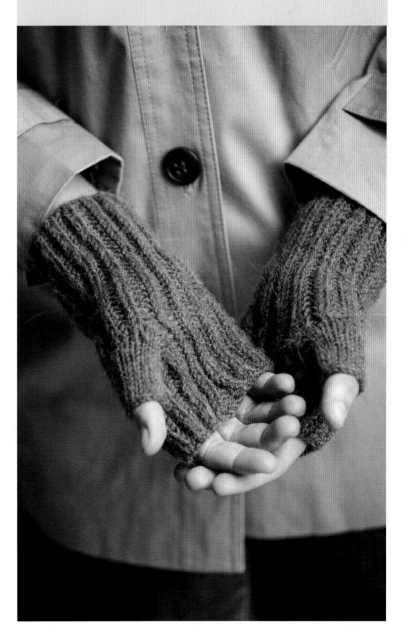

Glossary of Terms and Techniques

Abbreviations

beg(s)	begin(s); beginning	**kwise**	knitwise, as if to knit	**sl**	slip		
BO	bind off	**m**	marker(s)	**sl st**	slip st (slip 1 stitch purlwise unless otherwise indicated)		
cir	circular	**mm**	millimeter(s)	**ssk**	slip, slip, knit (decrease)		
cm	centimeter(s)	**M1**	make one (increase)	**st(s)**	stitch(es)		
cn	cable needle	**oz**	ounce	**St st**	stockinette stitch		
CO	cast on	**p**	purl	**tbl**	through back loop		
cont	continue(s); continuing	**p1f&b**	purl into front and back of same stitch	**tog**	together		
dec(s) ('d)	decrease(s); decreasing; decreased	**p2tog**	purl 2 stitches together	**WS**	wrong side		
dpn	double-pointed needles	**patt(s)**	pattern(s)	**wyb**	with yarn in back		
foll	follow(s); following	**pm**	place marker	**wyf**	with yarn in front		
g	gram(s)	**psso**	pass slipped stitch over	**yd**	yard(s)		
inc(s)('d)	increase(s); increasing; increase(d)	**pwise**	purlwise, as if to purl	**yo**	yarnover		
k	knit	**rem**	remain(s); remaining	*	repeat starting point		
k1f&b	knit into the front and back of same stitch	**rep**	repeat(s); repeating	* *	repeat all instructions between asterisks		
k2tog	knit 2 stitches together	**Rev St st**	reverse stockinette stitch	()	alternate measurements and/or instructions		
k3tog	knit 3 stitches together	**rnd(s)**	round(s)	[]	work instructions as a group a specified number of times		
		RS	right side				

Bind-Offs

Standard Bind-Off

Knit the first stitch, *knit the next stitch (two stitches on right needle), insert left needle tip into first stitch on right needle (**Figure 1**) and lift this stitch up and over the second stitch (**Figure 2**) and off the needle (**Figure 3**). Repeat from * for the desired number of stitches.

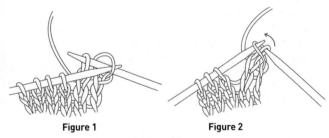

Figure 1 Figure 2

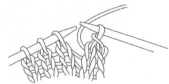

Figure 3

Three-Needle Bind-Off

Place the stitches to be joined onto two separate needles and hold the needles parallel so that the right sides of knitting face together. Insert a third needle into the first stitch on each of two needles **(Figure 1)** and knit them together as one stitch **(Figure 2)**, *knit the next stitch on each needle the same way, then use the left needle tip to lift the first stitch over the second and off the needle **(Figure 3)**. Repeat from * until no stitches remain on first two needles. Cut yarn and pull tail through last stitch to secure.

Figure 1

Figure 2

Figure 3

Blocking

Steam Blocking

Pin the pieces to be blocked to a blocking surface. Hold the steam head of a professional-grade steamer ½" (1.5 cm) above the knitted surface and direct the steam in long strokes over the entire surface (except ribbing). Use your hand to cool the fabric and repeat steaming as necessary. You can get similar results by lapping wet cheesecloth on top of the knitted surface and touching it lightly with a dry iron. Lift and set down the iron gently; do not let the iron rest on the fabric or move across in a pushing motion.

Wet-Towel Blocking

Run a large bath or beach towel (or two towels for larger projects) through the rinse/spin cycle of a washing machine. Roll the knitted pieces in the wet towel(s), place the roll in a plastic bag, and leave overnight so that the knitted pieces become uniformly damp. Pin the damp pieces to a blocking surface and let air-dry thoroughly.

Buttonholes

Note: This one-row buttonhole is worked over four stitches.

Bring the yarn to the front of the work, slip the next stitch purlwise, then return the yarn to the back. *Slip the next stitch, pass the second stitch over the slipped stitch **(Figure 1)** and drop it off the needle. Repeat from * once more. Slip the last stitch on the right needle to the left needle, then turn the work around. Bring the working yarn to the back, [insert the right needle between the first and second stitches on the left needle **(Figure 2)**, draw up a loop and place it on the left needle] three times. Turn the work around. With the yarn in back, slip the first stitch and pass the extra cast-on stitch over it **(Figure 3)** and off the needle to complete the buttonhole.

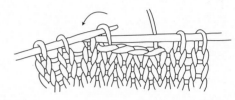

Figure 1

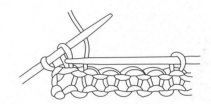

Figure 2

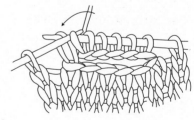

Figure 3

Cast Ons

Backward-Loop Cast-On

*Loop working yarn and place it on needle backward so that it doesn't unwind. Repeat from *.

Cable Cast-On

If there are no stitches on the needles, make a slipknot of working yarn and place it on the left needle, then use the knitted method (see page 173) to cast-on one more stitch—two stitches on needle. When there are at least two stitches on the left needle, hold needle with working yarn in your left hand. *Insert right needle between the first two stitches on left needle (**Figure 1**), wrap yarn around needle as if to knit, draw yarn through (**Figure 2**), and place new loop on left needle (**Figure 3**) to form a new stitch. Repeat from * for the desired number of stitches, always working between the first two stitches on the left needle.

Figure 1 **Figure 2**

Figure 3

Crochet Chain Provisional Cast-On

With waste yarn and crochet hook, make a loose crochet chain (see page 173) about four stitches more than you need to cast on. With knitting needle, working yarn, and beginning two stitches from end of chain, pick up and knit one stitch through the back loop of each crochet chain (**Figure 1**) for desired number of stitches. When you're ready to work in the opposite direction, pull out the crochet chain to expose live stitches (**Figure 2**).

Figure 1 **Figure 2**

Dewdrop Cast-On

This cast-on is a variation of the long-tail method that groups stitches in groups of two on the needle; be sure to work them individually on the next row.

Leave a tail four times the length needed for a long-tail cast-on (see page 173), fold the tail into fourths and place the needle into the fold closest to the end of the tail that is connected to the ball (**Figure 1**). Position the yarn so that the quadruped part (tail) is over your left thumb and the single strand coming from the ball is under your left index finger, as for the long-tail method (**Figure 2**). Hold the tip of the short tail against the needle with your right index finger to keep it from slipping. *Bring the needle under the first group on your thumb, around the top of the first strand on your index finger, then back through the loop on your thumb, just as for the long-tail method (**Figure 3**). Slip the yarn off your thumb and rewrap it in the opposite direction, then insert the needle under the four strands from the inside of the thumb loop, around the single strand of yarn on your finger, and then back under the same four strands on your thumb to cast on another stitch (**Figure 4**). Repeat from * for the desired number of stitches.

Figure 1

Figure 2

Figure 3

Figure 4

Knitted Cast-On

If there are no stitches on the needles, make a slipknot of working yarn and place it on the left needle. When there is at least one stitch on the left needle, *use the right needle to knit the first stitch (or slipknot) on left needle **(Figure 1)** and place new loop onto left needle to form a new stitch **(Figure 2)**. Repeat from * for the desired number of stitches, always working into the last stitch made.

Figure 1 **Figure 2**

Long-Tail (Continental) Cast-On

Leaving a long tail (about ½" [1.3 cm] for each stitch to be cast on), make a slipknot and place on right needle. Place thumb and index finger of your left hand between the yarn ends so that working yarn is around your index finger and tail end is around your thumb and secure the yarn ends with your other fingers. Hold your palm upwards, making a V of yarn **(Figure 1)**. *Bring needle up through loop on thumb **(Figure 2)**, catch first strand around index finger, and go back down through loop on thumb **(Figure 3)**. Drop loop off thumb and, placing thumb back in V configuration, tighten resulting stitch on needle **(Figure 4)**. Repeat from * for the desired number of stitches.

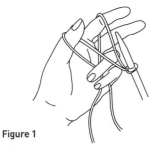

Figure 1

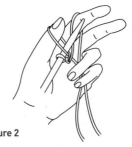

Figure 2

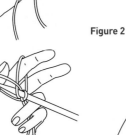

Figure 3

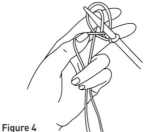

Figure 4

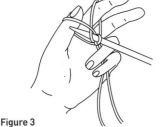

Crochet

Crochet Chain (ch)

Make a slipknot and place it on crochet hook if there isn't a loop already on the hook. *Yarn over hook and draw through loop on hook. Repeat from * for the desired number of stitches. To fasten off, cut yarn and draw end through last loop formed.

Single Crochet (sc)

*Insert hook into the second chain from the hook (or the next stitch), yarn over hook and draw through a loop, yarn over hook **(Figure 1)**, and draw it through both loops on hook **(Figure 2)**. Repeat from * for the desired number of stitches.

Figure 1

Figure 2

Decreases

Purl 2 Together Through Back Loops (p2togtbl)

Bring right needle tip behind two stitches on left needle, enter through the back loop of the second stitch, then the first stitch, then purl them together.

Slip, Slip, Knit (ssk)

Slip two stitches individually knitwise (**Figure 1**), insert left needle tip into the front of these two slipped stitches, and use the right needle to knit them together through their back loops (**Figure 2**).

Figure 1

Figure 2

Slip, Slip, Slip, Knit (sssk)

Slip three stitches individually knitwise (**Figure 1**), insert left needle tip into the fronts of these three slipped stitches, and use the right needle to knit them together through their back loops (**Figure 2**).

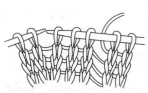

Figure 1

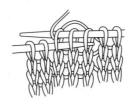

Figure 2

Slip, Slip, Purl (ssp)

Holding yarn in front, slip two stitches individually knitwise (**Figure 1**), then slip these two stitches back onto left needle (they will be twisted on the needle) and purl them together through their back loops (**Figure 2**).

Figure 1

Figure 2

Grafting

Kitchener Stitch

Arrange stitches on two needles so that there is the same number of stitches on each needle. Hold the needles parallel to each other with wrong sides of the knitting facing away from you. Allowing about ½" (1.3 cm) per stitch to be grafted, thread matching yarn on a tapestry needle. Work from right to left as follows:

Step 1. Bring tapestry needle through the first stitch on the front needle as if to purl and leave the stitch on the needle (**Figure 1**).

Step 2. Bring tapestry needle through the first stitch on the back needle as if to knit and leave that stitch on the needle (**Figure 2**).

Step 3. Bring tapestry needle through the first front stitch as if to knit and slip this stitch off the needle, then bring tapestry needle through the next front stitch as if to purl and leave this stitch on the needle (**Figure 3**).

Step 4. Bring tapestry needle through the first back stitch as if to purl and slip this stitch off the needle, then bring tapestry needle through the next back stitch as if to knit and leave this stitch on the needle (**Figure 4**).

Repeat Steps 3 and 4 until one stitch remains on each needle, adjusting the tension to match the rest of the knitting as you go. To finish, bring tapestry needle through the front stitch as if to knit and slip this stitch off the needle, then bring tapestry needle through the back stitch as if to purl and slip this stitch off the needle.

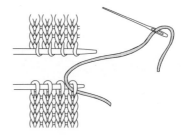

Figure 1

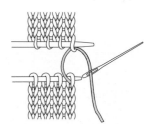

Figure 2

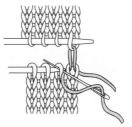

Figure 3

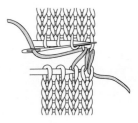

Figure 4

Increases

Raised Make-One (M1) Increase

Note: Use the left slant if no direction of slant is specified.

Left Slant (M1L)

With left needle tip, lift the strand between the last knitted stitch and the first stitch on the left needle from front to back **(Figure 1)**, then knit the lifted loop through the back **(Figure 2)**.

To work this decrease purlwise (M1L purlwise), purl the lifted loop through the back.

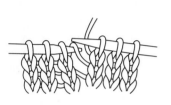

Figure 1

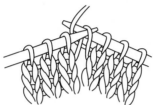

Figure 2

Right Slant (M1R)

With left needle tip, lift the strand between the needles from back to front **(Figure 1)**. Knit the lifted loop through the front **(Figure 2)**.

To work this decrease purlwise (M1R purlwise), purl the lifted loop through the front.

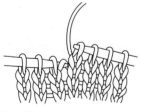

Figure 1

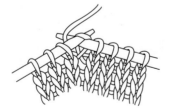

Figure 2

Spacing Increases and Decreases Evenly Across a Row or Round

To determine how to evenly space increases or decreases, divide the number of stitches on your needle by the number of stitches that you want to increase or decrease. For example, if you have 115 stitches and you need to increase 8 stitches, you'd divide 115 by 8:

115 stitches ÷ 8 stitches to increase = 14.375 stitches

In other words, you'll want to increase every 14.375 stitches for an even distribution of the increases. It's not possible to increase within partial stitches, but this number tells you that you'll place most of the increases every 14 stitches and increase every 15 stitches a couple of times. The difference between working some increases at 14-stitch intervals and a few at 15-stitch intervals is unlikely to be noticeable in the garment.

If you are working in rows, you'll want to position the first and last increases (or decreases) at least one stitch in from the selvedge. To prevent the last increase being made in the selvedge stitch, divide the first 14-stitch interval in half, working the first increase after just 7 stitches so that the last increase will be worked 7 stitches in from the end of the row.

Depending on the type of increase you use, you'll either increase in the 14th stitch or after the 14th stitch. For example, knitting in the front and back of a stitch (k1f&b) requires one stitch to be involved in the increase and you'd work the increase in the 14th stitch; making a yarnover or working into the horizontal strand between two stitches (as in a raised make-one increase), doesn't involve any of the existing stitches and you'd work the increases after the 14th stitch.

When working decreases, remember that two stitches are required to work a decrease (k2tog or ssk, for example). This means that you would work 12 stitches, then work the 13th and 14th stitches together to end up with one stitch decreased in 14 stitches.

Join New Ball of Yarn

When working seamless projects in rows, the best place to join is at either end of the row if an edging is to be added. When working in rounds, join yarn at a "seam," the underarm, or at cable crossings or decreases, where the fabric is a bit thicker anyway.

Make a Knot

For most yarns knotting the old and new strands together is not a recommended technique, but it works well with lighter yarns.

Wrap the end from the new ball around the end of the "old" yarn to make a knot close to the needles and give you something to tension against as you continue with the new yarn. If you'd like to remove the knot, do so right before weaving in the ends.

Knit with Two Strands Held Together

Place the end of the new yarn along the "old" yarn, leaving a long enough tail to weave in later. With both strands held together, work one or two stitches in pattern, then drop the old yarn and continue with the new yarn only.

Alternate Knitting One Stitch Each of Two Balls

Alternate knitting one stitch each of the new yarn and the "old" yarn for several stitches to secure both into the knitting. Continue with just the new yarn.

Overlap the Yarns in the Russian Method

In this technique, the new yarn is pulled through a loop created by the old yarn to form a very strong join without any ends to weave in.

Thread the smallest needle possible with a 4" (10 cm) tail of the old yarn and make a loop by inserting the needle inside the plies of the yarn (you may find it helpful to untwist the plies a bit as you do this). Pull the yarn through the plies for 1" (2.5 cm) or so, then let it hang free, leaving a loop at one end. Thread the end of the new yarn onto a tapestry needle, bring it through the loop formed by the old yarn, then insert it inside the plies of the new yarn in the same way to connect the two loops **(Figure 1)**. Pull the loose ends so that the loops tighten together **(Figure 2)** and cut off the excess tails.

Figure 1

Figure 2

Splice the Yarns Together

Splicing forms a very strong and invisible bond between wool yarns; it is ideal for bulky yarns.

Loosen the plies from both the old and new ends of yarn for about 2" (2.5 cm) **(Figure 1)**, moisten the loose ends and overlap them in the palm of your hand **(Figure 2)**, then quickly roll these strands back and forth vigorously with the palms of your hands until the fibers felt together **(Figure 3)**.

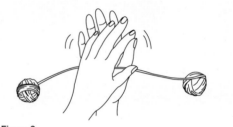

Figure 1 **Figure 2**

Figure 3

Pick Up and Knit

Along CO or BO Edge

With right side facing and working from right to left, insert the tip of the needle into the center of the stitch below the bind-off or cast-on edge **(Figure 1)**, wrap yarn around needle, and pull through a loop **(Figure 2)**. Pick up one stitch for every existing stitch.

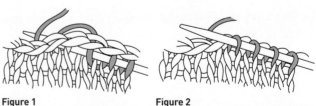

Figure 1 **Figure 2**

Along Shaped or Selvedge Edge

With right side facing and working from right to left, insert tip of needle between last and second-to-last stitches, wrap yarn around needle, and pull through a loop. Pick up and knit about three stitches for every four rows, adjusting as necessary so that the picked-up edge lays flat.

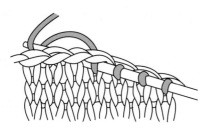

Pick Up and Purl

With wrong side of work facing and working from right to left, *insert needle tip under purl stitch in the last row from the far side to the near side (Figure 1), wrap yarn around needle, and pull a loop through (Figure 2). Repeat from * for desired number of stitches.

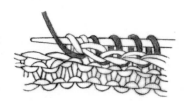

Figure 1

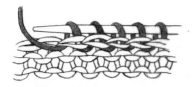

Figure 2

Seams

Mattress Stitch

Place the pieces to be seamed on a table, right sides facing up. Begin at the lower edge and work upward as follows for your stitch pattern:

Stockinette Stitch with One-Stitch Seam Allowance

Insert threaded needle under one bar between the two edge stitches on one piece, then under the corresponding bar plus the bar above it on the other piece (Figure 1). *Pick up the next two bars on the first piece (Figure 2), then the next two bars on the other (Figure 3). Repeat from *, ending by picking up the last bar or pair of bars on the first piece.

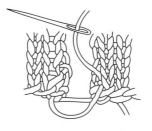

Figure 1 Figure 2

Figure 3

Stockinette Stitch with ½-Stitch Seam Allowance

To reduce bulk in the mattress stitch seam, work as for the one-stitch seam allowance, but pick up the bars in the center of the edge stitches instead of between the last two stitches.

Vertical-to-Horizontal Seam

With yarn threaded on a tapestry needle, pick up one bar between the first two stitches along the vertical edge (Figure 1), then pick up one complete stitch along the horizontal edge (Figure 2). *Pick up the next one or two bars on the first piece, then the next whole stitch on the other piece (Figure 3). Repeat from *, ending by picking up one bar on the vertical edge.

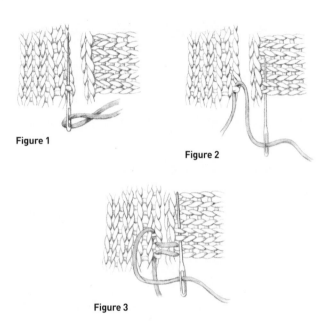

Figure 1

Figure 2

Figure 3

Whipstitch

Hold pieces to be sewn together so that the edges to be seamed are even with each other. With yarn threaded on a tapestry needle, *insert needle through both layers from back to front, then bring needle to back. Repeat from *, keeping even tension on the seaming yarn.

Short-Rows

Knit Side

Work to turning point, slip next stitch purlwise (Figure 1), bring the yarn to the front, then slip the same stitch back to the left needle (Figure 2), turn the work around and bring the yarn in position for the next stitch—one stitch has been wrapped and the yarn is correctly positioned to work the next stitch. When you come to a wrapped stitch on a subsequent row, hide the wrap by working it together with the wrapped stitch as follows: Insert right needle tip under the wrap (from the front if wrapped stitch is a knit stitch; from the back if wrapped stitch is a purl stitch; (Figure 3), then into the stitch on the needle, and work the stitch and its wrap together as a single stitch.

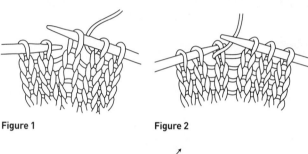

Figure 1

Figure 2

Figure 3

Purl Side

Work to the turning point, slip the next stitch purlwise to the right needle, bring the yarn to the back of the work (Figure 1), return the slipped stitch to the left needle, bring the yarn to the front between the needles (Figure 2), and turn the work so that the knit side is facing—one stitch has been wrapped and the yarn is correctly positioned to knit the next stitch. To hide the wrap on a subsequent purl row, work to the wrapped stitch, use the tip of the right needle to pick up the wrap from the back, place it on the left needle (Figure 3), then purl it together with the wrapped stitch.

Weave in Loose Ends

Thread the ends on a tapestry needle and trace the path of a row of stitches. To keep color changes sharp, work the ends into areas of the same color.

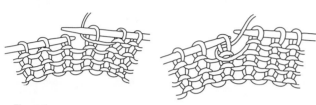

Figure 1

Figure 2

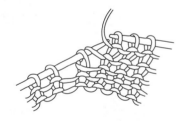

Figure 3

Bibliography

The Harmony Guides: 220 Aran Stitches and Patterns, Vol. 5.
New York: Collins & Brown, 2006.

Hiatt, June Hemmons. *The Principles of Knitting.* New York:
Touchstone, 2012.

Hollingworth, Shelagh. *The Complete Book of Traditional Aran
Knitting.* New York: St. Martin's Press, 1985.

Marchant, Nancy. *Knitting Brioche: The Essential Guide to the
Brioche Stitch.* Cincinnati, OH: North Light Books, 2009.

Starmore, Alice. *Aran Knitting, New and Expanded Edition.*
Mineola, NY: Dover Publications, 2010.

Swansen, Meg. *Handknitting with Meg Swansen.* Pittsville, WI:
Schoolhouse Press, 1995.

TECHKnitting, TechKnitting.blogspot.com.

Sources for Yarns

BERROCO, INC
1 Tupperware Dr., Ste. 4
North Smithfield, RI
02896-6815
berroco.com

BIJOU BASIN RANCH
PO Box 154
Elbert, CO 80106
bijoubasinranch.com

BLUE SKY ALPACAS
PO Box 88
Cedar, MN 55011
blueskyalpacas.com

CASCADE YARNS
PO Box 58168
1224 Andover Pk. E.
Tukwila, WA 98188
cascadeyarns.com

**CLAUDIA HAND
PAINTED YARNS**
40 W. Washington St.
Harrisonburg, VA 22802
claudiaco.com

**KELBOURNE
WOOLENS/
THE FIBRE COMPANY**
2000 Manor Rd.
Conshohocken, PA 19428
kelbournewoolens.com

**KNITTING FEVER
INC./DEBBIE BLISS/
QUEENSLAND
COLLECTION**
PO Box 336
315 Bayview Ave.
Amityville, NY 11701
knittingfever.com

MALABRIGO YARNS
8424 NW 56th St.
#80496
Miami, FL 33166
malabrigoyarn.com

Acknowledgments

We are so grateful to our team at Interweave, who helped us to bring our book to reality.

Special thanks to Ann Budd, our outstanding editor, who worked intensely on this project. We are very grateful for her knowledge, enthusiasm, and endless support. Huge thanks to Lori Gayle, whose clever and precise technical editing skills are incredible, and to our acquisitions editor, Allison Korleski, for believing in us right from the start.

Big thank you to the talented staff that made this book so beautiful: art director Liz Quan, photographer Joe Hancock, hair and makeup artist Kathy MacKay, cover and interior designer Pamela Norman, photo stylist Pamela Chavez, text illustrator Ann Swanson, and production designer Katherine Jackson. We would also like to express a huge thank-you to our sample knitters Irina Semenets, Kim Schneibolk, Karen Morin, Angela Davis, and Marietta Greene, who helped us make some of the projects in this book.

We also would like to thank the yarn companies who donated yarn for the projects in this book: Berroco, Bijou Basin Ranch, Blue Sky Alpacas, Cascade Yarns, Claudia Hand Painted Yarns, Debbie Bliss, The Fibre Company, Malabrigo, Manos del Uruguay, Rowan, Skacel Collection, Queensland Collection Kathmandu, and JUL Designs for gorgeous handles.

It was a privilege to work with all of you.

Index

Wondering what to knit next?

CHECK OUT THESE POPULAR KNITTING BOOKS FOR IDEAS AND INSPIRATION!

Essentially Feminine Knits

25 Must-Have Chic Designs

Lene Holme Samsoe

ISBN 978-1-59668-784-4

$24.95

The Knitter's Handy Book of Top-Down Sweaters

Basic Designs in Multiple Sizes and Gauges

Ann Budd

ISBN 978-1-59668-483-6

$29.95

Finish-Free Knits

No-Sew Garments in Classic Styles

Kristen TenDyke

ISBN 978-1-59668-488-1

$24.95